JAMES S. ACKERMAN

THE ARCHITECTURE OF MICHELANGELO

WITH A CATALOGUE OF MICHELANGELO'S WORKS BY JAMES S. ACKÉRMAN AND JOHN NEWMAN

THE UNIVERSITY OF CHICAGO PRESS

THE UNIVERSITY OF CHICAGO PRESS

The University of Chicago Press, Chicago 60637 Penguin Books Ltd., Harmondsworth, Middlesex, England

© 1961, 1970, 1986 by A. Zwemmer All rights reserved. First edition published 1961 First Penguin Books edition 1970. Second edition 1986

09 08 07 06

78910

Library of Congress Cataloging-in-Publication Data

Ackerman, James S. The architecture of Michelangelo.

Bibliography: p. Includes index. 1. Michelangelo Buonarroti, 1475–1564.—Contribution in architecture. I. Newman, John, 1936– II. Title. NA1123.B9A83 1986 720'.92'4 84-8671 ISBN 0-226-00240-3

Designed by Gerald Cinamon

Printed in the United States of America

(c) The paper used in this publication meets the minimum requirements of the American National Standard for Information Sciences–Permanence of Paper for Printed Library Materials, ANSI Z39.48–1992.

LIST OF ILLUSTRATIONS

- Francesco di Giorgio. Ideal church plan. Florence, Bibl. Naz., Cod. Magliabecchiano, fol. 42v (photograph: Harvard University, Cambridge, Mass.)
- 2. C. Cesariano. Plate from Vitruvius, *De Architectura*, ed. Como, 1521, Bk III, fol. xlix (photograph: Harvard University, Cambridge, Mass.)
- 3. Albrecht Dürer. Study of human proportion. Bremen, Kunsthalle (after Lippmann)
- 4. Profile studies. Haarlem, Teyler Museum, No. 20v (photograph: Teyler Museum)

ROME: CASTEL SANT'ANGELO

- 5. Chapel of Leo X. Exterior (1514) (photograph: Oscar Savio)
- 6. Giovanni Battista da Sangallo. Drawing after Michelangelo's chapel exterior (W. Gernsheim, Florence)

FLORENCE: FAÇADE OF SAN LORENZO

- 7. Giuliano da Sangallo or assistants. Façade project. Uffizi, Arch., 277 (photograph: Alinari)
- 8. Anonymous copy of Michelangelo's first project. Casa Buonarroti, No. 45 (photograph: Alinari)
- 9. Façade project. Casa Buonarroti, No. 91 (photograph: Soprintendenza alle Gallerie, Florence)
- 10. Façade project. Casa Buonarroti, No. 44 (photograph: Soprintendenza alle Gallerie, Florence)
- 11. Façade project. Casa Buonarroti, No. 47 (photograph: Soprintendenza alle Gallerie, Florence)
- 12. Façade project. Casa Buonarroti, No. 43 (photograph: Alinari)
- 13. Wooden model. Casa Buonarroti (photograph: Einaudi)
- 14. San Lorenzo, reliquary tribune (1531-2) (photograph: The Mansell Collection)
- Aristotile da Sangallo. Copy of a project by Michelangelo. Munich, Staatl. graphische Sammlung, No. 33258 (photograph: Staatliche graphische Sammlung)
- 16. Reconstruction of the façade of San Lorenzo from the block sketches and from the contract of January, 1518

FLORENCE: MEDICI CHAPEL

AND CHURCH OF SAN LORENZO

- 17. Interior, towards altar (photograph: Soprintendenza alle Gallerie, Florence)
- 18. The Old Sacristy, San Lorenzo. Filippo Brunelleschi, 1421-9 (photograph: Paolo Monti)
- 19. Church, Library and Cloister of San Lorenzo (after W. and E. Paatz)
- 20. The Medici chapel (after Apolloni)
- 21. Exterior of the Medici chapel (photograph: James Austin)
- 22. Tomb of Giuliano de' Medici (photograph: Soprintendenza alle Gallerie, Florence)
- 23. Interior, towards entrance (photograph: Brogi)
- 24. Tomb project. British Museum, No. 27r (photograph: British Museum, London)
- 25. Vatican, St Peter's. Tomb of Paul II, 1470s. Destroyed (after Ciaconius)
- 26. Tomb project. British Museum, No. 26r (photograph: British Museum, London)
- 27. Plan project. Archivio Buonarroti, Vol. I, 77, fol. 210v.
- 28. Tomb project. British Museum, No. 28r (photograph: British Museum, London)
- 29. Tomb project. British Museum, No. 28v (photograph: British Museum, London)
- 30. Medici tombs. Preliminary (left) and final (right) versions, showing the narrowing of the central bay (redrawn by Paul White)
- 31. Tabernacle over entrance door (photograph: Alinari)
- 32. Florence, Medici palace. Ground-floor window (c. 1517) (photograph: Alinari)
- 33. Sketch-plan for the 'Altopascio' house. Casa Buonarroti, No. 117 (photograph: Soprintendenza alle Gallerie, Florence)
- View of the church, cloister and library from the cathedral campanile. Photo by courtesy of Rollie McKenna (photograph: Rollie McKenna)

FLORENCE: LAURENTIAN LIBRARY

- 35. Interior of the reading-room (photograph: Einaudi)
- 36. Interior of the vestibule looking west (photograph: Alinari)
- 37. Laurentian Library. Longitudinal section and plan (after Apolloni)
- 38. Project for the elevation of the reading-room. Casa Buonarroti, No. 42 (photograph: Soprintendenza alle Gallerie, Florence)
- 39. Sketch for the reading-room ceiling. Casa Buonarroti, No. 126 (photograph: Soprintendenza alle Gallerie, Florence)
- 40. Study for the entrance portal to the reading-room. Casa Buonarroti, No. 111 (photograph: Alinari)

- 41. Michelangelo or assistant. Project for the vestibule elevation. Haarlem, Teyler Museum, No. 33v (photograph: Teyler Museum)
- Study for the west elevation of the vestibule. Casa Buonarroti, No. 48v (photograph: Alinari)
- 43. Studies for the interior elevation and (centre) section of the vestibule wall. British Museum, No. 36 (photograph: British Museum, London)
- 44. Structural system of the Library vestibule
- 45. Vestibule tabernacle (photograph: The Mansell Collection)
- 46. Vestibule stairway (photograph: The Mansell Collection)
- Plan projects for the vestibule (bottom) and a chapel (?top). Casa Buonarroti, No. 89r (photograph: Soprintendenza alle Gallerie, Florence)
- 48. Studies for the vestibule stairway and column profiles. Casa Buonarroti, No. 92v photograph: Soprintendenza alle Gallerie, Florence)
- Studies for the vestibule stairway and column profiles. Casa Buonarroti, No. 92r (photograph: Soprintendenza alle Gallerie, Florence)
- 50. Project for a small study at the south end of the library. Casa Buonarroti, No. 80 (photograph: Soprintendenza alle Gallerie, Florence)

FLORENCE: FORTIFICATIONS

- 51. Baldassare Peruzzi. Plan of Florence's medieval fortifications. Uffizi, Raccolta topografica (after C. Ricci)
- 52. Typical early bastion trace (after 'Delle Maddalene', Verona, 1527)
- 53. Project for the Porta al Prato. Casa Buonarroti, No. 14 (photograph: Alinari)
- 54. Project for gate fortifications. Casa Buonarroti, No. 25 (photograph: Soprintendenza alle Gallerie, Florence)
- 55. Preliminary project for the Prato d'Ognissanti. Casa Buonarroti, No. 15 (photograph: Brogi, Florence)
- 56. Developed project for the Prato d'Ognissanti. Casa Buonarroti, No. 13r (photograph: Brogi, Florence)
- 57. Project for gate fortifications. Casa Buonarroti, No. 27 (photograph: Soprintendenza alle Gallerie, Florence)
- 58. Vauban. Bastioned system with ravelins (*Manière de Fortifier*, Amsterdam, 1689, fig. 8)

ROME: CAPITOLINE HILL

- 59. Pienza, cathedral square. Plan (after Cataldi)
- 60. View (photograph: Leonard von Matt)
- 61. Marten van Heemskerk. View, c. 1535-6 (after Huelsen and Egger)
- 62. H. Cock. Capitoline Hill. View as of c. 1544-5 (Operum Antiquorum

Romanorum ... Reliquiae, Antwerp, 1562) (photograph: British Museum, London)

- 63. Anonymous. View, c. 1554-60. Brunswick, Kupferstichkabinett (photograph: Herzog Anton-Ulrich Museum, Brunswick)
- 64. Anonymous. View, c. 1554-60. Louvre, École d'Italie, No. 11028 (photograph: The Louvre, Paris)
- 65. Plan project, after Michelangelo. Engraving published by B. Faleti, 1567 (partially restored print) (photograph: Avery Library, Columbia University, New York)
- 66. Perspective, after Michelangelo. Engraving by E. Dupérac, 1569 (photograph: Avery Library, Columbia University, New York)
- 67. Michelangelo's project for the Capitoline Hill (after the Dupérac engraving of 1568)
- 68. Francisco d'Ollanda. Statue of Marcus Aurelius with Michelangelo's projected base, 1538–9. Escorial (after Tormò) (photograph: Collections of the Library of Congress)
- 69. Statue of Marcus Aurelius on Michelangelo's base (photograph: Leonard von Matt)
- 70. Palazzo de' Conservatori. View (photograph: John Vincent)
- Palazzo de' Conservatori, partial elevation. Engraving published by B. Faleti, 1568 (photograph: Avery Library, Columbia University, New York)
- 72. Palazzo de' Conservatori, interior of portico (photograph: John Vincent)
- 73. Anonymous fresco. Pagan Worship on the Capitoline Hill. Rome, Pal. Massimo alle Colonne (Gabinetto Fotografico Nazionale, Rome, courtesy W. Lotz)
- 74. Cosmological schema. From a tenth-century (?) manuscript of Isidor of Seville, *De natura rerum* (courtesy Harry Bober)

ROME: FARNESE PALACE

- 75. Entrance façade (photograph: John Vincent)
- 76. Cornice (photograph: The Mansell Collection)
- 77. Section and rear court elevation before remodelling. Engraving by Ferrerio, 1655? (Boston Public Library)
- 78. Anonymous. View of the court, c. 1554-60. Brunswick, Herzog Anton-Ulrich Museum (photograph: Herzog Anton-Ulrich Museum, Brunswick)
- 79. Project for the rear wing, after Michelangelo. Engraving published by A. Lafreri, 1560 (photograph: Metropolitan Museum, New York)
- 80. Court (photograph: Leonard von Matt)
- 81. Upper storeys of court (photograph: The Mansell Collection)
- 82. Court windows, third storey (photograph: The Mansell Collection)

12

- 83. Michelangelo or assistant. Study for a window frame. Oxford, Ashmolean, No. 333v (photograph: Ashmolean Museum, Oxford)
- 84. Façade and project for the square. Engraved by N. Beatrizet, 1549 (photograph: Metropolitan Museum, New York)
- 85. Anonymous. Elevation in 1549. Uffizi, Arch. 4939 (photograph: Ciacchi, Florence)
- 86. Farnese Palace. Plan
- 87. Anonymous. Ground-floor plan, c. 1560. Berlin, Kunstbibliothek Hdz., 4151, fol. 97v (photograph: Kunstbibliothek, Berlin)

ROME: BASILICA OF ST PETER

- 88. Plans for St Peter's
- 89. Caradosso. Medal, 1506, after Bramante's Basilica project (photograph: Mr Sigmund Morgenroth)
- 90. G. Vasari. View in 1546. Rome, Cancelleria palace (photograph: Musei e Gallerie Pontificie, Vatican)
- 91. Construction of St Peter's, 1506-64
- 92. Antonio da Sangallo the Younger. St Peter's project. 1539-45. Engraving by Salamanca, 1545 (photograph: Metropolitan Museum, New York)
- 93. Air view (photograph: Harvard University, Cambridge)
- 94. View from the Vatican gardens (photograph: Leonard von Matt)
- 95. Apse, detail (photograph: Fototeca Unione)
- 96. Dome model, as altered by Giacomo della Porta. Museo Petriano (photograph: Fototeca di Architettura e Topografica, Rome)
- 97. Projects for the dome and lantern. Haarlem, Teyler Museum, No. 29r (photograph: Teyler Museum)
- 98. Michelangelo and assistant (?). Study of the dome. Lille, Musée des Beaux-Arts, No. 93 (after K. Frey)
- 99. South elevation, based on Michelangelo. Engraving by E. Dupérac, 1569? (photograph: Metropolitan Museum, New York)
- 100. Longitudinal section, based on Michelangelo. Engraving by E. Dupérac, 1569? (photograph: Metropolitan Museum, New York)
- 101. B. Peruzzi. Drawing after Bramante's cupola of the Torre Borgia, of 1513. Florence, Uffizi, Arch., 130 (photograph: the author)
- 102. Domenico Passignani. Michelangelo presenting his model to the Pope, 1620. Casa Buonarroti (photograph: Brogi, Florence)
- 103. Exterior elevation. Engraving by V. Luchinus, 1564 (photograph: Metropolitan Museum, New York)
- 104. B. Ammanati? Crossing, looking west, c. 1559-61. Hamburg, Kunsthalle, No. 21311 (after Egger)
- 105. Plan, after Michelangelo. Engraving by E. Dupérac, 1569 (photograph: Avery Library, Columbia University, New York)
- 106. Vatican, Nicchione of the Belvedere, with Michelangelo's stairway (1550-51) (photograph: Musei e Gallerie Pontificie, Vatican)

107. G.-A. Dosio. The Cortile del Belvedere, c. 1558-61. Uffizi, Arch. 2559 (photograph: Soprintendenza alle Gallerie, Florence)

ROME: SAN GIOVANNI DE' FIORENTINI

14

- 108. Plan project, 1559. Casa Buonarroti, No. 121 (photograph: Alinari)
- 109. Antonio da Sangallo the younger. Plan project, c. 1525. Uffizi, Arch. 3185 (photograph: the author)
- 110. Plan project, 1559. Casa Buonarroti, No. 120 (photograph: Alinari)
- 111. Plan project, 1559. Casa Buonarroti, No. 124 (photograph: Alinari)
- 112. T. Calcagni. Plan for Michelangelo's final model. Uffizi, Arch. 3158 (photograph: Soprintendenza alle Gallerie)
- 113. Oreste Vanocci Biringucci. Plan project, after Michelangelo. Siena, Bibl. Comunale, S. IV, I, fol. 42 (photograph: New York University Institute of Fine Arts)
- 114. G.-A. Dosio. View of Michelangelo's first model. Modena, Bibl. Estense, ms. 1775, fol. 140v, 141. Photo by courtesy of E. Luporini (photograph: Dr E. Luporini)
- 115. Site (lower centre, on river bank). From U. Pinardo, Rome plan, published 1555
- 116. J. Le Mercier. View of Michelangelo's final model. Engraving. Photo by courtesy of C. de Tolnay (photograph: Dr C. de Tolnay)
- 117. V. Régnard. View of Michelangelo's final model. Engraving (photograph: Avery Library, Columbia University, New York)

ROME: SFORZA CHAPEL

- 118. Santa Maria Maggiore, Sforza Chapel. Plan (redrawn by Paul White)
- 119. Plan and cross-section. From G. G. de' Rossi, *Disegni di varii altari* ... Rome, n.d., pl. 13 (photograph: Boston Public Library)
- 120. Right Chapel (photograph: The Mansell Collection)
- 121. Detail of Order (photograph: Anderson)
- 122. Façade (destroyed). Paris, Bibliothèque Nationale (photograph: by courtesy of C. de Tolnay)

ROME: PORTA PIA

- 123. City façade (photograph: Einaudi)
- 124. Façade project. Michelangelo and successors. Engraving published by B. Faleti, 1568 (photograph: Harvard University, Cambridge, Mass.)
- 125. S. Serlio. Stage design. *Il secondo libro di prospettiva*, Paris, 1545, fol. 69r (photograph: Harvard University, Cambridge, Mass.)
- 126. The Via Pia, c. 1590. Fresco, Lateran palace, Sala del Concistoro (photograph: Musei e Gallerie Pontifice, Vatican)
- 127. Gate to the villa of Cardinal Rodolfo Pio of Carpi, c. 1565. From

Vignola, *Regole* ..., 1617 (photograph: Avery Library, Columbia University, New York)

- 128. S. Serlio. City-gate design, 1551, *Estraordinario Libro*, Venice, 1560, No. XXX (photograph: Harvard University, Cambridge, Mass.)
- 129. Porta Pia and Santa Maria degli Angeli. From E. Dupérac, Rome plan, published 1577
- 130. Study for the central portal. Casa Buonarroti, No. 106r (photograph: Alinari)
- 131. Study for the central portal. Casa Buonarroti, No. 102r (photograph: Alinari)
- 132. Study for the central portal and other details. Windsor, Royal Library, no. 12769v (photograph: by gracious permission of H.M. the Queen)
- 133. Study for a portal. Haarlem, Teyler Museum, No. A 29 bis (photograph: Teyler Museum)
- 134. Initial façade project, 1561. Medal of Pius IV, reverse (photograph: Musei e Gallerie Pontificie, Vatican)

ROME: SANTA MARIA DEGLI ANGELI

- 135. F. Martinelli. View into the chancel. *Roma ricercata*, Rome, 1644 (photo from 1700 ed.) (photograph: Harvard University, Cambridge, Mass.)
- 136. The great hall today (photograph: Leonard von Matt)
- 137. Santa Maria degli Angeli. Plan
- 138. View of chancel and south-east vestibule. From F. Bianchini, De Kalendario ..., Rome, 1703 (photograph: British Museum, London)
- 139. G. Franzini. Altar in its original position. *Le cose meravigliose . . . di Roma*, Venice, 1588 (photograph: Harvard University, Cambridge, Mass.)
- 140. G.-A. Dosio. View, c. 1565. Uffizi, Arch., 2576

This book was published first in 1961 by Zwemmer in London, with separate text and catalogue volumes; the text alone was issued the same year by Viking in New York. A revised edition of the Catalogue appeared in London in 1964, and of the text in 1966; further revisions were made for the Italian edition of 1968 (Einaudi, Turin), and for the first Penguin edition of 1970. At that time the Catalogue was abridged with the help of John Newman. The present edition has been again extensively revised, particularly in the Catalogue supplement, with the assistance of Beverly Brown, to account for scholarly contributions since 1970, which amount to some seventy additions to the Bibliography.

The text is unchanged except for portions affected by recent contributions, particularly those of Dal Poggetto and Elam following the discovery of Michelangelo's mural drawings in the Sacristy of S. Lorenzo in Florence; Buddenseig on the Capitoline Hill; Frommel, Lotz, Spezzaferro and Tuttle on the Farnese Palace; Millon and Smyth, Saalman and Keller on St Peter in the Vatican; Schwager on San Giovanni dei Fiorentini and the Porta Pia. The publication of Tolnay's handsome and comprehensive drawing catalogue is a significant contribution to Michelangelo research. Some of the essays in the richly illustrated *Michelagniolo Architetto* edited by Portoghesi and Zevi offer stimulating alternatives to my analyses.

Cambridge, Mass., February 1984

It is one of the delights of art historical studies that our predecessors have not exhausted - or even adequately surveyed - subjects as stimulating as Michelangelo's architecture. A foundation was laid in this field by H. von Geymüller's monograph of 1904 which, however, dealt principally with the Florentine projects, and was already outdated following the systematic publication of drawings and documents by Karl Frey and Henry Thode before and during the First World War. Dagobert Frey's book on the later buildings (1920) initiated a fifteen-year period of basic research including many studies by Charles de Tolnay (notably the Prussian Jahrbuch articles of 1930-32) and Rudolf Wittkower's exemplary work on the Laurentian library (1934). The first and only comprehensive survey is Armando Schiavo's La vita e le opere architettoniche di Michelangelo (1953), which contains some useful original scholarship but otherwise is vitiated by the author's ignorance of essential writings published outside Italy. It would be impossible even today to solve many of the historical problems raised by Michelangelo's architecture if Charles de Tolnay and Johannes Wilde had not further developed the meticulous science of Karl Frey and enriched it with rare sensitivity in analysis and criticism. They are leaving to their successors an impression that no useful tools of Michelangelo's scholarship remain untouched.

It seems unjust that this book, which owes so much to Tolnay's publications, should appear before his own on the same subject, long planned as the sixth and final volume of his Michelangelo monograph; but I trust that the following pages, by their occasional divergence from Tolnay's conclusions as well as by their tokens of the riches to be expected from his writings, may further whet the reader's appetite for the anticipated work.

When I first discussed my project with the editors of this series in 1956, I proposed to write a critical summary based on knowledge of Michelangelo's architecture as it had been established by others. But I soon found that a thorough re-study of the original sources for each building was needed to answer even basic questions of chronology and authorship. The change of emphasis and of scope threatened to appeal to specialists alone, and this neither the editors nor I intended; so my solution was to write, in a sense, both books: a general text for the non-specialist, composed of essays on Michelangelo's major designs in the context of comparable Renaissance structures, and a Catalogue for colleagues and students, where the history of each structure and the genesis of its design is reconstructed by the analysis of documents, letters, drawings, views and other sources.

In the text, as in the Catalogue, I have treated each building separately in order to avoid clouding my conclusions by pre-conceived images of Michelangelo's style and its 'evolution'. For similar reasons I have not referred to one of the most successful artifacts of twentieth-century art history - the concept of Mannerism. Though there is disagreement on the chronological and geographical limits of the Mannerist style in architecture, nearly every definition includes - or begins with - the Laurentian library and occasionally other designs of Michelangelo. I believe that while the concept of Mannerism has facilitated criticism in the past, gradually it has come to obstruct our perception by urging us to find in the work of art what our definition of it states we must find. The same may be said of the Baroque, a category into which Michelangelo was placed by critics of the period before the invention of Mannerism. While we do find in Michelangelo's buildings characteristics which conform to our definitions of the Baroque, it is surely more illuminating to say that they aroused architects of the seventeenth century to emulation rather than that Michelangelo 'anticipated' Baroque architecture or that his design was 'proto-Baroque', as if he had miraculously benefited from a glimpse into the future. In short, my approach has been guided by the conviction that generalizations on style should emerge from, rather than guide the examination of works of art themselves.

Because the Catalogue traces the evolution of each design by means of graphic sources, and because it discusses minor as well as major projects, the reader will find illustrations among the plates to which no reference is made in the text volume. To reduce production costs, we have restricted the size of many of the documentary illustrations; all but a few are handsomely reproduced elsewhere. The scholarly apparatus has been condensed wherever possible; Catalogue references are shortened to include only the surname of the author and the date of his work, and I hope to have lessened the reader's discomfort by following the same unconventional pattern in the bibliography. Notes appear only where it is necessary to supplement the references in the Catalogue. I have also economized on the citation of studies that have been superseded by recent research which incorporates their findings (e.g., the classification of drawings by Thode [1908-13] and Berenson [1938], now supplanted - at least for architectural studies - by Dussler, Die Zeichnungen des Michelangelo, of 1959; the K. Frey catalogue [1901-11] remains valuable because every entry is reproduced in facsimile). While adopting British orthography, I have retained one Americanism: what I refer to as the second and third storeys of a structure are known in Europe as the first and second storeys respectively.

With warm gratitude I acknowledge the assistance I have had from many students, colleagues and friends: Carroll Brentano and Elizabeth Breckenridge who helped me with

Preface to the First Edition • 21

research; Frank Krueger, Gustavo de Roza and Timothy Kitao, whose draughtsmanship brought life to my reconstructions, and the Research Fund of the University of California, which helped to provide this aid as well as a large part of the photographic material. Lapses in my chronology of St Peter's were keenly detected by Susan Mc. Killop.

Walter Gernsheim, Eugenio Luporini, Walter and Elizabeth Paatz, Herbert Siebenhüner and Charles de Tolnay have generously allowed me to reproduce illustrations made by or for them and have otherwise helped with their advice. I have been graciously assisted in locating and procuring photographs by Luciano Berti, Ulrich Middeldorf, Michelangelo Muraro, Janes van Derpool, Carl Weinhardt, jn., and particularly by Ernest Nash of the *Fototeca di architettura e topografia* in Rome. Four plates by John Vincent reproduced here are among the fruits of a campaign of architectural photography which he kindly undertook with me in the summer of 1956; others I owe to the generosity of Rollie McKenna, Sigmund Morgenroth and Leonard von Matt.

I am particularly grateful to Elizabeth MacDougall for sharing with me her discoveries on the later buildings, especially the Porta Pia, to Wolfgang Lotz for more ideas than I can account for, much less acknowledge, and to John Coolidge for his brilliant intuitions concerning the early works.

When the bulk of my manuscript was completed, it had the rare good fortune of being read by three scholars supremely qualified to judge it: Charles de Tolnay, Johannes Wilde and Rudolf Wittkower; their comments have led to substantial improvements, as have those of my wife, whose wise criticisms of style have saved the reader incalculable anguish.

Berkeley, California, June 1960

THE ARCHITECTURE OF MICHELANGELO

INTRODUCTION

In the early years of the sixteenth century the extraordinary power, wealth and imagination of the Pope, Julius II della Rovere (1503-13), made Rome the artistic centre of Italy and of Europe and attracted there the most distinguished artists of his age. Chiefly for political reasons, the rise of Rome coincided with the decline of great centres of fifteenth-century Italian culture: Florence, Milan and Urbino. The new 'capital' had no eminent painters, sculptors, or architects of its own, so it had to import them; and they hardly could afford to stay at home. This sudden change in the balance of Italian culture had a revolutionary effect on the arts; while the fifteenth-century courts and citystates had produced 'schools' of distinct regional characteristics, the new Rome tended to encourage not so much a Roman as an Italian art. No creative Renaissance artist could fail to be inspired and profoundly affected by the experience of encountering simultaneously the works of ancient architects and sculptors - not only in the everpresent ruins but in dozens of newly founded museums and collections - and those of his greatest contemporaries. Like Paris at the beginning of the present century, Rome provided the uniquely favourable conditions for the evolution of new modes of perception and expression.

I described the results as revolutionary. Since Heinrich Wölfflin's great work on this period,¹ the traditional concept of the High Renaissance as the ultimate maturing of the aims of the fifteenth century has been displaced by an awareness that many of the goals of early sixteenth-century artists were formed in vigorous opposition to those of their teachers. What Wölfflin saw in the painting and sculpture was characteristic of architecture too.

But there is an important difference in the architectural 'revolution': it was brought about by one man, Donato Bramante (1444-1514). This reckless but warranted generalization was concocted by a contemporary theorist, twenty-three years after Bramante's death; Sebastian Serlio called him 'a man of such gifts in architecture that, with the aid and authority given him by the Pope, one may say that he revived true architecture, which had been buried from the ancients down to that time'.² Bramante, like Raphael, was born in Urbino; he was trained as a painter and ultimately found a position at the court of Milan under Lodovico Sforza. Already in his first architectural work of the late 1470s his interest in spatial volume, three-dimensional massing and perspective illusions distinguishes him from his contemporaries, though the effect of his innovations was minimized by a conservative and decorative treatment of the wall surfaces. When Milan fell to the French at the end of the century, Bramante moved on to Rome, where the impact of his first introduction to the grandiose complexes of ancient architecture rapidly matured his style. The ruins served to confirm the validity of his earlier goals; they offered a vocabulary far better suited to his monumental aims than the fussy terracotta ornament of Lombardy, and they provided countless models in which his ideal of volumetric space and sculptural mass were impressively realized.

Architecture is a costly form of expression, and the encounter of a uniquely creative imagination with a great tradition could not have been of much consequence without the support of an equally distinguished patron. That Julius II sought to emulate the political grandeur of the Caesars just as Bramante learned to restore the physical grandeur of ancient Rome continually delights historians, because the occasion may be ascribed with equal conviction to political, social, or economic determinants, to the chance convergence of great individuals, or to a crisis of style in the arts.

26

Almost immediately after his election in 1503, Julius chose Bramante, who at the time had completed only one Roman building, the Cloister of Santa Maria della Pace (1500), to lead his majestic architectural and urban programme; the Pope found in his work the echo of his own tastes for monumentality and lost interest in Giuliano da Sangallo, the brilliant but more conservative Florentine architect whom he had consistently patronized when a Cardinal. In 1504 Julius commissioned Bramante to design a new façade for the Vatican palace and the huge Cortile del Belvedere; in the following year he asked for designs for the new St Peter's, to replace the decaying fourth-century Basilica. Another commission of unknown date initiated projects for a 'Palace of Justice' that would have rivalled the Vatican if it had been finished.

Bramante's Tempietto in San Pietro in Montorio was completed (c. 1506?) before the papal buildings had emerged from the ground. This building, though one of the smallest in Rome, is the key to High Renaissance architecture because it preserves traditional ideals while establishing the forms of a new age. It is traditional in being a perfect central plan, a composition of two abstract geometrical forms: the cylinder and the hemisphere. But fifteenth-century geometry had never (except in the drawings of Leonardo, which surely influenced Bramante) dealt so successfully with solids: buildings before Bramante, even those with some sense of plasticity, seem to be composed of planes - circles and rectangles rather than of cylinders and cubes - and to be articulated by lines rather than by forms. In the *Tempietto* the third dimension is fully realized; its geometric solids are made more convincing by deep niches that reveal the mass and density of the wall. Members are designed to mould light and shade so as to convey an impression of body. We sense that where the earlier architect drew buildings, Bramante modelled them. Because the Tempietto recites the vocabulary of ancient architecture more scrupulously than its predecessors, it is often misinterpreted as an imitation of a Roman temple. But just the feature that so profoundly influenced the future - the high drum and hemispherical dome - is without precedent in antiquity, a triumph of the imagination.

In the projects for St Peter's [88a, 89] the new style attains maturity. Here for the first time Bramante manages to coordinate his volumetric control of space and his modelling of mass. The key to this achievement is a new concept of the relationship between void and solid. Space ceases to be a mere absence of mass and becomes a dynamic force that pushes against the solids from all directions, squeezing them into forms never dreamed of by geometricians. The wall, now completely malleable, is an expression of an equilibrium between the equally dynamic demands of space and structural necessity. Nothing remains of the fifteenth-century concept of the wall as a plane, because the goal of the architect is no longer to produce an abstract harmony but rather a sequence of purely visual (as opposed to intellectual) experiences of spatial volumes. It is this accent on the eye rather than on the mind that gives precedence to voids over planes.

Bramante's handling of the wall as a malleable body was inspired by Roman architecture, in particular by the great baths, but this concept of form could not be revived without the technique that made it possible. The structural basis of the baths was brick-faced concrete, the most plastic material available to builders. For the Roman architect brick was simply the material that gave rigidity to the concrete, and protected its surface. In the Middle Ages the art of making a strong concrete was virtually forgotten, and bricks, now used as an inexpensive substitute for stone blocks, lost the flexibility afforded by a concrete core. Bramante must have rediscovered the lost art of the Romans. The irrational shapes of the plan of St Peter's [88a] are inconceivable without the cohesiveness of concrete con-

Introduction · 29

struction, as are the great naves of the Basilica, which could not have been vaulted by early Renaissance structural methods.³ Bramante willed to Michelangelo and his contemporaries an indispensable technical tool for the development of enriched forms.

In the evolution of the design of St Peter's, Bramante left for Michelangelo the realization of an important potential in the malleability of concrete-brick construction; for in spite of his flowing forms, the major spatial volumes of his plan are still isolated from one another. The chapels in the angles of the main cross and, more obviously, the four corner towers, are added to the core rather than fused into it, as may be seen more clearly in elevations [89].

The dynamic characterization of space and mass which was the essence of Bramante's revolution is equally evident in his secular buildings, even when he was concerned primarily with facades. In the fifteenth century it was the nature of a facade to be planar, but Bramante virtually hid the surface by sculptural projections (half-columns, balconies, window pediments, heavy rustications) and spatial recessions (ground-floor arcades and loggias on the upper storey, as in the court of the Belvedere and the façade of the Vatican). These innovations are not motivated by mere distaste for the flat forms of the early Renaissance façade but by a positive awareness of the range of expression available in a varied use of light. His projections capture the sun in brilliant highlights and cast deep shadows; his half-columns softly model the light; his loggias create dark fields that silhouette their columnar supports. In the facades, as in the interior of St Peter's, the purely sensual delights of vision inspire the design. The philosophical impulse of fifteenth-century architecture had become sensual.

Bramante's style rapidly changed the course of Renaissance architecture. This was due not only to its novelty, but to the unprecedented situation created by the great size of his papal projects: for the first time in the Renaissance it became necessary to organize a modern type of architectural firm with a master in charge of a large number of younger architects who were in one sense junior partners, in another sense pupils. Almost every eminent architect of the first half of the sixteenth century. Michelangelo excepted, worked under Bramante in the Vatican 'office': Baldassare Peruzzi, Raphael, Antonio da Sangallo, Giulio Romano and perhaps Jacopo Sansovino. Of these only Peruzzi actually practised architecture before Bramante's death (e.g. the Villa Farnesina in Rome, 1509); the others learned their profession at the Vatican and later developed Bramante's innovations into individual styles that dominated the second quarter of the century. The effect was felt all over Italy: Peruzzi built in Siena, Raphael in Florence, Sansovino in Venice, Giulio in Mantua and Sangallo throughout the Papal States. The death of Julius II in 1513 and of Bramante in 1514 simultaneously removed the coauthors of High Renaissance architecture, leaving the monumental Basilica and palaces in such an inchoate state that the next generation found it hard to determine precisely what the original intentions had been. Paradoxically, this was a favourable misfortune, because it liberated the imagination of the younger architects just as they reached maturity. Raphael, Peruzzi and Sangallo, inheriting the leadership of St Peter's and the Vatican, were free to compose variations on the theme of their master, and were actually encouraged to do so by successive popes who wanted distinctive evidence of their own patronage.

The fact that Michelangelo's career as an architect began in 1516 is directly related to this historical scene. Michelangelo's animosity towards the powerful Bramante kept him out of architecture during Bramante's lifetime. But the election of a Medici, Leo X (1513-21), as the successor to Julius II, provided opportunities in Florence. Leo, although he chose Bramante's chief disciple, Raphael, to continue the Vatican projects, needed an architect to complete the construction of San Lorenzo, the major Medici monument in Florence. Michelangelo was the obvious choice for this job because he was not only the leading Florentine artist but also a sculptor-painter, ideally equipped to carry out the half-figurative, half-architectural programme envisaged by the Medici family. Besides, the commission served the dual purpose of removing Michelangelo from Rome and of frustrating the completion of the Tomb of Julius II, which would have competed with Medici splendour.

Although Michelangelo's achievements in Florence proved that he was as eminent in architecture as in the other arts, he was excluded from any important Roman commissions so long as any member of Bramante's circle was alive. When Antonio da Sangallo died in 1546, the only member of the circle who survived was Giulio Romano (Raphael d. 1520, Peruzzi d. 1536), and it is significant that the Fabbrica of St Peter's called Giulio from Mantua to forestall Michelangelo's appointment as chief architect. But his death, immediately following Sangallo's, finally left the field open to Michelangelo, now seventyone years old.

Yet Michelangelo's personal conflict with Bramante cannot by itself explain why the intrigues that it engendered were so successful in excluding him from architectural commissions in Rome. That the popes of this period – Leo X, another Medici Clement VII (1523-34), and Paul III, Farnese (1534-49) – recognized Michelangelo's pre-eminence is proven by the fact that they tried to monopolize his services as a painter and sculptor. The Medici were even willing to retain him as an architect in Florence after he had fought against them for the independence of the city. The long delay in recognition at Rome must be attributed to the unorthodoxy of his style. It lacked what Vitruvius called *decorum*: a respect for classical traditions. And in the first half of the century cultivated Roman taste was attuned to a correct antique vocabulary in a classic context. Bramante had formed this taste, and it took a generation to assimilate his innovations.

Raphael was the ideal successor to Bramante. That his concerns as a painter for massive forms and volumetric space in simple compositions of geometric solids were a counterpart of Bramante's architectural goals may be seen in such architectural frescoes as the School of Athens and the Expulsion of Heliodorus. Consequently when he succeeded to Bramante's post he could pursue his own interests and at the same time design almost as Bramante would have done if he had lived another six years. If Raphael had been less sympathetic to his master, his architecture would certainly be better known. But in major Vatican works, at the Cortile di San Damaso and Belvedere, the two designers are indistinguishable, and uncertainty about the authorship of projects for St Peter's has always worried us. In his work outside the papal circle - Palazzo Branconio d'Aquila, Villa Madama in Rome, and Palazzo Pandolfini in Florence -Raphael developed Bramantesque principles and vocabulary into a more individualized expression notable for its greater sophistication, elegance of decoration, and for its success in binding into a unity masses and spaces that Bramante had tended to individualize. The propriety of Raphael's accession to Bramante's throne is further shown by the fact that the very qualities which distinguish him from his predecessor - moderation, respect for continuity, sophistication and elegance, unification of discrete elements - also distinguish his patron, Leo X, from Julius II.

A comparable poetic justice guided the careers of other Bramante followers. Peruzzi, who often worked with the linear and planar means of fifteenth-century architecture while concentrating his great ingenuity on exploring new forms and rhythms in plan and elevation (he was the first to exploit the oval plan and curved façade), was employed more in his native Siena than in Rome. That medieval town must have valued him rather for his superficial con-

Introduction · 33

servatism than for the extraordinary inventiveness which had too little opportunity for expression, and which now can only be appreciated properly in hundreds of drawings preserved in the Uffizi Gallery.

Giulio Romano, whose three or four small Roman palaces represent a revolt against Bramante's grandeur in the direction of repression, tightness, and an apparently polemic rejection of plasticity and volume, found himself more at home outside Rome, in the court of Mantua, where the tensions induced by the weakness of humanist duchies in a world of power-states could be given expression in a Mannerist architecture of neurotic fantasy (the Ducal palace, Palazzo del Tè).

So the Rome that rejected Michelangelo was equally inhospitable to other non-classic architects. Though Peruzzi, as a Bramante follower, was frequently given a chance to aid in the design of St Peter's and the Vatican and to compete for major commissions (San Giovanni dei Fiorentini and the great hospital of S. Giacomo degli Incurabili), he never was chosen as a chief architect. The victor was always Antonio da Sangallo the Younger, who gave the classic movement its definitive form.

Sangallo's dictatorship in the style of 1520-45 can be explained more by his propriety than by his eminence; he was probably the least gifted of Bramante's pupils. The first major Renaissance architect to be trained exclusively in the profession, he began as a carpenter at the Vatican in the early years of the century. His practice never had to be set aside for commissions in the other arts and, being a gifted organizer and entrepreneur, he was able not only to undertake all the important civil and military commissions of the papacy but those of private families, among them the Farnese, as well. Nearly a thousand surviving drawings in the Uffizi are evidence of vast building activity throughout central Italy. He is distinguished less for his innovations than for his capacity to apply the experiments and aesthetic of the High Renaissance to the complete repertory of Renaissance building types. The facade of Santo Spirito in Sassia in Rome is the uninspired source of later sixteenthcentury facade design; the Banco di Santo Spirito (Rome) has a two-storey colossal order over a drafted basement in a context that delighted Baroque architects and has never been entirely abandoned; the Farnese Palace [75] is the definitive secular structure of the Roman Renaissance. though major components of its design were anticipated by Bramante and Raphael. It is in the plans and models of St Peter's that the symptomatic weakness of Antonio's architecture may be seen [88c, 92]. The project is unassailable on the grounds of structure or of Vitruvian decorum, but it is confusing in its multiplicity: infinite numbers of small members compete for attention and negate the grandeur of scale required by the size of the building; the dome is obese, and the ten-storeved campanili are Towers of Babel. Antonio's superior technical and archaeological knowledge proved to be no guarantee of ability to achieve coherence or to control fully such raw materials of architecture as space, proportion, light and scale.

Sangallo, as the first architect of the Renaissance trained in his profession, knew more than his contemporaries about the technical aspects of construction. He was frequently called upon to right major faults in Bramante's structures: to fortify the piers of St Peter's and the foundations of the Vatican façade, to rebuild the loggia of the Belvedere, which collapsed in 1536, all of necessity to the detriment of the original design. But technical competence was not a pre-eminent qualification in the eyes of Renaissance critics: Bramante, though called *maestro ruinante* in allusion to his engineering failures, was universally recognized as the superior architect. Of course, this may be attributed simply to a difference in creative ability, or genius, or whatever one may call it, but it raises an important question for Renaissance architecture, and for Michelangelo in particular: was it possible, in the age of Humanism, for an individual to be fully successful as a specialist? Sangallo, in gaining the advantage of a long apprenticeship in architectural construction, lost the benefits of a generalized body of theoretical knowledge and principles traditionally passed on in the studios of painters and sculptors. Problems of proportion, perspective (the control of space), composition, lighting, etc., as encountered in the figurative arts, were more important in the development of Renaissance architecture than structural concerns, partly because, by contrast to the Gothic period or to the nineteenth century, technology was restricted to a minor role.

It is difficult today to appreciate the Renaissance view that sculptors and painters were uniquely qualified as architects by their understanding of universal formal problems. The view was vindicated by the fact that it was the artist who made major technical advances - the technician merely interpreted traditional practices.

The Renaissance architect was forced into a preoccupation with broad principles in one way or another. First of all, he had to find a way to justify a revival of pagan grandeur in a Christian society; this involved, among other dilemmas, a rationalization of the conflicting architectural principles of antiquity and the Middle Ages. Further, as is demonstrated by Sangallo's failure to construct a theory out of devoted study of Vitruvius and Roman monuments, antiquity itself taught no clear and consistent body of principles. To give order to a chaos of inherited concepts, many Renaissance architects - Alberti, Francesco di Giorgio and others in the fifteenth century, Palladio in the sixteenth developed and published theories of architecture of a metaphysical-mathematical cast. But formalized philosophies were not the sole solution; it is intriguing that nothing was written about architecture (or any other art) in the High Renaissance. This reveals a desire to solve the same problems in a new way; a reaction in all the arts against the

abstract principles of the fifteenth century produced a temporary shift from intellectual-philosophical precepts to visual and psychological ones that could better be expressed in form than in words. This change of emphasis is a key to Michelangelo's achievement, and for this reason I begin the study of his work with some observations on what we know of his architectural ideas.

36

[1] MICHELANGELO'S 'THEORY' OF ARCHITECTURE

Michelangelo, one of the greatest creative geniuses in the history of architecture, frequently claimed that he was not an architect.¹ The claim is more than a sculptor's expression of modesty: it is a key to the understanding of his buildings, which are conceived as if the masses of a structure were organic forms capable of being moulded and carved, of expressing movement, of forming symphonies of light, shadow and texture, like a statue. The only surviving evidence of Michelangelo's theory of architecture is the fragment of a letter of unknown date and destination in which this identity of architecture with painting and sculpture is expressed in a manner unique in the Renaissance:

Reverend Sir (Cardinal Rodolfo Pio?): When a plan has diverse parts, all those (parts) that are of one kind of quality and quantity must be adorned in the same way, and in the same style, and likewise the portions that correspond [e.g. portions in which a feature of the plan is mirrored, as in the four equal arms of St Peter's]. But where the plan is entirely changed in form, it is not only permissible but necessary in consequence entirely to change the adornments and likewise their corresponding portions; the means are unrestricted (and may be chosen) at will [or: as the adornments require]; similarly the nose, which is in the centre of the face, has no commitment either to one or the other eye, but one hand is really obliged to be like the other and one eye like the other in relation to the sides (of the body), and to its correspondences. And surely, the architectural members derive [*dipendono*] from human members. Whoever has not been or is not a good master of the figure and most of all, of anatomy, cannot understand anything of it.²

It is not unusual for Renaissance theorists to relate architectural forms to those of the human body; in one way or another this association, which may be traced back to ancient Greece and is echoed in Vitruvius, appears in all theories of the age of Humanism. What is unique in Michelangelo is the conception of the simile as a relationship which might be called organic, in distinction to the abstract one proposed by other Renaissance architects and writers. It is anatomy, rather than number and geometry, that becomes the basic discipline for the architect; the parts of a building are compared, not to the ideal overall proportions of the human body but, significantly, to its functions. The reference to eyes, nose and arms even suggests an implication of mobility; the building lives and breathes.

The scrap of a letter cannot be taken as evidence of a theory of architecture: in fact, it expresses an attitude which in the Renaissance might have been called anti-theoretical. But there is more in it than the fantasy of a sculptor, and it may be used as a key to the individuality of Michelangelo's architectural style, primarily because it defines his conscious and thoroughgoing break with the principles of early Renaissance architecture.

When fifteenth-century writers spoke of deriving architectural forms from the human body, they did not think of the body as a living organism, but as a microcosm of the universe, a form created in God's image, and created with the same perfect harmony that determines the movement of the spheres or musical consonances.³ This harmony could not be discovered empirically, since it was an ideal unattainable in actuality, but it could be symbolized mathematically. Thus the ideal human form was expressed either in numerical or geometrical formulae: numerical proportions were established for the body that determined simple relationships between the parts and the whole (e.g., head: body = 1:7) or the body was inscribed within a square or a circle or some combination of the two, sometimes with the navel exactly in the centre. Architectural proportions and forms could then be associated with these formulae [1].

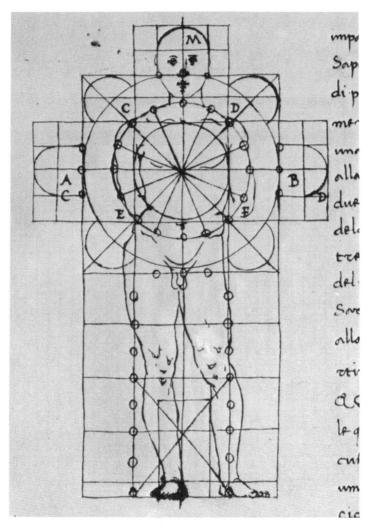

Michelangelo's 'Theory' of Architecture · 39

1. Francesco di Giorgio. Ideal church plan

This entirely intellectual attempt to humanize architecture really made it peculiarly abstract, for rather than actually deriving useful mathematical symbols and proportions from a study of the body, it forced the body, like Procrustes, into figures already idealized by a long metaphysical tradition traceable to Plato and Pythagoras [2].

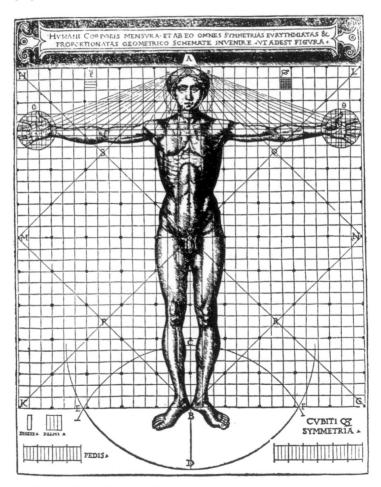

^{2.} C. Cesariano. Vitruvian figure, 1521

40

Michelangelo's 'Theory' of Architecture · 41

The perfect mathematical figures and ratios and the way in which they were used to establish the form and proportions of buildings remained quite unaffected by this attempt to 'humanize' them. But if reference to the human body was superfluous in practice, it gave fifteenth-century architects a timely philosophical justification for their method and helped to transform them from medieval craftsmen to Renaissance humanists.

If the human body was to be adapted by the fifteenthcentury theorist to a system of proportions, it had to be treated as a static object to be analysed into a complex of numerically or geometrically interrelated parts. This method inevitably emphasized units: the whole became a harmony among discrete members. By contrast, Michelangelo's demand for an architecture based on anatomy was motivated by a desire to restore the indivisibility of the human form, a unity to be found in the function of the brain and of the nerve and muscle systems, rather than in external appearances.

Michelangelo was fully aware of the significance of these differences and felt compelled to attack the abstract analytical principles of his predecessors and contemporaries. Condivi noted (chapter LII):

I know well that when he read Albrecht Dürer,⁴ it seemed to him a very weak thing, seeing with his (great) insight how much more beautiful and useful was his own concept of this problem [the human figure]. And to tell the truth, Albrecht deals only with the measurement and variety of bodies, concerning which no sure rule can be given, conceiving his figures upright like posts [3]. But what is more important, he says not a word about human actions and gestures.

At the same time, Condivi speaks of Michelangelo's desire to write a treatise on anatomy with emphasis on human *moti* and *apparenze*. Obviously this treatise would not have made use of abstract ratio and geometry; nor would it have been the more empirical one that Leonardo might have written; for the words *moti* (suggesting 'emotions' as well as 'motions') and *apparenze* imply that Michelangelo would have emphasized the psychological and visual *effects* of bodily functions.

Michelangelo sensed the necessary relationship between the figurative penetration into human beings that gave his art its unique psychological force, and a literal penetration that would reveal the workings of nerves, muscles and bones. His study of anatomy, in contrast to Leonardo's,

3. Albrecht Dürer. Proportion study

42

Michelangelo's 'Theory' of Architecture · 43

was motivated by an incalculably important shift from an objective to a subjective approach to reality.

Early Renaissance theories of proportion, when applied to buildings, produced architecture that was abstract in the sense that its primary aim was to achieve ideal mathematical harmonies out of the interrelationship of the parts of a building. Simple geometrical figures were preferred for the plan; walls and openings were thought of as rectangles that could be given a desired quality through the ratio of height to width. Given the basic concept of well-proportioned planes, the ultimate aim of architectural design was to produce a three-dimensional structure in which the planes would be harmonically interrelated. At its best, this principle of design produced a highly sophisticated and subtle architecture, but it was vulnerable to the same criticism that Michelangelo directed against the contemporary system of figural proportion. It emphasized the unit and failed to take into account the effect on the character of forms brought about by movement - in architecture, the movement of the observer through and around buildings - and by environmental conditions, particularly light. It could easily produce a paper architecture more successful on the drawing board than in three dimensions.

Towards the end of the fifteenth century, architects and painters began to be more concerned with three-dimensional effects, particularly those produced by solid forms emphasized by gradations of light and shadow. Leonardo pioneered in the movement away from the planar concept of architecture in a series of drawings which, while still dependent for their effect on mathematical ratios, employed the forms of solid, rather than of plane, geometry: cubes, cylinders, hemispheres. Leonardo's theoretical experiments must have inspired the extraordinary innovations of Bramante discussed in the introduction. These innovations, which substituted mass and spatial volume for planar design, cannot, however, be taken as evidence of a fundamental change in architectural theory. I believe that Bramante still thought in terms of proportion and ratio, as demonstrated by his tendency to emphasize the interplay of distinct parts in a building. In his project for St Peter's the exterior masses and interior spaces are semi-independent units harmoniously related to the central core [89].

Seen in this perspective, Michelangelo's approach to architecture appears as a radical departure from Renaissance tradition. His association of architecture with the human form was no longer a philosophical abstraction, a mathematical metaphor. By thinking of buildings as organisms, he changed the concept of architectural design from the static one produced by a system of predetermined proportions to a dynamic one in which members would be integrated by the suggestion of muscular power. In this way the action and reaction of structural forces in a building which today we describe as tension, compression, stress, etc., - could be interpreted in humanized terms. But, if structural forces gave Michelangelo a theme, he refused to be confined to expressing the ways in which they actually operated: humanization overcame the laws of statics in his designs to the point at which a mass as weighty as the dome of St Peter's can appear to rise, or a relatively light entablature to oppress.

While fifteenth-century architecture required of the observer a certain degree of intellectual contemplation to appreciate its symbolic relationships, Michelangelo's was to suggest an immediate identification of our own physical functions with those of the building. This organic approach suggests the injection of the principle of empathy into Renaissance aesthetics by its search for a physical and psychological bond between observer and object.

In Michelangelo's drawings we can see how the concept was put into practice.⁵ Initial studies for a building are vigorous impressions of a whole which search for a certain quality of sculptural form even before the structural system

Michelangelo's 'Theory' of Architecture · 45

is determined [10, 111]. Often they even deny the exigencies of statics, which enter only at a later stage to discipline fantasy. Details remain indeterminate until the overall form is fixed, but at that point they are designed with that sense of coherence with an unseen whole which we find in Michelangelo's sketches of disembodied hands or heads. Drawings of windows, doors, cornices are intended to convey to the mason a vivid experience rather than calculated measured instructions for carvings [83, 133]. Where his contemporaries would sketch profiles to assure the proper ratio of a channel to a torus, Michelangelo worked for the evocation of physical power [4]; where they copied Roman capitals and entablatures among the ruins to achieve a certain orthodoxy of detail, Michelangelo's occasional copies are highly personalized reinterpretations of just those remains that mirrored his own taste for dynamic form. Rome provided other architects with a corpus of rules but gave Michelangelo a spark for explosions of fancy, a standard that he honoured more in the breach than in the observance.

This indifference to antique canons shocked Michelangelo's contemporaries, who felt that it was the unique distinction of their age to have revived Roman architecture. They interpreted a comparable indifference in fifteenthcentury architects as evidence of a faltering, quasi-medieval search for the classic perfection of the early 1500s. Implicit in Humanist philosophy was the concept that the goal of endeavour, whether in art, government, or science, was to equal - not to surpass - the ancients. Thus Michelangelo's bizarre variations on classic orders, coming on the heels of the climactic achievements of Bramante and Raphael, frightened Vasari, who dared not find fault with the Master, but worried that others might emulate him.⁶ When Michelangelo claimed for his design of San Giovanni de' Fiorentini in Rome that it surpassed both the Greeks and the Romans, the Renaissance concept was already obsolete;

4. Profile studies

for the moment any improvement on antiquity is conceivable, the door is opened for a modern philosophy of free experiment and limitless progress.

Michelangelo's plan studies appear as organisms capable of motion: the fortification drawings obey a biological rather than a structural imperative [53-7]. But even in more orthodox plans [108, 110, 111] the masses swell and contract as if in response to the effort of support. Elevation sketches minimize the planes of the wall to accent plastic forms – columns, pilasters, entablatures, frames, etc. – which dramatize the interaction of load and support. I say 'dramatize' because the sculptural members, seen as bones and muscles, create an imagined epic of conflicting forces, while it is the anonymous wall that does the mundane job of stabilizing the structure. In building, the wall is further distinguished from its expressive articulation by the choice and treatment of materials.

By contrast to contemporaries trained in fifteenth-century proportions, Michelangelo rarely indicated measurements or scale on his drawings, never worked to a module, and avoided the ruler and compass until the design was finally determined. From the start he dealt with qualities rather than quantities. In choosing ink washes and chalk rather than the pen, he evoked the quality of stone, and the most tentative preliminary sketches are likely to contain indications of light and shadow [38, 83]; the observer is there before the building is designed.

Michelangelo rarely made perspective sketches, because he thought of the observer as being in motion and hesitated to visualize buildings from a fixed point. To study threedimensional effects he made clay models. The introduction of modelling into architectural practice again demonstrates the identity of sculpture and architecture in Michelangelo's mind. It is also a further sign of his revolt against early Renaissance principles, since the malleability of the material precludes any suggestion of mathematical relationships or even any independence of parts: only the whole could be studied in terracotta. We can infer that when Michelangelo used clay models he sought effects of mass rather than of enclosed space, as in his paintings, where the spatial environment exists only as a receptacle for the bodies. The architectural drawings show the same preference; they communicate mass by contrast to those of Bramante or Sangallo, where lines are drawn around spaces.

This approach to architecture, being sculptural, inevitably was reinforced by a special sensitivity to materials and to effects of light. Michelangelo capitalized upon the structure of his materials because of his desire to get a maximum contrast between members used to express force or tension and 'neutral' wall surfaces. He invariably minimized the peculiarities of surface materials such as stucco and brick, while he carved and finished the plastic members in order to evoke – even to exaggerate – the quality and texture of the stone [70, 82]. No one had a comparable sensitivity to the character of the traditional Roman masonry, travertine, the pitted striations of which became richly expressive in his design.

In speaking of modern architecture we often associate sensitivity to materials with an exposition of their technical functions, but in Michelangelo's work the latter is characteristically absent. In laying masonry, Michelangelo notably avoided any emphasis on the unit (block or brick). He disguised joints as much as possible in order to avoid conflict between the part and the whole, and to sustain the experience of the building as an organism [95]. He was the only architect of his time who did not use quoins, and he rarely employed rusticated or drafted masonry, the favoured Renaissance means of stressing the individuality of the block. If his buildings were to communicate muscular force, the cubic pieces had to be disguised.

Light, for Michelangelo, was not merely a means of illuminating forms; it was an element of form itself. The

Michelangelo's 'Theory' of Architecture · 49

plastic members of a building were not designed to be seen as stable and defined elements but as changing conformations of highlight and shadow. Much of Michelangelo's unorthodoxy in the use of antique detail can be explained by his desire to increase the versatility of light effects. If more of his interiors had been completed according to his design, I believe we would find an astounding variety of compositions in light, creating moods quite unknown in the Renaissance. It is fascinating to imagine, for example, what the interior of St Peter's might have been like if the lantern had been screened by an interior canopy as Michelangelo planned [100]. No doubt Michelangelo's sympathetic adjustment to the brilliance of the Mediterranean sun was a factor that inhibited the exportation of his style to hazier northern countries, where the intellectual reserve of Palladio was much preferred.

The common practice in the sixteenth century of building from large wooden scale models, rather than from drawings, explains the absence of any complete plans or elevations among Michelangelo's surviving sketches. But these sketches differ from those of other Renaissance designers in one significant respect: with two or three exceptions none represents even a small detail as it was ultimately built. It was Michelangelo's habit to keep his design in a constant state of flux until every detail was ready for carving, a method entirely consistent with his organic approach. His conception of a building literally grew, and a change in any part involved sympathetic changes in other parts. The final solution was not reached even in the model: the wooden model for St Peter's was executed probably without a façade or dome, in order to permit Michelangelo to alter those portions in response to his impressions of the body of the building as it was constructed. There, and at the Farnese palace, wooden mock-ups of cornices were made to full scale and hoisted into position to enable the architect to judge, and possibly to redesign, his project at

the last moment; had funds been available he doubtless would have destroyed portions already finished in order to improve them, as he did with his later sculptures. In all his work he seems to have carried the generative drive to a point at which it became an obstacle to completion, an obstacle so frustrating that most of his architectural projects were not executed, and no building was completed according to his plans. So contemporary engravers had to record his projects by combining scattered records of different stages in the process of conception with touches of pure fancy. And the problem is the same for the modern historian. We shall never know for certain what Michelangelo's unexecuted projects – whether abandoned or partly

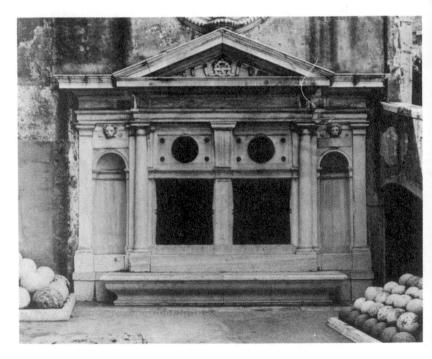

5. Castel Sant'Angelo. Exterior of Chapel of Leo X, 1514. See p. 291

50

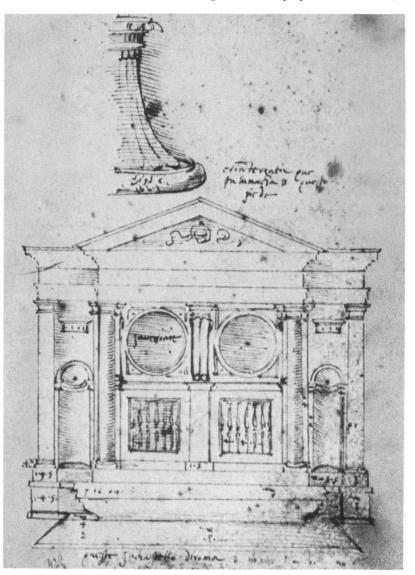

Michelangelo's 'Theory' of Architecture • 51

6. G. B. da Sangallo. Castel Sant'Angelo. Chapel exterior, after Michelangelo

completed – were to have been; in fact, the attempt to do so implies at the outset a misunderstanding of his conception of architecture. To visualize any of Michelangelo's designs, we must seek to capture not a determinate solution, but the spirit and the goals of a process.

[2] The façade of San Lorenzo In Florence

Nothing troubled medieval and Renaissance architects as much as façades. Among the great cathedrals of Gothic Italy only one – Siena – has a façade that is not largely modern, and the finest churches of Florence hide behind anonymous walls of stone or the brittle veneers of nineteenth-century antiquarians. Beyond the Alps this rarely happened; the façade was the showpiece of the Gothic cathedral, dominating the town and fields with its twin towers fused into the structure, and with its great portals and rose window becoming progressively more complex in order to carry the panorama of the Old and New Testaments in sculpture and painting.

The differences are deeply rooted in custom and taste. Italian cities meant to have luxurious façades as a pious obligation, but they were not called for by either the aesthetic or the structure of the architecture. The spirit of the Early Christian church survived with its splendidly decorated inner walls and simple geometric exteriors. Since narthexes and sculptured portals were never widely adopted in Italy, and campanili were never integrated with the church structure, the façade became no more than a protective screen where the building stopped growing, having no organic relation to the structural system. It could be laid up hastily by masons in the hope that it would be clothed later in a thin coat of elegance. So it is not strange that surviving drawings for Italian Gothic façades are barely distinguishable from those painted triptychs of the period with expanses of flat surface bordered by delicate gilt frames and pinnacles.

Since Italy became the pre-eminent centre of culture at the close of the medieval period, one of the shortcomings of her Gothic churches naturally became a major problem for Renaissance architecture. The problem was intensified by a conflict of traditions: the Renaissance church, with its high nave and low side aisles, preserved the outlines of the medieval basilica, but the new taste required that it be dressed in the forms of the ancient temple with its columns (or pilasters), entablatures and pediment. Antiquity prescribed fixed proportions for the orders; if more than one storey had to be faced with columns or pilasters, either these members had to be greatly broadened to gain height. or one order had to be superimposed upon another. Consequently it was difficult to achieve a uniform system as a facing for the low aisles and high nave of a church. But this was not the only problem; the interior nave elevation of Renaissance churches tended to be divided, as was Brunelleschi's San Lorenzo, into three levels - columns or piers, arches and clerestory - of which the second or arch level was by its nature substantially less high than the others. Such a division could not be employed easily on the exterior while preserving the vocabulary of the Roman temple, since the second of the three levels was too narrow to admit a proper order of its own. If, on the other hand, the elevation were to be disguised behind a two-storey facade, one of these storeys was apt to become disproportionately high.

Starting with Alberti's ingenious experiments, architects of the fifteenth century tried every solution for the problem, but the very variety of results – in notable contrast to the uniformity of later Renaissance façades – testifies to their failure to reach a viable standard. This may be due partly to the unsuccessful attempt to abandon the basilical form in favour of central plan churches, where façade design, though equally challenging, was at least not complicated by reminiscences of medieval forms.

This is one explanation of the absence of a façade on San Lorenzo, a church which Medici patronage had in other respects made one of the most splendid in Florence [19, 34]. When the first Medici Pope, Leo X (1513-21), decided to finish the church, Florentine architects swarmed to the Vatican to get the commission, because the sum assigned to construction, in addition to the prestige of the patron, assured it of being the most important basilical façade of the generation. Michelangelo, normally modest about his work, said that he could make it 'the mirror of architecture and sculpture of all Italy'. There was a competition for the design in 1515, Vasari says, involving Antonio da Sangallo (Elder), Andrea and Jacopo Sansovino, Raphael and others, in addition to Michelangelo.

We would know much more about Renaissance architecture if the competing projects had survived, but unfortunately we have only a few drawings by Giuliano da Sangallo, a candidate whom Vasari overlooked. These are the last records of the aged Quattrocento architect, and while they show his ability to rise to the demands of the new Roman style, they also betray his insecurity in the face of the old problems. He offers two solutions: one is a three-storey elevation (Uffizi, Arch. 276, 281) with an extremely tall lower order, set forward as a porch, a rather squashed upper one, and between them a mezzanine with stunted unclassical pilasters; the other (Uffizi, Arch. 280) is more successful, proposing two storeys of equal height and also of equal width, a solution which, except for a low pediment that covers only the central bays, disguises the difference in elevation between the side aisles and the nave. The latter design includes a pair of five-storey campanili loosely related to the façade, which would have clashed with the scale of the church. These drawings are important because Michelangelo seems to have studied them for his

project, together with another drawing by Giuliano [7] (Uffizi, Arch. 277) which, though made at an earlier date for another church, probably was shown to the Pope at the time of the competition. Like the first solution, it has a mezzanine, but of the same width as the lower order, since the latter does not project forward from the plane of the

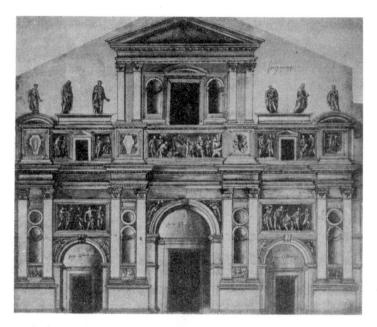

7. G. da Sangallo. San Lorenzo. Façade project

façade. Here the disproportionate heights of the lower and upper orders are minimized by raising the ground-floor pilasters on high socles.

Apparently Michelangelo was initially engaged to direct the façade sculpture, while others were invited to compete for the architectural commission. Ultimately his inability to collaborate with anybody brought him both jobs, but whether this attests to the success of his designs or of his

The Façade of San Lorenzo in Florence • 57

intrigues is uncertain. In any event, he was appointed, though lacking previous architectural experience, because the Pope envisaged the facade as a great framework for statues and reliefs. Nobody had had such an idea in Ouattrocento Tuscany; it was too pictorial to appeal to humanists and rather suggests late medieval practice (Giovanni Pisano at Siena) or the North Italian Renaissance (Certosa of Pavia). Perhaps boredom with fifteenth-century purism explains the change of taste already evident in Giuliano da Sangallo's drawing originally done for Julius II [7]. The pictorial style gained impetus from a rapidly growing interest in theatre design, from the new vogue for painted palace facades, and from temporary festival architecture such as the façade erected on the Cathedral of Florence for the entry of Leo X in 1515. The Cathedral decoration may have suggested to Leo a scheme for San Lorenzo that would make the most of Michelangelo's genius.

In the first of three stages in the development of the design [8], the sculpture is really more important than the building, which becomes a skeleton for relief panels and statue niches; probably one of the reasons for abandoning this project was that some of the sculptures would have been monstrously big while others were dispersed without much cohesion, if we can trust at all the weak copies that are preserved. We may compare the architectural solution at this stage to one of Sangallo's drawings [7] which it echoes in some obvious ways: the lower order raised high on socles and the upper order in the guise of a somewhat stunted temple front; alternation of recessed entrance bays and projecting bays with paired pilasters or half-columns; the outermost bays crowned by curved pediments; the profusion of sculpture, etc. Yet Michelangelo grappled more seriously with the façade problem; his project succeeds in being at the same time two and three storeys high by the dissimilar design of the central and outer bays, and avoids the disruption of Giuliano's mezzanine; it unifies the nave portion of the façade by giving the four central columns a single entablature – a device retained in all subsequent studies. Though the solution is far from perfect, Michelangelo from the beginning of his architectural career exhibited an ability to fuse discrete members into a convincing whole. The far more experienced Giuliano was unable to keep the parts of his façade from scattering; he was too interested in the individual pilasters and courses.

In all remaining schemes, Michelangelo chose a threestorey system in which the second storey was a kind of mezzanine or attic extending the whole width of the façade; a little sketch that may have been the first of his surviving drawings [9] gives the mezzanine undue prominene by muting vertical accents. This departure from the unity of the original solution [8] was encouraged by the side elevations of Brunelleschi's church, which had an

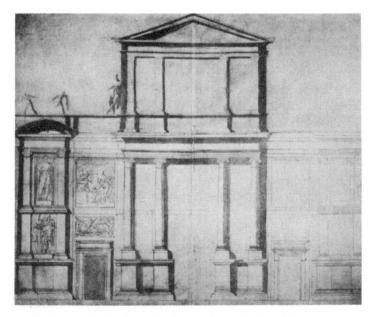

8. San Lorenzo. Façade project (copy after Michelangelo)

58

The Façade of San Lorenzo in Florence · 59

emphatic three-storey elevation accented by three cornices all around; the height of the mezzanine level was dictated by the height of the nave arches. This was abandoned because of the divisions of its outer bays, which did not correspond to those of the church and would have caused confusion at the corners where the façade and side elevations could be seen together. A further advantage of the mezzanine system was that it produced three ample bays of like dimensions to accommodate relief panels, and four spaces for statues

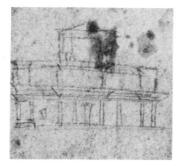

9. San Lorenzo. Façade project (*detail*)

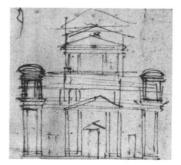

10. San Lorenzo. Façade project (*detail*)

between the uprights, without interfering with the architectural character as the first scheme tended to do. The solution may have been inspired by the attic design of Roman triumphal arches, such as that of Constantine.

In [10] the better features of the preceding designs were combined, so that the outer tabernacles could be retained without abandoning the mezzanine. In this sketch Michelangelo may have been toying with the idea of bringing the central bays forward under a gabled roof to create a Pantheon-like porch. All of these ideas reach maturity in [11], which could well be the design that won Michelangelo the commission when he went to see the Pope at the end of 1516. Cohesion is regained here by the device,

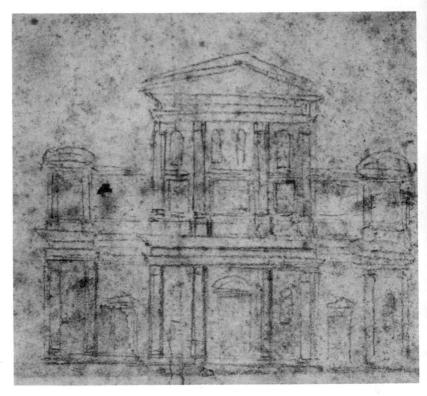

11. San Lorenzo. Façade project

already foreseen in the initial scheme, of combining a two- and three-storey elevation; but here it is the upper rather than the lower order that embraces the mezzanine. Now there is a well-distributed accommodation for ten statues in niches, as requested by the Pope, for three major reliefs in the mezzanine, and for minor ones on the lower storey. Only one problem remained unsolved: in terms of the actual measurements of the church, the upper pilasters of the order would have had to be so much taller and hence broader than the columns (?) beneath them that even

The Façade of San Lorenzo in Florence · 61

Michelangelo might have paused at the affront to classical canons. Yet a design close to this one probably became the basis of the model made by Baccio d'Agnolo early in 1517.

Michelangelo would not accept Baccio's model, even after it had been altered according to his instructions. Although this can be explained by his inability to work with anyone except subordinates and by his apparently unreasonable suspicion of Baccio's loyalty, the most likely reason was that he had conceived an entirely new kind of façade, the nature of which he had kept secret even from his patron (he refused to send to Rome the clay model he had made in the spring of 1517, and even announced without any explanation that the cost would be increased by over a third).

The new design, while it retained many superficial elements of the preceding studies, was fundamentally different. It was no longer a veneer to be attached to the surface of the old façade, but a three-dimensional structure in its own right, a narthex that was to project forward one bay from the existing church which thus would have three faces rather than one. This proposal appears in the last and most impressive of Michelangelo's drawings [12], where the side elevations are suggested only by the projections of members on the far right. Now the lateral bays as well as the centre are three storeys in height, a solution that became structurally imperative with the decision to erect a semi-independent building. The independence of the narthex also relieved the architect of the obligation to express the unequal heights of nave and aisles behind. Again the mezzanine level is accentuated; it no longer has to be embraced within the upper or lower order of columns or pilasters because the raising of the outer bays to the full height of the facade adds sufficient vertical emphasis to counterbalance the strong horizontal (cf. [11] and [12]). The mezzanine is divided by an emphatic cornice into two levels of pilaster-strips in order to urge us to read the upper

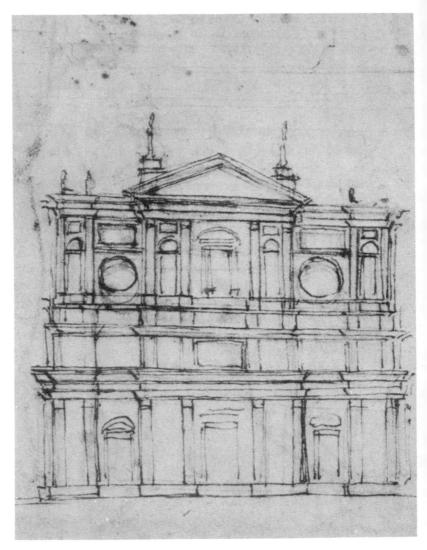

12. San Lorenzo. Façade project

The Façade of San Lorenzo in Florence · 63

level as part of the pilaster order above, so that the proportions of this order should not appear to be as squashed as they are in [10] or in G. da Sangallo's comparable design [7].

This solved most of the problems that bedevilled earlier architects; it did not deny the existence of a three-aisled, three-storeyed basilica behind; it had no false fronts that would conflict with the side elevations; and it made legitimate use of classical vocabulary by adding to the normal superposition of orders an adaptation of the triumphal-arch attic to solve the dilemma of the narrow intermediate order. Furthermore, the design was ideally suited to the sculptural programme, allowing space for six statues on each of the three storeys (counting those that would be placed on the side façades); for two round relief panels in the lateral bays of the upper storey; and for five rectangular ones - three in the mezzanine and two above the tondi. These reasons, coupled with the practical fact that new foundations were required anyway, motivated the adoption of a narthex scheme; we need not search for profound philosophical or pressing liturgical causes.

There was a precedent for Michelangelo's decision in the work of Leone Battista Alberti who, after two early experiments with veneer façades (San Francesco in Rimini, Santa Maria Novella in Florence), produced narthex designs in his last years (San Sebastiano and Sant' Andrea in Mantua) because they were easier to adapt to the templefront motif. Furthermore, Alberti, and other theorists after him, spoke of the narthex or porch as an essential element of the church.

Everyone admires Michelangelo's drawing [12] more than the model [13], which represents a revised version of the project close to the one accepted by the Pope in 1518. No doubt Michelangelo preferred it too; but the drawing has serious practical drawbacks. If the design is redrawn to scale, the total height diminishes so that the lower part of the mezzanine no longer retains well-proportioned spaces for statues and reliefs (see [12] where the disadvantages are somewhat exaggerated). Consequently, Michelangelo decided to unify the two levels of the mezzanine, thus gaining space for over-life-size seated statues.

It is not the unified mezzanine that makes the model less successful, but an arid linear quality often found in Florentine Mannerist architecture. The fault does not necessarily originate in the design, since the model could not have been very different if it had been made from [12]. It is due partly to the small scale, which inevitably changes much of the modelling into line and the apertures into dull planes, and partly to the absence of the eighteen statues and seven reliefs which justify the formal composition. On the other hand, a certain brittleness is inherent in the material; marble is bound to produce an effect sharper and colder than that

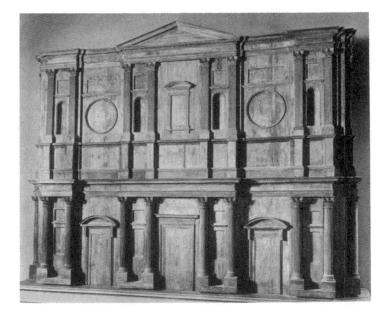

13. San Lorenzo. Façade. Wooden model

The Façade of San Lorenzo in Florence · 65

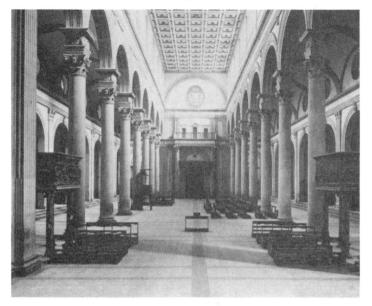

14. San Lorenzo. Reliquary Tribune, 1531-2. See p. 299

of softer stones. In judging this model we might ask if a model of the Medici tombs at the same scale and without sculpture would not have been equally unexciting. There are some minor differences between the model and the measurements given in the final contract of January 1518 for the construction of the façade, so we cannot be sure that it was the one made by Michelangelo. But even if it was a copy it is a fairly good record of the design [16].

We get closer to Michelangelo's final purpose by analysing the measurements in the contract and those on the sketches made in Carrara from the façade blocks as they were cut to measure. The reconstruction drawing shows the result of this analysis [16]. The major differences from the model are the broadening of the central portal-bay at the expense of the lateral ones and the raising of the mezzanine at the expense of the upper pilaster order. Both of

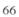

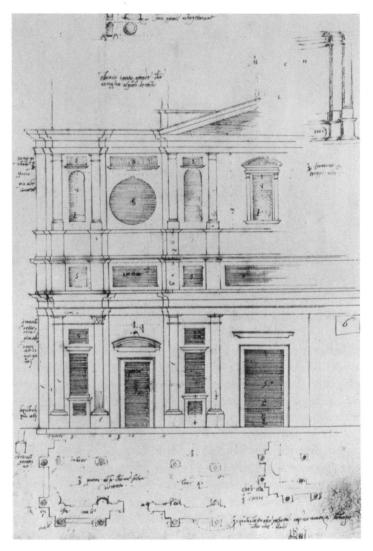

15. San Lorenzo. Façade project (copy)

The Façade of San Lorenzo in Florence · 67

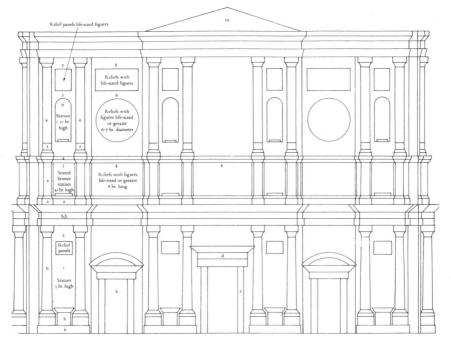

0 2 4 6 8 IO BRACCIA

(One Florentine braccia = .584 m)

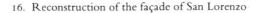

these solutions are anticipated in [12], so that it may have been the model-maker, and not Michelangelo, who tried the more contracted scheme.

Whether we speak of the drawing, the model, or the reconstruction, the unique virtue of Michelangelo's design is the equilibrium of its parts; though the membering makes the façade a complicated grid of horizontals and verticals, there is still an impression of unity and, what is especially apt, the members serve a dual function of symbolizing the structure of a post-and-lintel system and of providing frames for apertures and sculptured panels. Usually when Renaissance architecture was allied closely to sculpture the tectonic quality was lost. Furthermore, Michelangelo brings to the architectural design a sculptural character previously unknown; his façade is not a plane cut up into rectangles but an organization of bodies that project and recede. Even before he thought in terms of a narthex he had made his outer bays semi-independent forms that by their nature were suited to being echoed in the side elevations.

Yet we cannot judge the façade as we see it in either the model or drawing, for Michelangelo would not have subordinated the profusion of huge figures and panels to the architecture. The narrative might not have overwhelmed its setting to the extent that it does in the Sistine ceiling, but perhaps sufficiently to produce an effect determined more by the *terribilità* of Michelangelo's figural style than by the equilibrium of his architectural design.

68

[3] The medici chapel

In almost all of Michelangelo's architectural commissions there was a restricting condition - some predetermined and unchangeable factor in the design. At one time the proportions would be fixed by existing foundations (San Lorenzo façade, San Giovanni de' Fiorentini), at another, existing buildings could not be removed (Laurentian library, Capitoline Hill); a half-finished building would be left by another architect (Farnese Palace, St Peter's), or a complete structure would have to be transformed to serve a new function (Santa Maria degli Angeli). It is tempting to speculate on what Michelangelo might have done without obstacles, but apparently he liked them, perhaps even sought them out; these buildings he worked on with fervour, while not a drawing, much less a stone, remains to recall his major unencumbered commissions (Rialto bridge, Il Gesù in Rome).

Perhaps Michelangelo needed some limitation to direct and restrain his imagination just as the confines of a stone block controlled his sculptures. Some of his greatest marble figures were formed in response to confining conditions: the second-hand block given to him for the *David* was astonishingly thin. In architecture as in sculpture, he could evoke a tension between pre-existing, static boundaries, and dynamic forms that strain against them. Consciously or not, Michelangelo managed to convey in any art his view of the human body as the *carcer terreno*, the earthly prison that confines the flight of the soul.

In the Medici chapel there are two distinct architectural systems [17, 23]. One, the masonry construction of the

17 (overleaf). Medici Chapel. Interior, towards altar

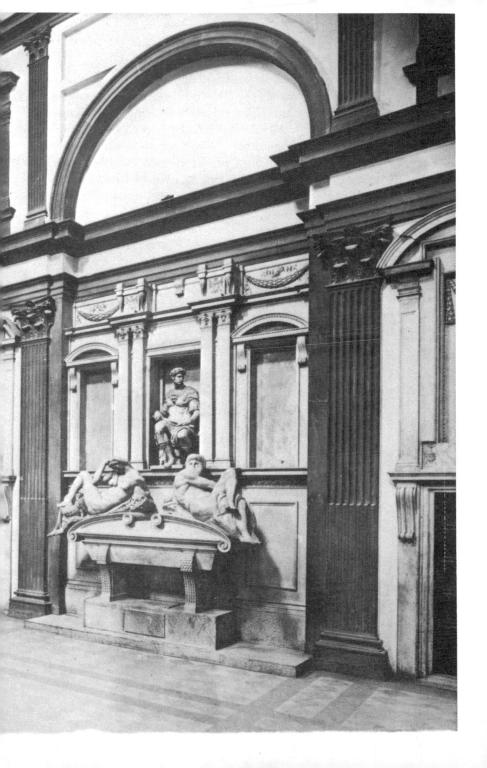

sacristy itself, is faced inside with white stucco and articulated by membering in the grey *pietra serena* of Tuscany; the other, made entirely of veined white marble, belongs to the tombs of the Medici and is fitted into recesses framed by the *pietra serena* members. The Sacristy system constitutes one of Michelangelo's predetermined encumbrances: the chapel was to be a sister, if not a twin of Brunelleschi's Old Sacristy on the opposite side of the transept of San

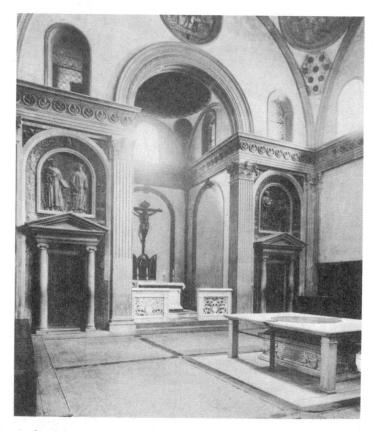

18. San Lorenzo. The Old Sacristy, 1421-9

Lorenzo, built in 1421-9 [18, 19 (1)]. In plan [19 (2)] it had to be roughly of the same dimensions; the materials had to be the same, and the fluted Corinthian pilaster order, though slightly modernized, was to remain basically Brunelleschian.

Vasari, in his account of the chapel, noted the tension between the conservative Sacristy system and the unprecedented tomb architecture (VII, p. 193):

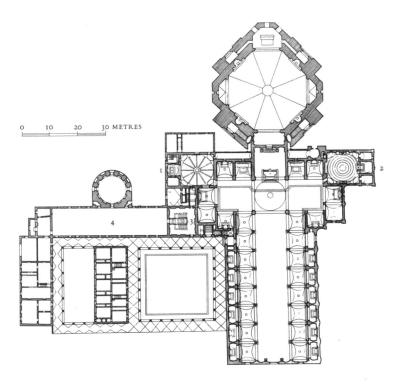

- 19. San Lorenzo. Church, Library and Cloister
 - (1) The Old Sacristy
 - (2) The New Sacristy (Medici chapel)
 - (3) Vestibule and stairway
 - (4) Library

... and because he wanted to make it in imitation of the old sacristy which Filippo Brunelleschi had made, but with a different order of ornaments [the marble veneer, not used by Brunelleschi], he made on the interior an ornament composed in a manner more varied and novel than ancient or modern masters had been able to achieve at any time; because in the innovations of such beautiful cornices, capitals and bases, doors, tabernacles and tombs he proceeded quite differently in proportion, composition and rules from what others had done following common practice, Vitruvius and antiquity, fearing to add anything [of their own]. This licence greatly encouraged those who saw his work to try to imitate it, and shortly new fantasies appeared in their ornament, more grotesque than rational or disciplined. Whence, artisans have been infinitely and perpetually indebted to him because he broke the bonds and chains of a way of working that had become habitual by common usage.

The marble architecture of the chapel may not seem so shocking today; but Vasari, in mixing admiration with apprehension, reminds us that it was one of the first works of a generation obsessed with Roman antiquity in which the classical canon was ignored, even violated. The tabernacles and entablatures which belong to no recognizable order appear especially peculiar in their Quattrocento framework.

In his earliest sketches for the lateral tombs [24], Michelangelo may have visualized the architecture as an almost literal copy of the Old Sacristy. But by the time the contract for the *pietra serena* membering was prepared, in October 1519, he must have settled already on the final solution, which gave the tombs a different, more vertical proportion [30]. Niches were needed in the thickness of the walls, and the three-bay system that Brunelleschi had used only on the choir wall had to be repeated on all four walls of the New Sacristy (cf. [17] and [18]). Michelangelo did not keep the proportions of Brunelleschi's bays. He shifted the pilasters nearer to the corners without, however, adding to the width of the central bays, since he added a plain *pietra serena* pier where Brunelleschi's pilasters had been. Characteristically, he went out of his way to squeeze the entrances without thereby gaining equivalent breathing-space for the tombs. Now both were constricted, by virtue of an innovation that increased the already confining pressure of the old architectural system upon the new.

The most important innovation was the addition of an entire storey between the entrance level and the dome. While Brunelleschi had put pendentives on the entablature of the first order, Michelangelo inserted an intermediate zone with windows flanking the arches. He elevated the pendentives to a higher zone with central windows [20] and raised on them a coffered dome and a lantern entirely different in style from the exotic orientalism of Brunelleschi's design.

Michelangelo retained a quasi-Brunelleschian flavour in the lower portions, and asserted his individuality increasingly as the building rose. The entire *pietra serena* order of the lower storey is in the Quattrocento style – but closer to the nave of San Lorenzo than to the Old Sacristy. The intermediate order is transitional: the windows, as Tolnay noted, are close to those of Cronaca (d. 1508). The only obviously sixteenth-century features at this level are the projecting strips in the spandrel above the arch, which are a new device for reducing the wall mass and breaking the monotony of plane surfaces.

Michelangelo's individuality bursts out at the third level, where the window frames were done after his drawings. They are vigorous counterparts of the frames in the Laurentian library, but they are unique in diminishing in breadth towards the top, as if in a perspective with its vanishing point at the lantern; the canted lines continue those of the cupola. The coffering of the cupola, distantly related to that of the Pantheon, is unusually small, and the ingenious pattern of recessions around the oculus helps to accentuate the grid between the coffers, introducing a lively

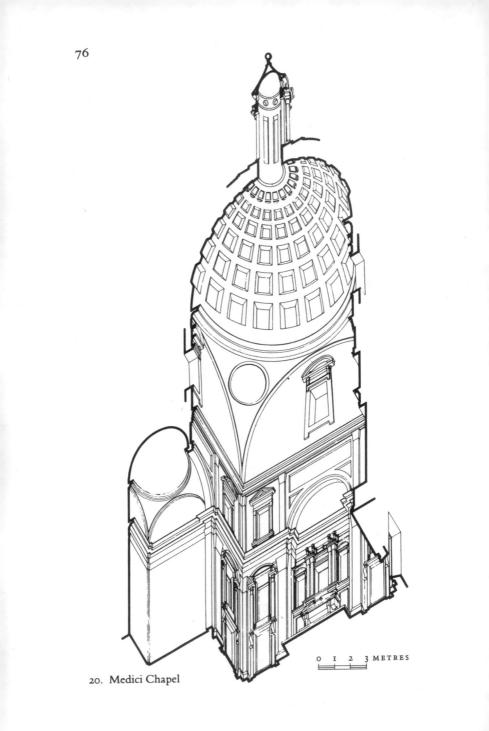

The Medici Chapel · 77

dialogue between circular and radial accents, in which the latter come to appear as structural ribs.

The lantern [21] is Michelangelo's only important contribution to the exterior of the chapel. Its animated fantasy inspired della Porta's lantern design for the minor domes of St Peter's. Large, simple windows attract a maximum

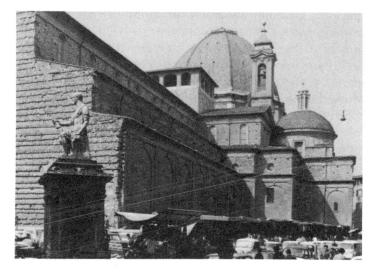

^{21.} Medici Chapel. Exterior

of light, and the order of free-standing colonnettes is one of the first in the Renaissance to carry a projection of the entablature, giving a dramatic impression of a radiating cornice in the form of a cogwheel casting varied shadows. This sharp angularity contrasts with the fleshy curves of a concave cone that holds aloft a gilded polyhedron.

It seems, in short, that Michelangelo tried to influence the design of the chapel as little as possible, though two changes were essential to his aim: the tombs had to be given enough depth, and the overall height had to be increased. Wherever these innovations permitted, he retained the Brunelleschian vocabulary as an antithesis to his own invention.

Michelangelo's metamorphosis from sculptor to architect was not fully consummated in the design of the Medici chapel. In our admiration for the sculptures and their settings we gratefully overlook the failure of the chapel to evoke a moving or even a coherent spatial experience. The power of the composition is generated by the vigour of the figures and their architectural framework, and heightened by the compression of the pietra serena members. In Michelangelo's later architecture the conflict is made more effective by the implication of tension between organically related parts. Here the marble architecture is patently of a different species from that of the chapel, and there is even a lack of coherence within the marble system: the tombs seem isolated from the lateral tabernacles by a shift in style and in scale. The upper storeys might have been quite different without fundamentally affecting the tombs, and, if the projected programme of fresco decoration had been completed, the unity of the chapel would probably have been further compromised. Maybe for this reason the garlands painted on the dome by Giovanni da Udine were quickly hidden by whitewash.

In making the architectural membering of the lower order of marble, Michelangelo associated it with the sculptured sarcophagi and figures rather than with the structure of the building [22]. Vasari rightly referred to it as ornament; it is a veneer hung on to the walls of an already self-sufficient structure and, as such, is freed of the responsibility of performing any tectonic function. Furthermore, it has no utilitarian function except to provide doors to adjoining areas – doors significantly overpowered by the more expressive tabernacles above them. The conception of a relief independent from the chapel in structure and

78

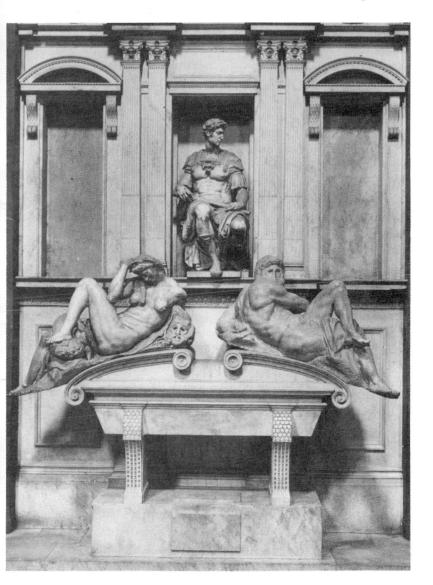

materials was a purely sculptural one, and the extensive use of an architectural vocabulary was a matter of choice, not of necessity. But the choice was almost predetermined by the tradition of funerary wall monuments: a system of architectural niches not only offered the most convenient setting for effigies, but had carried since ancient times a symbolism, associated with the baldachin or aedicula, of apotheosis, originally the prerogative of deities and rulers.

In some of the preparatory drawings and in sketches by Michelangelo's followers, the niches alongside the effigies of the Dukes are filled with allegories, and studies such as [24] indicate that the upper portion was to have been a monumental crown, rich with symbolic figures, thrones (of which only the bases were executed [22]), and a complex composition of arms and trophies. It is difficult to judge the tombs without these important complements, which would have altered completely their effect and their relationship to the chapel. The crown, for example, projecting into the zone of the entablature, would have exaggerated the independence of the tombs from the chapel architecture.

The wall-tomb in the form of a semi-independent architectural relief was the commonest type of funerary monument in fifteenth-century Italy. Michelangelo, in placing tombs into a recessed arched niche divided vertically into three bays behind an ornate free-standing sarcophagus [23, 24], respected a tradition that had inspired the finest efforts of early Renaissance Tuscan sculptors.¹ Many elements of the Medici monuments may be found, for example, in the original tomb of Pope Paul II in St Peter's, carved by Giovanni Dalmata and Mino da Fiesole in the 1470s [25]. Even Michelangelo's fantasy was hallowed by usage, because the Quattrocento tomb was far more experimental and unconventional in architectural detail than contemporary buildings. But in the early sixteenth century imaginative sepulchral designs began to give way to proper

80

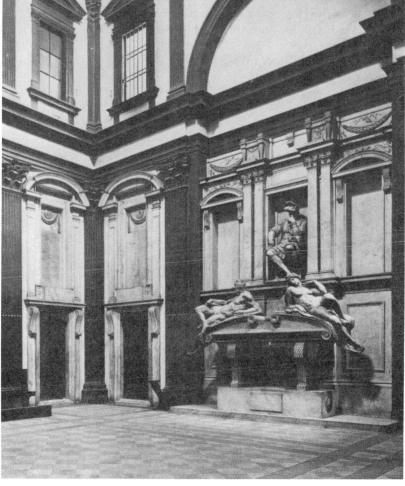

23. Medici Chapel. Interior, towards entrance

and often dull classical solutions, such as those of Andrea Sansovino; Michelangelo must have aimed consciously to revive the earlier freedom, which partly explains why Vasari congratulated him for his liberating influence.

24. Medici Chapel. Tomb project

The surviving preparatory drawings for the tombs affirm a Quattrocento inspiration [26-30] in representing isolated reliefs designed for a frame of given proportions and indicating nothing of the architectural setting or flanking bays. Yet these studies aim, far more than the final solution,

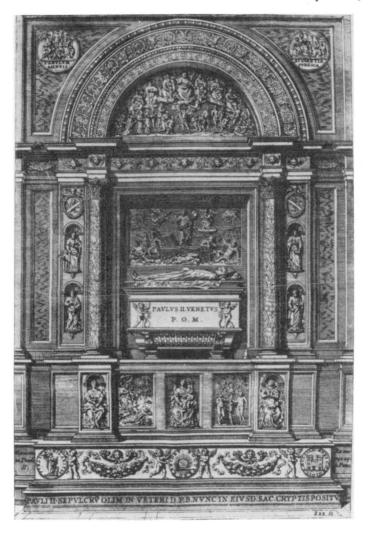

The Medici Chapel · 83

25. St Peter's. Tomb of Paul II (1470s)

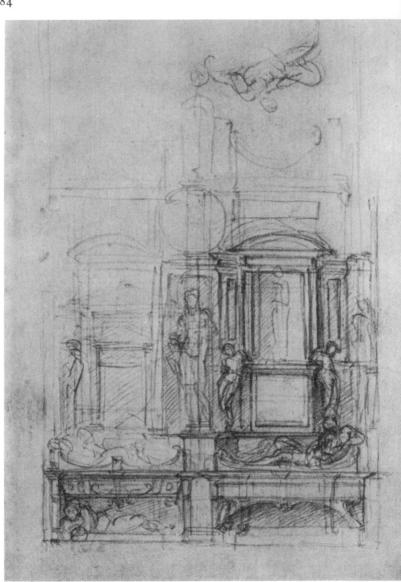

26. Medici Chapel. Tomb project

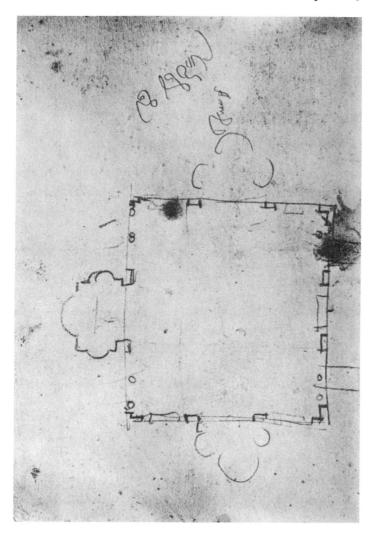

27. Medici Chapel. Plan project

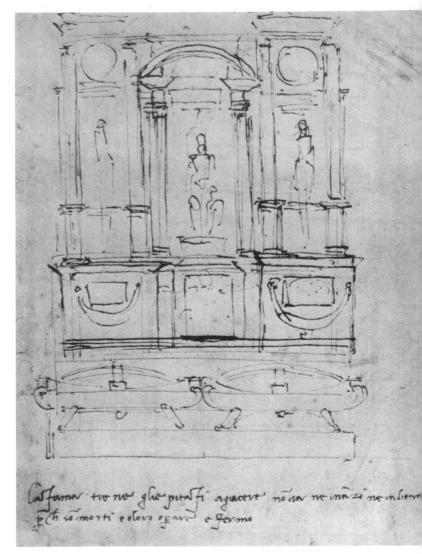

28. Medici Chapel. Tomb project

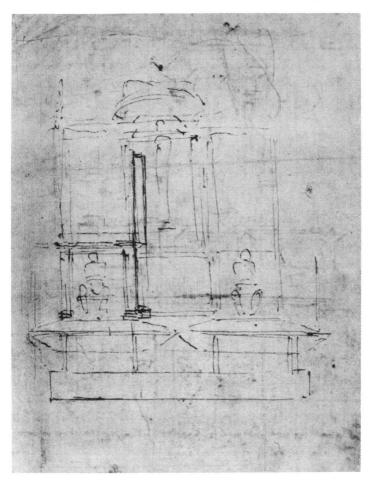

29. Medici Chapel. Tomb project

to reflect in the design of the tombs the arrangement of the wall into which they are set. In the last project for a ducal monument [24], the tomb repeats the pattern of the wall as a whole [30a]: the relationship of the wall bays (ABA) is repeated in the tomb bays (aba); in both, the central bay

(B,b) is larger, almost a square, and the side bays (A,a) contain tabernacles with segmental pediments; even the entrance doors are reflected in the rectangular panels beneath the tomb-tabernacles.

This may explain the overpowering scale of the tabernacles over the doors; it is the outcome of enlarging the smaller tomb-tabernacles according to the ratio established in the overall composition: B:A=b:a. A comparable proportioning of tabernacles to tombs was planned for the Magnifici monument in the entrance wall [28, 29], but here the rhythm was changed: the side tabernacles were to be reflected in the *central* bay rather than in the lateral bays of the tomb, thus: AbAbA. Since the two sarcophagi planned for this wall removed the emphasis from the central axis, it had to be restored by accentuating the central aedicula, a solution also prompted by the project to place the *Madonna* there.

In execution, this rhythmical unity was lost; the Magnifici tomb was not built at all, and the Ducal tombs were entirely altered in proportion. In [24] and [30 left] they are drawn as if to fill the entire opening between the pilasters, but in the final version [22, 30 right] *pietra serena* piers were crowded between the pilasters and the tombs, narrowing the whole tomb design. Michelangelo chose to subtract the lost width from the central section of the tombs, changing

30. Medici tombs. Preliminary (left) and final (right) versions showing the narrowing of the central bay

88

The Medici Chapel · 89

it from a square panel to a tall niche enclosing the effigy. This solution disrupted the continuity between the entrance bays and the tomb, and made the former seem disproportionately large. We do not know what prompted the change, since there are no studies of the wall elevation as a whole: perhaps purely structural considerations, since the piers support relieving arches over the tomb niches. But there may have been expressive motivations also: if [24] had been drawn for a two-storey chapel like Brunelleschi's, the later addition of a third storey might have suggested confining the tombs to a more vertical frame consonant with the higher elevation; whether the decision to put only one effigy at the centre of each tomb ([24] has two on a level with the sarcophagus), which also produced a more vertical composition, was a cause or a result of narrowing the tomb, cannot be determined. The loss of architectural coherence in the final design suggests that Michelangelo was concerned primarily with the sculpture.

It is the sculpture rather than the marble architecture that gives the interior space its three-dimensional unity. The dynamic forces generated by the figures and sarcophagi organize the two lateral walls – forces that would have been intensified had Michelangelo finished the rivergods at the base of [24], which initiate an upward and outward movement. The side walls are bound to the entrance wall across the intervening space by the intense gazes of the Dukes and by the gestures of the allegories, which focus attention on the *Madonna* [23].

The dissimilarity in style between the architectural members of the chapel and those of the tombs is partly due to differences in material. Marble is particularly suited to sculptural refinements and may be carved with the most meticulous detail, while *pietra serena* does not lend itself to such finesse. Yet the sharp precision of Michelangelo's treatment is not implicit in the nature of marble, which is equally congenial to softly modelled forms, as the tomb figures show; the emphasis on line, plane and fine detail was the outcome of a purposeful effort to accentuate by contrast the plasticity of the figures. Modelling was avoided in the architecture as far as possible: there are no columns, and mouldings are so narrow that they appear as lines, an impression that is reinforced by the soft, uniform diffusion of light from high above, which favours surfaces more than recessions. Such linearity is another indication of the revival of later fifteenth-century architectural sculpture; it is not found to the same degree in Michelangelo's subsequent work. Already in later designs for the chapel more plastic forms appear; projecting columns were used in the initial drawings for the Magnifici tomb [28, 29]; they appear more distinctly in later copies; and a mid-century plan of the chapel shows a revised version with deep niches containing encased columns comparable to those of the library vestibule [36]. Apparently Michelangelo came to re-evaluate his conservative approach to the chapel architecture in the process of designing the library in the mid 1520s.

In the light of Vasari's comments, the term 'conservative' would appear to be applicable only to the treatment of the material. Yet few of the architectural elements are radical in design: the pilaster system and the flanking aediculas with segmental pediments on brackets are sober, almost canonical by contrast to the extraordinary tabernacles over the doors [31]. These tabernacles are a sign of Michelangelo's emancipation from the proprieties of Vitruvian rule and ancient models and establish a fantastic theme that was to reappear in all his later designs for doors and windows. The fantasy, however, is always strictly disciplined by the realization that its effect depends on the variation of traditional forms and would be lost if these were abandoned for uncontrolled innovation. The tabernacle pediments are broken at the base and jut forward at the crown, and yet are adequately supported by pilasters which we recognize as such in spite of the absence of definable capitals;

90

31. Tabernacle over entrance door

32. Medici Palace. Ground-floor window, c. 1517. See p. 295

the niche is conventional in its deepest recession, but in a nearer plane it violates the expected independence of parts by expanding horizontally and vertically beyond its proper limits. Where the inventiveness of Quattrocento sculptors had been manifested in the free embellishment of familiar

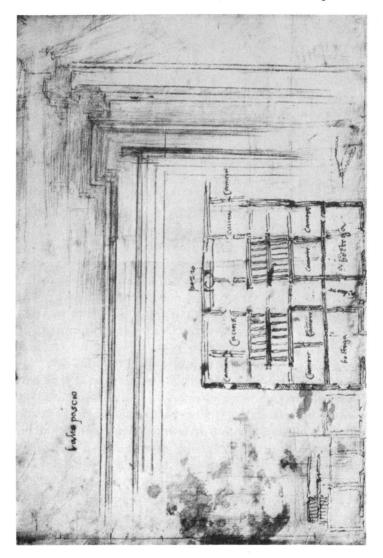

33. 'Altopascio' house. Plan project (detail). See p. 296

forms, Michelangelo penetrated into the nature of the forms themselves to give them unprecedented significance: the wall is transformed from an inert plane to a vital, many-layered epidermis, and elements formerly assembled - niche, frame, pediment - are now inextricably bound together by an architectural anatomy. The tabernacles signify an abandonment of traditional expression, and, by this token, a fundamental departure from the spirit of the tombs. The absence of any Quattrocento model for the entrance bays partly explains the differences but we must also suppose a substantial passage of time between the designs of the tombs and tabernacles. The tombs were planned by 1521, when quarrying began, but drawings for the tabernacles were sent to the patron only in 1524, and even then Michelangelo refused for more than a year to send specific instructions to the guarries. The likelihood that the final tabernacle design was determined four or five years later than that of the tombs is strengthened by its similarity in style to the reading-room portals of the Laurentian library, drawn in 1526. The Magnifici tomb on the entrance wall, started only in 1533, would also have been closer in style to the library than to the ducal tombs.

In the Medici chapel, then, as in all of Michelangelo's later buildings, an idea changes and matures before our eyes as we glance from one part to another. Here the change is drastic, because it is the outcome of rapid development from the acceptance of an old tradition to the formulation of a new one which, while it is barely suggested in the chapel, was ultimately to create a unity of ornament and structure never surpassed in architecture.

[4] The library of san lorenzo

The pioneers of modern architecture vigorously attacked the superficial adaptation of ancient and Renaissance forms that typified late nineteenth-century design and, in their effort to express a new technology and social order, lost interest in the Renaissance itself. Preoccupied with structural and utilitarian problems, they followed the lead of Ruskin and Viollet-le-Duc in criticizing Renaissance architecture as 'dishonest', unconcerned with the practical aspects of building, and devoted solely to impressing the eye with façades of borrowed ornament. Later, as modern design gradually won acceptance, architects came to feel sufficiently secure to approach the Renaissance more sympathetically, particularly for its monumental planning, control of space, and principles of scale and proportion.

This change in attitude is partly due to the efforts of historians and critics whose discovery of new dimensions in Renaissance theory and practice has encouraged a deeper understanding. But even the apologists of the Renaissance have submitted unconsciously to the old bias; in arguing that purely visual delight is a proper function of architecture, they have tacitly allowed that Renaissance buildings could not be defended on technical or practical grounds.¹

Criticism of the Laurentian library has been affected by this bias to an extent that the building is commonly interpreted as if it were simply an essay in sculptural form and space-manipulation. But in this case purely formal analysis is especially unjustified, for a constant and guiding concern with problems of utility and structure is documented by an extensive correspondence between the patron and the architect.

The Medici library, greatly enlarged by Lorenzo the Magnificent (hence 'Laurentian') at the close of the fifteenth century, had been kept in the family palace as one of the embellishments of a worldly court; its removal to the cloister of the near-by church of San Lorenzo may have symbolized to contemporaries the shift in the roots of Medici power from mercantile to ecclesiastical activity. But in Italy the urban monasteries were indeed the only conceivable repositories of private book collections; their libraries were generally larger and more widely used than those of the universities. From them the humanists of the fifteenth century formed their private collections by copying and ultimately by printing from the ancient manuscripts. And some of these collections in turn became the nucleus of great new church libraries like the Piccolomini in the Cathedral of Siena, founded with the books of Pius II, and that of Sixtus IV in the Vatican.

A vigorous revival of monastic scholarship and book collecting in the first half of the fifteenth century, particularly in the great urban centres of northern and central Italy, prompted a demand for the construction of buildings specifically designed for the preservation and use of manuscripts. Of the few surviving examples, one of the earliest and best known is the library built after 1438 by Michelozzo in the Dominican monastery of San Marco in Florence. The long, narrow three-aisled room built on the upper level of a two-storey free-standing structure to protect the collection from dampness and to provide good lighting became the model for a majority of the monastic libraries of the succeeding century, Michelangelo's included. The library and church of San Marco were also built under Medici patronage; it was among the first major public philanthropies of Cosimo de' Medici, and the architect was selected later to design the family palace and to complete the church of San Lorenzo.²

Because the Renaissance monastic library could be

96

The Library of San Lorenzo · 97

specially built for its purpose and because it served a public function – and in particular in Italy, to supplement the small university libraries – utility became an important consideration in design. It might be a civic ornament, like the great Quattrocento palaces and villas, but this no longer could be its chief function; as if to accentuate the change, its expressive effects were kept inside, for the benefit of scholars, while the exterior remained anonymous [19 (4), 34–7].

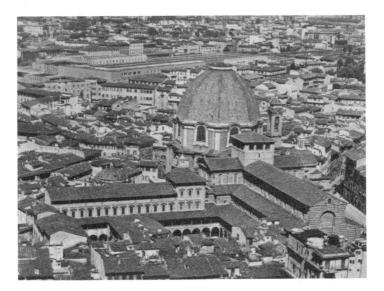

34. San Lorenzo, from the cathedral campanile

Correspondence between Pope Clement VII in Rome and Michelangelo in Florence reveals the new approach; as in modern practice, the patron was constantly concerned with the utilitarian programme while the architect strove for a maximum of expressive effect within its confines. In the initial instructions of 1524, economy and convenience were guides to the choice of site, and preoccupation with

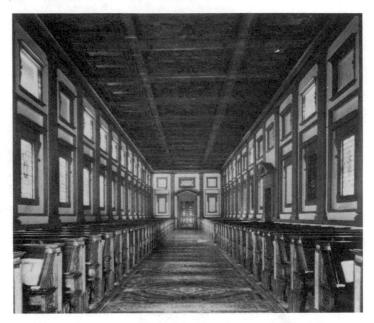

35. Laurentian Library. Interior of the reading-room

utility moulded the plan; separation of Latin and Greek books in the first scheme, later the isolation of rare books into small studies, finally the amalgamation of the studies into a large rare-book room. Michelangelo met the requirements readily, but constantly sought to guide decisions towards aesthetic goals. A site on the church square, for example, he rejected in spite of its convenience for construction because the new building would have hampered the view of the façade.

Having selected the present site, the Pope demanded the strengthening and vaulting (for fire prevention) of the monastic quarters beneath the library with minimal disturbance of their customary functions. In the spring of 1524 Michelangelo concentrated on sustaining the weight of the new structure without substantially thickening the walls of

36. Laurentian Library. Interior of the vestibule looking west

the old. His solution was a buttress system applied to the exterior which may be seen between the façade windows [34] and on the opposite side, where a Romanesque device of blind arcades was applied to the old building. This method imposed two limiting controls on the design: first, it did not greatly thicken the walls below, so that the library walls had to be as thin as would be compatible with security, and second, its regularly spaced buttresses established a bay-system which controlled the placement of the windows and the interior articulation. These are major determinants in the design of late medieval buildings, and Michelangelo, like his Gothic predecessors, responded to them by submitting his expressive forms to the discipline of structure.

This discipline is most evident in the reading-room in-

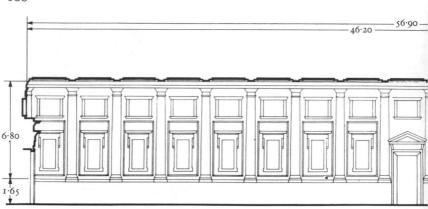

37. Laurentian Library. Longitudinal section and plan

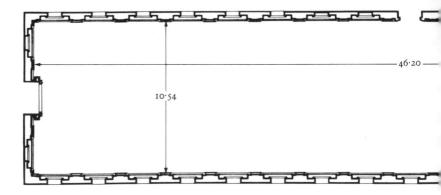

terior [35, 37] where the bay-system of the buttresses determines not only treatment of the wall elevations, but of the ceiling and floor as well. The ceiling, designed as if its decorative partitions were set within a skeleton of longitudinal and transverse beams, appears to be supported by the wall pilasters. Earlier Renaissance ceilings were composed in abstract patterns of coffers independent of the supporting wall.

The Pope was aware of this difference; he started by demanding a ceiling which would differ from those in the Vatican, and when Michelangelo sent him a drawing, he was disturbed that the skeleton did not appear to conform to the wall membering. Though the skeleton is only a symbol of actual structure, it must conform closely to the beams and ties of the roof trusses above, because the walls between the pilasters are too thin to support the roof [37,

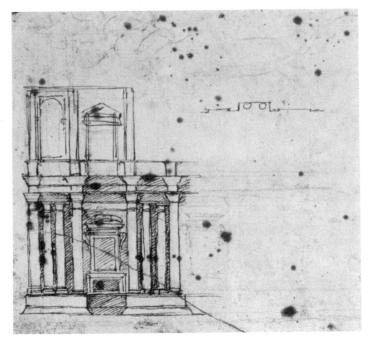

38. Laurentian Library. Reading-room. Interior elevation study (detail)

plan]. This uncommon thinness is a response to structural imperatives which did not occur to Michelangelo in his initial designs. In an early sketch, motivated more by purely expressive impulses [38], he proposed a wall which may have been no thicker at the base, but which would surely have been heavier. Apparently this drawing preceded the structural solutions, since it ignores the final buttressing system. This is familiar Renaissance practice; what is remarkable is that such a marvellous invention should have been cast aside in favour of a quite different one under pressure of structural and practical requirements.

In the final design for the reading-room [37] the windows were placed closer together and brought down to a level as low as the cloister roof allowed [34]. This change,

The Library of San Lorenzo · 103

which increased the light and brought it closer to the reading-desks, was prompted also by a change in the position of the desks; [38] shows the articulation starting at the floor, and was drawn with free-standing desks in mind. while the final scheme placed them flush to the wall [35]. Now even the wooden furniture was to play a part in the structural system, as a visual support for the pilasters; in response to the new relationship, Michelangelo abandoned the massive, sculptural handling of his sketch in favour of a typically Florentine delicacy of membering and emphasis on planes. The second design reduced the wall mass to a minimum. Frames for windows and niches were not the usual sculptural aediculas projecting from the surface, but were placed in rectangular recessions behind the wall plane so that a greater part of the area between the pilasters became no deeper than the window embrasure, a mere screen less than a foot thick [37, plan]. In compensation, the pilasters were not used as ornaments hung on the surface in the usual fashion, but as structural members - interior complements to the buttresses - bracing the wall sufficiently to relieve the thin panels between them of a bearing function.

In every detail Michelangelo gave formal expression to the lightness of the structure: the window frames are composed of lines rather than of masses; their attenuated volutes are weightless and seem to hang rather than to sustain. The baluster-like forms on the tabernacles above, though potentially sculptural, are studiously confined within the planes of the frame. There is a rococo grace in the ceiling panels, which are recessed so slightly that they have hardly more body than the sheet of preparatory sketches [39]. The entrance door, like the walls, was first drawn in heavy, modelled forms [40] and later compressed into a framework composed of thin layers. The evolution of the design tended to give the room a more calm and regular character conducive to study.

39. Laurentian Library. Reading-room. Ceiling study

The vestibule design developed in the opposite direction, from an emphasis on planes [41] to a sculptural treatment resembling the first study for the reading-room [38, 42]. The ultimate contrast between the two rooms signifies their difference in purpose; the vestibule, as an area assigned only to communication, imposed fewer restraints on expression. But, like the reading-room, it had to be designed to a restricted wall thickness though, as it was higher, this thickness was slightly increased [37, plan].

Michelangelo met serious practical problems from the start; an initial attempt to unify the vestibule and readingroom interiors by putting the members and openings at the same height [41] produced a spiritless base of great height all around the vestibule. Later his hope of unifying the exterior of the two rooms under a common roof had to be abandoned, too [42]. Wittkower discovered that before the modern restoration of the exterior, when the three upper window frames were added, the masonry showed a

40. Laurentian Library. Vestibule. Study for the reading-room portal

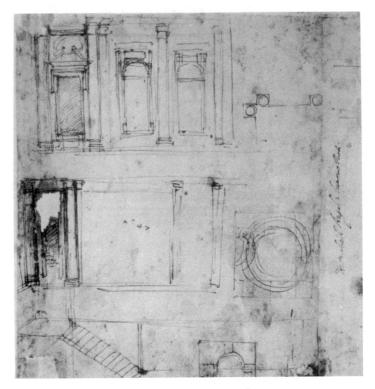

41. Laurentian Library. Project for vestibule elevation. Michelangelo or assistant (*detail*)

change in plan: the vestibule cornice was started at the height of the reading-room cornice and later was raised about 3 m. to its present height. The early project appears in [42], where the vestibule has a flat vault the height of the reading-room ceiling with small windows in the centre of each of its sides. Much of the final design is already fixed in this drawing, but because the overall height is much less, the proportions are all reduced, which made it possible to put pilasters between the columns and the tabernacles of the main order, and to use a complete entablature. The

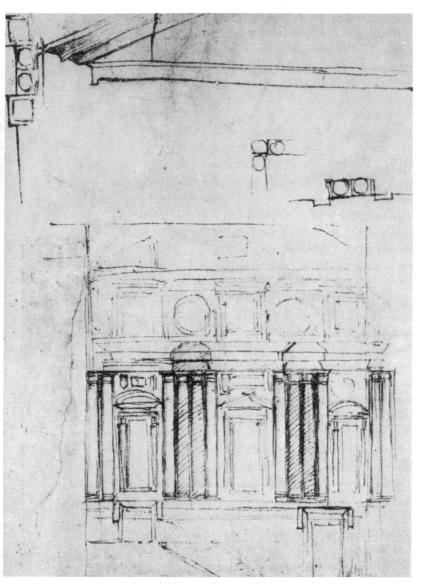

42. Laurentian Library. Vestibule. Study for the west elevation

scheme had to be changed at the end of 1525 for structural reasons, and a wooden ceiling with overhead skylights was proposed as a substitute for the heavy vault. Now lighting became a problem, because the Pope objected to the unprecedented skylights, and the only possible solution was to raise the walls to admit orthodox windows, thereby destroying the overall unity of the library design. The heightening of the vestibule changed its proportions [36, 37]: the columns were greatly heightened and correspondingly broadened, so that there was no longer room for the flanking pilasters (the pilaster motif returned, however, on the inner faces of the column niches), and the entablature was reduced to a thin moulding. Each of these alterations reduced the horizontal accents of the early design and, in combination with the tall clerestory windows, increased verticality; at this point the additional vertical motif of the volutes beneath the columns may have appeared [36, 43].

The restricted width and expanded height of the vestibule made an interior of a strange, irrational quality, unique in the Renaissance. It is pointless to discuss whether this compelling space was the product of practical lighting requirements or Michelangelo's abstract search for form; like all great architecture it owes its distinction to the fact that it is more than either. Michelangelo did not simply submit to the rejection of his original scheme, but used the demand for heightened proportions as an inspiration to conjure a new spirit from existing motifs. The retention of the basic forms of [42] in the final design illustrates Michelangelo's organic approach to design. Columns, pilasters and tabernacles grew as the body grows: with the heightening of the walls, the membering expanded; and since here only upward growth was possible, vertical accents overcame the horizontal as if by biological necessity.

The most extraordinary innovation in the vestibule design is in the main order, where columns are placed in recessions behind the surface of the wall [36, 44]. In ortho-

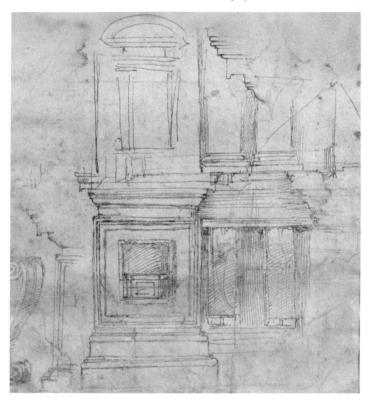

43. Laurentian Library. Vestibule. Study for the interior elevation and section

dox Renaissance practice, columns project forward to sustain lintels or entablatures as they do in the San Lorenzo façade [13], but in the library the foundations were only as thick as the wall, and could not have supported projecting members. Michelangelo's design alters the classical role of columns, which seem to be independent from the architecture, like statues in niches, while the projecting wall appears to support the roof. But this impression is the result of our own conditioned responses to the Renaissance: paradoxically, it is the canonical use of the column [13] that is

44. Structural system of the Library vestibule

entirely ornamental, while Michelangelo's invention is as essential to the stability of the structure as a Gothic pier. The isometric projection [44] shows that the wall behind the columns is a fragile screen that could support nothing without their aid, so that they function as a substitute for the wall-mass. But they are more than a substitute; being monolithic stone shafts, they are stronger in compression than the brick masonry of the walls, and Michelangelo capitalized on this property by making the columns the chief support of the roof. Before the clerestory got its deceptive

The Library of San Lorenzo • 111

facing, one could see that the columns support heavy piers which sustain the roof, while over the tabernacles the walls recede to a thin plane that accommodates the windows [44]. In the final design, then, the structural function of column and wall are exactly the opposite of their visual effects. Michelangelo disguised his technical ingenuity because he was chiefly concerned with form, which partly justifies the failure of modern critics to detect the nature of the structure. Like many engineering discoveries, the recessed column device started as an expressive motive; in [38] the stresses are concentrated on the flanking pilasters rather than on the columns, and contemporary tomb designs by Michelangelo used the recessed columns for sculptural effect. But even where it was not a conductor of major forces, the recessed column remained an efficient substitute for the wall, and in this respect was more utilitarian than its projecting cousins.

Everywhere in the vestibule Michelangelo's licentious use of classical vocabulary, obscuring the actual relationships of load and support, created paradoxes for his academic contemporaries [36]. On the lower level, the volutes, which others used as supporting members, stand in a plane well forward of the columns, sustaining nothing but themselves. The pilaster frames of the tabernacles [45] invert the traditional design by narrowing towards the base rather than towards the top, and are crowned by 'capitals' which are thinner rather than broader than the shaft; just below the capitals appear vestigial regulae, motifs boldly pilfered from the eaves of Doric temples. These and lesser details of the tabernacles, niches and door frames show an extraordinary fertility of invention; striking in themselves, they are given more impact by our foreknowledge of the ancient models from which they err.

Though Michelangelo's drawings for the vestibule are all elevations of one wall – the west – this conventional device did not commit him to working in line and plane:

45. Laurentian Library. Vestibule tabernacle

The Library of San Lorenzo • 113

shading and the indication of projection and recession give them sculptural mass. This consciousness of the third dimension is what made the design uniquely successful spatially, for the room is not an assemblage of four walls but an organic unity: at the corners the elevations can be described as mating rather than meeting. Furthermore, motifs conceived for the west wall serve a different purpose on the north and south; at the entrance to the reading-room the recessed columns may be read as a monumental framework for the door, and on the wall opposite the door the central bay remains blank, without a tabernacle. Though the four walls of this remarkably confined space have three different elevations, unity is enforced by the power of the insistent and continuous alternation of receding and projecting elements.

Continuity in the design of the wall heightens the shocking effect of the stairway [37, 46], which pours out into the vestibule as an alien intruder, a monumental piece of furniture, yet the only essential feature of the design (Michelangelo intended to emphasize this contrast by constructing it in wood). The present stairway, executed by Ammanati after Michelangelo's model of 1558-9, in no way resembles plans of 1524; at that time two flights were placed against the side walls, mounting to a platform before the reading-room entrance [47]. The aim of the early project was to achieve tectonic and visual unity of stairs and walls so that the flights would start and end beneath the major bay divisions of the elevation. There was no sense of intrusion or of contrast at that time, and the design was quite practical because it left a maximum of free circulation space between and before the stairs. Two stairways flanking a central entrance rarely appeared earlier in Renaissance architecture, but the motif was not Michelangelo's invention; a generation before, Giuliano da Sangallo had sketched³ exterior entrances for the Medici Villa at Poggio a Caiano in the form that appears in the uppermost drawing [48].

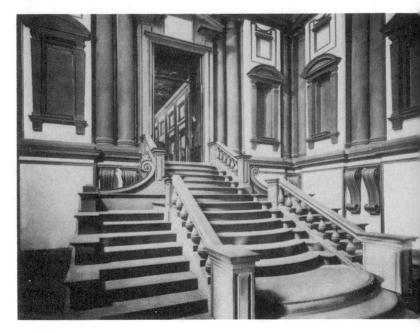

^{46.} Laurentian Library. Vestibule stairway

The final plan [37] departed from both utility and tradition. Since the vault beneath the vestibule was uniformly strong, no restrictions were imposed on the placement of the stairs, and at an early date Michelangelo must have regarded this exceptional freedom as an invitation to bold expression. Once permitted to abandon the wall flights, he was able to change an area subservient to convenience to one which commands the visitor's experiences. While the wall flights, like relief sculpture, had been devised for an established framework, the free-standing stairway, like sculpture in the round, could be nearly independent from its environment. Its modelled, curvilinear motifs and irrational form signify the release from tectonic laws and actually clash with the surrounding walls. The stairway so

Bernardine Gidisidere nonni foldi eldi Bono darro ne zza no mebbe denti quaro Sandrondibertino menti foldi e Gi paradro si dette Jolai federi e deia grossi

The Library of San Lorenzo · 115

47. Laurentian Library. Plan project, with a chapel (?top)

lavishly fills the room that the limited remaining space is wasted for circulation, exaggerating a confinement already implied by the shaft-like proportions and the unattainable height of the windows. To the sense of compression which this imposes on the visitor is added a factor of frustration: he seeks to mount towards the goal, but the steps appear to be pouring downward and outward. On the side flights the upper storey of each successive pair projects forward over the lower, while in the centre the

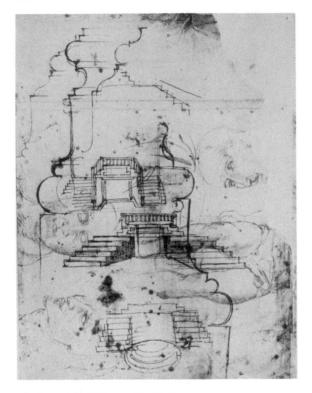

48. Laurentian Library. Vestibule. Studies for the stairway and column profiles

softened convex treads appear to advance, spreading out, as Tolnay phrased it, like a flow of lava, which they resemble in colour. The globules emerging at their sides fortify this impression; they seem to have been forced ahead by the pressure of the balustrade. While the centre flight suggests the discomfort of ascent against the tide, the side flights, being unprotected by railings, are a more real hazard.

There is, after all, a dramatic if not a formal harmony between the stairway and the walls, because both conspire by their aggressiveness against the observer's ease; the wall

49. Laurentian Library. Vestibule. Studies for the stairway and column profiles

planes, emerging forward from the columns, seem to exert inward pressure on the confined space in response to the outward pressure of the stairs.

To anyone familiar with Michelangelo's sculpture it should be no surprise to find the evocation of compression and frustration in his architecture as well. Here, in an enclosed space, he had the opportunity to engender in the visitor the ambivalence between action and immobility which we imagine his *Moses*, for example, to be experiencing. So we, in a sense, become the subjects as well as the observers of the work. We may look at the *Moses* without attempting to share or even to analyse his state of mind, but we should have to muster uncommon resistance not to experience some of the conflicts that Michelangelo prepared for us in the vestibule.

As the vestibule design evolved from an initial unity of stairs and walls to an opposition of the two, so the concept of the library as a whole developed from a unification to a contrast of the reading-room and vestibule. As the one was systematically sobered, the other was progressively dramatized. The two must be seen together; the vestibule does not engender frustration for its own sake, but rather intensifies the experience of relief as one passes into the reading-room. The small study, if it had been built ([50]; planned for the south end of the library, at the top of [37]), would have added another experience mediating between the contrasting moods by its combination of static

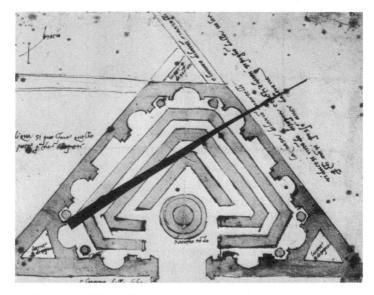

50. Laurentian Library. Project for a small study

The Library of San Lorenzo · 119

form and vigorous modelling. Its plan reveals Michelangelo's consciousness of the geometrical sequence of his scheme: square, long rectangle, triangle, and suggests the psychological, as well as the utilitarian, aptness of his decision to articulate the upright, vertical vestibule actively, and the recumbent, horizontal reading-room passively.

We can gain from the history of the Laurentian library a singular insight into the relative significance of 'commodity, firmness and delight' in Renaissance architectural design. The aim of this analysis has been to emphasize the neglected factors of utility and technique without sacrificing awareness of Michelangelo's constant preoccupation with expressive and commanding form. If this preoccupation was dominant in the sixteenth century, it was not exclusive; Renaissance architecture, like that of any other period, was a product of social and technological forces as well as of ideals. Michelangelo himself justified the fantastic design of his stairway by explaining that the central flight was for the ruler and those on the side for retainers.⁴

[5] THE FORTIFICATIONS OF FLORENCE

War was considered an art in the Renaissance. The Quattrocento *condottieri* fought for fame and money and aimed to outwit rather than to destroy one another; they were colleagues in an honourable profession. But by the mid sixteenth century the aggressive politics of great states and the increasing efficiency of firearms turned war into the deadly science that it has been ever since. So, for a century after the introduction of heavy artillery (*c.*1450), military installations were designed by artists; but when technical knowledge of arms and tactics became more important qualifications than imagination and improvisation, military engineers pre-empted the field.

Art historians rarely have made the distinction between the aesthetic and the technical age of warfare, and have set aside the military treatises and designs of the Renaissance as if they were irrelevant to the study of artistic personality. But for many artists of the century 1450-1550, military design was not only a major source of income, but a major preoccupation. Leonardo da Vinci recommended himself to Lodovico il Moro in 1482 as a civil and military planner, suggesting only casually that he was a competent painter. And over a half-century later Michelangelo said that while he knew little of painting and sculpture, his long study of and experience in fortification qualified him as an expert.

Medieval fortifications with their long walls interrupted at regular intervals by high, square projecting towers [51] became obsolete after the introduction of heavy mobile siege artillery in the mid fifteenth century.¹ Early cannon

The Fortifications of Florence · 121

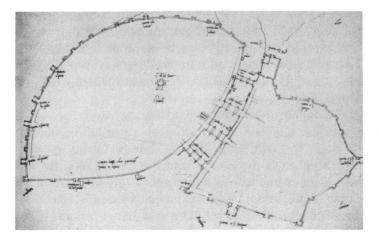

51. Peruzzi. Plan of Florence's medieval fortifications

were powerful enough to destroy defences made vulnerable by thinness, height and sharp angles. And the artillery of the defenders could not be manoeuvred on the narrow parapets designed for small arms. The need for a drastic change in design was demonstrated to the Italians by the French invasions of the 1490s, the success of which was not due so much to superiority of arms as to an earlier grasp of the tactical potential of large batteries of artillery. (An Italian military treatise of 1476 advised using one cannon for a force of 18,000 men.)

It was a long time before cities could afford to do more than to lower old walls and towers and to remove crenellations; the chief problem for early designers was to strengthen angles and gates or to build compact fortresses at strategic points. At the close of the fifteenth century, the favoured solution was a fortress of square or triangular plan with low, heavy round towers at the corners having gun emplacements in vaulted interior chambers and on the roof.

Variations of this method are found in the theoretical studies of Leonardo and of Dürer² and were built at the

Fortresses of Ostia (1483-6 by Giuliano da Sangallo and Baccio Pontelli), the Castel Sant'Angelo in Rome (1490s, Giuliano and Antonio da Sangallo the Elder), Sarzanello in Tuscany (1490s, designer unknown), the Port of Civitavecchia (1508, Bramante) and, via Leonardo, influenced the design of the château of Chambord.

The round tower had two advantages over the square: it was less vulnerable to missiles and it had an unimpeded coverage of a wide arc. But the interior chambers were made impractical by fumes from the cannon, and the forward faces of the towers could not be protected from the curtain walls behind, so that the enemy might take cover directly before the towers. This was such a serious drawback that the tower system was abandoned a few years after the first experiments; it was already extinct in Italy by the time of Dürer's publication.

The alternative was the bastion [52], which became the basis of modern systems of fortification. It was not a tower but a projecting platform, level with the walls; its basic form was triangular, since this shape allowed all its surfaces to be flanked by fire from the curtain walls behind. At the base the triangle was modified to provide emplacements

52. Typical early bastion trace, 1527 A. face B. flank C. casemate D. curtain walls E. gorge

for gunners to shoot parallel to the curtain walls in case the enemy came close.

Early versions of the bastioned system were recorded by the Sienese artist Francesco di Giorgio Martini, in his *Trattato di architettura civile e militare* (1487–92), written with the assistance of the most learned of Quattrocento *condottieri*, Federigo da Montefeltre. Though he was a partisan of the round tower, Francesco built some bastioned fortresses in Federigo's Duchy of Urbino. J. R. Hale has recently shown that he reflected a widespread experimental approach of the later fifteenth century rather than being the innovator that earlier studies represented him as being.

In view of the historical importance of the bastion, it is curious that the effort to determine when and where it was first used was abandoned after the initial researches of nineteenth-century military writers. It may have been invented by members of the Sangallo family in the service of the papacy at the turn of the sixteenth century; primitive versions appear in the Siena sketchbook of Giuliano da Sangallo dating from 1503; and two small coastal forts in papal territory - at Civita Castellana (1494-7) and Nettuno (1501-2) - reveal successive stages in the evolution of the form. A few years after the French invasions, the flurry of fortress building subsided, and until the eve of the Imperial invasion of 1527 that ended with the Sack of Rome, we know of only two major defensive systems raised in Italy, at Ferrara in 1512 and at the Port of Civitavecchia in 1515-19. The Ferrara enceinte, which Michelangelo inspected in preparation for defending Florence, was modernized later in the century, and no earlier plans have been published; but projects for Civitavecchia by Antonio da Sangallo the Younger are preserved in the Uffizi and show an irregular enceinte in which the bastioned system appears to be fully developed. The younger Antonio subsequently became a leading Italian authority on fortifications; in 1526, with Michele Sanmicheli, he surveyed the defences of the papal

territories in the Marches and the Po Valley for Clement VII, and was invited by Machiavelli to consult on the Florence fortifications; three years later, as chief engineer of the Imperial forces, he was pitted against Michelangelo in the siege of Florence and afterwards was commissioned to build the permanent defences and the Fortezza da Basso (1534-?). Sanmicheli, who was probably a disciple of Sangallo, was credited by Vasari with the invention of the bastion and with the design of the earliest surviving example called 'delle Maddalene' in Verona, in 1527 [52]. Recently the engineer Michele da Leone was found to be the designer; round tower-bastions had been raised at Verona as late as 1525, and Leone's innovations were refined by Sanmicheli in completing the city's enceinte after his arrival in 1529-30.3 These bastions remained for decades the most advanced in Italy because of their large vaulted and ventilated interiors, covered passages and retired flanks. In the year that Verona changed to the modern system, Siena also built six bastions on designs by Baldassare Peruzzi. In the 1530s many of the major cities in Italy followed the lead: Ancona (1532), Turin (1536), Castro (1537), Naples (1538), Perugia and Nepi (1540).

The little we know of the early history of the bastioned system is enough to show that a lethargic development in the first quarter of the sixteenth century was suddenly accelerated throughout Italy in the years 1526-30. This places Michelangelo's fortification projects among the incunabula of modern military architecture, just at the most fluid and inventive moment in its history, at a time when experience had established no proven formula of design. Unlike the situation in other arts, the lessons of antiquity and of preceding generations were of little account; this is one of those rare events in the history of architecture when technological advances altered the basic precepts of design. As a rule, technical discoveries that most affect buildings are in the field of structure – such as the invention of concrete in ancient Rome or of structural steel in the last century – but the challenge encountered by Michelangelo and his contemporaries was more comparable to that of the modern architect in planning for the requirements of the automobile. Artillery, like motor transportation, is a mechanical innovation which is not a part of a building but which affects the way it is used, and consequently the way it must be built.

The foremost problem of fortification is to reconcile two exigencies of artillery warfare that are incompatible: defence and offence. A design with maximum security against enemy missiles is likely to allow the defenders only a minimum of manoeuvrability and range, and vice versa. In the Renaissance a satisfactory equilibrium was reached only after a long period of experimentation. The early solutions discussed here were overbalanced on the side of defence; Michelangelo's designs were the first to suggest the full potentialities of offensive planning.

The drawings eloquently testify to Michelangelo's concentration on the power of the defenders; his bastions spring from the walls like crustacean monsters eager to crush the enemy in their claws [53-7]. Compared with the blunt and massive blocks of the Sangallos and Sanmicheli [52], they seem to be fantastic visions created rather to symbolize than to implement the terrifying power of firearms. Apparently this is the impression they made on contemporaries, for further evolution of sixteenth-century fortification followed the path of the other architects; but the fact that Baroque fortification ultimately produced designs similar in many respects to Michelangelo's impels us to find in these drawings not only their unparalleled expressive force but the special grasp of military functions that made them prophetic if not influential.

Part of the motivation for the aggressive biological forms in these drawings is certainly purely formal: the curved orillons of some of the bastions [53] are monumen-

tal versions of the stairway motifs in the Laurentian library; in other designs what Scully has aptly called the 'reflex diagonal' has the dynamic spirit of the Medici tomb sarcophagi allegories and of the stairways of the Capitoline Hill and Belvedere. But an analysis of the nature of artillery defence reveals a peculiar practical justification for such forms.

While civil and religious buildings are planned to suit the people who use them, fortifications must be planned to suit guns. The architect may visualize people in motion or at rest, and in the Quattrocento he chose the latter; but he must visualize guns in action, since they are no use unless constantly propelling missiles. On this account, the development of modern fortifications aided the radical change from a static to a dynamic conception of architecture which came about in the course of the sixteenth century. Though most military architects were slow to see the special implications of planning for artillery, Michelangelo was prepared to grasp them immediately, because his projects for the Laurentian library represent the first dynamic planning of the Renaissance in that they urged the visitor to pass through the building rather than to seek a static vantage point.

The uniqueness of Michelangelo's fortification drawings is the result of his concentration on the aggressive action of heavy missiles as they explode outward from a defensive nucleus. These are the only military designs of the age – with the exception of a few of Leonardo's sketches – that consistently specify the trajectories of cannon; they are stroked with a vigour that evokes their spread and power; the structures themselves take shape around them. The peculiarly organic character of Michelangelo's bastions is due to the fact that they are envisaged as a framework to house and to release dynamic forces. A comparable adjustment of form to mechanical forces is found in the 'streamlining' of modern airplanes, which also produces certain zoomorphic suggestions.

53. Project for gate fortifications. Porta al Prato

54. Project for gate fortifications. Unidentified

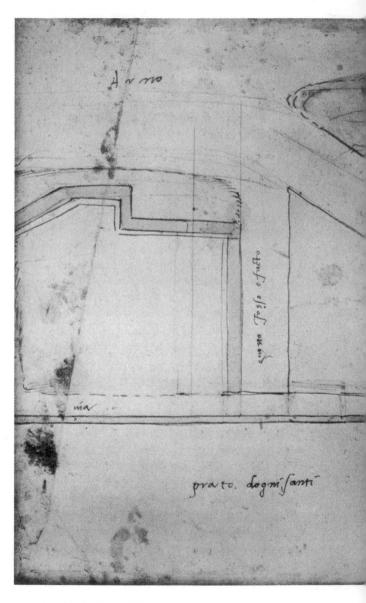

55. Preliminary project for the Prato d'Ognissanti

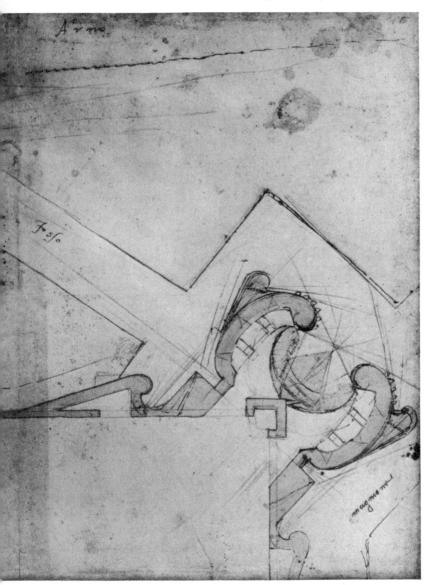

The Fortifications of Florence • 129

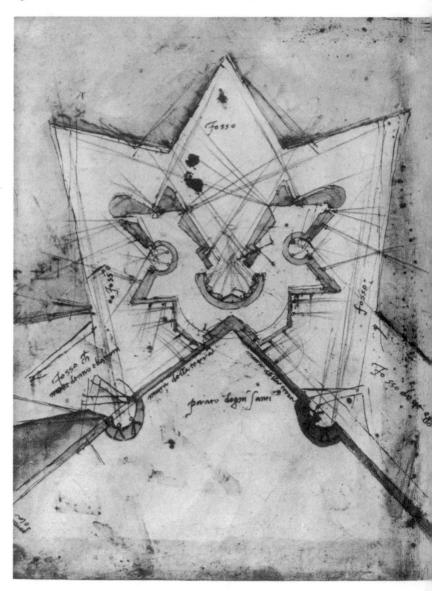

56. Developed project for the Prato d'Ognissanti

What Michelangelo did not consider in his plans was the equally powerful artillery of the enemy: the fact that cannon balls would be hurtling into, as well as away from, the bastions seems to have played little part in his thinking. Had he given more attention to this inescapable condition of defensive action, prudence might have dictated a more sober expression.

His many sharp and attenuated salients are comparable to small and lightly armed commando units; they provide maximum range and versatility but are not calculated to sustain prolonged attack from concentrated forces. Since bastions are devices by nature more defensive than offensive, Michelangelo's ideas were not destined to be accepted; but his contemporaries, who thought almost exclusively of defence, would have found better balanced solutions had they studied his drawings.

In the most zoomorphic of the projects [54, 55] there are curves on the faces of the bastions which cannot be flanked by fire from other positions and so give cover to an enemy close to the walls. In some of the later (?) drawings [57] these blind spots are eliminated, which may be due both to criticism from military experts and to Michelangelo's habit of starting with a formal statement and later adjusting it to structural and functional conditions.

It is in these 'later' drawings that Michelangelo anticipates the forms of Baroque fortifications. Projects such as [57] are strikingly similar to ideal bastions suggested in the *Manière de fortifier* (1689) by the great French military engineer Vauban [58], particularly in the use of ravelins, the isolation of the several salients, and the acute, attenuated triangular trace. But in comparing isolated bastions by Vauban and Michelangelo we may fail to detect a crucial difference between the two which explains the obscure fate of the latter: Vauban's system is part of an overall fortress plan in which every bastion is supported by flanking fire from adjacent salients and bastions, while Michelangelo's is

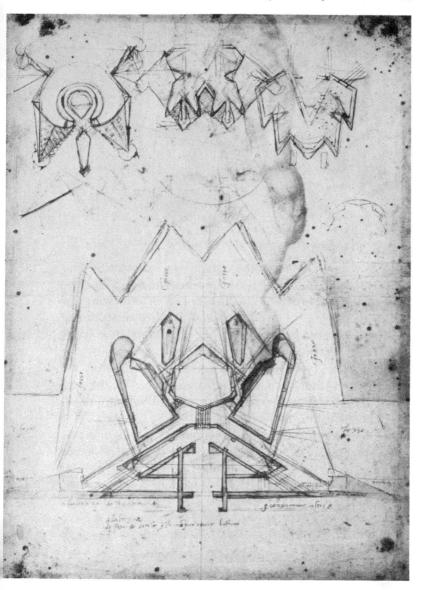

57. Project for gate fortifications

58. Vauban. Bastioned system of fortifications with ravelins, 1689

an isolated unit, added to the curtain wall, that must fend for itself. The attitude of contemporaries towards this deficiency is expressed by Bonaiuto Lorini in criticizing his French colleagues:⁴ 'Since (the bastions) were small in size and the curtain walls were long, the defenders were hampered both by the distance between bastions and by the restricted space, which easily became congested; thus the faces of the bastions remained undefended ...' In the perfected late Renaissance system the mutual support of all salient elements was taken for granted.

We do not know whether the temporary earthworks that Michelangelo hurriedly erected for the siege of Florence in 1529-30 resembled his drawings, which were projects for permanent installations, probably done a year earlier. Antonio da Sangallo the Younger, who replaced the earthworks with masonry in the later 1530s, could not have retained much of Michelangelo's system, since the permanent installations were typical examples of his more cautious style. It is ironic that Michelangelo's remarkable experiments should have reached posterity filtered through the hands of his worst enemy and most unsympathetic com-

The Fortifications of Florence • 135

patriot, and that Vauban himself should have studied the late defences of Florence as authentic works of Michelangelo.

The drawings never were circulated. Military historians have not discovered them yet, and have interpreted Michelangelo on the grounds of his dubious contribution to the defences of the Vatican and the papal ports, and from literary chronicles of the siege of Florence. But the chroniclers, brief as they are, left a record of Michelangelo's temporary defences that adds a dimension to the data in the drawings. They describe curtains and salients of packed earth and straw covered with unbaked bricks made of organic materials, the principle of which was to nullify by absorption the shock of missiles on exposed surfaces. The theory of elastic defence opposed the current preference for massive rigid walls, and was conceptually attuned to the supple, zoomorphic character of the drawings which, in fact, have frequent indications of earthen escarpments serving the same purpose along the curtains [53, 57 marked 'terra']. Thus Michelangelo applied his organic theory of design both to the offensive and defensive problems of military architecture.

If the drawings had no chance to affect the future history of fortifications, they were an important factor in the formation of Michelangelo's mature style. The necessity to find an architectural solution for projectiles in constant radial motion along infinitely varied paths must have helped to remove from his mind the last vestiges of the static figures and proportions of the Quattrocento. The experience was a catalyst to ideas tested in the Laurentian library, where the visitor was impelled to move, but still along a fixed axis and through independent spaces; the next stage, represented by the Capitoline Hill and the projects for San Giovanni de' Fiorentini, imposed a variety of radial axes on a unified space, allowing the visitor a multiple choice of movements (cf. [57] and [65]). Perhaps the study of artillery suggested this new way of dealing with human motion.

[6] The capitoline Hill

Medieval Rome had no centre. Other Italian towns that had been smaller in antiquity grew in clusters about their ancient squares, while Rome gradually shrank until its fora and major churches were on the outskirts, and the remnants of a metropolis settled in compressed disorder along the banks of the Tiber. When the city government decided to raise a communal palace in the twelfth century, it chose the deserted site of the Tabularium on the slope of the Capitoline hill overlooking the Republican Forum. The decision must have been dictated by the dream of renovatio - the restoration of ancient glory - as the hill had been the site of the Arx of the earliest settlers and of the major temples of Imperial Rome.¹ Isolated from the everyday life of the city on a summit without paved accesses, the Capitol, or Campidoglio as the Romans called it, failed until the sixteenth century to arouse sufficient civic pride to foster the construction of a monumental communal piazza such as nearly every major Italian city had produced in the Middle Ages. We owe to this delay one of the most imposing architectural compositions of all time; nowhere but in Rome had a Renaissance architect been given the opportunity to create a grandiose environment for the political life of a great city.

It was lack of opportunity rather than of desire that deterred early Renaissance designers from executing ambitious civic schemes. Every architectural theorist of the Renaissance was a philosopher of urbanism; Alberti and Leonardo thought primarily of improving the appearance

The Capitoline Hill · 137

and convenience of existing towns; Filarete and Francesco di Giorgio drew ideal, geometrically perfect projects to be raised anew. But their schemes remained on paper, and only in occasional provincial villages, such as Pienza, Cortemaggiore, or Vigevano, or in the refurbishing of existing squares, could modern ideas be tested. Unfortunately, the largest planning project of the sixteenth century was totally destroyed: the town of Castro, redesigned by Antonio da Sangallo the Younger for Pope Paul III as the capital of a Duchy fabricated for the Pope's son.²

The square at Pienza, of 1456/8-64 [59], is the only Quattrocento scheme comparable to the Campidoglio. Built for Pope Pius II by Alberti's follower Bernardo

59. Pienza, cathedral square. Plan

Rossellino, it was the core of the town's life, containing the cathedral at the centre, and, on three sides, the palaces of the Bishop, the Piccolomini family and the Commune.³ By chance, the plan is trapezoidal, like Michelangelo's [65], because of the axes of the pre-existing streets on either side, and because the expansion in width opened prospects past the cathedral transepts over a panorama of Tuscan valleys and hills. Though the major street runs through the base of the trapezoid, a lesser one enters, like the Capitoline cordonata, on the principal axis. Rossellino divided the piazza into rectangles by horizontal and vertical bands which help to draw together the façades and lead the eye towards the cathedral. The projects of Rossellino and Michelangelo have similar devices: the regular plan, symmetrically organized about the entrance axis of the central building; the systematization of the entrance ways into the piazza, and the pavement pattern calculated to integrate the several buildings. But the effect is quite different; the Pienza buildings are diverse in size and scale, and above all, in style; the sole monument within the square - a wellhead - is eccentrically placed on the right edge. The harmonious relationship among independent units, characteristic of the Quattrocento (cf. Chapter 1), focused attention on the individual buildings, and spatial effects were a by-product of the design of the enframing masses. Only in the last generation of the fifteenth century did architects begin to think of single elements as a function of the whole - to regard a given environment not merely as a neutral repository for a work of art, but as something that might be formed and controlled by the manipulation of voids and the coordination of masses. The difference in approach is illuminated by a similar change in the music of this generation; the polyphonic structure which produced harmonies through the superposition of independent melodies began to give way to homophonic forms in which the several lines were subordinate to harmonies constructed vertically to produce

60. Capitoline Hill. View

sequences of chords; a concordance of voices became primary.⁴

The new spirit, foreseen in certain sketches of Francesco di Giorgio, appeared in the planning schemes of Leonardo and Giuliano da Sangallo, but was first applied in practice by Bramante. In his plan of 1502 for the precinct of the Tempietto of San Pietro in Montorio, the central building was not intended to stand isolated in a neutral space as it does today, but to be the nucleus of a scheme which controlled the total environment, which formed palpable spatial volumes as well as architectural bodies, in such a way that the observer would be entirely enveloped in a composition that he could grasp only as a whole. Two years later Bramante applied the principles of environmental control to the most monumental programme of the age, the Cortile del Belvedere [107]. Here his raw material was an entire mountain side; his design had to impose the authority of intellect upon nature. Inspired by antique precedents, he devised a sequence of rectangular courts on ascending levels, bound by stairways and ramps of varying form and framed by loggias. His principles of organization were: first, emphasis on the central axis (marked by a centralized monumental fountain in the lowest court, a central stairway and niche in the central court, and a focal onestorey exedra in the garden at the upper level, the last already destroyed by Michelangelo in [107]); second, the symmetrical design of the lateral facades; and third, a perspective construction in three dimensions devised for an observer in a fixed position within the Papal stanze, and reinforced by the diminishing heights of the loggias as they recede towards the 'vanishing point' at the rear.⁵

Michelangelo must have borrowed certain elements of his composition from the Belvedere; the fact that he used a replica of the Senatore staircase in remodelling Bramante's exedra in 1551 [60, 106] indicates his awareness of the similarity of the two plans. Both required the regular-

The Capitoline Hill • 141

ization of rolling hillsides, the integration of pre-existing buildings, and covered porticoes on either side. Several of Bramante's devices were applicable to the Campidoglio, particularly the central monument and stairway used for axial emphasis, and the niche centred in a triangular plane formed by ramps. Bramante's static perspective construction was unsuitable to the Capitoline topography and was anyhow uncongenial to Michelangelo's interest in movement through space; but the Campidoglio plan does fix the observer's viewpoint momentarily by forcing him to enter the piazza on the central axis at the only point from which the composition can be viewed as a whole.

The common feature of the two plans is a unity achieved by the organization more than by the character of the component parts, a unity imposed by general principles axis, symmetry, convergence - which command the voids as well as the architectural bodies. The actual form of certain elements might be changed without disturbing the organization - for example, the Marcus Aurelius monument could be a fountain; and this illuminates what Michelangelo meant when he said in speaking of axial compositions (p.37): 'the means are unrestricted and may be chosen at will.' What distinguishes Michelangelo from his predecessor is that his choice of means more effectively reinforces the principles of organization and binds the Campidoglio into a coherent unity. His individuality emerges in dynamic composition; the elements in the Campidoglio do not produce the restful progression of the Belvedere, but are directed towards a dramatic climax at the portal of the Senators' palace. Internal tensions built up by contrasts of equally potent forms - horizontals and verticals in the façades; oval and trapezoid in the pavement - offer diversions and ambiguities that only amplify the ultimate confluence towards the goal. This crescendo of forms was destined to become archetypal in civic planning; though the vigour and ingenuity of the Campidoglio have rarely been equalled, the U-shaped plan, the convergence of low wings towards a dominant central accent, the doubleramped stairway and the centralized monument were to become characteristic components of urban and villa design in the following centuries.

On 10 December 1537, 'Master Michelangelo, sculptor', appeared on a list of foreigners awarded Roman citizenship in a ceremony at the Capitol;⁶ in the same month, he probably started designing for the statue of Marcus Aurelius – which Pope Paul III had brought to the hill against his advice – a pedestal, the shape and orientation of which implies the conception of the entire plan. No more is known of the circumstances leading to his project for the Piazza; but certain conditions of the commission may be

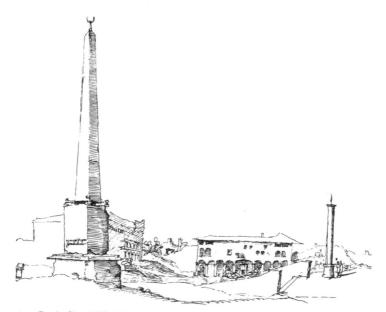

61. Capitoline Hill. View, 1535-6

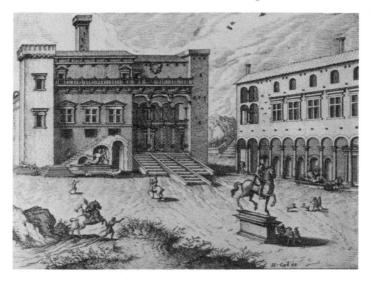

62. H. Cock. Capitoline Hill. View as of c.1544-5

63. Capitoline Hill. View, c.1554-60

deduced from knowledge of the site in these years. The statue had been placed in an uneven plateau in the saddle of the hill between the northern peak occupied by the church of Santa Maria in Aracoeli and the southern rise towards the Tarpeian Rock [61]. Two structures bordered the plateau: the medieval Senators' palace on the east, and the Quattrocento Conservators' palace on the south. The only paved access was a stairway descending from the transept of the Aracoeli; towards the city the slope of the hill, creased by muddy footpaths [64], fell sharply off to the west. Michelangelo must have been asked to submit proposals, first, for an entrance from the city, second, for the conversion of the plateau into a level paved area, and third, for a modest restoration of the dilapidated palaces.

The plan that transformed the disorderly complex into a symmetrical composition unifying five entrances, a piazza, and three palace fronts [65-7] was too extraordinary to have been foreseen by lay administrators; Michelangelo must have found in their mundane programme an inspir-

64. Capitoline Hill. View, c. 1554-60

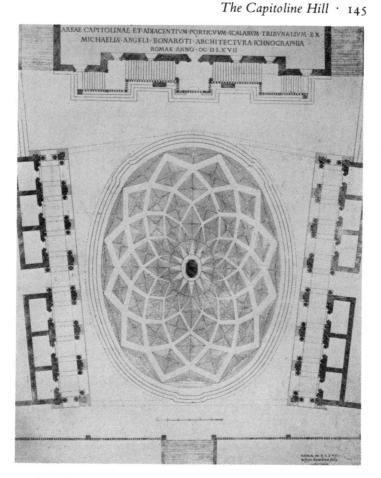

65. Capitoline Hill. Plan, after Michelangelo, 1567

ation for a design the grandiose character of which persuaded them to raise their goals. The Conservators may not have assented easily: their budget was restricted throughout the sixteenth century, and they cannot have anticipated proposals to build a new campanile simply to emphasize the axis, and to raise a third palace along the left side of the square the function of which was to be purely aesthetic. Yet without the 'Palazzo Nuovo' (the name indicates the absence of a practical purpose), no order could be imposed on the scheme; it achieved precisely the goal that Michelangelo so vigorously defined in the letter quoted on page 37, where he affirmed the relationship of architecture to the human body in the sense that necessary similarity of the eyes and uniqueness of the nose implies

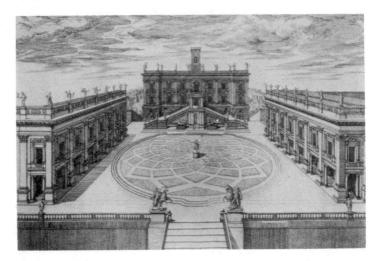

66. Capitoline Hill. Perspective, after Michelangelo, 1569

that architectural elements to the left of a central axis must be mirrored by those on the right, while the central element must be unique. Aside from the gratuitous addition of a palace front, economy was a major determinant in Michelangelo's solution; he accepted the condition that the existing palaces were to be retained intact and merely to be covered with new façades. This gave his patrons the freedom to execute the project in stages, according to their means; the Senators' stairway could be finished fifty years before the façade, and the Conservators' façade be built in

The Capitoline Hill · 147

one-bay sections without demolishing the earlier façade or interrupting the normal functions of the offices inside.

In accepting the existing conditions, Michelangelo had to rationalize the accidental orientation of the two palaces, the axes of which formed an 80° angle. An irregularity that might have defeated a less imaginative designer became the catalyst that led Michelangelo to use a trapezoidal plan and to develop from this figure other features of his scheme; he so masterfully controlled this potential disadvantage that it appears quite purposeful.

In the engraved plan and perspectives after Michelangelo's design [65, 66] only those elements are specified that may be seen by an observer within the square: of the five access stairways only the first steps are indicated, and nothing is shown of the palaces except the façades and porticoes. Obviously the project was not envisaged as a complex of individual building blocks, but as an outdoor room with three walls. This is a response to topographical conditions that are falsified by engravings and modern photographs [60] where the observer is artificially suspended in mid-air. In actuality, one cannot grasp the composition from a distance; it unfolds only upon arrival at the level of the piazza, as upon entering a huge salone. So Michelangelo did not continue the palace facades around the buildings; they stop short at the corners as if to indicate that they belong properly to the piazza. Consequently, the Palazzo Nuovo was planned simply as a portico with offices; the present interior court is a seventeenth-century interpolation. Michelangelo built the niched wall that appears in [64] just at the rear of the offices (note the shallow roof in [66]).

Another explanation for the apparent artificiality of the solution is the immemorial function of the Campidoglio as the site of solemn public ceremonies performed in the open air. The piazza was to be the chief locus of civic events, rather than the conference halls, prisons and tribunal within

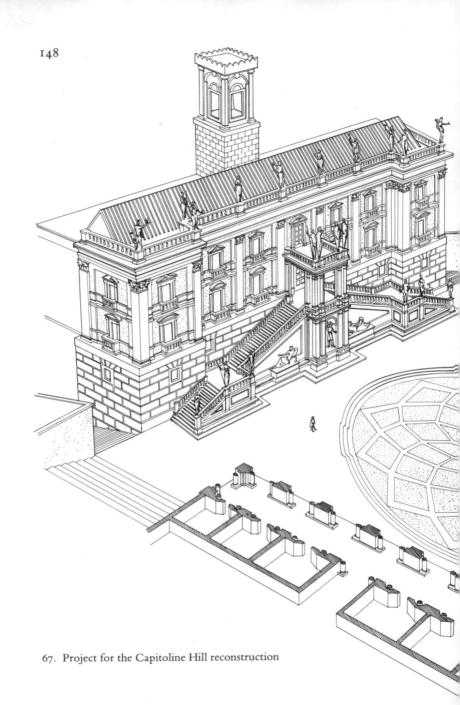

The Capitoline Hill • 149

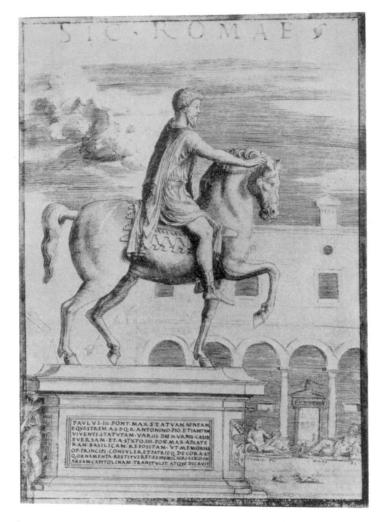

68. Francisco d'Ollanda. Statue of Marcus Aurelius, 1538-9

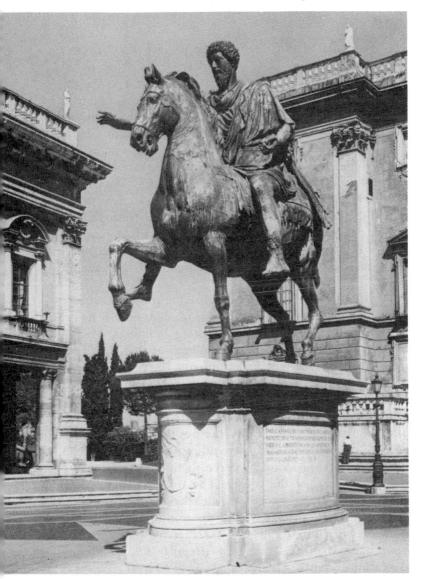

69. Statue of Marcus Aurelius on Michelangelo's base

the palaces. The average citizen would come to the hill only to witness some ritual that demanded an awesome and spectacular setting. Perhaps the project was visualized as a translation into permanent materials of those arches, gates, and façades of wood and canvas erected in the sixteenth century for the triumphal entries and processions of great princes. Indeed, an occasion of this kind prompted the renovation of the Capitol. When the Emperor Charles V entered Rome in 1536, the lack of a suitable access and the disreputable condition of the piazza combined with political considerations (it was only nine years after the sack of the city by his troops) to frustrate the enactment on the hill of the traditional climax to an Imperial triumph. The Pope's determination to acquire the statue of Marcus Aurelius for the Campidoglio in 1537 appears to have been the initial reaction to the embarrassment of the previous vear.

In order to place the equestrian statue properly when it arrived in 1538, an overall plan was needed, since it had to be purposefully related to the existing buildings. Michelangelo's plan must have been produced at that time since the oval statue pedestal, which mirrors the proposed form of the piazza, bears an inscription of 1538, and appears in a drawing made shortly after by Francisco d'Ollanda [68]. The oval area, with its vigorous stellate pattern [65], is one of the most imaginative innovations of the Renaissance: set off by a ring of three steps descending to its depressed rim, it rises in a gentle domical curve to the level of the surrounding piazza at the centre. The oval was almost unknown in earlier architecture: Michelangelo had proposed it in projects for the interior of the tomb of Julius II, and it appears in church and villa sketches by Baldassare Peruzzi; but humanistic distaste for 'irregular' figures discouraged its use.7 Further, it was traditional to treat pavements - particularly in outdoor spaces - in rectilinear patterns, either in grid form [59, 84] or, in the courts of large palaces,

The Capitoline Hill • 153

as bands radiating out from the centre. But neither solution was adaptable to the trapezoidal boundary of the Campidoglio. The problem, so elegantly solved by the oval, was to find an organizing figure that would emphasize the centre where the statue was to be set, and yet not counteract the longitudinal axis of both the piazza and the statue itself. While the circles, squares and regular polygons that formed the vocabulary of the Quattrocento could meet only the first condition, the oval combined in one form the principles of centrality and axiality; it was this dual character that later made it so popular in church design. As a pure oval, however, Michelangelo's figure would have conceded nothing to its trapezoidal frame, but it contains a further refinement: three concave recessions formed in the surrounding ring of steps suggest to the visitor entering from the cordonata the expansion of the piazza towards the rear, and at the same time introduce him to the choice of two ascents to the Senators' palace.

The offer of alternative routes imposes an unclassical ambivalence: while the visitor enters the piazza, and later the Senators' palace, on axis, his direct progress is barred first by the statue, and then by the entrances to the double-ramped stairway. He is not only forced to choose between two equally efficient routes, but is distracted by an emphatic stellate pavement that suggests movement of a different sort, along curvilinear paths towards and away from the centre. He thereby becomes intensely involved in the architectural setting to a degree never demanded by earlier Renaissance planning. By forcing the observer into a personal solution of this paradox, Michelangelo endowed movement, which usually is just a way of getting from one place to another, with aesthetic overtones.

The stairway to the Senators' palace [66], though also anticipated in Peruzzi's sketches, was the first of its kind to be adapted to a palace façade. Like the oval, this form solved several problems at once: it pre-empted a minimum of space in the piazza, it gave direct access to the great hall on the *piano nobile*, and it was the perfect setting for the reclining river gods that had previously blocked the entrance to the Conservators' palace [61]. Its purpose was expressive as well as practical; the dynamic effect of the triangular form, which so powerfully coordinates the three façades and masks their inequality in height, had been evoked by Michelangelo in organizing the figures of the Medici chapel and in his fortification drawings [21, 53]; perhaps it was initially suggested by the analogy of the river gods to the reclining allegories in the chapel. The baldachin at the summit of the flights, which may have been devised as a ceremonial setting for the appearance of dignitaries, diverts the angular accents of the stairway into the mainstream of the central axis, echoing the form of the campanile above.

As the stairway covered most of the lower storey behind and raised the entrance to the level of the *piano nobile*, the façade could not conform to the three-storey Florentine tradition exemplified by the Farnese Palace [75]. The lower storey had to be treated as a basement distinct from the upper floors; its drafted facing emphasized this distinction and also expressed the rude character of the prisons behind. In effect, the palace became a two-storey structure like those on either side, so that it proved possible to harmonize the composition by adapting to all three palaces the colossal order with its heavy cornice and crowning balustrade; within this syntax the central palace could be differentiated by the design of its apertures.

The open porticoes of the lateral palaces belong, like the loggia of Brunelleschi's Foundling Hospital in Florence and the Procuratie of St Mark's Square in Venice, as much to the square as to the buildings [70, 71]. They even favour the piazza by screening the entrance portals within, so as to increase the dominance of the longitudinal axes over the cross-axes. They are extraordinary in structure as well as in form. Early Renaissance porticoes had been a succession of vaults

The Capitoline Hill • 155

supported by arches. Though Alberti insisted that antique precedent demanded that arches be sustained by piers while columns should carry only lintels, his advice was ignored before 1500; Ouattrocento arcades are generally columnar. Bramante reintroduced the column-and-lintel system in open loggias in the Cloister of Santa Maria della Pace and in the Vatican façade (now Cortile di San Damaso), but only in upper storeys, where the interior could be spanned in wood. Peruzzi's entrance to the Massimi palace of 1535 was perhaps the first revival of the ancient technique of spanning a portico with stone beams, though on a much more modest scale than at the Campidoglio. Michelangelo's combination of column and pier provided sufficient bracing to allow expansion of the system to monumental scale. The scale actually precluded the use of arches; openings as broad as those of the Conservators' palace could not have been arched without penetrating into the pre-existing second storey. Furthermore, Michelangelo preferred the effects of post-and-beam construction; in 1548 he walled up Sangallo's arch over the central window of the Farnese Palace to replace it with a lintel [85], and on the one occasion when he used structural arches on the exterior of a building - at the Porta Pia, where they were imperative - he disguised the form [123]. Semicircular arches have a static effect uncongenial to Michelangelo's powerful interplay of horizontal and vertical forces. Although Michelangelo used monolithic lintels or beams over the columns of the piazza facade of the Conservatori, the portico itself is spanned by flat 'arches' - horizontal members composed of three separate voussoir stones doubtless joined internally by iron braces; these are made to look as much as possible like monoliths [72].

In the Conservators' palace, this interplay recalls the effects of a framed structure; the façade construction is as close to a skeletal frame as it is possible to attain in stone. Where the columns, pilasters and entablatures of San Lor-

enzo and St Peter's [12, 94] merely express stresses of load and support that actually are absorbed by the wall-mass. here they really do the work that they appear to do. The cornice is supported by the pilaster-piers and the lower entablature by the columns; the facade wall is no longer a major bearer of loads; it is itself supported on beams and takes so little stress that della Porta was able to replace almost an entire section with glass [70]. Consequently, so little wall is left that attention is drawn to the members. where it is held by the contrast of their rugged texture and light, advancing colour to the smooth surface and receding colour of the brick wall-plane. But the stability of the portico [72] and façade is not wholly due to the 'skeleton'; it requires stiffening by internal walls perpendicular to the principal axis - those in the rooms above, and especially by those of the lower floor [65], which Michelangelo ingen-

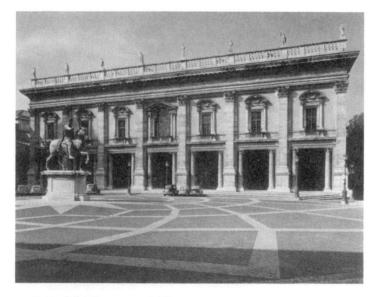

70. Palazzo de' Conservatori. View

71. Palazzo de' Conservatori, 1568

iously calculated to work both as buttresses and as partitions between the guild offices.

Because the Conservatori design gives the antique order a structural as well as a decorative function, it may be used profitably to illustrate the relationship of building techniques to expression in Michelangelo's architecture. The decision to unify the three palaces by a continuity of horizontal accents indicated lintel construction and emphatic cornices. In the final design it appears that Michelangelo intended to keep the potentially overwhelming horizontal accents in check by applying verticals of equal power: the colossal pilasters which, in embracing two storeys, interrupt the continuity of the lower entablature and, together with the columns, window-colonnettes and balustrade figures, establish a tense equilibrium of forces. But a structural analysis reverses the process proving that ingenious devices

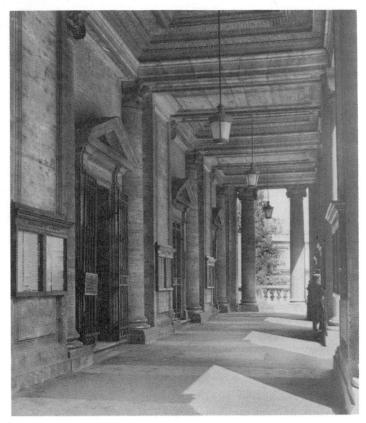

72. Palazzo de' Conservatori. Interior of portico

were necessary to prevent *verticals* from dominating the façade. The loads are concentrated in heavy masses of masonry extending from the foundations to the cornice, out of which the pilasters are carved [65, 70]. To de-emphasize these, Michelangelo made it appear that the pilasters alone sustain the weight. The remaining surfaces of the pier-mass on either side of the pilasters he disguised as superficial decorative bands – first, by covering them with horizontal relief elements that make them seem discontinuous, and

The Capitoline Hill • 159

second, by applying to the wall-surface above the windows horizontal bands of the same dimensions, so that the recessed pier-surfaces should be read as part of an applied wall-frame. So the colossal pilaster order functions as a means of diminishing rather than of emphasizing the preponderant verticality of the piers; perhaps Bramante had a similar purpose when he first used the colossal order on the piers of St Peter's. Conversely, the horizontals had to be exaggerated to maintain an equilibrium, and again Bramante's inventions were called into service: the crowning balustrade, which appeared first in the Tempietto of 1502, augments the crown of the building to nearly six metres without substantially increasing its weight; the windowbalconies which Bramante had used in the House of Raphael diminish the verticality of the apertures without obstructing light.

When the vocabulary of the Conservators' palace was adapted to the Senators' façade it became purely expressive, since there were no structural problems in facing the existing medieval structure [64]. Now the pier surfaces, which had originally masqueraded as ornament, became honestly ornamental; and it is this change in function which suggests that the design of the lateral palaces preceded that of the Senators'. Moreover, it strengthens the hypothesis that the Campidoglio façades were designed in tentative sketches if not in their final form before the elevations of St Peter's (1546-7); a similar motif appears there in a context that must be ornamental, since the structure depends wholly on wall-masses and not on surface members.

To appreciate fully the significance of the Campidoglio design we must understand what might be called its subject-matter as well as its architectural character. Like the Cortile del Belvedere, which was built to rival the great villas of antiquity, the Campidoglio was a monumental symbol in which the haunting dream of ancient grandeur became concrete. Like paintings of their time, both communicated a specific content of a more complex sort than is usually found in architecture.⁸

Sculpture played a peculiarly formative role in the evolution of the Belvedere and the Campidoglio. Distinguished collections of antiquities assembled in the fifteenth and early sixteenth centuries stimulated the urge to build; the statues had priority, and the architecture took shape around them. The Belvedere was planned as a setting for and approach to the papal museum, and the resurgence of the Capitol awaited the arrival of its equestrian centrepiece.

The ancient bronzes donated to the people of Rome by Sixtus IV and Innocent VIII in the fifteenth century were chosen more for their associations than for their beauty. They were objects of almost totemic power which the medieval mind had endowed with the responsibility for sustaining the legal and imperial symbolism of antiquity. A figure of the mother wolf which had nursed Romulus and Remus, mythical founders of Rome, was placed over the entrance of the old Conservators' palace [61] - and to emphasize her significance, a pair of suckling infants was added by a Quattrocento sculptor. A colossal Constantinian head, and a hand from the same figure bearing a sphere, were placed in the portico [62]; the medieval pilgrim's guidebook called the Mirabilia Urbis Romae identified these as the remains of a colossal 'Phoebus, that is, god of the Sun, whose feet stood on earth while his head touched heaven, who held a ball in his hand, meaning that Rome ruled the whole world'. Both stood by the Lateran, near the Marcus Aurelius, throughout the Middle Ages, in a spot of which the Mirabilia says 'There the law is final'. A third figure of Hercules, whose relation to the city was less firmly established, was installed on a base pointedly inscribed 'IN MONUMENTUM ROMANAE GLORIAE'. Further additions were made in the sixteenth century: Leo X installed the colossal statues of two river gods before the

Conservators' portico [61], and donated reliefs depicting the triumphal procession of Marcus Aurelius on to the hill.

Some of these pieces were integrated into Michelangelo's scheme, and others were moved indoors, but the theme *Romanae gloriae* was reinforced by new acquisitions, and made explicit by inscriptions. A tablet alongside the portal of the Conservators' palace reads: 'S.P.Q.R., imitating as far as possible its ancestors in spirit and deed, restored the Capitolium decayed by the ravages of time, the year 2320 after the founding of the city.' But on the opposite side of the portal, a similar inscription, dated 'in the year of our salvation 1568' consigns 'to Jesus Christ, author of all good' the care of the people of Rome and of the Campidoglio 'once dedicated to Jove'. The twin tablets are a clue to hidden meanings in the design of the Campidoglio and a reminder that a Christian motivation underlies the pagan splendour.

It was Pope Paul III rather than the city fathers who insisted that the statue of Marcus Aurelius be brought to the hill against the wishes of its proper owner, the Chapter of St John in the Lateran. Michelangelo opposed the project, but managed only to dissuade the Pope from expropriating the statues of Jupiter's twin sons, Castor and Pollux, with their rearing horses, that had stood throughout the Middle Ages on the crown of the Quirinal Hill [126]. It is difficult to explain the choice of the Marcus Aurelius, not because the meaning of the transfer is unclear, but because it had so many meanings. The most important, perhaps, is that the statue, one of the finest and best preserved ancient bronzes known to the Middle Ages, had grown, rather like the Wolf, into a symbol of law and government, so that executions and punishments regularly took place before it. Consequently, once it was in place, two hallowed legal symbols were removed from the piazza: the Wolf, and the group with an attacking Lion on

the steps of the Senators' palace which marked the spot for the sentencing of criminals far back into the Middle Ages. In this penal role, the equestrian group was known from the earliest records in the tenth century as the *Caballus Constantini*. The convenient misnomer, which combined Imperial power and Christianity, survived throughout the Renaissance.

But another legend, nearly as old, identified the rider as *il gran' villano* ('villein', in English); it was fostered for political reasons in the twelfth century, at a moment when the Holy Roman Emperor was in bad repute in Rome. It told of a low-born folk hero in Republican – not Imperial – days who, singlehanded, captured a besieging army and its royal general and was honoured with a statue. So the figure came to symbolize a mixture of Republican, anti-monarchial *virtù* and romantic heroism that reminds one of the iconography of the French Revolution. The *villano* tradition may have led to the type of Early Renaissance equestrians: Simone Martini's *Guidoriccio*, Uccello's *Hawkwood*, Donatello's *Gattamelata*, Verrocchio's *Colleoni*, and others – all soldier adventurers of low birth rather than prelates or princes.

The inscription designed for the statue by Michelangelo identifies the rider as Antoninus Pius [68]; though the correct identification had been made in the fifteenth century, it still was not accepted generally. But in any case, both Antoninus and his adopted son and successor Marcus Aurelius were represented by Renaissance humanists as the ideal emperor - the *exemplum virtutis*: peacemaker, dispenser of justice and maecenas. Paul III must have stolen the statue both to capitalize on the public pride in the Roman heritage and its medieval glosses and to suggest that his rule of the Roman people and of the Papal States reflected the virtues of a heroic antecedent. This would explain why there was no thought of commissioning a new statue from Michelangelo or another contemporary sculptor, and why Marcus Aurelius was not merely set into the piazza but inspired its very shape.

In Michelangelo's design [65, 66] the two river gods were given a more imposing setting before the triangular stairway, the form of which must have been influenced by their characteristic attitude of fluvial repose. Yet, if the decision to use the pair was made for formal reasons, it was essential to give it an iconic rationale. One was the Nile, supported by a sphinx; the other was the Tigris, identified by his crouching tiger; but before being reinstalled by the steps, he became the Tiber, Rome's own river, by the ingenious expedient of replacing his Mesopotamian prop with a new wolf suckling the two founding fathers. According to Pirro Ligorio, the exchange was made 'through the ignorance of a poor councillor', meaning Michelangelo, one supposes. Its purpose, however, was not to please such testy antiquarians as Ligorio, but to suggest the scope of Roman culture by linking great rivers at home and abroad.

If Rome is symbolized as the Tiber, it is incongruous that the figure in the central niche should be *Roma*, an ancient *Minerva* supplied with urban attributes. Her presence is, in fact, a makeshift solution; Michelangelo's plan was to place a *Jupiter* in the niche. The statue would have called to mind the temple of Jupiter Optimus Maximus which had stood on the Capitoline in antiquity, and which appears in the background of the triumphal relief displayed in the Conservators' palace. Had the god been in the centre of a triangle flanked by the two rivers, the composition might have suggested the temple pediment, with the titular deity in the dominant position.

Attention is also attracted to this area of the piazza by a baldachin or canopy over *Jupiter's* head at the top of the stairs, a curious appendage to a Renaissance façade. In late antiquity and in the Middle Ages it was one of the most universally used symbols of Imperial power. But it could

be Christian, too: in the sixteenth century one would have seen such a baldachin only over the main altar of a large church.

A visitor's first impression on ascending the hill is of the statuary along the forward edge. In the earlier engraving of Michelangelo's project (cf. [67]) four male figures adorn the balcony: they are all Imperial state portraits, and the two in the centre, who carry spheres, are Constantinian figures found for Paul III in about 1540. The second version [66] replaces two emperors by a pair of horse-trainers. They appear to be the Quirinal Castor and Pollux [126] sought by the Pope thirty years before; but in this respect the engraving is inexact. A second, more relaxed version of the twins, found near the Capitol in 1560, was ready for mounting [60]. So the Pope's wish came true posthumously without despoiling the Quirinal of its traditional monuments. We may ask why Paul had so coveted the Dioscures. Contrary to my interpretation in earlier editions, it has been shown that the twins had not been identified as Dioscures in the mid sixteenth century, but were believed to be paired portraits of Alexander the Great carved in competition by Pheidias and Praxitiles. Paul III, Alexander Farnese, used references to his great namesake frequently in the ubiquitous self-glorifying artistic programmes of his pontificate.9 Opposition to his effort to put his personal stamp on the hallowed hill was sufficiently strong to preserve the two groups in their original site to be incorporated by Michelangelo into an urban design of a later Pope [126].

After the Pope's death in 1549 the Conservators gained a greater control of the acquisition of symbolic statuary. The antiquarian-architect Pirro Ligorio identified the Dioscures set up in 1560 as coming from the ancient Curia of Pompey, and the association with that Republican hero would have made the two horse-tamers appealing to the representatives of the people, if not to the Pope. Next to the Dioscures on the forward balcony were placed, in 1590,

The Capitoline Hill · 165

two still-lifes on a military theme, of Imperial origin, taken from an aqueduct near the city walls [60]. They were acquired – again no doubt at the instigation of the Conservators – because they were believed to be trophies of the victories of the Republican, anti-patrician leader Marius, which ancient sources located on the Capitoline. The original Capitoline, moreover, had been the goal of all great triumphal processions. The tradition was revived in 1571, when Marcantonio Colonna, the victor over the Turks at Lepanto, was given a glorious triumph in the antique mode which ended in ceremonies on the piazza.¹⁰

The outermost decorations of the balcony crowd together as many symbolic overtones as is possible in so little space. They are columns, symbolic of power, carrying spheres, symbolic of Rome's world-wide rule. To clarify the point, the columns are mileposts from the Via Appia. The theme so abundantly illustrated on the piazza was continued in the palace courts, and in the halls of the Conservators' palace, frescoed with scenes from Republican Roman history.

To support the foregoing analysis, which may appear to discover more allusion than the Cinquecento intended, we may call on a contemporary witness whose interpretation took the form of a frescoed vignette in the salone of a Roman palace [73].¹¹ The painter of about 1550-60 depicted the oval piazza with Marcus Aurelius in the centre, the cordonata and the rear stairway as Michelangelo had planned them. But in place of the Senators' palace are three huge chapels of pagan divinities, the central one in baldachin form. There the herm of Jupiter is the object of unreserved adoration on the part of two Romans not vet imbued with the spirit of the Counter-Reformation. Yet it is inconceivable that Christian imagery was absent from the iconographic programme. Our knowledge of Michelangelo's deep religious convictions following the period of his association with Vittoria Colonna tempts us to see the

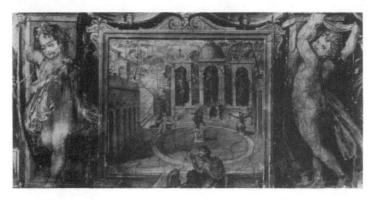

73. Anonymous fresco. Pagan Worship on the Capitoline Hill

central Jupiter figure as an anagogical reference to Christ; the presence of the baldachin overhead and the absence of any other member of the Roman pantheon admits such an interpretation.

Furthermore, the arrangement of the piazza unites the ancient Rome of the forum and the New Rome of the church, a connection suggested in the inscriptions quoted above as well as in the engravings which pointedly show the ruins behind the Senators' palace [66], although they are not actually visible from any standpoint in or before the piazza [60].¹²

We come finally to the most intriguing and original feature of Michelangelo's design, the central oval which supports *Marcus Aurelius* at the apex of a gentle domical mound. Tolnay has persuasively suggested that the design may be connected with the medieval designation of the Campidoglio as the *umbilicus* or *Caput Mundi*;¹³ but his belief that the convex form is intended to represent the curve of the terrestrial globe is not similarly supported by tradition or texts. The curvilinear grid dividing the pavement into twelve compartments recalls a symbolism commonly used in antiquity on the interior of cupolas, where

The Capitoline Hill · 167

the twelve signs of the zodiac were used to suggest the Dome of Heaven or the Music of the Spheres;¹⁴ in Christian architecture the twelve Apostles surrounding a central figure of Christ sometimes took the place of the signs. The twelve-part division appeared almost as often in circular pavements as a kind of counter-dome. Vitruvius (V, 6) advised that the circular pavement of theatre orchestras be inscribed with four interlocking triangles forming a twelve-pointed star, since 'in the number twelve the astronomy of the celestial signs is calculated from the musical concord of the stars'. These parallel traditions were fused in Cesariano's Vitruvius edition of 1521, where an entire theatre is reconstructed as a round, domed 'Tholos' inscribed within a twelve-pointed star.¹⁵

While the duodecimal division in these examples is usually formed by radiating lines or by triangles, Michelangelo's complex curvilinear construction is found among a class of medieval *schemata* in circular form used to coordinate the lunar cycle with other astronomical inferences of the number twelve, such as the Hours and the Zodiac. [74] is only one of many, fror1 a tenth-century (?) manuscript of *De Natura Rerum* of St Isidor of Seville, in which the lunations and signs appear in a form that differs from Michelangelo's chiefly in not being oval. The manuscript *schemata* of Isidor were reproduced in early printed books, establishing a contact with the sixteenth century.¹⁶

The fact that the prototypes were round, rather than oval, may be explained as an aesthetic prejudice: the circle was preferred in architecture prior to the sixteenth century – and in astronomy, until Kepler's time; Michelangelo introduced the oval in a project of the early years of the century, and the first oval dome was built by Vignola shortly after the foundation of the Campidoglio.¹⁷

The cosmological pavements and schemata do not explain the mound-like rise of Michelangelo's oval; its convexity adds a new dimension to the tradition in meaning

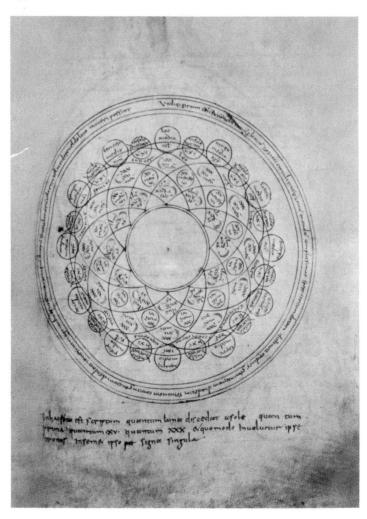

74. Isidor of Seville. Cosmological schema, ? tenth century

The Capitoline Hill · 169

as well as in form. The exception to the ancients' distaste for the oval may be found in a type of military shield that was well known to Michelangelo since it was represented not only in the vault stuccoes of the Conservators' portico and on the 'Trofei di Mario', but had been adopted by the Commune as the coat of arms of the S.P.Q.R. - it appears in wooden ceilings of the Conservators' palace dated 1516-18 and 1544.18 As was customary with the ornamental arms of the sixteenth century, these ovals are convex in shape. While ornamental shields cannot be associated with the twelve-part division of Michelangelo's pavement, there was a type of ancient shield upon which the zodiac was represented. The legendary shield of Achilles was adorned with the celestial signs, and Alexander the Great adopted the Achillean type along with the epithet Kosmokrator - ruler of the Universe.¹⁹ The title, and the shield along with it, was transferred to Roman Emperors. Another attribute of certain Kosmokrator portraits is a corona simulating the rays of the sun, indicating the resplendent powers of Apollo; and armoured Imperial portraits where the corona is not used have images of Apollo on the breast-plate.

Usually the snake Python appears at the centre of these shields, as it does in non-military representations of the zodiac. The myth of Python is associated with the shrine of Apollo at Delphi, where the snake reportedly dwelt under a mound-like stone known as the *omphalos* or *umbilicus*, which marked the centre of the cosmos.²⁰ (So the central boss on military shields came to be called the *umbilicus*.) The *omphalos* stone became an attribute of Apollo, who appears seated upon it in Greek vases and Roman coins.

The ancient Romans moved the *umbilicus mundi* figuratively from Delphi to the Forum, where it remained until medieval legend shifted it once more to the Campidoglio.²¹ Here it was permanently fixed in Michelangelo's pavement, which combined its zodiacal inferences with its

170

mound-like form. *Marcus Aurelius*, mounted at the centre, might have been a foreign element if iconic tradition had not permitted his association with the *umbilicus*. As Kosmokrator, he succeeded to Apollo's position upon the mound, and since the ancient sculptor had not equipped him with the requisite attributes, Michelangelo placed around his base the corona of Apollo: the twelve pointed rays which also serve as the starting-points of the zodiacal pattern.

[7] The farnese palace

When Cardinal Alessandro Farnese became Pope Paul III in 1534, the palace that he had been building for nineteen years on the Tiber bank seemed incommensurate with his elevated position; as Vasari said, 'he felt he should no longer build a cardinal's, but a pontiff's palace'. Paradoxically, the 'pontiff's palace' was to be occupied not by the Pope, who had moved to the Vatican, but by his illegitimate son Pier Luigi, for whom he fabricated the Duchies of Castro and Nepi (in 1537) and of Parma (in 1545). The palace was to become a symbol of the temporal power which the pontificate had brought to the Farnese dynasty – not so much a home as a monumental instrument of propaganda.

A century earlier a new fashion in urban domestic architecture had been formed by the rising élite of commerce and politics. Florentine merchants of the mid fifteenth century - the Pitti, the Rucellai and especially the Medici grasped the potential of monumental classicizing architecture as a symbol of power and of progress. The Medici palace was the earliest and most grandiose of all; towering over medieval Florentine streets and low dwellings and crowned by a huge antique cornice, it announced a new era in the evolution of the city. Contrary to popular belief, early Renaissance architecture marked the end rather than the beginning of an orderly system of town planning. Medieval ordinances had severely restricted the height, placement, overhangs and general design of private houses and palaces in order to gain a uniformity that may be appreciated still in the streets of Siena. The new palace style violently disrupted communal controls to substitute an aesthetic of maximum individuality for one of conformity. The Renaissance palace succeeded in so far as it was dramatically unique in its environment.

The economic revolution of the Quattrocento benefited churchmen as well as merchants; like the Florentine families, high ecclesiastics vied with one another for architectural distinction. At Pienza, Pius II Piccolomini actually had his palace built in imitation of the Rucellai palace in Florence, but he outdid his predecessors in creating an entire city square, complete with Bishop's palace, town hall and a cathedral too large for the small rural diocese [59]. Rome remained a feudal city in the early Renaissance, but Popes and Cardinals from the richer northern centres began at an early date to challenge the ancient emperors with the size and pomp of their palaces. The fashion started in the 1450s when the Venetian Cardinal Barbo, later Pope Paul II, started the palazzo Venezia, and the greatest challenge to the resources of sixteenth-century competitors was Cardinal Riaro's huge palace of the Cancelleria, begun in the 1480s in the neighbourhood later chosen by the Farnese. Shortly after the turn of the century, Pope Julius II made an unsuccessful attempt to build the still larger Palazzo de' Tribunali on Bramante's design, but the project was too ambitious even for his great fortune, and we know it only from drawings and remains of the rusticated ground floor.

The significance of palace design in the social and political struggles of the Renaissance is emphasized in a contemporary description of the planning of the Strozzi palace in Florence during the 1480s, which explains how 'Filippo [Strozzi],¹ having richly provided for his heirs, and being eager more for fame than wealth, and having no greater nor more secure means of memorializing his person, being naturally inclined to building, and having no little understanding of it, determined to make a structure that should bring renown to himself and to all his family in Italy and abroad'. Filippo's great fear, however, was that he might

arouse the envy of his fellow citizens, prompting them into competition. He therefore 'astutely feigned to everyone his wish and goal for no other reason than better to pursue it, saying all the while that a comfortable, everyday house was all he needed. But the masons and architects, as is their habit, enlarged all his projects, which pleased Filippo for all his protestations to the contrary.' But the palace was to play more than a private role, for 'he who was ruling [Lorenzo de' Medici] wished that the city might be exalted by every kind of ornament, since it seemed to him that just as the good and the bad depended upon himself, so the beautiful and the ugly should be attributed to him. Judging that an undertaking of such grandeur and expense could be neither controlled nor exactly envisaged and that it might [if not supervised] not only take credit from him as often happens to merchants, but even lead to his ruin, he therefore began to interfere and to want to see the designs, and having seen and studied them, he requested in addition to other expenses that of rusticated masonry on the exterior. As for Filippo, the more he was urged, the more he feigned irritation, and said that on no account did he want rustication, since it was not proper and too expensive, that he was building for utility, not for pomp, and wished to build many shops around the house for his sons.' In both cases he was grateful to be overruled, with the result that 'one may say that Filippo not only succeeded magnificently, but surpassed the magnificence of every other Florentine'.

Naturally, these structures were built to be looked at more than to be lived in: the splendours of the Medici palace, for example, except for an elaborate but tiny chapel, were reserved for the street façades and ample courtyard. This gave the architect an opportunity to design regular and stately elevations without much regard for internal arrangements, and at a scale so monumental that the inhabitants had to climb stairs to peer over the windowsills. The typical elevation was of three storeys, usually varied on the exterior in the treatment of wall surfaces and windows. The lower storey was devoted to business affairs, storage, kitchens and other practical requirements; the second storey, or piano nobile, to reception halls, public ceremonies and living quarters for the head of the family; the uppermost housed lesser members of the family and more distinguished members of the huge retinue of retainers. Servants were given dark chambers in mezzanines between the floors or under the roof. The rooms were mostly grandiose stages for the performance of the rites of commercial and political leadership, and it is hard to imagine where one slept, washed, or found privacy. Medieval palaces were often far more comfortable, and the most congenial residence of the Quattrocento, the Ducal palace at Urbino, has a characteristically Gothic air in spite of its Renaissance ornament; there the rooms were designed first and the facades took shape around them.

Renaissance domestic architecture has been criticized frequently in recent times for the fact that an emphasis on the symmetry and regularity of the façade made it impossible to achieve a 'functional' interior plan. The criticism is justified so long as we assume that the essential function of a dwelling is invariably to accommodate the day-to-day activities of family life. But where the purpose is to awe and to impress, an imposing facade and court are far more 'functional' than a warm and well-lighted bed chamber. Like the nouveaux-riches of all ages, the Medici and the Farnese found security in the expression of their power a security that they would not compromise to gain comfort or privacy. This is perhaps less difficult to understand today than it might have been a generation ago in the heyday of functionalist criticism, since the situation is closely paralleled in contemporary architecture, though it has shifted from the domestic to the commercial stage. In the past decades leading industrialists who were once committed to architectural conservatism have become aware of the

propaganda potential of 'progressive' monumental architecture and, like the Renaissance dynasts, have called upon the most advanced architects to design huge structures without regard to expense or convenience.

The colossal scale of Quattrocento enterprises was beyond the reach of a private family in the early sixteenth century, though imposing plans and unfinished palaces and villas survive to prove that ambitions, at least, were not hampered by lack of funds. Sangallo's project for the Cardinal's palace of 1515 was comparatively modest, but with the expanded plan of 1535-41 the era of moderation in Roman domestic architecture was brought to a close; the new palace, a magnificent version of the Florentine type, was the first to challenge the Cancelleria and the Vatican in size and elegance.

Vasari, who left Rome shortly after Sangallo's death, in the autumn of 1546, wrote that there appeared to be no hope that the palace would ever be finished or seem to be the work of one architect [86]. He erred on both counts; forty years later it was completed so homogeneously that observers were unable to distinguish the work of the four architects who contributed to the design. Michelangelo, though noted for his inability to collaborate with colleagues, showed remarkable skill in harmonizing his own dynamic style with the portions already built by Sangallo. No two architects of the mid sixteenth century were less congenial than these; it is symptomatic of their relationship that at St Peter's Michelangelo erased almost every trace of Sangallo's Basilica. Perhaps he would have done the same at the Farnese Palace if it had not been so far advanced when he started, but economy must have forced him to keep what was there and even to make use of members that had been carved but not put in place, such as the uppermost façade windows. Consequently the palace has a Sangallesque personality throughout. Michelangelo enhanced and gave vigour to this personality, and at essential

points rescued it from dull propriety; in doing so he created Sangallo's masterpiece.

Fundamental differences in the style of the two architects are illustrated in the façade [75]. Sangallo's scheme, influenced by Raphael's Florentine palazzo Pandolfini, is the antithesis of Michelangelo's organic design, and also represents a revolt against the richly articulated and pictorial Roman façades of Bramante and Raphael. Sangallo treated the façade as a neutral two-dimensional plane of brick upon which the stone frames of windows and doors could be set as sculptural relief. The relief is frankly applied to the surface, and we can imagine it stripped away without damage to the wall. But the frames are not mere ornament: Sangallo made them the basic vertical module of the design. applying them symmetrically about the central axis like links in a chain. This system, which might be called the additive module, supplants earlier principles of proportion in determining the overall form; the palace could be one window longer or two shorter without appearing mis-

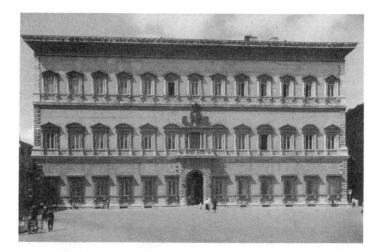

75. Farnese Palace. Entrance façade

shapen, and indeed its early history shows that it was not essential to determine either the height or width before construction started. This thoroughgoing reaction from the geometrical and harmonic planning of the fifteenth century made it easier for Michelangelo and his followers to alter the design of unfinished portions without noticeable breaks.

In this sense, Sangallo's palace again recalls the modern structures whose neutral, two-dimensional curtain-walls are articulated by modular relief elements which determine the scale and which may be repeated at will to the desired height or width. This parallel suggests further that Sangallo's method may be explained partly by the huge scale of mid sixteenth-century Roman programmes, in which subtleties of design would be lost on the observer. It represented, moreover, a step towards mass production: Sangallo found it unnecessary to draw the Farnese façade as a whole: he had only to sketch the central openings and four different window frames, which the carvers then executed in quantity. The neutral brick wall could be raised without supervision and far more rapidly and inexpensively than the facades of drafted masonry and pilaster orders of the earlier generation: we might even conclude from the way in which the masonry of the corner quoins and central portal spreads over on to the wall behind that the failure to extend it over the whole surface was due chiefly to the necessity to save time and money.

What differentiates Sangallo's approach from Michelangelo's is the absence of the metaphorical expression of the stresses in the structure. The neutral plane of the wall veils any intimation of the equilibrium – or as Michelangelo would have it, the struggle – of load and support. There is nothing to suggest the ponderous downward pressures of the building, since the horizontal accents overwhelm the vertical, and this is particularly noticeable at the corners, where stone quoins are carved so as to counteract the effect of the only continuous vertical in the elevation. This imparts a calm and ease to the façade unknown in Michelangelo's work, and to complete the effect Sangallo envisaged a thinner and lighter cornice; one which would be less calculated to suggest compression than Michelangelo's.

A contrast to Michelangelo is implicit in Sangallo's drawings, which are mostly carefully measured studies of relief elements such as window aediculas, rather than of compositions. The plain paper represents the neutral wall surface, and there is rarely an indication of masonry, texture, or light and shadow. An avid student of ancient architecture, Antonio constantly drew in the ruins, concentrating of necessity on the relief details, since the total structure was seldom preserved and nothing but the brick and rubble core remained to indicate how the Romans had originally faced their walls. This experience must have reinforced Sangallo's tendency to visualize the whole in terms of the parts.

At Sangallo's death the façade had been completed to a level above the third-storey windows. Michelangelo was immediately put in charge of the design and instructed to complete the façade before continuing with the unfinished side and rear wings. He made only three changes in Sangallo's project, designing a new cornice, raising the height of the third storey and altering the form of the central window. The first two were closely related; we know from the complaints of Sangallo's supporters that Michelangelo substantially increased the size of the cornice; in order to avoid an oppressive effect he increased the distance between the window pediments and the top of the wall to a height equal to that of the cornice itself. The third storey now became equal in height to those below.

The massiveness of Michelangelo's cornice [76] lends the façade a gravity, in the sense of seriousness as well as weight, that Sangallo's lower and lighter crown would have lacked. The cornice sketched by Sangallo in a late

The Farnese Palace · 179

project for the facade contains many of the same elements, and appears similar to a modern eye unpractised in the subtleties of Renaissance design. But important differences are revealed in a contemporary criticism of the existing cornice on Vitruvian grounds preserved in a copy by Michelangelo himself.² The anonymous author complains, in effect, that the cornice is far too heavy for the facade, while the membering is too small and confused; that the ornament, moreover, is pure caprice, and mixes elements of the Doric, Ionic and Corinthian Orders. It is precisely these affronts to academic propriety that give Michelangelo's design its unique force. The massiveness of the form is mitigated by an overall pattern of ornaments calculated to produce a flickering arpeggio of highlights within the bold shadows of the overhang. Michelangelo's superiority in the handling of light and texture produces a vitality which alleviates the dry precision of Sangallo's relief.

Michelangelo's desire to give the façade a more sculptural character also prompted the revision of the central

76. Farnese Palace. Cornice

window. His changes affected only the portion above the entablature, where Sangallo had spanned the opening with concentric arches resting respectively on the free-standing and on the applied columns and enclosing a small papal coat of arms attached to a central tympanum. Michelangelo walled over the arches, extended the entablature to form a flat lintel, and filled the void with a colossal arms over three metres high [75]. The lintel accentuated the horizontal facade members and the arms the vertical ones, to substitute an equilibrium of opposing forces for Sangallo's equilibrium of rest. The stability of the complete arch had little appeal for Michelangelo, who never used it on doors or windows, and he must have found the form particularly incongruous in the Farnese facade where it was flanked by two segmental window pediments. But his main purpose in suppressing the arch must have been to gain space for arms of an adequate scale; he was confident, as Sangallo could not have been, of his ability to make a sculptural

77. Farnese Palace. Court in 1655 (?) before remodelling

78. Farnese Palace. View of the court, c. 1554-60

^{79.} Farnese Palace. Engraving

climax to the façade design more effective than an architectural one.

The great court of the palace [77, 80] is one of the most stately and impressive of the Renaissance; it encloses a perfectly cubic space and, by contrast to the façade, achieves its effect through an equilibrium of tangible horizontals and verticals. Its effectiveness is the paradoxical result of a chaotic and unpremeditated growth; the arcades of the two lower storeys were built by Sangallo according to his 1515 designs; Michelangelo altered the balustrades and the frieze

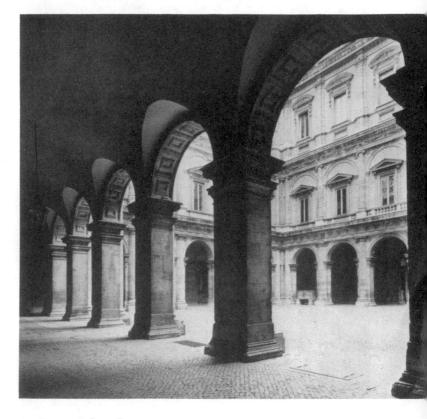

80. Farnese Palace. Court

The Farnese Palace · 183

of the *piano nobile* and he or Vignola provided a new design for the windows; he then changed the entire upper storey [81]. Further innovations were made by Vignola and della Porta, who ignored Michelangelo's project for the rear elevation [79] to build both the front and rear wings as shown in [77]; finally, nineteenth-century restorers equalized the four sides by closing off the open galleries of the second storey and substituting replicas of the windows on the side wings [81].

What is preserved of Sangallo's programme differs from the façade in emphasizing relief rather than surface; the massive members were conceived in three dimensions and convey a sense of the weight of the structure. The Tuscan and Ionic orders, inspired by Bramante's unexecuted Tribunal palace plan and by the Theatre of Marcellus, are the most monumental in Renaissance domestic architecture and the most powerful expression of Sangallo's classic style.

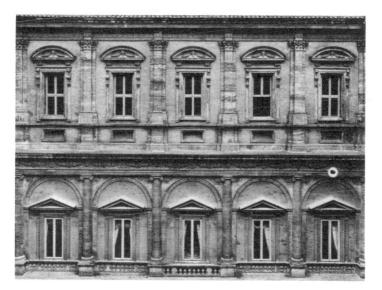

81. Farnese Palace. Upper storeys of court

Sangallo's distinctive court design was a greater challenge to his successor than the façade, since it promised to emphasize any change in style. Michelangelo ingeniously solved the problem by using the second storey as a transitional passage of a kind that composers use in changing key [81]. Retaining the original Ionic order, he (or Vignola?) added windows which subtly fuse Sangallo's classicism with a new fantasy, and on the chaste entablature he imposed his characteristically rich frieze of masks and garlands.

Having effected the transition, Michelangelo was unimpeded in the design of the upper storey, where the dramatic style of St Peter's is transposed to a domestic scale suitable to an opulent fantasy of detail. After inserting servants' quarters in a mezzanine above the second storey [79], Michelangelo had to raise the upper windows and order correspondingly higher than those below, which justified the abandonment of the arch motif in favour of a trabeated system, as on the facade window. The restricted height and width of the pilaster order were counterbalanced by the grouping of three pilasters and a consequent multiplication of vertical accents. The cornice [82] is more radical in design than that on the exterior; its elements are bizarre variations on classical themes, and the minuscule ornament dissolves into a pattern of highlights and shadows when seen from below. The fantastic window frames are manifestoes of an anti-classical spirit surely calculated to shock the academicians. Their lateral frames extend below the sills as if they were hanging from the lions' heads like bell-cords; and the pediments, with their extraordinary recessed tympana, are detached from their supports and lose their structural rationale. Again, Michelangelo's consciousness of the purely conventional character of the classical aedicula prompted him to satirize the convention. Ironically, his leaps of fancy were to become conventions for early Baroque architects.

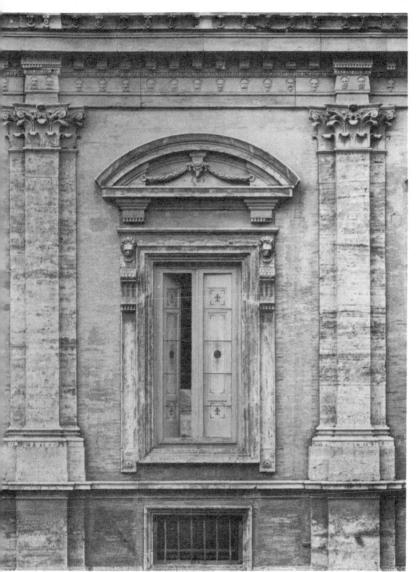

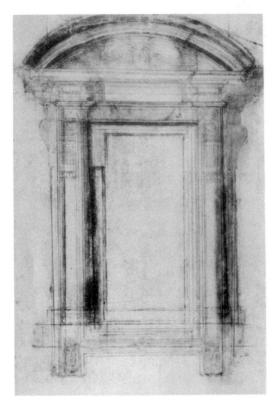

83. Farnese Palace. Study for a window frame

It is not merely a talent for invention that distinguishes Michelangelo's design from Sangallo's, but an ability to make every surface and detail essential to the vitality of the total effect. The upper storey is without those mechanically executed neutral areas such as the arch spandrels that appear in Sangallo's elevations. Moreover, Sangallo lacked the sensitivity to texture that Vasari noticed in Michelangelo's portion of the court and used to illustrate the virtues of travertine as a building material.³ Although travertine was used by both architects, Michelangelo evoked from it a

The Farnese Palace • 187

warmer, more rugged texture, while achieving, as Vasari noted, the sharp precision typical of marble carving.

Michelangelo's later Florentine projects were distinguished by a dynamic treatment of spatial sequences that impelled the observer along predetermined axes. This kinetic factor is absent from the Farnese Palace as envisaged by Sangallo and as completed in the later sixteenth century; but it was an essential element of Michelangelo's original project. Evidence for his rejected scheme is preserved in engravings of 1549 and 1560 [79, 84], and in the closing paragraph of Vasari's account of the palace (VII, p. 224):

In that year [1545-6] there was found in the Antonine [Caracalla] Baths a marble seven *braccia* square [over 4 m.] on which the ancients had carved Hercules on a hill holding the bull by the horns, with another figure aiding him and around the hill various shepherds, nymphs and other animals ... and Michelangelo advised that it be transported into the second [garden] court and restored so that it might spout water, which pleased everyone. For this purpose the work has been in the process of restoration by the Farnese family until now [1568]. Michelangelo then directed that a bridge should be built in line (with the fountain),

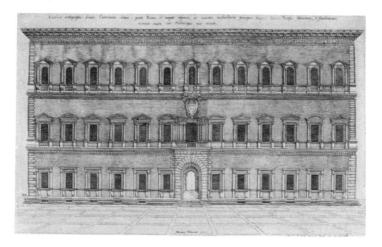

84. Farnese Palace. Façade and project for the square, 1549

crossing the Tiber River so that one might go from the palace into Trastevere, where there was another Farnese garden and palace [adjacent to the Villa Farnesina], with the intention that from a position at the main portal of the palace toward the Campo di Fiori one might see at a glance the court, the fountain, the via Giulia, the bridge, and the beauties of the other garden terminating at the other portal giving onto the Strada di Trastevere.

This grandiose concept would have transformed the introspective palace block into a great open vista embracing architecture, sculpture, greenery and water; the static quality of the court would have become dynamic by the introduction of a dramatic axis of vision and communication. The engraving of 1560 [79] illustrates the architectural components of the new design, but the engraver, who probably knew only Michelangelo's loggia model of 1549, was unaware of the total plan, and installed behind the palace a fictitious panorama with ruins after the fashion of northern landscape painters. Even without the monumental fountain, and the Tiber bridge and gardens, the engraving conveys an impression of flow that would have drawn visitors through the court towards distant goals. From

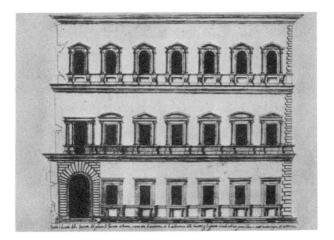

85. Farnese Palace. Elevation in 1549

The Farnese Palace · 189

ground level the open loggia of the second storey gives a glimpse of the sky and lessens the great weight of the building, but its chief purpose was to provide a *belvedere* on the *piano nobile* for the delight of the inhabitants. Though there are only three open bays on the court side, there are five towards the rear, so that the distant vista might be had from any point along the second-storey galleries.

The grandeur and uniqueness of Michelangelo's plan must have been appreciated, but abandoned for practical reasons; by reducing the rear of the court to the depth of one bay, it sacrificed an important portion of the private living-quarters apparently indispensable to the accommodation of the Farnese family.

Michelangelo cannot have intended to reduce the entire rear wing to the depth indicated in [79]: this would have destroyed the apartments started by Sangallo in the right rear corner and would have disrupted the symmetry of the side façade by eliminating the four bays nearest the river. It is likely that to the right and left of the rear loggias the palace was to extend back to the line of Sangallo's garden front. The resulting U-shaped rear façade with open loggias at the base revived the favoured form for the suburban villa of the Roman Renaissance. A distinguished and particularly relevant example was the Villa Farnesina, which stood directly across the river near the goal of Michelangelo's perspective. The aptness of the decision to complement the sombre urban façade with a more pastoral one facing the garden must have delighted Michelangelo's contemporaries.

The façade engraving of 1549 [84] illustrates a project for the piazza in front of the palace which is too ingenious to be explained away as a convention of the engraver.⁴ It is improbable that Michelangelo would have developed an embracing scheme for the garden area behind the palace without organizing the urban setting in front of it. The planning of an ample piazza within the crowded medieval quarter was essential if the façade was to gain its full effectiveness, and the problem must have been discussed just at the moment when the façade was completed and the engraving was published. The pavement of the piazza as represented in the engraving is subdivided by bands into squares of a kind dear to the perspective painters of the early Renaissance [59]. Each square corresponds to the width of one bay of the façade, so that an observer in the piazza would find underfoot a measure of the scale of the palace, thus giving to the façade design a third dimension (significantly, the piazza pavement extends along the streets on either side of the palace). Assuming that Michelangelo's piazza was roughly of the same form as the existing one, its principal entrance would have been directly opposite the portal along a short and narrow street connecting it to the

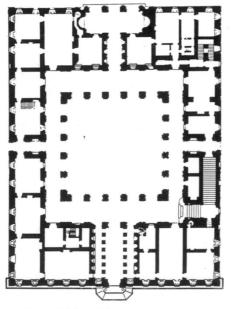

86. Farnese Palace. Plan

87. Farnese Palace. Ground-floor plan, c. 1560

medieval market-place – called the Campo di Fiori. For an observer entering the piazza along this street the bands in the pavement leading to the façade would act as orthogonals in a perspective construction, the vanishing point of which would lie beneath the central arch at the rear of the court; the engraver accordingly took special care to demonstrate that the central subdivision of the piazza continued the perspective of the entrance vestibule. By this device the first distant glimpse of the façade would carry with it an invitation to follow the pre-ordained path through the palace to the goal beyond the Tiber.⁵

So, in spite of its apparent perfection, the Farnese Palace must be added to the long list of Michelangelo's unfinished works; though the portions that he completed are vigorous and effective, the unexecuted planning scheme is a more imposing mark of his genius, a giant stride – fully realized in the Campidoglio and Porta Pia – towards an extension of the confines of architecture beyond the limits of the static and self-sufficient structure.

[8] The basilica of St Peter

Almost every major architect in sixteenth-century Rome had a hand in designing the Basilica of St Peter; each in succession changed his predecessor's scheme, yet the final product is a cohesive whole, formed more by the genius of the Italian Renaissance than by the imagination of any individual. The evolution of the Basilica shows the degree to which Michelangelo's image of buildings as organisms pervaded the architecture of his time. Although Bramante's successors were inspired by the originality and majesty of his design, each felt free to feed the organism new ideas and to cast off obsolete ones [88]. The oscillation between central and longitudinal plans apparent even in Bramante's drawings continued throughout the century and was halted only with the construction of the nave one hundred years after the foundation. Consistency was assured by the huge scale of the structure; architects were compelled to accept the portions built by their predecessors, and once Bramante had raised the crossing piers, no subsequent innovation could be wholly independent.

Medieval monuments the size of which necessitated comparably long periods of construction were much less cohesive in style. The large French cathedrals grew by the accretion of successive units, each of which reveals the fashion of its time; at Paris and Laon, the bays at the end of the nave differ from the rest, and at Chartres the two façade towers are entirely dissimilar. Even in the Renaissance, great châteaux such as Blois, Fontainebleau and the Louvre became museums of architectural history in which each wing or court was built as a pure example of the style of its period.

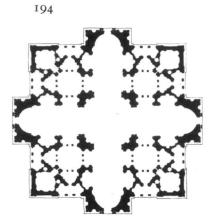

a. Bramante. 1506

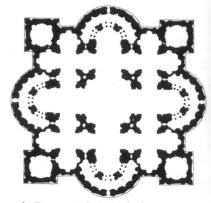

b. Bramante-Peruzzi, before 1513

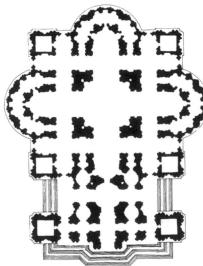

c. Sangallo, 1539

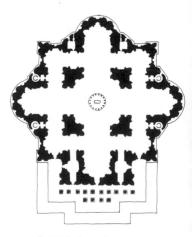

d. Michelangelo, 1546-64

88. Plans for St Peter's

The Basilica of St Peter · 195

This extreme differentiation is the manifestation of a peculiarly French logic, but it is found in Italy to a lesser degree. At the Ducal palaces in Venice and Urbino, Gothic portions were retained and completed in their original form, while new construction was initiated in Renaissance style. The Certosa of Pavia remained consistent until, in the 1490s, a façade of an entirely different design was added to complete the church; and at the Cathedral of Florence. Brunelleschi retained the basic scheme of the fourteenthcentury dome project, but added a lantern and aediculas inspired by ancient architecture. As long as Renaissance architects were forced to continue medieval structures, inconsistencies were inevitable. Only buildings started in the Quattrocento could be entirely harmonious in style, but they posed another problem so vexing that, whenever their construction extended over a long period, they often remained, like the palaces and churches of Brunelleschi and Alberti, unfinished. The mathematical principles of Quattrocento design established an interdependence among elements in the plan and elevation that encouraged consistency but discouraged flexibility. The design of a structure begun in accordance with a modular system of proportions could not be changed much, and the architects who succeeded Brunelleschi at San Lorenzo [19] and at Santo Spirito had to adhere anonymously to his style. This became more difficult as time passed and as the style became oldfashioned, so that when Michelangelo was called to design the New Sacristy and façade of San Lorenzo he could not avoid innovations that differed radically in character from Brunelleschi's forms

The style of the early sixteenth century was less restricting to the extent that it was less geometrical; moreover, a new attitude was encouraged by professional and technological changes. While most Florentine Quattrocento buildings were small in scale and could be designed and supervised by one architect, the grandiose schemes of the following century turned the fabbrica into a community in which elder architects were partners and younger ones students. Because Raphael, Peruzzi and Sangallo had worked with Bramante at St Peter's and the Vatican palace, and because Sangallo assisted Raphael at the Villa Madama, there was no break in continuity when the masters died. Patrons awarded commissions on the basis of competitions and sometimes - as in the project for the San Lorenzo facade - attempted to enforce collaboration. By the mid century it was possible for Julius III to assign the relatively modest programme for the Villa Giulia to a team of three architects: Vignola, Ammanati and Vasari, with Michelangelo as a consultant. In architecture as in the political structure of the Renaissance state, size promoted collaboration, centralization and continuity, and kept designers as well as princes from disrupting the orderly evolution of the institutions they directed.

Structural factors, above all, secured the organic growth of St Peter's. Bramante, in visualizing the Basilica as an expansion of spatial volumes and masses about a vast central area, made the crossing the heart of a cellular structure [88a, 104]. Every element in his design depended for its stability upon the four central piers, and the dome, in turn, depended on the buttressing powers of the four arms. So the construction had to proceed uniformly outward from the core towards the periphery. This radial evolution differed radically from the chain-like process demanded by the bay-system of Gothic structures, in which spatial frames, each depending on neighbouring frames for stability, had to be raised in sequences beginning at the apse, at the façade, or any terminal point in the plan.

Though the Gothic system survived into the Renaissance, the autonomy of the single bay often gave way to what might be called a box system, in which cubic or cylindrical volumes were applied to a core; even the central-plan buildings of the Quattrocento give the impres-

The Basilica of St Peter · 197

sion of having been built up by the addition of autonomous units. The uniqueness of Bramante's St Peter's project – visible in the plan [88a] to a greater degree than in the less radical elevation [89] – was in the interdependence of the core and its arms. A study of the malleable wall masses of ancient Roman architecture must have helped Bramante to break down the confines of the Quattrocento box, but it was the Byzantines, not the Romans, who had found techniques for integrating domed and longitudinal volumes.

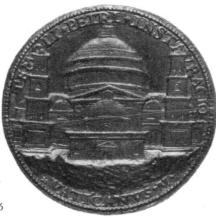

89. Bramante. Project for St Peter's, 1506

Consciously or not, Bramante revived the structural principles of Hagia Sofia in Constantinople, where all spaces had been generated outward from a domed core. Surviving drawings from Bramante's workshops indicate that the four crossing piers were raised before the final form of the arms had been determined, and for decades after his death each of his successors in turn was free to clothe Bramante's skeleton in a new skin. A sixteenth-century view of the Basilica [90] shows how its radial evolution gave Michelangelo a maximum of freedom in designing the exterior façades.

90. G. Vasari. St Peter's. View in 1546

The interior volumes, however, were firmly fixed at the time of Sangallo's death in 1546: one arm had been completed entirely, another partially, so that there were strong reasons for following his design for the remaining arms; the vaults that form aisles around the crossing, between the outer buttressing piers and the crossing piers, had been built, too. Even when Michelangelo got leave to lop off the outer rings of the hemicycles that terminated all but the façade arms, he was constrained to keep the inner ring, and could reform only its exterior plan [91]. The limitations here were greater even than those imposed on the

The Basilica of St Peter · 199

Vaulted by Michelangelo

Started by Sangallo. razed by Michelangelo

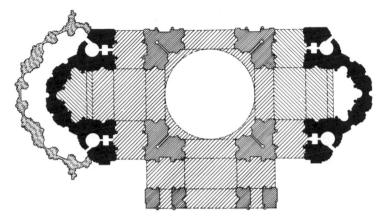

91. Construction of St Peter's, 1506-64

design of the Medici chapel: the interior could be influenced only by the design of the central dome, the four domed areas at the corners, and the hemispherical vaulting at the ends of the arms. Michelangelo was left in undisputed command solely of the lighting, since these restrictions did not limit the formation of the exterior surfaces. But after his death in 1564, most of his plans for the interior were altered: della Porta redesigned the central dome and those of the four corner chapels, so that all we can see of Michelangelo on the interior of St Peter's is the main drum and the vaulting of the terminal hemicycles; but the original character of both is entirely changed by an overlay of seventeenth-century ornament and veneers.

The extent to which Michelangelo was able to impose his personal style upon St Peter's without essentially altering the interior is astonishing. We can see in comparing his plan to Sangallo's [88, 91] that a few strokes of the pen were sufficient to change a complex and confused form into a simple and cohesively organized unit. Sangallo, in taking from Bramante the scheme of a major cross echoed in four lesser crosses at the corners, had expanded the latter to constitute isolated pockets of space no longer knit into the fabric of the crossing; similarly, his semicircular ambulatories became independent corridors - superfluous successions of volumes and orders which forced him into absurd devices for lighting the main arms [92, far right]. Michelangelo, by merely walling off the entrances to each of Sangallo's disconnected spaces, made one church out of many; he surpassed the clarity that he admired in Bramante's plan in substituting for the concept of major and minor crosses a more unified one of an integrated crossand-square, so that all circulation within the Basilica should bring the visitor back to its core. The solution was strikingly simple, and far more economical than any proposed before: it even seems obvious, once it is familiar; but in a generation distinguished for great architects, it took one

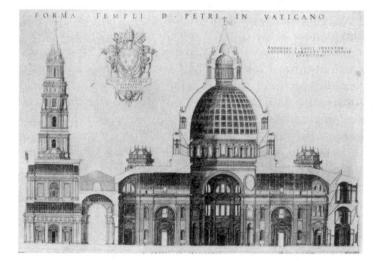

92. A. Sangallo. Project for St Peter's, 1539-45

trained as a sculptor to discover a form that would express the organic unity of the structure.

Unity was Michelangelo's contribution to St Peter's: he transformed the interior into a continuum of space, the exterior into a cohesive body. In the exterior massing he was restricted less by earlier construction, since his predecessors had not arrived at the outer periphery. Here again, the problem was to find a form which would integrate two autonomous motifs in the plan - the cross and the square - and again it was solved with the simplest and most economical means [88, 105]. With a minimum of construction the secondary buttressing piers were transformed to serve entirely new practical and expressive functions. Inside, the passages which Sangallo had cut through the piers were ingeniously converted into stairwells; outside, the diagonal faces of the piers bound the hemicycles of the cross to the angles of the square in such a way that the two shapes were fused without losing their distinctness. The solution was technically impeccable; it changed the form of the piers without affecting their structural function and it efficiently solved the problem of lighting the stairwells. Aesthetically, it was an inspired breach of classical dogma. In plan, the piers were formed essentially as mirror-images of the crossing-piers. But, unlike the crossing-piers, their diagonal outer faces do not form a 45° angle; they were drawn on the principle that a straight line is the shortest distance between two points, without regard for the angle of incidence, and in violation of Renaissance laws of geometry and proportion. Michelangelo interpreted these diagonals as building elements - as muscles, not the limits of a regular polygon. Simple as the form seems to a modern eye, it represents - even more than the oval and trapezoid of the Campidoglio - a bold and difficult revolt against the immemorial sovereignty of rational geometric figures in architecture.

Comparison with Sangallo's plan reveals the skill with

which Michelangelo resolved the continuing conflict between the centralized and longitudinal schemes [88]. Sangallo had artificially appended a nave and facade on to one arm, forming, in effect, another church. Michelangelo differentiated the facade arm just enough to give the Basilica a major axis without prejudicing the centrality of the interior. The Pantheon-like columnar porch emphasized the entrance axis, yet permitted the pilaster system of the side and rear elevations to continue across the facade without interruption. Moreover, the pediment carried over the forward row of columns was low enough to leave an unimpeded view of the dome from the piazza (a virtue lacking both in Sangallo's and in Maderno's designs); its triangular form would have directed the eye towards the dome, while its proportions and forward projection would have announced the scale and significance of the nave bevond.

The façade was to be a screen before the undulating mass of the Basilica; it is astonishing how much Michelangelo

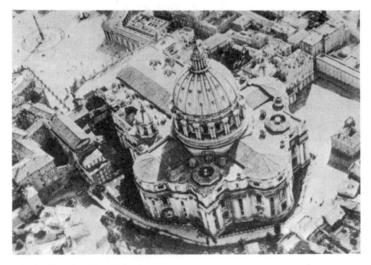

93. St. Peter's. Air view

managed to alter Bramante's formulation of the character of this mass [89, 93]. Bramante saw the exterior as a society of distinct geometrical forms bound together by proportion. Michelangelo as a single body so cohesively organized that the differing functions and structural features of the interior plan barely can be discerned. The structural technique - a revival of the heavy, plastic wall-masses of Roman and Byzantine architecture - permitted Michelangelo to treat the body of the Basilica as a sculptural block, and left him free in the choice of surface articulation: the exterior orders were to be exclusively expressive. Perhaps this is why the colossal pilasters and the strips behind them were distinguished so clearly from the wall surfaces [94, 95]: they carry a projecting segment of the entablature so that the whole decorative apparatus appears as a detachable overlay (at the Capitol, where similar pilasters have an essential structural function, they support an unbroken entablature). Fenestration was the sole limiting factor: it dictated a tripartite division of the hemicycle and elevations and inspired the rhythmical sequence of broad and narrow bays separated by pilasters. The dynamic vertical accents of the pilasters, reinforced by the strips behind them, by the projections in the entablatures, and by the multiplication of shadows that results from compressing two pilasters into one that bends around each angle, entirely overwhelms the discontinuous horizontals of the window and niche frames. The dominance of verticals makes the Basilica appear to grow upward rather than to weigh ponderously on the ground; it suggests an aspiration comparable only to the effects of Gothic architecture, and anticipates a climax in the equally Gothic buttresses and ribs of the dome.

Turning again to Bramante's elevation [89] we find an entirely opposing effect; horizontals dominate in spite of high campanili, and the weight of the structure is expressed by the accumulation of masses towards the earth, beginning with the low ribless dome and its stepped base, which

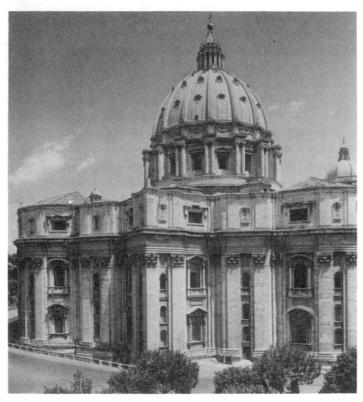

94. St Peter's. View from the Vatican gardens

seems to settle into the drum. Bramante, who developed the plan from the crossing outward, must have designed the elevation from the dome downward. For him, the great central volume was the cause of the design; for Michelangelo it was the result. Such a distinction was warranted by the peculiar chronology of Michelangelo's studies for the construction; the design was not wholly fixed at the start, but grew as the builders advanced upwards from the foundations. At the beginning, only the lower portions were determined definitively: probably the model of

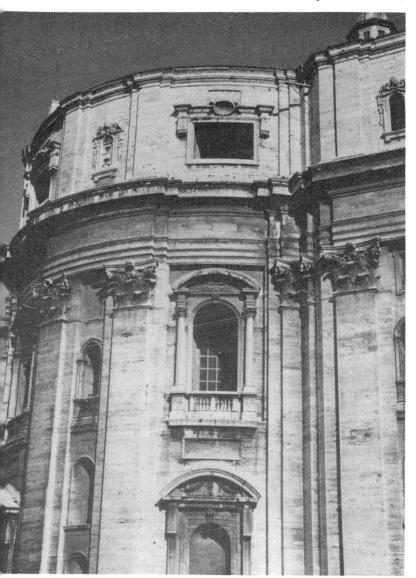

95. St Peter's. Apse, detail

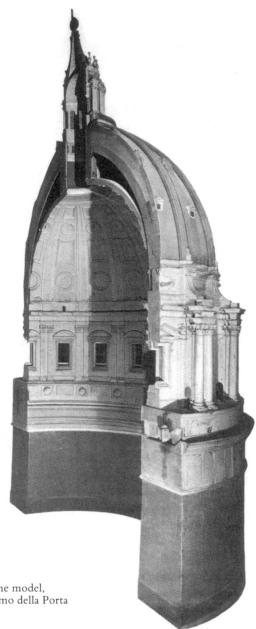

96. St Peter's. Dome model, as altered by Giacomo della Porta

97. St Peter's. Projects for the dome and lantern

1546/7 had no façade, roof or domes. In 1554/5 the drum was begun, before the construction of a dome model in 1558-61 [96]. Between 1561 and Michelangelo's death in 1564, the dome was again revised and the façade project, which was dependent on the definition of the attic, was tentatively sketched in plan. This does not mean that Michelangelo ignored the dome until the end: his earliest studies for it [97, 98] may have been made just after the construction of the model for the lower portions in 1547. But these studies constantly evolved as Michelangelo watched the walls rise and saw the effects of his vigorous verticals in full scale. We can imagine that the definitive

98. St Peter's. Study of the dome

The Basilica of St Peter · 209

design of 1546-7 for the paired colossal pilasters prompted the ultimate decision to use external ribs on the dome and paired columns on the buttresses. If Michelangelo ever considered retaining Bramante's smooth, stepped hemisphere, he would have abandoned the thought before generating a dynamic upward thrust in the lower part of the building. But only the ribs and buttresses survived to the end; the

99. St Peter's. South elevation, based on Michelangelo, 1569?

design of the drum and the lantern changed, and above all, the profile of the dome, which developed from the elevated curve of [97] to the hemisphere of [99, 100].

The progressive lowering of the dome is a key to the understanding of Michelangelo's purpose, yet modern critics were at first reluctant to accept it as a fact. A progression from the spherical dome of the engravings [99] and [100] to the raised profile of [97] (now recognized as an early study) to the dome executed by della Porta [94] seemed

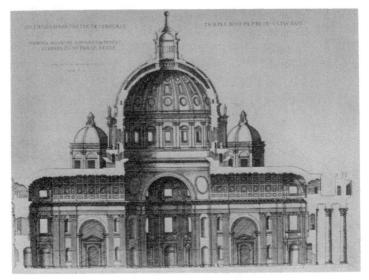

100. St Peter's. Section, based on Michelangelo, 1569?

natural; moreover, it is admirably suited to the popular Wölfflinian theory of a somehow preordained and systematic evolution from classic Renaissance to dynamic Baroque forms. The irrelevance of these presuppositions is sufficiently proven by the elevated profile proposed by the most 'classic' of early Cinquecento architects, Antonio Sangallo [92] and by the low dome of Michelangelo's San Giovanni de' Fiorentini [114, 116, 117], which is contemporary with the St Peter's dome model.

Shortly after determining the insistent verticals of his elevation, Michelangelo wrote to Florence for measurements of the cathedral lantern. The Florentine cupola had exerted a strong influence upon him from the start; he took from it the double-shell construction, the raised profile and octagonal lantern of [97], the rib construction and the drum *oculi* of [98]. The cathedral cupola was the only available prototype of scale comparable to St Peter's, and its

The Basilica of St Peter · 211

medieval rib construction gave a secure and sufficiently calculable means of controlling great loads. The Gothic profile was congenial to the vertical thrust of the colossal order, which could not have been resolved in a sunken or smooth dome of Bramante's type. Bramante's dome [89], with its solid mass of masonry, and without external buttressing, would have been excessively difficult – perhaps impossible – to build over such a span. In his last work, the Torre Borgia cupola of 1513 [101], Bramante embraced the structural and expressive potentialities of the Gothic rib: this design probably suggested to Michelangelo the advantages of increasing the eight ribs of the Florentine dome to sixteen, as a means of avoiding an over-emphasis on planes.

Bramante's dramatic Torre Borgia lantern had the effect of resolving the forces of the converging ribs; Michelangelo also found the lantern to be the key to his design: before and after writing to Florence in 1547 he was preoccupied with its form and proportion more than with the dome profile ([97] - with five lantern-elevations and one plan -[98]); on completion of the dome model in 1561 he was still uncertain of the lantern scheme, and later even Vasari was confused about the final design. Since the accents of the paired colossal pilasters on the body of the Basilica were to be channelled into the paired drum columns and from there into the dome ribs. the lantern became the climax and resolution of the dynamics of the entire composition. The letter and the drawings show that Michelangelo cared less about the dome profile than about the ratio in height between the dome and the lantern; his choice was between an elevated dome with a low lantern and a hemispherical dome with a high lantern.

The final solution recorded by Dupérac [99,100] shows the lantern raised on a high podium to compensate for the lowering of the dome, so that the overall height of the Basilica would not have been much less than in the early

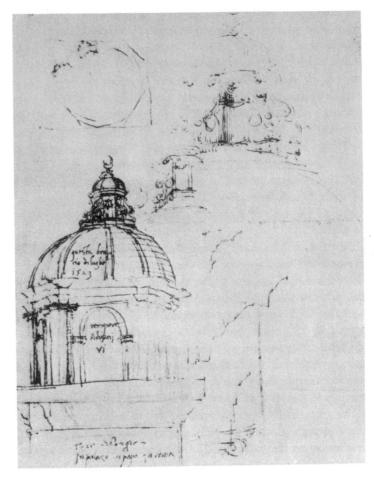

101. Bramante. Vatican, Torre Borgia cupola, 1513

designs. Moreover, the diminution in the width of the dome ribs towards the top would have preserved by perspective illusion the original effect of the elevated profile. The hemispherical profile represents not so much a rejection of Gothic in favour of classic prototypes as an internal

The Basilica of St Peter · 213

crisis in Michelangelo's style. In the space of twelve to fourteen years between the design of the lower order and the construction of the dome model, he had turned from the active tensions of the Campidoglio project and the frescoes of the Cappella Paolina to the subjective gravity of San Giovanni de' Fiorentini and the late Passion drawings. The state of mind that produced the reserve and calm horizontality of the San Giovanni model (1559-60) cannot

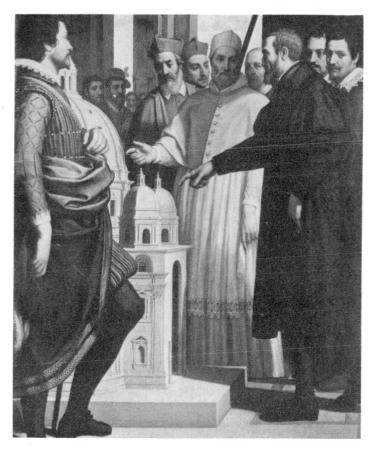

102. D. Passignani. Michelangelo presenting his model to the Pope, 1620 (detail)

have been wholly congenial to the uninhibited verticality of the initial St Peter's designs (1546): the hemispherical dome (1558-61) approaches the mood of San Giovanni without denying the forces generated in the body of the Basilica; the steps in the ribs and the rings of dormer windows reinforce the new sedative element. We know from Dosio's drawings that Michelangelo thought at one point of combining the low dome and low lantern, but he must have found through experiments on the model that this would over-emphasize the shift in style; the early spirit had to be resolved in the lantern.

In earlier editions I suggested that the attic which Michelangelo built on the south hemicycle in 1557, as it appeared in the model [102] and in an engraving of 1564 [103], was a *temporary* solution, and that Michelangelo wanted to wait until he had fixed the form of the dome before adding relief articulation to the plain surfaces of the

103. St Peter's. Exterior elevation, 1564

attic [94, 95]. I also proposed that the first portion of the attic facing, which already was being built on the north hemicycle at the time of an engraving of 1565 (see HBE, plate 53b), followed a decision by Michelangelo himself, made shortly before his death, to cover the tall arched windows with horizontal rectangular frames as a means of reducing the vertical accent. Recently a penetrating analysis based on new data makes it appear that the 1557 attic was Michelangelo's definitive design,¹ and that he counted on the simplicity of the wall surface to contribute to the mood of calm and to inhibit the vertical surge – an effect I attributed to the horizontal frames. The simple attic facing would constitute another close bond between St Peter's and the San Giovanni de' Fiorentini designs, particularly as interpreted by Le Mercier (cf. illustrations 104 and 117).

The restraint of vertical forces in the final project did not result in the kind of tensions found at the Campidoglio, but in equilibrium gained without loss of vigour. The coexistence of static and dynamic forms - a product of the profound introspection of Michelangelo's late years - was too subtle to be understood by contemporaries. In executing the existing dome [93, 94, 96], della Porta could not rise to the challenge of Michelangelo's testament; in his details he greatly reduced its rigour by eliminating the distinctions between horizontal-circumferential accents and vertical-radial ones. His rich decoration obscured and softened the clarity of Michelangelo's transitions, and disconnected the bones of the structure. By thinning the ribs and their supports, and eliminating their perspective diminution, by elevating the dome profiles and lowering the lantern, della Porta summoned the more familiar image of the Florentine dome. But the aspiring effect of della Porta's dome would have been more powerfully achieved in Michelangelo's final solution, where the climax at the lantern is amplified by the contrasting calm of the dome. We cannot tell how Michelangelo's minor domes would have

influenced the final solution: though he probably planned them, he apparently left no designs; those on the engravings seem to be by Vignola, while the existing ones were built from della Porta's design.

Michelangelo's dome fused the forms of antiquity and the Middle Ages in a way incomprehensible to della Porta, who had to return to the more consistent solution of the early studies, and to many modern critics, who failed to see the logic behind the evolution of the design. But for all its deficiencies, della Porta's dome preserved the essential potency of the original concept, and gave the architects of the Baroque one of their most compelling sources of inspiration.

While Michelangelo absorbed certain medieval forms into the predominantly Roman character of Bramante's Basilica, the final design was so thoroughly transformed by the individuality of his own style that it no longer symbolized its traditional roots. It was a statement so unique and so powerful that it became itself a symbol for future centuries. The form of the dome was to become the receptacle for the expression of civic as well as religious ideals; even in Protestant countries, where its association with the centre of Catholicism might have discouraged emulation, the functions of local and national governments are carried on under the cover of replicas of Michelangelo's dome.

Twenty-five years after Michelangelo's death, his design for St Peter's as emended by della Porta was represented on a fresco in the Vatican library (HBE, plate 58f). The Basilica appears in the centre of a huge square surrounded by porticoes designed in the style of Serlio, the construction of which would have required the removal of the Vatican palace. None of the architects of St Peter's could have hoped to demolish the palace, but the fresco represents more than a painter's fantasy; it demonstrates a great sensitivity to the spirit of the design. The artist returned to a fifteenth-century formula typified in Perugino's *Delivery of*

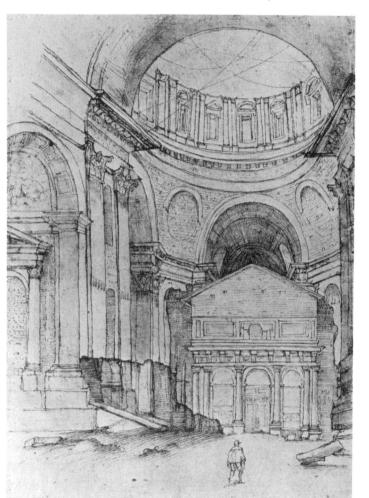

104. B. Ammanati? St Peter's. Crossing, looking west, c. 1559-61

I dolla chiesa

di bon

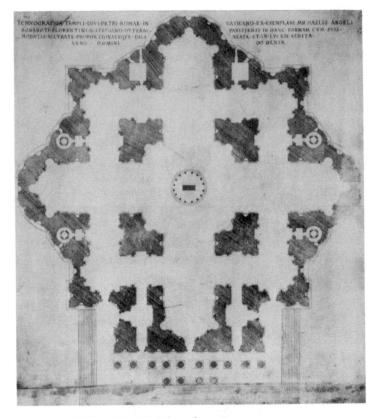

105. St Peter's. Plan, after Michelangelo, 1569

the Keys in the Sistine chapel, in which a monumental central-plan structure appears in the centre and to the rear of a vast piazza with a pavement marked off into squares. Perugino and his latter-day heirs illustrate the principles of Leone Battista Alberti, who demanded that the principal 'temple' of the city should be centralized in plan, that it should be isolated in the centre of an ample square, and that it should be raised on a podium to elevate it from worldly things. Alberti would have approved of Michelangelo's pedimented entrance-porch which, in fact, he had used himself in his Mantuan churches.

In all of the centralized projects for St Peter's the impact of the form would have been severely compromised by the congestion of the surroundings. The observer would have been frustrated by the fact that while the form of the Basilica invited him to circulate freely around it, the buildings on either side and the slope of the Vatican hill barred the way. Circulation was invited much more by Michel-

106. Vatican, Belvedere, Michelangelo's stairway (1550-51). See p. 325

107. G.-A. Dosio. The Cortile del Belvedere, c. 1558-61

angelo's design [93, 105] than by Bramante's, where block-like forms established finite, self-sufficient planes. Michelangelo, constrained by the portions already built to retain the ideals of the Quattrocento, but unwilling to compromise the kinetic force of his own style, brought into focus the paradox between the early Renaissance aesthetic of stability and centrality and the late Renaissance aesthetic - in the foundation of which he played a dominant role - of movement, axis and climax. No wholly successful solution to this paradox was possible; one alternative is represented in the fresco; another - prompted by the symbolism and liturgy as well as by the taste of the Counter-Reformation - in the existing Basilica, finished in the early years of the seventeenth century, where centrality was destroyed and the effect of the dome obscured by the extension of the nave.

[9] San Giovanni de' fiorentini And the Sforza Chapel

When Michelangelo prepared preliminary sketches for San Giovanni de' Fiorentini in 1559 to show to the commissioners of the Florentine colony in Rome, he returned to the central-plan proposal that his predecessor Sangallo had considered and later abandoned [109]. But the plans have nothing else in common. Sangallo had reverted to a fifteenth-century concept: a domed circular central area with radiating chapels and entrances, its simple uniformity broken only by an unintegrated facade and by a choir somewhat larger than the chapels but disguised to appear the same size. For the Quattrocento, a major aim in central planning had been to retain the regularity of a simple geometric figure; where that figure was a circle or a polygon, the favoured method was to construct all major lines radially from the central point, so the observer would be drawn to the centre from which he was intended to contemplate with equanimity the stabilizing uniformity of his surroundings.1

At first glance, Michelangelo's studies for San Giovanni appear to be motivated by this geometric spirit too. In his first drawing [108] a square intersects a circle and the central altar is an octagon; in the second [110] the octagon dominates, while in the final study [111] the circle reappears with a square central altar podium and oval chapels. But the fact that none of these figures is consistent throughout the series indicates that Michelangelo felt no commitment to a particular geometrical shape. Furthermore, the purity of each figure is violated in some way by

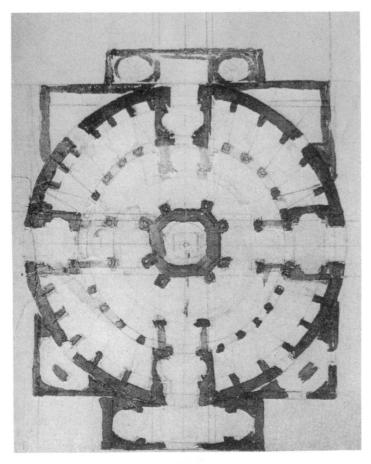

108. San Giovanni de' Fiorentini. Plan project, 1559

another. The consistent spirit throughout the series is rather a fascination with *axes*; in all the studies they are sketched first and the building takes shape around them. There are two patterns of cross-axes, one a + which accents the entrances and is assigned to circulation, the other a \times which accents the chapels and is assigned to liturgy. In the first plan, the former dominates; in the second, including the

San Giovanni de' Fiorentini and the Sforza Chapel · 223

auxiliary sketches, the latter, while in the last drawing they are equalized.

An understanding of the contrast between a plan generated from axes and one formed from regular geometric shapes is of basic importance in evaluating Michelangelo's aim. One principle implies directed movement; the other, stability. Furthermore, if the axial principle is complicated by the superposition of two pairs of cross-axes, dynamic tensions are established; the suggested movements are in conflict.

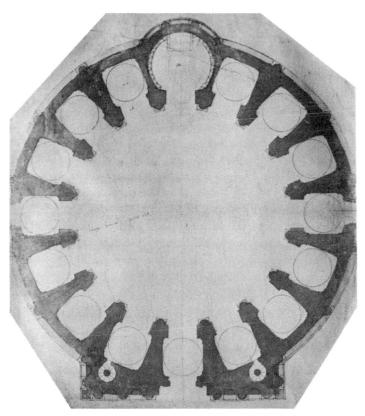

109. A. Sangallo. San Giovanni de' Fiorentini. Plan project, c. 1525

While it would be possible to emphasize axes without abandoning a truly radial construction, Michelangelo persistently sought to avoid focusing on a central point. He was so little concerned with the radial concept of his predecessors [109] that in his first drawing [108], those lines (from the circle of columns to the circular wall) that should be radial are not, while the choice of an octagonal altar tabernacle of unequal sides makes a consistent radial construction impossible. In the second study [110] nothing is constructed from the centre; the pier-system is emphatically anti-radial. The same is true of the last drawing [111], though the heavily inked altar podium obscures the fact that the principal structural lines cross away from the centre to form a perfect octagon about it. In establishing a focus in an area about the centre rather than upon a point at the centre, Michelangelo again displays his disposition to think in three-dimensional terms. His axes are not lines, but channels of space that converge in an area rather than at a point: and this is the area chosen for the altar in all but one of the studies. Michelangelo's decision to distinguish the circulation + from the chapel × conforms with his requirement (p. 37, above) that 'when a plan has diverse parts, all those that are of one kind and quality must be adorned in the same way and in the same style ... But when the plan is entirely changed in form, it is ... necessary to entirely change the adornments, and likewise their corresponding portions.' The two crosses offered the opportunity Michelangelo always sought to create a tension between equal and opposing forces. But evidence of a gradual relaxation of tension can be found in the revisions required to transform the drawings into a sound and usable structure. A more restrained, less physical solution emerges that reflects the religious intensity of the artist's late years.

Michelangelo's last drawing [111], unlike the earlier two [108, 110], reveals his awareness of the problem of supporting a dome; heavy masses gather to resist thrust. But

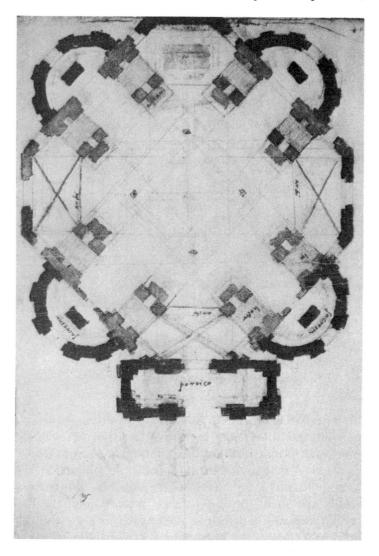

San Giovanni de' Fiorentini and the Sforza Chapel · 225

110. San Giovanni de' Fiorentini. Plan project, 1559

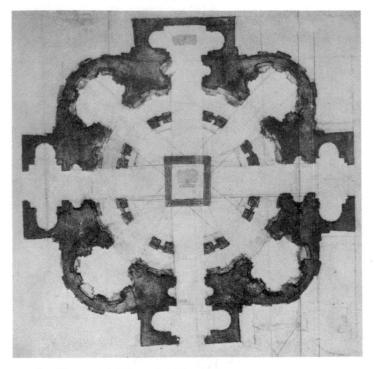

111. San Giovanni de' Fiorentini. Plan project, 1559

the inner circle of paired columns is mystifying; the columns are far too fragile to support a drum or even the groin vault planned behind them, though a pair of sketches is preserved that toys with the problem.² But to thicken them sufficiently would have overcrowded the central area, already too small for convenience. Accordingly, the first step in preparing a definitive design was to draw the columns back against the buttressing piers, changing them in the process to pure decoration, and allowing the piers to carry all the weight. The plan copied by Vannocci [113] is a record of this initial sacrifice to statics; it results in a diminution of axial tension, but the central altar, which in

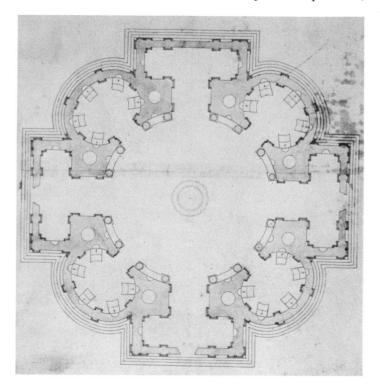

San Giovanni de' Fiorentini and the Sforza Chapel · 227

112. Calcagni. San Giovanni de' Fiorentini. Plan for final model

two of the earlier drawings is spiritually the generator of that tension, is still retained. In the succeeding stage the central altar is abandoned, too. The removal of the altar to the chapel opposite the entrance had already been proposed in the second of the preparatory drawings [110]; but there the diagonal axes were so vigorously emphasized that it was almost hidden: the focus remained in the central area. This illustrates the major problem of the centralized church in the Renaissance: while architects wanted a central altar for the sake of formal consistency, the clergy demanded that it be placed on the periphery where it would stand

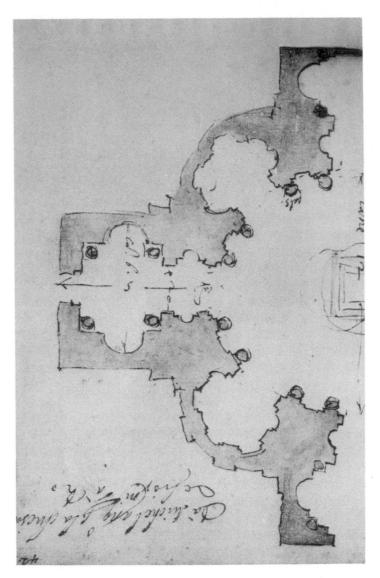

113. San Giovanni de' Fiorentini. Plan project, after Michelangelo

San Giovanni de' Fiorentini and the Sforza Chapel · 229

free of the congregation and be simpler to service. Michelangelo discovered that in acceding to liturgical tradition it was not enough merely to move the altar; he had to give the entrance-to-altar axis special emphasis, which further compromised the theme of an unresolved conflict of axes.

The first model [114] seems to be an initial response to the changed conditions: the entrance portico is elaborated and the side entrances are suppressed, so that the effect of centrality is sacrificed. The Calcagni plan for the engraved model [112] must be later, because it represents a subtler solution, restoring the centrality of the drawings without requiring a central altar. Now the axial emphasis is on the +, for the × axes of the chapels are subdued by narrowing the chapel entrances (the classicist Regnard overlooked this in engraving the plan). The solution is liturgically defensible and even suggests concern for symbolizing the Cross.

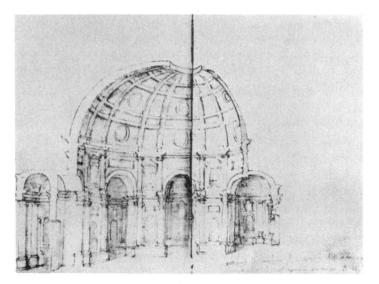

114. San Giovanni de' Fiorentini. First model (Dosio)

115. San Giovanni de' Fiorentini (lower centre, on river bank), 1555

In the final model [116, 117], the resolution of conflict in the central area is accompanied by a new emphasis on the axial theme in the peripheral entrance-ways and chapels The former are expanded – for no functional reason – to become ample rectangular vestibules which have their own axes, counter to those of the principal +, while the chapels are now elliptical so that they, too, have counter-axes. In Calcagni's drawing [112] the focus of the small chapelaltars is not at the centre; instead, each pair of flanking altars is oriented towards the two foci from which the ellipse is constructed. In this astonishingly un-Renaissance solution, the chapel plan fully anticipates Bernini's scheme for Sant' Andrea al Quirinale, an archetypal Baroque church.³

The many alterations in plan between the last of the preparatory sketches [111] and the model did not compromise the emphatically sculptural quality of the initial conception. In the the sketch, Michelangelo thought of the

San Giovanni de' Fiorentini and the Sforza Chapel · 231

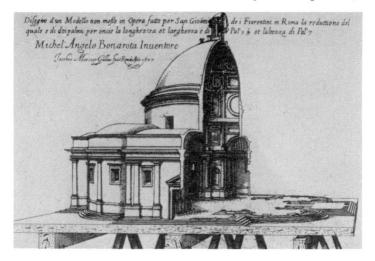

116. San Giovanni de' Fiorentini. Final model (Le Mercier)

exterior as a great cubic block the four faces of which were defined by the four rectilinear porticoes, while the chapels were carved out of the corners. It is a unique quality of Michelangelo's sculpture that a sense of the outer surfaces of the original block is preserved in the finished work. because he cut back from the foremost plane in a sequence of planes rather than working continually around the block. The method produced a certain frontality in all of his sculptures, and the same effect is achieved in San Giovanni where, for the first time in the Renaissance, we find a circular plan that is entirely successful on the exterior. Earlier architects were caught in a dilemma: if their exteriors were circular, it was impossible to sufficiently differentiate their entrance façades; if they designed a monumental entrance façade, the effect of circularity was lost. Here the problem is solved, because for a great sculptor there is no necessary conflict between plane and modelling.

It is characteristic of Michelangelo's sculptural approach that in the evolution from sketch to model the major

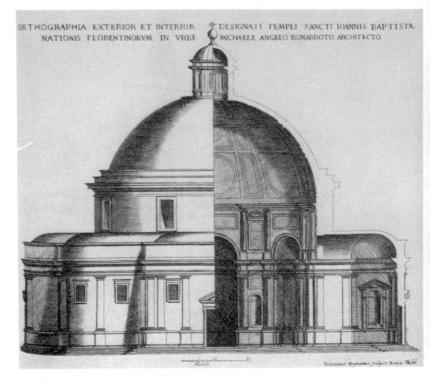

117. San Giovanni de' Fiorentini. Final model (Régnard)

changes were made on the interior, while the exterior remained nearly the same. The exterior massing, light effects and rhythms could be studied in the rough clay model, as in a terracotta sketch for statuary; but the interior design involved the exclusively architectural problem of enclosed space. Michelangelo visualized the interior entirely in terms of modelling [111]. The sole plane surface in his plan is in the chapel opposite the entrance, because only there is the plan of the exterior cube revealed. A reflection of the generating cube is preserved, however, in the central altar podium, which is not modelled because it has no structural function.

San Giovanni de' Fiorentini and the Sforza Chapel · 233

As the plan developed, the dynamic modelling was subdued [112]: niches were reduced in size or eliminated, to be replaced by planes in the vestibules and passage ways. The changes primarily affected the periphery; the central area retained much of its plasticity. To the extent that the reduced modelling represented Michelangelo's intentions and not the academic hands of Calcagni and the engravers, it can be seen as consistent with the reduced conflict of axes and with the restful understatement of the exterior. Even in the short period between the sketches and the model, Michelangelo's style appears to have departed from the dramatic tension and aspiration of his earlier work.

For the first time, Michelangelo proposes to allow the great mass-forms to speak for themselves rather than placing emphasis on articulating members. On the exterior there are no lantern-colonettes or volutes, no dome ribs, no buttressing or even membering on the drum [116, 117]. Inside, there is not even a cornice to separate dome from drum; outside, the pilaster order is raised on a high podium to lighten it. The minimizing of vertical and horizontal incidents reinforces the unity of the design, as is especially apparent in the exterior entablature and attic of the lower storey: uninterrupted by projections of any sort, they bind together the powerful rectilinear and curvilinear bodies of the porticoes and chapels. But more remarkable is the unity achieved by eliminating any conflict of effect between the façades and the dome: the latter remains in full view, uninhibited by any of the habitual Renaissance facade solutions - pediments, balconies, projecting cornices. The engravings accentuate the horizontals of the exterior and the verticals of the interior, but Michelangelo must have sought an equilibrium throughout: the inner shell of the dome is a grid [114, 116, 117] that keeps the directional forces balanced; within the grid - in the final model [116, 117] - the rising accents of small vertical ovals are stabilized by large circles in alternating fields.

We have seen that changes in the dome and attic of St Peter's made during Michelangelo's last years were also calculated to increase equilibrium; but there the powerful verticals of the lower portions designed in the 1540s had already set in motion dynamic forces that could no longer be restrained. At San Giovanni, Michelangelo was free to express a mood which he could no longer impose on St Peter's; for the first time he affirmed the crushing weight of masonry construction. The aspiration of the ribs and lantern of St Peter's dome is quite absent from the smooth hemisphere of San Giovanni, its springing hidden in the final solution by spreading steps to emphasize a settling quality. But the most evocative feature of the design is the gradual increase in plasticity from dome to base on both the interior and exterior, which subtly stresses the accumulation of weight and forces towards the ground. What is achieved in massing is reinforced by illumination, for the light gains intensity towards the base: the small lantern apertures would have spread a diffused light on the dome, but the large drum windows with their angled embrasures are channels through which the brightest light would constantly be focused on the floor of the central area.⁴ On the periphery, each chapel is amply lit by three relatively low windows, to attract attention along the axes rather than upwards. Nothing in Michelangelo's previous architecture prepares for what might be called the resignation of this late project. It is surely another manifestation of the profound religious experience of his last years, an architectural version of the Pieta's and Passion drawings of the 1550s, where again the forms sink gravely earthwards.

The San Giovanni model was a preamble to the more radical solution for the Sforza chapel in Santa Maria Maggiore. Michelangelo left the execution of the chapel and the design of details to assistants, so that the crude elevations

234

San Giovanni de' Fiorentini and the Sforza Chapel · 235

of the structure today tend to overshadow the extraordinary inventiveness of the plan [118]. This plan is the most subtle variation on the centralized type; its length and width are equal, as in a Greek cross, but the square of the crossing has been moved from a central position towards

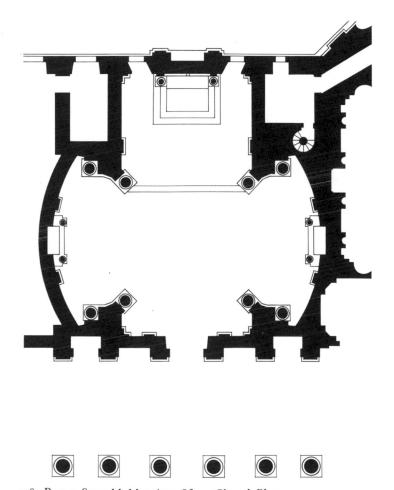

118. Rome, Santa M. Maggiore, Sforza Chapel. Plan

the entrance. In part, this solution was a response to lighting problems: as the chapel was an appendage to an existing church, no light could be had from the entrance and little from the side. The altar-chapel was the most promising source of illumination, and Michelangelo decided - after initial experiments with a more centralized scheme - to extend it at the expense of the entrance-way. This would have been unnecessary had the chapel been provided with a dome and lantern, but Michelangelo decided to give the chapel an unprecedented covering in the form of a slightly deflated version of the balloon vault used by Brunelleschi at the Foundling Hospital in Florence and elsewhere. The engraving [119] shows how the vault section echoes the segmental plan of the chapels: both must have been - even more than the ovals of San Giovanni - an affront to Renaissance taste, which demanded the 'completeness' of hemicycles and hemispheres. These curves imply a state of becoming rather than of being; their form is essentially unstable in masonry constructions.

The conflict of axes that Michelangelo had planned for San Giovanni is absent from the chapel scheme, for there is but one entrance, and this necessarily makes the altar-axis primary. An early plan study minimized the longitudinal axis in proposing three nearly equal chapels flanking the crossing: it is wholly consistent with the last of the San Giovanni plans, an echo of the design for the three entrance porticoes in [111] and [113]. We recognize in this preliminary study the calming classicism noticeable at San Giovanni, but it is gone again in the final project [118], as if Michelangelo could sustain only momentarily a state of repose.

A slight change in the placement of the four central columns dramatically shifted them from a passive to an active role; now they seem to jut aggressively into the central space, forming the beginning of an \times made not of voids, as at San Giovanni, but of masses [120, 121]. Perhaps

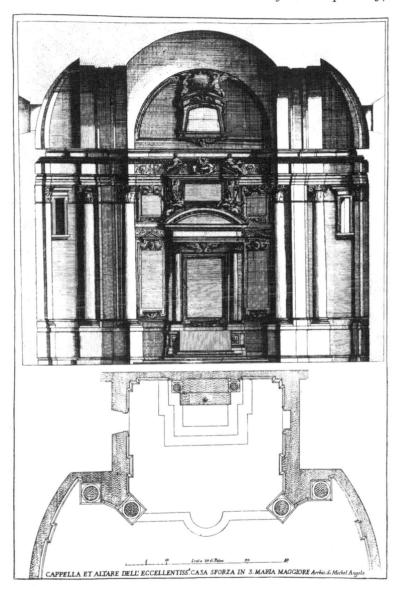

San Giovanni de' Fiorentini and the Sforza Chapel · 237

119. Sforza Chapel. Plan and cross-section

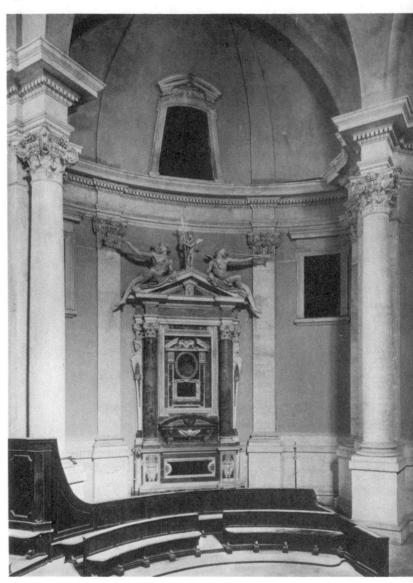

120. Sforza Chapel. Right chapel

San Giovanni de' Fiorentini and the Sforza Chapel · 239

121. Sforza Chapel. Detail of Order

this free use of the Order was suggested by the decision not to employ a dome.

The plan as a whole, with its equal but differentiated arms and its dynamic forms, was to become one of the most influential of Michelangelo's inventions. Architects of the following generations learned from it how to combine the virtues of a longitudinal and centralized plan, and were fascinated by Michelangelo's demonstration that the side chapels could be dramatized without prejudicing the dominance of the altar chapel. The influence on Borromini's planning is especially noticeable (San Carlo alle Quattro Fontane; Sant'Agnese in Piazza Navona).

If the unprecedented character of the design for San Giovanni can be related to the religious intensity of Michelangelo's late years, then the church cannot be understood as a typical Renaissance centralized structure inspired by antique models. At the height of the Counter-Reformation the humanists' arguments for the central plan, stressing the perfection of the circle, square and polygon, were considered irreligious, and would not have appealed to either Michelangelo or his patrons if Christian tradition had not offered equally convincing justification.

The central plan was suitable at San Giovanni, as at St Peter's, because it was the form chosen in Early Christian times to memorialize martyrs. This helps to explain why Michelangelo in his first plan turned to two martyria: the ancient Santo Stefano Rotondo, where the circular colonnade is also interrupted by cross-axes, and the modern project of Bramante for the Tempietto precinct of San Pietro in Montorio, where, as we know from Serlio, the famous central shrine - like the altar tabernacle of Michelangelo's drawings - was to have been surrounded by a colonnade with an ambulatory behind which chapels were set in the corners of a square. But a more subtle symbolism is implied in the octagonal altar base with its tabernacle supported on columns [108], the prototype for which may be found only in baptisteries; the octagonal central font and colonnade of the Lateran Baptistery was apparently Michelangelo's altar model;⁵ the wide entrance-vestibule with niched sides appears to come from the same source. The connexion is confirmed by the first model [114] in which the vestibule becomes an open portico with two free-standing columns, a virtual replica of the Baptistery as it appears in sixteenth-century drawings. A shift in symbolism from the martyrion to the Baptistery tradition would be inconceivable in any church other than one consecrated to St John the Baptist; and even here it might have escaped detection and was ultimately abandoned. In the second plan [110], the baptismal symbolism passes from a central tabernacle to the octagonal form of the building itself. Michelangelo

240

San Giovanni de' Fiorentini and the Sforza Chapel · 241

122. Sforza Chapel. Façade (destroyed)

may have presented this plan to the Florentine colony as a version of the Baptistery at home; the two have in common an octagonal form visible from the exterior, a free central space, and three entrances, the principal one in Florence – Ghiberti's 'Gates of Paradise' – being opposite a high altar.

The symbolism of the octagon disappears in the mature schemes, but the Early Christian portico type (familiar also from Santa Costanza in Rome, San Vitale in Ravenna and elsewhere) is preserved, and the treatment of contending axes begins to reflect Roman prototypes as the modelled masses of the wall suggest Roman construction. The opposition of + and \times axes is a frequent manifestation of the Roman fascination with conflicting choices of direction: it appears in the domed areas of the Domus Aurea, the Flavian palace on the Palatine, in the Piazza d'Oro of Hadrian's villa in Tivoli, and in nearly all the Baths.

Axial planning became Michelangelo's guiding principle because of its suggestion of movement and because it could be used to symbolize the Cross and baptismal font. The fact that it was tested first in an Early Christian, and finally in a Roman, context demonstrates that Michelangelo used tradition as a means of reinforcing his individualized form and not as an end in itself. This conclusion is borne out by his claim that in this design he had surpassed both the Romans and the Greeks.⁶ Vasari said that this was a rare boast for such a modest man; we may add that it was an impossible one for a truly Renaissance man, and marks the end of an era.

There is an almost neo-classic repose, simplicity and unity in the San Giovanni design. It is as if Michelangelo, having foreseen seventeenth-century architecture at St Peter's, was now ready to face the problems of the eighteenth century. Had this church been built under his supervision, the future history of architecture would have been quite different.

242

[10] The porta pia

PIUS IV PONT. MAX. PORTAM PIAM SUBLATA NO-MENTANA EXTRUXIT VIAM PIAM AEQUATA ALTA SEMITA DUXIT, the inscription on a tablet in the pediment of the Porta Pia, records the construction of both the gate and the avenue running through it [123 and 126]. Twenty years later the project was described by Ferrucci:¹

Be it known that Pius IV, in 1561 or 1562, wishing to leave a handsome street, which along with the city gate should bear his name, opened, or rather remodelled and levelled the beautiful strada Pia, where earlier there had been an old street,² curving and irregular, signs of which still appear where [the tops of] certain gates of villas or gardens ... now serve as benches or railings on account of the unevenness of the site as it used to be. The Pope had in mind to begin this street at the portal of the Palazzo San Marco³ because he was accustomed to go there every summer; from there it was to curve up to the Quirinal hill and continue through the Porta Pia to the bridge on the Nomentana. This was begun, but since the portion from San Marco to the Quirinal was not much used, and indeed was not open in those days, due to the difficulties of the ascent which was very steep and uneven, not much progress was made. In addition, certain individuals were greatly incensed on account of the considerable damage which their homes and property suffered from this street. Therefore he began the street from the Cavalli di Tiridate,⁴ making it long, wide, and level all the way to the Porta Pia, which is more than a mile; and from the gate he continued on with a straight, but in some places uneven, road for some distance beyond the gate, levelling certain portions and continuing to the church of Sant' Agnese. Because this street was in a most agreeable site and enjoyed the most perfect and salubrious air of all the parts of the city of Rome, it is full of the most beautiful gardens and pleasure spots of the most distinguished citizens ...

The Porta Pia, erected on the inner face of an ancient fortified gate enclosure just north of the original Porta

123. Porta Pia. City façade

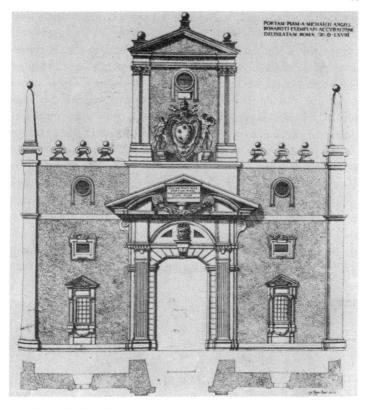

124. Porta Pia. Façade project (engraved), 1568

Nomentana [129], differed in function and form from any city gate of the Renaissance or earlier times. Though set into a defensive system, it was an indefensible, thin brick screen barely strong enough to sustain its own weight (cf. plan in [124]) – a record of the moment when the Romans abandoned hope of using their ancient walls as an effective defence against modern artillery. Furthermore, it faced inward, towards Rome, evading for the first time a tradition which from prehistoric times had turned gates towards the highway and countryside as an introduction to the city behind. Michelangelo's gate belongs more to the street than to the walls; it was pure urban scenography – a masonry memento of the temporary arches erected in the Renaissance to celebrate the arrival of princes, though without their triumphal connotations. The street, too, was more theatrical than utilitarian, since it crossed one of the least populated and congested quarters of Rome, where no important buildings were raised before the end of the century.

The scheme as a whole calls to mind the most popular Renaissance convention for stage scenery, borrowed from Vitruvius' account of the ancient theatre: a broad and regular city street, shown in perspective, which terminates in a monumental arch [125].⁵ Tragic drama demanded settings of palatial, severely classical architecture, while comedy permitted more common and varied structures. There is something of both in Michelangelo's gate: the

125. S. Serlio. Stage design. 1545

246

126. The Via Pia, view, c. 1590

nobility of the monumental tradition, and a fantasy and variety more commonly associated with villa design. Illustrations 126 and 129 show the original Via Pia, bordered by the walls of villas rather than by Palace façades – walls punctuated at intervals by new gates which succeeded so well in simulating Michelangelo's ingenuity that they were attributed to him as long as they survived [127].

Whether theatrical conventions were consciously adopted or simply absorbed from the atmosphere is of no account. In either case it is not the specific devices but the conception of the city street as an integral work of art that establishes Pius' programme as one of the great innovations in urban design. For a century before, the Popes had been levelling, straightening and broadening Roman streets (e.g. Julius II's Via Giulia), but their aim was primarily utilitarian, and aesthetic only to the extent that order was

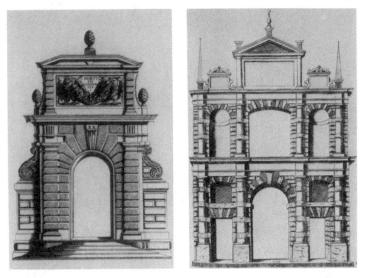

127. Villa gate, Via Pia, c. 1565

128. S. Serlio. City-gate design, 1551

preferable to chaos. The Via Pia was much more than an ennobled traffic artery: it was a kind of extended enclosure, terminated at one end by an imposing façade gate and at the other by the colossal statues of the Dioscures, and closed on the sides by walls embellished with architectural incidents designed to fit the scheme [126, 129].⁶ Italians had always been alive to the aesthetic factor in urban vistas; the novelty here was in the homogeneity of the conception. The Via Pia is to earlier streets what the Campidoglio was to earlier *piazze*, in that the designer exercised absolute control over the environment while his predecessors had only managed to improve existing conditions.

In all these respects Michelangelo's design anticipated the urbanistic programme of Sixtus V and Domenico Fontana (1585-90), which is generally designated as the source of Baroque city planning.⁷ The Sistine plan is characterized by long street perspectives terminated by obelisks which,

The Porta Pia · 249

like the narrow attic of the Porta Pia – where Pius IV also wanted to place an obelisk – give the pedestrians a measure of distance, a goal that rises above the buildings along the street and is silhouetted against the sky. The use of ancient sculptures as a focus of major streets and squares is another feature of the plan. Sixtus V must have thought of his programme as a continuation of Pius', because his network of streets crosses and continues the avenues of his precursor. He particularly emphasized the point at which the Via

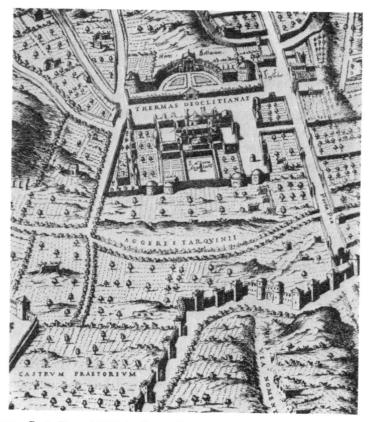

129. Porta Pia and S.M. degli Angeli, 1577

Sistina-Felice, from Santa Maria Maggiore to the Pincio, crossed the Via Pia; there Fontana embellished the intersection by inserting fountains at the four corners (hence the name of Borromini's San Carlo alle Quattro Fontane). And farther along the Via Pia, he placed the monumental fountain at the outlet of a new aqueduct, the Aqua Felice [126].

If the basic components of Baroque urban design were inherited by Sixtus V from Pius IV, then credit for the new vision goes to Michelangelo rather than to Domenico Fontana, whose desiccated architecture has always made him seem poorly cast in the role of father of modern town planning.

Drawings for the Porta Pia show that Michelangelo was almost exclusively interested in the central portal. He thought of the gate façade as a neutral field, an extension of the medieval walls where a few sculptural ornaments might be placed. The role of the gate as street scenery made the portal and attic the heart of the design, since they were all that could be seen from a distance. The centre is therefore isolated by a dominance of travertine over brick and by dramatic contrasts of light and shadow which are minimized on the sides by the use of flat bands and cartouches with shallow recessions. The absence of definitive drawings for the attic would surprise anyone unfamiliar with Michelangelo's habit of designing from the ground up. But the general effect of an attic was not overlooked in the process of sketching portals: in each of the drawings known to be for the Porta Pia, preliminary construction lines extend the vertical lines of the portal frame beyond its pediment to indicate the placement and dimensions of the upper storey. Probably Michelangelo never arrived at a definitive attic solution; the spiritless attic of the engraving [124] must have been invented by someone else.

The surviving drawings do not indicate that Michelangelo designed more than the portal and the central car-

250

touches (see HBE plate 79a). Other details, except perhaps the spheres perched on the crenellations and the round platters with pendant bands, could have been added by assistants. The size and placement of the cartouches imply that Michelangelo determined the overall proportions of the gate, and a vague similarity in composition to the Palazzo dei Senatori reinforces this impression.

The misty technique of the portal sketches [130, 131, 132], while partly due to Michelangelo's advanced age and to the collaboration of assistants, was obviously calculated, and reveals something about the effects intended for the building. They are perceptual rather than conceptual, in that overall impressions are more important than the objective forms of the members that produce them. While certain basic patterns and rhythms consistently appear in the studies, the specific architectural motifs that make them possible remain in flux: volutes may become a pediment [130 and 132] only to mature into a pediment-volute; or a bull's horn may be transformed into a garland [123 and 131]. Capitals, bases and mouldings are mere blurs of light and shadow fused by an ambient atmosphere, as in the contemporary painting of Titian, where patterns of light and colour overcome the individuality of figures. In his latest years Michelangelo had turned from a sculptural to a painterly approach to architecture, perhaps stimulated by the fact that the scenographic, two-dimensional Porta Pia was more like a canvas than a statue. The unifying impressionistic vision, in de-emphasizing single elements, abandons the effects of tension which in Michelangelo's early work were created through conflict of strongly individualized members. We are no longer expected to read the members as metaphors of human limbs; they have become a variegated pattern of optical effects organized by internal rhythms. Thus, there is a freedom, even a looseness, in the executed portal which is unique in Michelangelo's architecture, and which explains his extraordinary

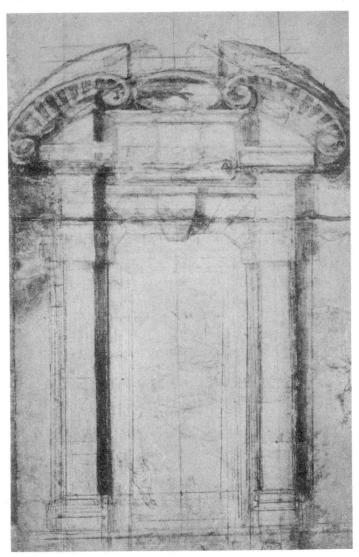

130. Porta Pia. Study for the central portal

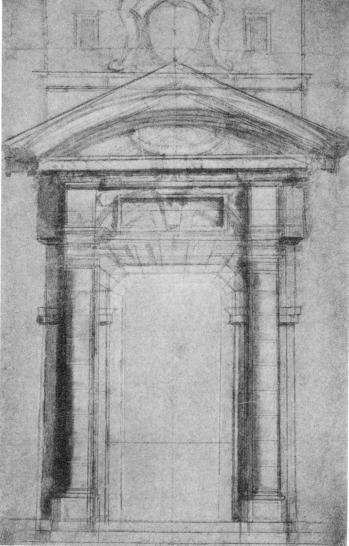

131. Porta Pia. Study for the central portal

132. Porta Pia. Study for the central portal and other details

achievement in imparting to a massive and grandiose structure an air of festivity, almost of gaiety.

The portal has the most complex architectural detail of the era and an extraordinary variety of curves and angles. Its multiplicity of forms is the result of accumulating rather than selecting the ideas generated so rapidly in the preparatory drawings, so that each sheet contains several superimposed designs. No structural or theoretical principles guided the sequence of drawings – only an inspired, almost

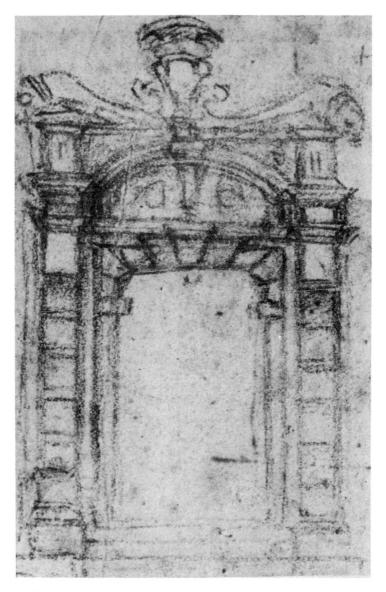

133. Study for a portal

unconscious search for visual impressions. A last-moment shift from columnar to pilaster supports is symptomatic of the painterly approach to design; here Michelangelo suddenly wanted vertical shadows rather than masses, even if it made no sense in terms of tradition and the weight of the superstructure. He succeeded because the vitality of the fluting fully compensated for the loss of body.

In the actual building the impression of the drawings could not be fully sustained; the chisel was bound to sharpen the atmospheric softness. But close inspection shows the extent to which the portal rejects the linearity and sharpness of Michelangelo's earlier work; the drafting of the jambs and arch gives an impression of cushion-like blocks; the mouldings have been stripped of the multiple channels and protrusions of antiquity to become simple plane or curved surfaces. The impact of such subtleties is lost to the modern eye, but their significance for the Renaissance is amusingly revealed in a sketch from the portal made by an assistant, who automatically drew intricate mouldings into the pediment, and later had to add the note 'tutto questo non ci va'.⁸

The Porta Pia was an innovation in city-gate design which had neither forerunners nor imitators. Historically, its most notable feature is that it is not Roman. Everything we know of sixteenth-century civic architecture would lead us to expect that the first major Renaissance city gate built in Rome would imitate, or at least obviously refer to the surviving ancient gates – such as the Porta Maggiore – or triumphal arches. The pride and symbolic meanings that accumulated about city gates in antiquity and the Middle Ages should have conspired to place them among the architectural forms least susceptible to innovation, and the rarity of modern gates in the Renaissance is probably due to the sacrosanct character of those surviving from earlier times. In the twilight of Humanism, Roman forms could have been avoided only by intention; Michelangelo and his

256

The Porta Pia · 257

patron must have favoured a language that would give Counter-Reformation monuments a vocabulary of their own.

Accordingly, the Porta Pia recalls the medieval, rather than the ancient walls of Rome, with its crenellations. which Michelangelo used to support Medici palle. Antique elements could not be avoided entirely in the portal, but their conventions were totally ignored: if the order of the portal is classified as Doric because its 'capitals' are composed of gigantic guttae (the wedge-shaped pegs) transplanted from the Doric entablature, then Roman decorum would not permit the pilasters to have Ionic fluting. The fantastic miscegenation makes the canonical Corinthian order of the attic in [124] particularly suspect, and suggests that the nineteenth-century restorer came closer than the Renaissance engraver to Michelangelo's spirit. But the odd pilasters were not concocted specifically for the Porta Pia; they appear in slightly different form in the vestibule tabernacles of the Laurentian library [45], and in the portals of the Palazzo dei Conservatori [71]. In casting off ancient formulae, Michelangelo adhered to conventions he had established himself; even the greatest genius needs schemata. It is surprising how many motifs he recalled from sketches of thirty-five years before. The Library drawings include portals in which a segmental pediment is set into a triangular one, and in which inscription tablets with projecting upper mouldings project forward at the centre of the pediment. In studies for the central cartouches of the Porta, a motif from the ceiling of the reading-room reappears nearly unchanged. Only Michelangelo could have succeeded in using the same vocabulary in both a small interior and a huge civic monument; the choice is another proof of his indifference to ancient gate traditions.

The flat arch is the only motif that remained unchanged throughout the series of preparatory drawings; possibly an element of conscious anti-Romanism guided experiments in new arch forms which are the insignia of Michelangelo's late style (the Farnese galleries; the Sforza chapel; the plan of San Giovanni de' Fiorentini; the arches of the Ponte Santa Trinita). At the Porta Pia, however, the combination of motifs is inspired by a structural logic as well as by a search for new forms: the flat arch would not sustain its stresses without a semicircular relieving arch in the wall above it, and the tympanum is a visible expression of the inner workings.

There are so few surviving Renaissance city gates that it is tempting to over-emphasize the eccentric character of the Porta Pia. In old engravings and in illustrations to theoretical works we find that a certain fantasy was de rigueur in sixteenth-century gate design that would not have been admissible in other civic structures. Together with villas and garden architecture, gates were classified in the genre called Rustic, partly for the reason that the grandest of all ancient Roman city gates was the rusticated Porta Maggiore. The popularity of the Rustic genre is attested by Serlio's Libro estraordinario of 1551, containing 'thirty gates in mixed Rustic style (opera) with divers orders; and twenty in delicate style of divers kinds ...' The Rustic genre not only favoured roughly finished masonry but encouraged unorthodox motifs, combinations of orders and materials. Serlio, in the preface to his book, explained the

134. Porta Pia. Initial façade project, 1561

258

fashion on the grounds first, that the public liked new things, and secondly, that the taste for inscriptions, arms, symbols, sculptural relief and statuary could be better accommodated by cautiously breaking the rules: 'But', he added, 'if you architects steeped in the doctrine of Vitruvius (to which I grant the highest praise and from which I do not intend to depart much) hold that I have gone astray with so many ornaments, so many panels, so many cartouches, volutes and other superfluities, I beg that you consider the country where I am [the book was published in Lvons] and that you supply what I have missed: and stay sound.' This cautious variation of traditional rules is illustrated in Serlio's plates, where the ancient orders, though overlaid with roughly dressed masonry and Mannerist ornament, remain basically Vitruvian. Sanmicheli was equally orthodox in his famous Rustic gates of Verona. Serlio's model gates have several motifs used in the Porta Pia; in No. XXX, for example [128], a three-bay, threestorey façade is crowned by a central pedimented attic and there are obelisks at the corners; even a segmental arch appears. But the differences are more revealing than the similarities; the parts of the Porta Pia designed by Michelangelo abandon all conventions whether of ancient, or of modern rusticated, orders.

Rustic can be characterized as a genre rather than an order because there is more in it than a certain vocabulary of ornament. Associated with the countryside rather than with the city, it may be thought of as an architectural equivalent to the pastoral genre in literature, connoting what we would call today a romantic or primitive rather than a classical spirit. It was this distinction that imparted to villa and gate design its licence to fantasy and invention; perhaps the whispered suggestion of rustication which Michelangelo executed for the first time in the jambs and arch of the Porta Pia was intended as an application for that licence.⁹

[11] Santa Maria degli Angeli

In 1561 the ruins of the huge Baths of Diocletian [129, 136] were consecrated by Pius IV as the church and monastery of Santa Maria degli Angeli, and the reconstruction of the well-preserved structures at the centre of the building complex was begun under Michelangelo's direction. Ancient Roman buildings had been remodelled often into churches in Early Christian times (the Pantheon as Santa Maria Rotonda; the tomb of Constantia as Santa Costanza; the temple of Antoninus and Faustina as SS. Cosmas and Damian, etc.), but the tradition died out in the later Middle

135. S. M. degli Angeli. View into the chancel, 1644

136. S. M. degli Angeli. The great hall

Ages. It is symptomatic of the Renaissance failure to resolve the conflict between an intellectual adoration of the pagan past and a spiritual adherence to Christianity that this tradition could not be revived until the Counter-Reformation had confirmed the primacy of the Church.

The transformation of the Baths was promoted by a pious Sicilian priest, Antonio del Duca, who, inspired by a vision of the angels, pestered the papacy for twenty years to gain his end. Rebuffed by Paul III and only temporarily encouraged by Julius III, he finally won enthusiastic support from Pius IV, who envisaged the church as the crowning ornament of the Via Pia, the new avenue he had started alongside the Baths under Michelangelo's direction. Today almost nothing can be seen of Michelangelo's church: the remodelling carried on throughout the eighteenth century altered the plan and covered every accessible surface with late Baroque ornament [136]. Only the plain stuccoed vaults of the main hall remain to evoke the original attempt to form a church with the minimum of change in the ancient remains [135]. Because Michelangelo left the elevations untouched except for the addition of plain partition walls, two entrance portals, and window mullions, his design can be reconstructed by a study of the plan alone [137].

Discussion of the plan has focused on the unprecedented

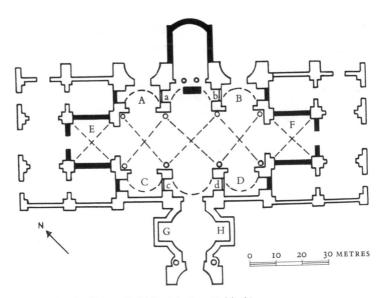

137. S. M. degli Angeli. Plan, showing (in black) Michelangelo's additions to the baths of Diocletian

262

Santa Maria degli Angeli · 263

use of the great hall of the Baths. It has been read as an over-sized transept, anticipating the Baroque emphasis on the cross-axis (Borromini's Sant'Agnese, Bernini's Sant'Andrea al Quirinale) and conversely, as a radial central-plan with no crossing – only a single central space with attached vestibules on three sides, a major chapel on the fourth, and without anything that might be called a nave.¹ Modern interpretations of Santa Maria degli Angeli have been clouded by unwillingness to admit that Michelangelo could be moved by anything except a will to form. Without denigrating the aptness of Michelangelo's solution, we may see in it more common sense than inspiration; any competent architect might have hit upon it.

Given the problem of converting the Baths with a minimum of new construction, two equally practical solutions were available. The more obvious and conventional, in a liturgical sense, was that of Antonio del Duca, who wanted to use the great hall as a long nave; the entrance would have had to be at the north-west [137 E], where there was access to the Via Pia; consequently the altar would have been placed in the ante-room at the opposite, south-east end. Michelangelo chose the only alternative axis, at a right angle to del Duca's, placing the entrance at the rotonda on the long side [137 G/H] and the altar across the hall, where there had been a broad passage to the exterior frigidarium. The decision not only produced a more interesting relationship of spaces, but had several liturgical advantages as well, the most important of which was its response to the needs of the Carthusian monastery, emphasized by Vasari.² When del Duca's plan was temporarily adopted in 1550, the church had not yet been granted to the Carthusians. After the grant, the plan became impractical because it offered the monks. whose rule was the most hermitic of any Renaissance Order, no seclusion from the lay congregation. Michelangelo's alternative [137] isolated the chancel from the main hall with its public altars, giving it a

maximum of privacy. In [135 and 138] where we look into a deep chancel with the altar in an apse at the end, Michelangelo's design had already been changed. Earlier views [139] show the altar in front of the chancel and, behind it, two columns preserved from the ancient Baths [137]. By preserving the columnar screen, Michelangelo gave the brothers an isolated choir required by the traditions of monastic architecture. The choir was probably opened to view after 1565, when Pius IV violated his contract with

138. S. M. degli Angeli. View of chancel and south-east vestibule, 1703

the Carthusians by declaring Santa Maria degli Angeli a titular church.

The setting of the cloister [129] and the need to connect it directly with the chancel was a second determinant. Only one area of the Baths was sufficiently unencumbered by ruins to erect a cloister without costly demolitions: the site of the frigidarium, a huge pool originally open to the sky on the north-east of the main hall. So economic and litur-

139. S. M. degli Angeli. Altar in its original position, 1588

gical demands conspired to place the altar on the northeast, or, to accept the inaccuracy of the contemporary chronicler Catalani, on the east, in conformity with traditional orientation.

In satisfying the Renaissance predilection for symmetry, Michelangelo's choice was aesthetically more conventional than del Duca's. If the great hall had been used as a nave, the plan would have been grossly unbalanced by the large rotonda on one side. In making the rotonda into the main vestibule, every part of the church became symmetrical about the entrance-to-altar axis. Michelangelo's orientation had appealed to Renaissance taste long before it was suggested by the needs of the Carthusians: around 1515 and 1520 Giuliano da Sangallo and Baldassare Peruzzi both anticipated it in perspective drawings which show the main altar in its present position.³ Finally, it followed the principal axis of the ancient Baths, as may be seen from the layout of the ruins surrounding the church, especially the great exedra [129].

While Peruzzi intended to close the ends of the main hall [137 E, F] with semicircular apses, Michelangelo left them open and made the adjoining rectangular chambers into entrance vestibules. Then he used the door-to-door measurement to fix the distance from the main (southwest) entrance to the end of the new apse. This simple solution, involving a minimum of new construction, produced a Greek cross plan which, on account of the great difference in the scale and form of the arms, is difficult to experience visually. A Greek cross with vestibules on three sides and an altar on the fourth was the underlying scheme of the final plan for San Giovanni de' Fiorentini [111], drawn only two years before, so that Michelangelo had a ready-made iconographic exemplar to impose upon the Baths.

Years before, del Duca had taken the cross-axis of the Baths, together with the cruciform brick-stamps of Diocletian's kilns, as proof that the original builders had been Christians. Members of the intelligentsia were not so naive: their description of the ruins 'magnificentissimae illae Caesaris Diocletiani thermae toto orbe celebres' has suggested to modern critics⁴ that the programme for the church, which left the ancient remains virtually unchanged, was evidence of the pervasive Humanistic passion for the pagan past. But the fact that the first Renaissance conversion of a major mon-

Santa Maria degli Angeli · 267

ument into a church should have been achieved only at the height of the Counter-Reformation warns against a simple Humanist-antiquarian interpretation. The taste that formed St Peter's on the model of Roman Baths was far different from that which half a century later reversed the process to turn a Bath into a titular church. Counter-Reformation society respected ancient monuments in so far as they might be made to contribute to the glory of the church; and the more 'magnificent' the monument the greater the contribution.

Though Humanist patrons had pilfered from the ruins every portable stone and column, their respect for the ancients was so great that they dared not openly invite comparison by turning antique buildings to Christian uses. So the Christianization of the Baths was not inspired or even supported by Humanists; it was the achievement of a simple Sicilian visionary who despised the ancients and wanted only to honour the Virgin and the Angels. This dream was fulfilled not only by the construction of the church, but by the motto inscribed in the apse: 'Quod fuit Idolum, nunc Templum est Virginis - Auctor est Pius ipse Pater, Daemones aufugite.' In the same spirit, the anti-Humanist Pope Sixtus V (1585-90), who zealously destroyed some of Rome's greatest remains, spent incredible sums to re-erect antique obelisks before the major churches in order to top them with crosses and thereby to symbolize the triumph of Christianity over the pagan past.

Michelangelo, as we know him in his profoundly religious late poetry and drawings, was equally far removed from the Humanist position. The sense of liberation from the weight of the past that had prompted his claim to have surpassed ancient architecture in the design of San Giovanni now made it possible for him to mould it in his own image. Admittedly, he did as little moulding as possible, and left the ancient remains almost as he found them [129, 137]; but this does not necessarily indicate a reverence for the past. Though his design could be explained by economic restrictions alone, it must have been intended to conform to the spirit of Pius' inscription. The Virgin's victory was surely more impressive in the days when the austere halls of her antagonists were left untouched. After eighteenth-century reconstructions had covered all but the vaults and columns of the original building [140], the thermal atmosphere evaporated, carrying away the whole drama of her struggle with the demons.

140. G.-A. Dosio. S. M. degli Angeli. View, c. 1565

268

[12] CONCLUSION

Certain common traits may be found in reviewing the whole of Michelangelo's work which help us to characterize his architectural style.¹ Among these are what I call a 'relief' style, dominant in designs before the Laurentian library, and a 'kinetic' style – suggesting movement along axes – dominant in the library and in subsequent buildings. I shall also examine the transition from the two-dimensionality of the earlier buildings to the volumetric character of the later ones, promoted by a series of bold experiments in the expressive potentialities of structure, and finally, Michelangelo's vocabulary of motifs, which remained the most consistent feature of his architectural style.

Relief played a major role in Michelangelo's sculpture: in the early years, bas-relief in the familiar sense, and later, as a feature of full-round statuary – such as the *Pietà* in Florence – which remained frontal and restricted in depth. The same may be said of the architecture: early projects (the chapel front at Castel Sant'Angelo [5]; the San Lorenzo façade and reliquary tribune [13, 14]; the Medici chapel [17]) were reliefs to be applied to plane surfaces, and a late design such as the Porta Pia returned to the same principle.

Bas-relief is to be seen from one position, preferably at a fixed distance on its central axis; it discourages the observer from movement because nothing happens on its sides or back; in this respect it is like painting. Before 1500, architects borrowed from painting both its static and its planar character; after 1500 a new taste for the definition of masses in space prompted the building-out-from and digging-into surfaces. The relief style marks a transition from the panel-painter's to the sculptor's approach to architecture; it also represents an adjustment by architects interested in a complete conquest of the third dimension (e.g. Bramante at St Peter's [89]) to the conditions of congested urban settings, where typically only one - twodimensional - façade is exposed to view. In Bramante's and Raphael's palace façades the wall plane disappeared behind a dense armature of sculptural elements - columns, balconies, roughly rusticated blocks - which invited a rich interplay of lights and shadows. The Medici palace windows [32] prove Michelangelo's awareness of these experiments; the upper parts are surprisingly close to those of Raphael's Antonio da Brescia house in Rome. But other early designs were not so aggressively anti-Quattrocento: they rather followed Giuliano da Sangallo [7 and 10] in preserving some of the linear, two-dimensional quality of the Florentine past. That quality was peculiarly suited to programmes requiring monumental sculpture (the San Lorenzo façade and the Medici chapel [12, 17]), where the architecture had to be a frame for figural compositions; had the buildings themselves been as sculptural as Bramante's they would have overshadowed the figures. For a Florentine artist of this period, the preservation of Quattrocento values, by evoking recollections of the days of leadership and liberty, must have been an act of patriotism, and Michelangelo's Florentine buildings, like contemporary paintings of Pontormo and Andrea del Sarto, could preserve local traditions without being either conservative or provincial.

When Michelangelo turned to architecture at about forty, he was deeply involved in work on the tomb of Julius II, and it was a short step from this sculptural composition of architectural scale to architectural commissions dominated by sculpture. He found a bond between the two arts in the material itself: the white-to-ivory marble of Carrara adopted for architectural as well as for sculptural elements in the chapels of Leo X [5] and the Medici [17], and in the San Lorenzo façade [13], invites the linear, crisp effects which Michelangelo sought as a younger man, and which are emphasized by the tools and techniques of his earlier drawings [12] by contrast to the effects of later drawings [133] which suggest less exacting, more malleable travertine and brick. The years wasted in the quarries fruitlessly extracting the blocks for San Lorenzo must have discouraged Michelangelo from the further architectural use of marble, but he continued to get comparable properties from traditional Tuscan materials: hardness and precision from grey *pietra serena*; whiteness from stucco [17, 36].

The façade and chapel at San Lorenzo are the last proiects in which Michelangelo attempted to combine architecture and sculpture; chances are that the façade would not have met its author's expectations; the rather delicate architectural trellis would have been overwhelmed by the force of the reliefs and statues it was destined to support. Later Michelangelo preferred to treat buildings themselves as if they were sculptures rather than merely a framework for sculptural compositions. Why is it that the Renaissance, which cultivated both architecture and sculpture with such distinction, produced no monuments in which the two arts are joined as successfully as in the Parthenon and Chartres Cathedral? Probably because the Renaissance emphasis on individuality destroyed the gift of anonymity which in primitive, and occasionally in sophisticated societies promotes the collaboration of large teams of gifted artisans without sacrifice of quality. Michelangelo, an archetype of the new image of the individual, had to dominate every step from quarrying, to architectural design, to carving, yet he was still enough of a medieval artisan to want to do so by working with his own hands. A century later Bernini was to fuse the other arts with monumental architecture without loss of individuality by organizing a specialized labour force trained to function as an extension of his own hands.

The relief style of the early designs was a solution to commissions which emphasized architectural ornament rather than the design of buildings. For the Laurentian library new principles were needed; problems of statics and of utility elicited from Michelangelo a hitherto dormant genius for structural design and for the composition of enclosed spaces.

In the library, for the first time in the Renaissance, the wall ceased to be the dominant structural and aesthetic element; piers and columns supporting a framework of roof trusses formed the basic system, and a thin wall merely sustained and strengthened it [37]. By this means attention was deflected from wall surfaces, which hide the force and direction of stresses, to the armature which, like the musculation in the body, discloses stresses. Technically the system was more Gothic than antique; but where the Gothic architect sought by progressively dematerializing his structure to remove awareness of load, Michelangelo used supports to accentuate it, so that the observer should experience the conflict of forces acting in the structure. A medieval device thus achieved a characteristically Renaissance goal, by urging the observer to identify with the building physically. The library experiment was continued in the design of the Campidoglio [70], where the frame became dominant, leaving the wall to function only as a curtain to screen interior spaces. The frame-system of the library interior and the palace exterior emphasized individual bays to a degree unknown in Renaissance architecture, and permitted construction by the addition of autonomous, boxlike units; the effect is of unprecedented cohesiveness and strength.

But Michelangelo's purpose in accentuating structural members was not invariably to specify the forces at work in a building; he might exaggerate or repress apparent stresses to evoke a certain mood. So the design of the Conservators' palace does not merely reveal the structural

Conclusion · 273

system – it exaggerates the apparent weight of the cornice and minimizes the apparent strength of the pilaster-piers to intensify the conflict between supporting and supported elements.

This demonstration of the manipulation of structure for expressive ends was a preamble to the design of St Peter's, where powerful tensions are suggested in the body of the Basilica which are quite unrelated to the actual structure [94]. A surface network of dynamic horizontals and verticals in apparent conflict covers a dense masonry mass which really just sinks down. The colossal order supports nothing - it merely draws attention to the drum and dome, where actual structural forces could again be revealed and exaggerated by the treatment of ribs and buttresses. The dome, where stressed supports alternate with lighter, unstressed planes, is a hemispherical counterpart of Michelangelo's earlier bav-designs, and the drum is essentially an inversion of the wall-system in the library vestibule: the columns now project while the tabernacle/window frames with their alternating pediments recede (cf. [36 and 94]). Michelangelo turned to Brunelleschi's Florentine dome for inspiration because across the 130-year gap the two designers were bound by a common sensitivity to the interdependence of form and structure. In the intervening years architects had learned from Roman antiquity to hide the skeleton and muscles of buildings under a rich Vitruvian vocabulary and stuccoed, painted or veneered surfaces.

The projects for San Giovanni de' Fiorentini [114, 116, 117] are quite different; there the design arose from a predisposition to certain principles of space and mass composition rather than from any structural considerations. The dome gives no clue to technique: its exterior, apparently monolithic, returns to the antique type, while the exterior order is minimized to the same degree that that of St Peter's is magnified. The exterior of San Giovanni was to communicate through the interplay of simple masses alone, the interior chiefly through volumetric spaces. So the project preserved neither the relief character of the first buildings nor the anatomical character of the intervening years; it is a sculptor's architecture in a new sense, close in concept to the statue carved from a block. But prophecies of the new style may be discovered at St Peter's: while structure was still applied as ornament in the manner of relief architecture around the body of the Basilica, it was more convincingly integrated with the wall than ever before, and the fact that it was applied no longer to a two-dimensional surface but to an undulating mass encourages us to see it, as we do the San Giovanni project, in terms of body rather than planes. More important is that the evolution of the St Peter's dome from an elevated curve inspired by Florence Cathedral to the classical hemisphere in Michelangelo's last solution [99, 100] prepared the way for the low, Pantheon-like dome of San Giovanni; the attic design, like that of San Giovanni [cf. 103, 116], calmly subdues the vertical thrust. Nevertheless, the San Giovanni project emphasizes a factor of unpredictability in Michelangelo's work which makes it especially difficult to define the style of his architecture as a whole or a consistent 'development' in style. The design shows a fresh respect for antique sources used with unprecedented sobriety and reserve in tune with the Counter-Reformation. Still, it is almost coeval with the antithetical Porta Pia, which achieves a festival brilliance by fantastic distortions of antique sources. Finally, after discovering that Michelangelo made the church of Santa Maria degli Angeli merely by raising a few partitions in the Baths of Diocletian [137], we may wonder whether this was due to respect for the ancient monument or to a new spirit of Christian asceticism.

Michelangelo's later architecture, like his painting and sculpture, might be called 'kinetic'; it incites an emotional response through its capacity to move the observer physically as well as emotionally. One is drawn around, into,

Conclusion · 275

through his buildings not only by the composition of spaces but by that 'organic' design of masses that makes a wall or a stairway seem to be in motion. The kinetic spirit, repressed by the limitations of Michelangelo's earliest commissions - none of which required even the making of a plan - first emerged in the Laurentian library, where spaces as well as surfaces might be controlled [35, 37]. These spaces were arranged in a sequence - square, high vestibule; long, narrow reading-room; triangular study [50] - each unit of which was distinct, even in the technique of covering, and yet integrated into the whole as the head, body and limbs of a statue. The stairway, which seems to flow downward from the reading-room into the vestibule [46] shows how the integration is aided by masses as well as by voids. In place of the typical Renaissance symmetry in all directions about a central point, Michelangelo proposed a symmetry on either side of the central axis along which a visitor had to proceed. For the first time in Renaissance architecture, movement was 'built in', since the design of the interior unfolded only as one advanced along a predetermined path. The substitution of an axis for a point as the focus of architectural planning was a necessary preamble to the substitution of dynamic for static design.

Both the biological metaphor and the invocation of movement emerge extravagantly in the fortification drawings of 1528 [53-7]. The bastions are devouring sea monsters calculated to frighten the enemy by their form as well as by their function. Here again, although space is envisaged for the movement more of missiles than of men, the design is generated axially; but where the library provided movement in two directions along one axis, the bastions provide it in one direction – outward – along many.

The concept of axes exploding outward from a central core was inverted in the plan of the Capitoline Hill, where paths from all directions in the surrounding space converge upon the piazza and from there are diverted towards the interior of the Senators' palace [65, 66]. Instead of implying an aggressive expansion of forms, the Campidoglio plan is enclosed and somewhat introverted, suggesting a room more than a building complex. As in the Laurentian library, the full impact of the design is reserved for the observer *inside*, for once within the space he finds his freedom of action and of experience guided into the channels prepared by the architect. As in the library, these channels are complex and calculated to involve the observer psychologically: just as an ascent of the vestibule stairway seems a struggle against a descending cascade, so the crossing of the Capitoline piazza seems challenged by the expanding rays of the central oval.

Michelangelo's desire to control the observer even in the out-of-doors is illustrated in the design of single buildings as well as in large planning projects. The engraving of the Farnese Palace [84] preserves a proposal for integrating the piazza and the façade by means of the pavement pattern, and for drawing the observer into and through the palace, the garden, and across the Tiber, with the result that the stable, cubic mass of Sangallo would have been transformed into another axial, dynamic composition. Even at St Peter's [93], where the environment could not be changed, every attempt was made in forming the building to urge the observer into constant, circulatory motion. It is impossible to believe that Michelangelo planned to build the piazza around the basilica shown in a contemporary fresco based on his model since it would have supplanted the Vatican palace, but he must have had ideas for a square before the basilica that would have drawn the visitor inward. The sense of protective enclosure, of gathering-in, that one gets from the piazza as ultimately designed by Bernini owes much to the planning concepts of Michelangelo.

The indoor quality that passes from the library to the

Conclusion · 277

Campidoglio explains the strange flatness which gives the Porta Pia an effect of temporary ceremonial architecture [123]. The gate is to be seen as the end of the long, corridor-like Via Pia – an ornamental screen marking the transition from a controlled urban space into the open countryside where architecture no longer commands the environment [126]. The Via Pia itself is an application of the axial principle of the Laurentian library to the problems of town planning. Without the benefit of this principle Renaissance urbanism might never have progressed beyond the design of squares.

Seen in this context, Michelangelo's preoccupation with axes in the San Giovanni projects [108, 110, 111] becomes understandable. The drawings resemble those for the fortifications of Florence in that the boldly modelled masses appear to throb with life and the axes of movement - now widened to accommodate a congregation - seem to push outward in a similar way. Even in a centralized building, with its inevitable focus on a point at the centre, Michelangelo found ways of prompting the visitor into action. The same is true of the Sforza chapel; within restricted cubic confines he formed a dominant longitudinal axis, though the transverse axis is equal in length and more compelling in design. This principle is expanded to monumental scale in Santa Maria degli Angeli, where means were found to focus attention on the altar in spite of a colossal transverse vessel. Baroque church and chapel designers were profoundly affected by Michelangelo's success in emphasizing the altar without sacrificing the unity of the centralized scheme.

In architectural as well as literary expression, vocabulary is a major component of style, and nowhere is the cohesiveness of Michelangelo's work more clearly revealed than in the ornamental motifs that he used consistently throughout his life. Half-human, half-animal masks give a frieze (Medici chapel [22]; Farnese Palace [82]) that zoomorphic character found in some of the plans. A related antique motif is the ceremonial bucranium holding swags and banderoles which appears on the sarcophagi of the Medici chapel, the ceiling of the Laurentian library [39] and in the window pediments of St Peter's and the Farnese Palace [82, 103]. One of Michelangelo's favourite devices was a bracket in the form of a volute; from its earliest appearance on the Julius tomb he used it as an expressive rather than a structural element, attracted by the curvilinear and welling profiles so uniquely suited to his purposes. It plays an important role in all the early commissions (particularly the library vestibule [36]), and a variation appears as a transition from the lantern to the cone of St Peter's [94]; at the Porta Pia it is frivolously used to form mock-crenellations [123].

Michelangelo's door and window frames may be classed in two categories: the conservative, in which a simple frame is topped by a triangular or segmental pediment stoutly supported on blocky brackets (San Lorenzo façade [13]; Medici palace windows [32]; library exterior [34]; windows at the Campidoglio and St Peter's [70, 71, 95]; and the destroyed portals of Santa Maria degli Angeli [140]); and the fantastic, in which the component elements either play their normal role in an unexpected way, or are borrowed from some foreign source (tabernacles at the Medici chapel and the library [31, 45]; inner portals of the Conservators' palace [72]; Farnese windows [82]; dormers of St Peter's dome [99]; the Porta Pia [123]). An example of the unexpected is the pilaster narrowed towards the base, as in the library tabernacles and Campidoglio portals; the same design shows the commonest form of borrowing: the transposition of guttae (pegs) from the Doric entablature to the base or crown of an effaced capital. Other motifs that appear more than once in buildings and drawings are the colossal order [8, 66, 94] and the recessed column [36, 72].

Michelangelo's lifelong predilection for certain formal

configurations contributed also to the unity of his work; for example, the symmetrical juxtaposition of diagonal accents in plan and elevation. Often the diagonals form quasi-triangular shapes and serve to focus attention on the apex of a composition, as do the sarcophagi and figures of the Medici chapel [22], which at the same time accentuate the effigies and bind together the strong vertical elements in the architecture. In the fortification drawings [53-7] the expressive potential of diagonal forms is at its height; they demonstrate how vigorous movement may be communicated by the mere inclination of lines. Perhaps this is because diagonal strokes seem to echo more convincingly than horizontals or verticals the spontaneous motion of the draughtsman's hand. Elements of these Florentine schemes are combined at the Campidoglio [66], where the symmetrical diagonal appears both in elevation - the Senators' stairway, a repetition of the Medici chapel scheme - and in plan [65]; at the Cortile del Belvedere the double-ramped stairway was used again to focus attention at the centre of the composition [107]. By using diagonal wall-masses to fuse together the arms of the cross, Michelangelo was able to give St Peter's a unity that earlier designs lacked [88], and the diagonal again is basic to the plans of San Giovanni (axes of the chapels [110, 111]) and of the Sforza chapel [118] (axes of the projecting columns).

Michelangelo's taste for oval forms was equally persistent. The free-standing project for the tomb of Julius II was to have had an oval interior chamber – so far as I know, the first space of its kind proposed in the Renaissance – and the form appears again in the wooden ceiling of the Laurentian library [39] and in the central steps of the vestibule [46]. The oval becomes dominant in the Campidoglio plan [65] and reappears in the chapels of San Giovanni [111] and, in incomplete form, those of the Sforza chapel [119]. Oval ornamental frames appear in versions of the interior design of the domes of St Peter's and San Giovanni [116, 117]. But the figure does its most valuable service in suggesting an unprecedented approach to the design of arches and vaults. Michelangelo designed for the corridors of the Farnese Palace and later for the Sforza chapel vaults halfoval in section [77, 119] to bring about the first major innovation in the form of coverings since Brunelleschi.² One of the earliest and most effective fruits of this contribution was the Ponte Santa Trinita in Florence.

The diagonal and the oval are dynamic transformations of two of the basic forms of classic composition, the upright and the circle.

Michelangelo's architectural vocabulary is one indication of a casual attitude towards antiquity antithetical to Renaissance Humanism. While his contemporaries spoke of emulating and rivalling ancient Rome, he took from it only what suited his taste, rarely adopting a motif without giving it a new form or a new meaning. Yet he invariably retained essential features from ancient models in order to force the observer to recollect the source while enjoying the innovations. By the time Michelangelo turned to architecture, the Renaissance of antiquity was no longer an issue for every artist; it had been achieved, and one might borrow classical forms as readily from some building of the century 1420-1520 as from the ruins. Michelangelo learned from ancient Rome rather its syntax than its vocabulary; ways of using shadow and texture, a sense of scale, and the like. Otherwise he was no more inclined to pagan than to Christian antiquity; in his architecture as in his sculpture. Early Christian and later medieval elements gained equality with the Roman. This was a result of the acceptance of the Renaissance as an accomplished fact; once no medieval institutions survived to challenge the supremacy of Renaissance culture - once, that is, the Middle Ages had become ancient, too - the past could be surveyed

Conclusion · 281

dispassionately, as a continuum.³ The shift from an exclusive to an inclusive historical ethic – from a Renaissance to a 'modern' view of the past – immensely increased the storehouse of tradition to which artists might look for inspiration.

Because Michelangelo emerged so late as an architect, his contemporaries belonged, paradoxically, to an earlier generation: two major architects of the classic age - Bramante and Raphael - had died at the start of Michelangelo's building career; a third, Peruzzi, had already developed a mature style. In the period 1520-50 several able younger men carried individualized versions of Bramante's style to the north (Sanmicheli, Giulio Romano, Jacopo Sansovino), so that Michelangelo was challenged in central Italy only by Antonio da Sangallo the Younger. None of these was touched by Michelangelo's style, which began to exert its influence only after mid-century, when Michelangelo was the sole survivor of the group. Faint signs of his impact may be found first in the later portions of Serlio's treatise and in the early work of Palladio (Palazzo Chiericati, Vicenza, of 1550, which reflects the Conservators' palace). During the fifties and sixties still younger architects formed into two distinct camps of Michelangelo adherents. The Tuscans (Ammanati, Dosio, Vasari, Buontalenti) seemed to learn only from Michelangelo's Florentine buildings; the Romans (Guidetti, del Duca, and especially della Porta) only from those in Rome. The Tuscan branch flourished in the third quarter of the century (e.g. Vasari's Uffizi palace, a free transposition of the library reading-room to the outdoors) but quickly settled down to the simple domesticity of the typical seventeenth-century villa; it was the Roman works that were destined to guide the future - particularly the Campidoglio and St Peter's, which for centuries influenced the planning of squares and the design

of domes. Della Porta deserves a share of the credit, since he finished these buildings effectively by modifying the original designs to suit a less sophisticated and more imitable fashion. Porta showed Roman architects of the seventeenth century how Michelangelism could profit from the master without losing originality. From Rome the style spread in an expanding circle to encompass the western world, penetrating more deeply, however, in Catholic countries than in England and North America, where taste veered towards the more cerebral architecture of Palladio. Yet if Michelangelo had not reluctantly become an architect, the domes of St Paul's in London and of the Washington Capitol could not have been the same, and the Capitol surely would have had another name.

NOTES

INTRODUCTION

1. Heinrich Wölfflin, Die klassische Kunst, Munich, 1899.

2. Il terzo libro di Sebastiano Serlio bolognese, Venice, 1540 (quoted from the edition of Venice, 1584, fol. 64v).

3. On Bramante's revival of Roman vaulting technique, see O. Förster, *Bramante*, Munich, 1956, p. 277f.

CHAPTER 1: MICHELANGELO'S 'THEORY' OF ARCHITECTURE

For a general view of Michelangelo's theories of art, see E. Panofsky, Idea ..., Leipzig and Berlin, 1924, p. 64ff. (English ed., Idea: a Concept in Art Theory, Columbia, S.C., 1968); idem, 'The History of the Theory of Human Proportions as a Reflection of the History of Styles', Meaning in the Visual Arts, N.Y., 1955, esp. pp. 88–107, Harmondsworth, 1970; C. de Tolnay, Werk und Weltbild des Michelangelo, Zürich, 1949, pp. 87– 110 (republished in English, cf. Tolnay, 1964); David Summers, Michelangelo and the Language of Art, Princeton, 1981. Reflections of Michelangelo's theories appear in Vincenzo Danti, Il primo libro del trattato delle perfette proporzioni, Florence, 1567.

1. Lettere, p. 431; Wilde, 1953, p. 109f.; Condivi, ch. LIII.

2. Lettere, p. 554; Schiavo, 1949, Fig. 96 (facsimile). Interpreted by Tolnay, 1949, op. cit. p. 95 and Summers, 1981, pp. 418-46; see also Summers, 1972. Summers proposes a different translation of the passage 'e i mezzi sempre sono liberi come vogliono', rendering it as: 'and the middle parts are always as free as could be'.

3. On fifteenth-century theory, see R. Wittkower, Architectural Principles in the Age of Humanism, London, 1949; H. Saalman, 'Early Renaissance Architectural Theory and Practice in Antonio Filarete's Trattato ...', Art Bulletin, XLI, 1959, p. 89ff.; P. Tigler, Die Architekturtheorie des Filarete, Berlin, 1963; R. Betts, The Architectural Theories of Francesco di Giorgio, Ph.D. Dissertation, Princeton, 1971; M. Kemp, 'From Mimesis to Fantasia: The Quattrocento Vocabulary of Creation, Inspiration and Genius in the Visual Arts', Viator, 8, 1977, pp. 347-98.

4. Vier Bücher von menschlicher Proportion, Nürnberg, 1528. Cf. E. Panofsky, Dürer, Princeton, 1943, p. 200f. Michelangelo's theory of proportion is discussed by Summers, 1981, pp. 380-96.

5. On the development of architectural drawing in the Renaissance,

see W. Lotz, 'The Rendering of the Interior in Architectural Drawings of the Renaissance', *Studies in Italian Renaissance Architecture*, Cambridge, Mass., 1977, pp. 1-65; J. Ackerman, 'Architectural Practice in the Italian Renaissance', *Journal of the Society of Architectural Historians*, XIII, 1954, p. 3ff.

6. See the quotation from Vasari on p. 74.

CHAPTER 3: THE MEDICI CHAPEL

1. C. de Tolnay, 'Studi sulla cappella medicea', L'Arte, V, 1934, p. 5.

CHAPTER 4: THE LIBRARY OF SAN LORENZO

1. e.g., Geoffrey Scott, The Architecture of Humanism, London, 1914.

2. See James F. O'Gorman, The Architecture of the Monastic Library in Italy, 1300-1600, pp. 29ff., 54-7; Isabelle Hyman, Fifteenth Century Florentine Studies: the Palazzo Medici and a Ledger for the Church of San Lorenzo (Distinguished Dissertations in the Fine Arts), New York, 1976; idem, 'Notes and Speculations on San Lorenzo, Palazzo Medici and an Urban Project by Brunelleschi', Journal of the Society of Architectural Historians, XXIV, 1975, pp. 98-120. Hyman shows with new documents that Michelozzo supervised the construction of the Medici Palace and the nave of San Lorenzo simultaneously as a coordinated project.

3. Giuliano's drawing, Uffizi Arch., 1640, is reproduced by G. Marchini, Giuliano da Sangallo, Florence, 1943, pl. II, fig. a.

4. Letter to Vasari in Florence of 28 September 1555 (*Lettere*, p. 548; *Nachlass* I, p. 419f.).

CHAPTER 5: THE FORTIFICATIONS OF FLORENCE

1. On the development of Italian fortifications in the fifteenth and sixteenth centuries, see N. Machiavelli, L'arte della guerra e scritti militare minori, Florence, 1929; A. Guglielmotti, Storia delle fortificazioni nella spiaggia romana ... (Storia della mariana pontificia, V), Rome, 1887; E. Rocchi, Le piante ... di Roma del secolo XVI, Turin and Rome, 1902; idem, Le fonti storiche dell'architettura militare, Rome, 1908; B. Eberhardt, Die Burgen Italiens, Berlin, 1908-18; F.C. Taylor, The Art of War in Italy, Cambridge, 1921; J. W. Wright, The Development of the Bastioned System of Permanent Fortifications, 1500-1800, Washington, D.C., 1946 (mimeographed volume); A.R. Hall, 'Military Technology', A History of Technology, III, Oxford, 1957, pp. 347-76; H. A. de la Croix, 'Military Architecture and the Radial City Plan in Sixteenth-century Italy', Art Bulletin, 42, 1960, pp. 263-80; idem, 'The Literature on Fortification in Renaissance Italy', Technology and Culture, IV, 1963, pp. 30-50; J.R. Hale, in The New Cambridge Modern History, Cambridge, 1958, vol. I, ch. IX; vol. II, ch. XVI; idem, 1958, 'The Development of the Bastion;

284

Notes · 285

an Italian Chronology', Europe in the Late Middle Ages, ed. Hale, Highfield and Smalley, London, 1965; idem, Renaissance Fortification, Art or Engineering?, London, 1977; M. Dezzi Bardeschi, 'Le rocche di Francesco di Giorgio nel ducato di Urbino', Castellum, 8, 1968, pp. 97-140; Simon Pepper, 'The Meaning of the Renaissance Fortress', Architectural Association Quarterly, 5, no. 2, 1973, pp. 21-7; idem, 'Planning Versus Fortification: Antonio da Sangallo's Plan for the Defence of Rome', Architectural Review, 159, March 1976, pp. 162-9; Nicholas Adams, 'Le fortificazion di Baldassare Peruzzi a Siena', Rilievi di fabbriche attribute a Baldassarre Peruzzi, Siena, 1982. On Michelangelo's fortification drawings, see Tolnay, 1940; Scully, 1952; Manetti, 1980.

2. Unterricht der Befestigung, Nürnberg, 1527.

3. On Sanmicheli's fortifications, see E. Langenskiöld, Michele Sanmicheli, Uppsala, 1938, ch. VIII; L. Puppi, Michele Sanmicheli, architetto di Verona, Padua, 1971, pp. 19-41.

4. Delle Fortificationi, Venice, 1597, pp. 140-41.

CHAPTER 6: THE CAPITOLINE HILL

I. A. Graf, Roma nella memoria e nelle immaginazion del medio evo, 2nd ed., Turin, 1923; P. Schramm, Kaiser, Rom u. Renovatio, Leipzig, 1925; F. Schneider, Rom und Romgedanke im Mittelalter, Munich, 1926.

2. On Italian Renaissance urbanism, see G. Giovannoni, Saggi sull' architettura del Rinascimento, Milan, 1935, pp. 265-304; W. Lotz, 'Italienische Plätze des 16 Jahrhunderts', Jhb. der Max-Planck Gesellschaft, 1968, pp. 41-58; L. Benevolo, Storia dell'architettura nel Rinascimento, Bari, 1968; G. Simoncini, Città e società nel Rinascimento, Turin, 1974; E. Guidoni and Angela Marino, Storia dell'urbanistica: il Cinquecento, Bari, 1982; on medieval planning, see W. Braunfels, Mittelalterliche Stadtbaukunst in der Toskana, Berlin, 1953.

3. L. H. Heydenreich, 'Pius II als Bauherr von Pienza', Zeitschrift für Kunstgeschichte, VI, 1937, pp. 105-46; E. Carli, Pienza, la città di Pio II, Rome, 1967; Giancarlo Cataldi, 'Pienza e la sua piazza: nuova ipotesi tipologica di lettura', Studi e documenti di architettura, 7, 1978, pp. 75-115.

4. See E. Lowinsky, 'The Concept of Musical Space in the Renaissance', *Papers of the American Musicological Society Annual Meeting*, 1941, Richmond, 1946, p. 57ff.

5. See J. Ackerman, *The Cortile del Belvedere*, Vatican, 1954, p. 121ff.; and the broader treatment of planning concepts by B. Lowry, 'High Renaissance Architecture', *College Art Journal*, XVII, 1958, p. 115ff.

6. Document published by F. Gregorovius in R. Accad. dei Lincei, cl. di scienze morali etc., Atti, III, 1876-7, p. 314ff. Michelangelo's designs for the Campidoglio have been thoroughly studied in De Angelis d'Ossat and Pietrangeli, 1965, and Thies, 1983.

7. For a general discussion of the oval in Renaissance architecture, see

W. Lotz, 'Die ovalen Kirchenräume des Cinquecento', Rom. Jhb., VII, 1955, p. 9ff.

8. On the iconography of the Capitol, see note 13; H. Sedlmayr, 'Die Area Capitolina des Michelangelo', Jhb. d. preuss. Kunstslg., LII, 1931, p. 176ff.; Siebenhüner, Das Kapitol in Rom. Idee und Gestalt, Munich, 1954, passim; W. Heckscher, Sixtus IV ... Aeneas Insignes Statuas Romano Populo Restituendas Censuit, The Hague, 1955; J. Ackerman, 'Marcus Aurelius on the Capitoline Hill', Renaissance News, X, 1957, p. 69ff.; F. Saxl, 'The Capitol during the Renaissance: A Symbol of the Imperial Idea', Lectures, London, 1957, p. 200ff. My analysis is improved and expanded by Tillman Buddensieg, 'Zum Statuenprogramm in Kapitolsplan Pauls III', Zeitschrift für Kunstgeschichte, 1969, pp. 177-228.

9. Buddensieg, 1969, p. 196ff.

10. Buddensieg, 1969, p. 205f. (Dioscures), 207 (Trophies); G. Borino et al., 'Il trionfo di Marc'Antonio Colonna', Misc. della R. Dep. rom. di storia patria, XII, 1938.

11. I know of this painting through Wolfgang Lotz, who supplied the photograph.

12. This interpretation of the siting was suggested by Richard Krautheimer.

13. 'Beitrage zu den späten architektonischen Projekten Michelangelos', Jhb. d. Preuss. Kunstslg., LI, 1930, p. 25f.; LIII, 1932, p. 245f.

14. K. Lehmann, 'The Dome of Heaven', Art Bulletin, XXVII, 1945, p. Iff., with rich bibliography.

15. Cf. R. Bernheimer, 'Theatrum Mundi', Art Bulletin, XXXVIII, 1956, p. 225ff.

16. Harry Bober kindly supplied the photographs and much information on medieval *schemata*.

17. See note 7 and E. Panofsky, Galileo as a Critic of the Arts, The Hague, 1954, esp. p. 20ff.

18. C. Pietrangeli, 'Lo stemma del commune di Roma', *Capitolium*, XXVII, 1952, p. 41ff., 143ff.; XXVIII, 1953, p. 61.

19. O. Brendel, 'Der Schild des Achilles', Die Antike, XII, 1936, p. 273ff.

20. G. Karo, 'Omphalos', *Dict. des antiquités grecques et romaines*, IV, I, Paris, 1904; J. Fontenrose, *Python*, Berkeley, 1959, p. 374ff., and Fig. 27, a fresco from the House of the Vetii, Pompeii, showing Python on an *omphalos* inscribed with intersecting bands forming lozenges like those of the Capitoline pavement. My attention was first drawn to the relationship of the Zodiac and the *omphalos* by E. R. Goodenough, 'A Jewish-Gnostic Amulet of the Roman Period', *Greek and Byzantine Studies*, I, 1958.

21. B. Gamucci, Le antichità della città di Roma, Venice, 1569, fol. 10^v: 'Il qual colle, nell' accrescimento della città essendo restato come umbilico di quella...'

286

CHAPTER 7: THE FAR NESE PALACE

I. 'Ricordo di Lorenzo di Filippo di Matteo Strozzi' (c. 1500), in Gaye, *Carteggio* ..., I, Florence, 1839, p.354. On palace building in Florence, see R. Goldthwaite, *The Building of Renaissance Florence*, Baltimore, 1980; and in Rome, Frommel, 1973.

2. See S. Meller, 'Zur Entstehungsgeschichte des Kranzgesims am Pal. Farnese in Rom', *Jhb. d. K.-preuss. Kunstslg.*, XXX, 1909, p. 1ff; Frommel, 1981, p. 161.

3. Vasari, I, p. 123.

4. Wolfgang Lotz brought this to my attention.

5. The planning scheme is imaginatively interpreted by Spezzaferro and Tuttle, 1981.

CHAPTER 8: THE BASILICA OF ST PETER

I. Millon and Smyth, 1969, 1975, 1976; Keller, 1976. Hirst, 1974, and Saalman, 1975, believe that Michelangelo adopted the existing attic design at the end of his life.

CHAPTER 9: SAN GIOVANNI DE' FIORENTINI AND THE SFORZA CHAPEL

I. On the Renaissance central-plan tradition and its philosophical overtones, see R. Wittkower, *Architectural Principles in the Age of Humanism*, London, 1949, pp. 1–28.

2. Casa Buonarroti, No. 36A; T. 611; P & Z. 716.

3. Wolfgang Lotz ('Die ovalen Kirchenräume des Cinquecento', *Römische Jhb.*, VII, 1955, p. 20ff., fig. 5) has found a prototype for the chapel design in a study for San Giovanni by Baldassare Peruzzi.

4. For this and other insights into the projects for San Giovanni and the Porta Pia I am indebted to Elizabeth MacDougall.

5. Tolnay believes that in this drawing Michelangelo actually may have projected a font rather than an altar.

6. Vasari, VII, p. 263.

CHAPTER 10: THE PORTA PIA

1. In A. Fulvius, L'antichità di Roma, Venice, 1588, fol. 23.

2. Called 'l'alta semita': see the inscription above.

3. i.e., the Palazzo Venezia. For an earlier project to link this palace with the Quirinal hill, see HB Catalogue, p. 294f.

4. Statues of the Dioscures as horse-trainers stood in a clearing at the peak of the Quirinal hill (see [126]).

5. S. Serlio, Il secondo libro di prospettiva (Tutte l'opere d'Architettura), Venice, 1584, fols. 48-51; cf. R. Krautheimer, 'The Tragic and Comic Scene of the Renaissance', *Gazette des Beaux-Arts*, ser. 6, XXXIII, 1948, p. 327ff. Only the tragic scene has a gate, as Tolnay reminded me.

6. The spirit of the design is vividly captured in two views of the Via Pia by the seventeenth-century Fleming Lieven Cruyl, who pointedly exaggerated the width of the street (Egger, *Römische Veduten*, II, Vienna, 1932, pls. 69, 70).

7. L. von Pastor, Sisto V, creatore della nuova Roma, Rome, 1922; Torqil Magnuson, Rome in the Age of Bernini, I, Stockholm, 1982, pp. 1-37.

8. Uffizi, Arch., 2148, see E. MacDougall, 1960, p. 103, Fig. 13.

9. James S. Ackerman, 'The Tuscan/Rustic Order: A Study in the Metaphorical Language of Architecture', *Journal of the Society of Architectural Historians*, XLII, 1983, pp. 15-34. Marcello Fagiolo, ed., *Natura e artificio*, Rome, 1979.

CHAPTER 11: SANTA MARIA DEGLI ANGELI

I. H. Siebenhüner, 'Santa Maria degli Angeli in Rom', *Münchner Jhb.*, VI, 1955, p. 194f.

2. VII, p. 261: 'con tante belle considerazioni per comodità de' frati Certosini'.

3. Uffizi, Arch. 131, 161, identified with S. M. Angeli by Tolnay, 1930, p. 21; cf. Siebenhüner, 1955, figs. 17, 18. The Bianchini engraving [138] was published by Tolnay, 1930, fig. 10.

4. Particularly Siebenhüner, op. cit., p. 201f.

CHAPTER 12: CONCLUSION

I. There are two brief but excellent essays on Michelangelo's architecture as a whole: D. Frey, *Michelangelo Buonarroti architetto*, Rome, 1923: C. de Tolnay, 'Michelangelo architetto', *Il Cinquecento*, Florence, 1955.

2. These experiments were prepared in studies for the vaults of the Laurentian library, particularly [42], which is an innovation not only in form but in its illumination through windows in the sides and crown of the vault. The vaulting of the triangular room planned for the library [50] would have been equally unconventional.

3. In the 1460s the Florentine sculptor-architect Filarete still called Gothic architecture *moderna* and the Renaissance style *modo antico*. See the fascinating study of Renaissance attitudes towards ancient and medieval art and literature by E. Panofsky, *Renaissance and Renascences in Western Art* (The Gottesman Lectures, Uppsala University, VI), Stockholm, 1960, 2nd ed., New York, 1969.

288

LIST OF ABBREVIATIONS

for use in CATALOGUE and BIBLIOGRAPHY

HBE	Refers to the hardback edition of this text published by A. Zwemmer, Ltd, 1966.
HB Catalogue	Refers to the hardback Catalogue, published separately from above text, first in 1961 with the first edition of the hardback and reprinted
Aufzeichnungen	in 1964. It is this second edition we use. Wolf Maurenbrecher, Die Aufzeichnungen des Michelangelo Buonarroti in Britischen Museum, Leipzig, 1938.
Briefe	Karl Frey, ed., Sammlung ausgewählter Briefe an Michelagniolo Buonarroti, Berlin, 1899.
Carteggio	Giovanni Poggi, Paola Barocchi, Renzo Ris- tori, eds., Il Carteggio di Michelangelo, 2 vols,
Condivi	Florence, 1965-7. Vita di Michelagnolo Buonarroti raccolta per As- canio Condivi de la Ripa Transone, Rome,
Corr.	1553. Ed. P. D'Ancona, Milan, 1928. Gaetano Milanesi, ed., Les correspondants de Michel-Ange, I, Sebastiano del Piombo, Paris,
Dicht.	1890. Karl Frey, ed., Die Dichtungen des Michelag-
Gaye	niolo Buonarroti, Berlin, 1897. Giovanni Gaye, Carteggio inedito d'artisti dei se- coli XIV-XVI, 3 vols, Florence, 1839-40.
Lettere	Gaetano Milanesi, ed., Le lettere di Michelangelo Buonarroti pubblicate coi ricordi ed i contratti ar- tistici, Florence, 1875.
Nachlass	Karl Frey, Der literarische Nachlass Giorgio Va-
P. & Z.	saris, I, Munich, 1923; II, Munich, 1930. Paolo Portoghesi and Bruno Zevi, eds. Mich- elagniolo architetto, Turin, 1964.
Pastor, Geschichte	L. von Pastor, Geschichte der Päpste seit dem Aus-
Т.	gang des Mittelalters, Freiburg i. B., 1885ff. Charles de Tolnay, Corpus dei disegni di Michelangelo, 4 vols, Novara, 1075-80

290 Vasari

Le vite de' più eccellenti pittori, scultori, e architettori, scritte da Giorgio Vasari pittore aretino, Florence, 1568. Ed. Gaetano Milanesi, 9 vols., 1906.

Venturi, Storia

Adolfo Venturi, *Storia dell'arte italiana*, 11 vols., Milan, 1901–48.

CATALOGUE OF MICHELANGELO'S WORKS

Rome, Castel Sant'Angelo, Exterior of the Chapel of Leo X, 1514

This chapel [5], on the north-east end of the Cortile delle Palle overlooking the Tiber, was built under the direction of Antonio da Sangallo the Younger, as we know from an estimate of 10 November 1514 (K. Frey, 1910, p. 34, doc. 19). The Medici arms appear on the interior, and symbols of Leo's patronage on the exterior.

The attribution of the marble front facing the court to Michelangelo, who left Rome in 1516, is not supported by any original drawing yet published. It first appears in the sketchbook of *c*. 1535-40 by Aristotile and Battista da Sangallo in Lille [6] (Musée des Beaux-Arts, No. 733). Battista's inscription reads 'queste in chastello diroma di mano di Michelangelo di traverti(no)'.

The important differences between the façade illustrated here and Battista's drawing (cf. [5] and [6]) have been partly eliminated by a modern restoration (Borgatti, p. 282) based on a late sixteenth-century drawing (Uffizi, *Arch.* 4686; 'Finestre e porte', No. 92) which probably derives from the Lille drawing. Whether the glazed roundels indicated in the drawings were planned or built by Michelangelo is uncertain, since they are ill suited to the proportions of the surviving structure. The overscaled statue niches were designed by Antonio da Sangallo the Younger after 1534 (as indicated by the Farnese *giglio*).

There is no reason to question the attribution to Michelangelo.

Florence, Façade of San Lorenzo, 1515–20

I. HISTORY

In 1513 the Medici family gained their greatest distinction, the election of Cardinal Giovanni de' Medici as Pope Leo X. The family had supported the construction of San Lorenzo since it began in 1420-21, to the design of Brunelleschi, but still the rough masonry of the façade [34] remained exposed inside and out. It is probable that Leo ordered its completion during his visit to Florence late in 1515. Vasari (VII, p. 188) and Condivi (chapter XXXIV) agree that he commanded Michelangelo to take charge of the project, against his will, for he wanted to finish the tomb of Julius II. What happened next is unclear, for Vasari gives three different versions (VII, p. 188; VII, p. 496; IV, p. 47). Apparently the Pope invited designs from other architects, and even held a competition in Rome (VII, p. 188). The invitation to Raphael is confirmed by a letter of Baccio Bandinelli of 1547 (V. Golzio, Raffaello, Vatican City, 1936, p. 36); the Pope also asked Jacopo Sansovino. His subsequent dismissal because Michelangelo wanted to work alone is confirmed by Sansovino's vituperative letter to Michelangelo of June 1517 (Gotti, 1875, I. p. 136), Giuliano da Sangallo's designs (Uffizi, Arch., 276-81) have been identified in an unpublished thesis by Richard Pommer (New York University, 1957). In the autumn of 1516 Michelangelo, in partnership with his weakest rival, Baccio d'Agnolo, intrigued to gain the commission (Carteggio, I, CLXIV, CLXXIII). This intrigue and association with Baccio, nearly a year after the original activity, make sense only if Michelangelo was already involved in the project and wanted to make sure that he would not have to collaborate with anybody whom he could not dominate. No doubt the Pope was being advised that Michelangelo was too inexperienced in architecture to have charge of the project.

From this point the account books and Michelangelo's correspondence with Domenico Buoninsegni clarify the chronology of the design. See the excellent summaries by Tolnay (1934, p. 25ff.; see also 1948, pp. 3-7) and by Paatz (1952, II, p. 527ff.).

Early in October 1516 the Pope agrees to allow Michelangelo and Baccio to do the façade. By December Michelangelo has permission to drop Baccio if necessary. The Pope in Rome accepts his sketch, and he returns to Florence before 22 December to have a model made. In a letter of 2 February 1517 (*Carteggio*, I, CXCV) Michelangelo gets instructions from Rome on the iconography of the statues (4 on the lower level, 4 seated above, 2 at the upper level) for the façade.

Baccio makes the FIRST MODEL from Michelangelo's drawing, completes it on 7 March 1517, but Michelangelo rejects it as 'childish', and says he will make a clay one himself (*Carteggio*, I, CCXI, CCXII). The CLAY MODEL is finished by 2 May, but it is misshapen 'like pastry'. This must be a new design, as Michelangelo's estimate has risen from 25,000 scudi to 35,000 scudi. Baccio has now been dropped, and Michelangelo goes to Florence on 31 August to have executed a SECOND WOOD MODEL with twenty-four wax figures, at the command of the Pope. This is completed in December, and Michelangelo is called to Rome to sign a contract dated 19 January 1518, for the execution of a façade based on the new model.

NEW FOUNDATIONS are planned in January 1517, and completed in December. Michelangelo is living all this time, until 1519, at Carrara, to

supervise quarrying. Two years (1517-19) are wasted by the Pope's insistence that new veins of marble be opened up in Florentine territory rather than at Carrara. On 4 November 1519 work starts on the Medici chapel (Corti and Parronchi, 1965, pp.9, 28). Early in March 1520 Michelangelo complains that the marble cut for the façade is being assigned to other uses (*Carteggio*, II, CDLVIII), and on 10 March the Pope terminates Michelangelo's contract at Carrara.

II. THE DESIGNS

The project on Casa Buon. 45 [8] is called the 'primo disegno' by Aristotile da Sangallo in his copy of it (Lille, Musée des Beaux-Arts, No. 790; Illustrated: T. IV, p. 35). There are several other copies but no surviving original (though T. IV, p. 35 and Tolnay, 1972, p. 57 attributes [8] to Michelangelo and Baccio d'Agnolo). Other preliminary sketches are on Casa Buon. 41v (T. 496; Tolnay, 1972, p. 54, figs. 5-8).

Three related Michelangelo drawings combine the 'primo disegno' motifs with a three-storey elevation. All these, unlike the 'primo disegno', provide room for the ten figures requested by the Pope before 2 February 1517. In [9] (Casa Buon. 91; T. 499; P. & Z. 81)¹ a high mezzanine is introduced between the two orders. [10] (Casa Buon. 44; T. 498, P. & Z. 83) is a rapid sketch in which the curved-top tabernacles of the 'primo disegno' re-enter as pentimenti. In [11] (Casa Buon. 47; T. 500; P. & Z. 84) these conflicting ideas are reconciled into a convincing project.

As [10] contains the start of a letter datable 13-16 January 1517, these three sketches were probably all drawn while Baccio's model was under way. As it is not clear whether the ten-figure scheme referred to in the letter of 2 February 1517 was agreed on at the meeting in Rome in early December or subsequently by letter, it cannot be determined whether Baccio's model was based on the 'primo disegno', or on a lost ten-figure project which the existing sketches modify.

The final design is known from four main sources. An original drawing, Casa Buon. 43 [12] (T. 501; P. & Z. 85) and a copy, Casa Buon. 41r (T. 496; attributed to Michelangelo; Tolnay, 1972, p. 54, fig. 12) show a first version with a divided mezzanine between the lower and upper Order. The wooden model in the Casa Buonarroti [13] has a unified mezzanine. This allows sufficient space for the programme of sculpture ordered in the contract of January 1518 (*Lettere*, pp. 671-2), drawn up according to 'the wood model built with wax figures and

¹ References to other catalogues of drawings such as those of Frey, 1909-11; Dussler, 1959; Barocchi, 1962, 1964; and Hartt, 1971, have been omitted because they are provided in the concordance of the most recent *Corpus* completed by Tolnay in 1980, the most complete for architecture. Illustrations in the volume of Portoghesi and Zevi are cited ('P. & Z.') for the convenience of readers to whom the costly Tolnay volumes are not accessible. made by and for said Michelangelo, which he sent from Florence last December'.

Finally the group of folios in the Archivio Buonarotti with drawings of blocks extracted from the quarries with their measurements, first related to San Lorenzo and published by Tolnay (1954, plates 145ff.), provide sufficient information for a fairly accurate reconstruction of the lower two orders of the final façade design.

The concept of the elevation in the final design is not drastically altered, but it elevates the wings to the height of the central portion, absorbing the independent outer tabernacles and central temple-front motif into a more unified grid. Now, however, the design is not for a veneer façade, but for a narthex, with return façades of one bay. [15] indicates this cursorily. Three plan-and-elevation drawings, the first by Michelangelo himself: Casa Buon. 100 (T. 506; Hirst, 1972; Tolnay, 1972, p. 63, fig. 26); Milan, Bibl. Trivulziana, and Munich Kupferstichkabinett, No. 33258 [15], show the depth of the new structure more clearly. There are several quick sketches of plan details on Casa Buon. 77v (T. 505. P. & Z. 90) and 113 (T. 503; P. & Z. 87, 88). Two planand-elevation drawings after Michelangelo: Munich, Kupferstichkabinett, No. 33258 [15]; Milan, Bibl. Trivulziana, Racc. Bianconi, IV, 35) show the depth of the new structure more clearly. Antonio da Sangallo the Younger also made a drawing of this version (HBE, plate 4c: Uffizi, Arch., 790) which shows the disposition of the free-standing sculpture.

The clay model finished in the first week of May 1517 was probably the first design for the narthex scheme, for after finishing it Michelangelo wrote (*Carteggio*, I, CCXXI) that the cost would increase from 25,000 to 35,000 ducats. This would explain why Michelangelo refused to proceed with the foundations until July, after the model was completed.

The contract with stone cutters at Carrara of 16 August 1517 (*Lettere*, p. 667) is for a seated figure which would fit the lower level of the divided mezzanine. This suggests that the second version, with unified mezzanine, was adopted only in the wood model initiated in the autumn. The second version of the mezzanine seems to be studied in a cross-section by Michelangelo in the British Museum (Wilde, 1953, no. 19v, p. 35; P. & Z. 91).

The wood model, in spite of its lifeless dryness, seems to be the one made by Urbano in the autumn of 1517, on the basis of which the contract dated 19 January 1518 was signed. Its one surviving pedestal block, for one of the twenty-four figures, found by Tolnay, proves that it is not a later copy. But we do know of '*un altro, quasi simile modello* ...*ma più piccolo*'. (See the inscription on Nelli's engraving.) Furthermore, the surviving model disagrees with the contract in one important way: its central bay is wider than the side bays at all levels except in the mezzanine; whereas the contract demands bays of equal width. Further

minor differences appear from a comparison of the block-sketches and the model (as analysed in detail in HB Catalogue, p. 15). Plan 16 is a reconstruction based on the comparison of all sources.

Studies for the Ballatoio of the Cathedral of Florence, c. 1516–20

In 1460 Antonio Manetti, having completed the lantern of Brunelleschi's dome, left unfinished the broad band between the drum and the base of the dome, where a combined gallery and cornice (*ballatoio*) was to be built. In 1507 a competition was held for the design of a facing. Michelangelo, then in Bologna, was asked to submit a model and was sent specifications, but no model of his of this date has survived (Marchini, 1977, p. 37). Baccio d'Agnolo, one of the winning contestants, completed the *ballatoio* on one of the eight sides (unveiled in June 1515).

Michelangelo's objections, on his return from Rome in 1516, caused work to stop (Vasari, V, p. 353). He then made a model, but to this day the *ballatoio* is unfinished.

Michelangelo's preparatory drawing for the model, a rough sketch combining elevation and section, is Casa Buonarroti, 50r (T. 491; P. & Z. 22). A sketch on the verso and two similar drawings have been identified as projects for the elevation of one side of the drum facing (T. 491, 492; P. & Z. 23, 24, 25; cf. Saalman, 1975, pp. 374-80). I am not persuaded by the attribution by Marchini, 1977, p. 41, of model no. 144 of the Museo del Opera del Duomo to Michelangelo on the grounds of its similarity to the sketches.

Florence, Windows of the Medici Palace, c. 1517 [32]

Vasari refers twice (VII, p. 191; VI, p. 557) to 'finestre inginocchiatie' (i.e., supported on 'knees') for the Medici Palace for which Michelangelo made a model of *c*. 1517. Two windows are set into walls built to close the fifteenth-century arches of a loggia at the corner of the palace; a recent study demonstrates that two others were made at the same time, one adjacent to the loggia on the present Via Cavour, and one on the side façade adjacent to the garden (Marchini, 1976, 1976* with new observations on the interior design of these windows).

A drawing (Casa Buon. 101; T. 495; P. and Z. 375) of a similar window appears to be a study for the Medici model.

Florence, the 'Altopascio' House, date uncertain

One of a pair of drawings for a large house [33] (initially a single sheet: Casa Buon. 117, 118; Joannides, 1981, p. 686; T. 586, 587; P. & Z. 379, 380) has the note 'l'alto pascio'. Ugolino Grifoni purchased the site of the present palace in 1549. Tolnay, 1975, no. 199, citing the dissimilarity of this palace from the drawings, suggested without convincing grounds that the latter were for the Casa Buonarroti. Both drawings have dome studies on the verso generally associated with work at St Peter (in the late 40s and 50s), but recently with S. Giovanni de' Fiorentini, 1559 (Joannides, op. cit.). The plans are for a house like those built in Rome by Bramante and his school, with shops on the street, a tiny enclosed garden at the rear, and stairs in the middle. The drawing foreshadows the villa plans of Palladio in its symmetry.

Other sketchier house plans (Casa Buon. 119; T. 588; P. & Z. 381; Casa Buon. 33 and Arch. Buon., vol. XI, fol. 772v (T. 585, 584; P. & Z. 383, 382) may be related to the 'Altopascio' plan. The last of them appears on the verso of a letter of 1518.

Florence, San Lorenzo, The Medici Chapel, 1520-34

I. HISTORY

The death of Lorenzo, Duke of Urbino, in May 1519, closed the dynastic prospects of the Medici family. The Pope and Cardinal Giulio de' Medici abandoned the project for the San Lorenzo façade and proposed instead a family memorial at the church. From the recently discovered ricordanza of Giovan Battista Figiovanni (Corti & Parronchi, 1964; Parronchi, 1968) it appears that the library and the new sacristy with four tombs, for the two 'Magnifici' and the two Dukes, were proposed at the same time, and that demolition on the site began on 4 November 1519. A contract of October 1519 for the supply of the pietra serena membering of the interior indicates that the design had already been determined at this time (Elam, 1979, p. 63; doc. 5). On 1 March 1520 the chapter assigned Figiovanni to supervise construction, described as already under way (Elam, doc. 2). The new sacristy [19 (2)] on the opposite side of the transept from Brunelleschi's sacristy [19 (1)] which served as a model for its design, was a new structure from the ground up. The accuracy of a view of the church by Leonardo, probably of 1502, and of a plan datable c. 1500 discovered by Burns (1979), showing the north transept without a sacristy, is confirmed by Figiovanni, who says that the builders demolished 'dua case della famiglia de' Nelli et delle

mura della chiesa da quella parte dove la sacrestia far si doveva'. The illogical relationship between the interior and exterior design – only partly explained by lighting problems and the abutting Nelli houses – is puzzling (see Elam, p. 171ff.).

On I March 1520 the Chapter allotted funds for the programme and Figiovanni was appointed *provveditore*.

Two sheets in the Archivio Buonarroti (vol. 1, 77, fol. 210v, 211v; T. 178, 179) contain an estimate for stone membering, identified by Wilde (1955, p. 65f.) as referring to the Old Sacristy, and a plan of the chapel by Michelangelo [27], closer to the Old Sacristy than to the final form of the chapel; but with two doodled chapels projecting from the side walls, an impractical fantasy. The estimate must be related to the 1519 contract. On 28 November 1520 Michelangelo sent Cardinal Giulio de' Medici a 'schizo della capella' (Carteggio, CDLXXXIII). The Cardinal approved the architecture, but thought that the free-standing chapel would crowd it. As late as the end of December 1520 a free-standing monument was still being considered (Carteggio, CDLXXXIX).

As early as 20 April 1521, however, the membering of the first order was in progress (*Carteggio*, DVII). A letter of April 1521 reports that the *pietra serena* cornice is being carved (*Carteggio*, DX). During that month Michelangelo was in Carrara to supervise the quarrying of blocks for the tomb figures (*Lettere*, p. 582), which indicates the acceptance of a final design both for the tombs and for the architecture.

The next record of construction is early in 1524, when the lantern was in place (*Lettere*, p. 424), and the cupola ready for stuccoing. The stucco work, which must have been decorative (Michelangelo made a drawing for it: *Briefe*, p. 211), was executed by Giovanni da Udine in 1532-3. According to Vasari (VI, pp. 560f.; and *Corr.*, p. 104) the decoration was not strong enough to make an impression at a distance and ultimately was whitewashed over.

The tombs and marble architecture also progressed slowly. Nothing much was done until early in 1524, when Michelangelo promised to complete the tombs within a year (*Briefe*, p. 221). By June of 1524 the tomb of Lorenzo was far enough advanced to rule out any major alteration in design (*Briefe*, p. 230); its architectural parts are mentioned during the summer and autumn (*Lettere*, p. 596); but the tomb was not completed until June 1526 (*Briefe*, p. 285). The Giuliano tomb was probably executed 1531-3 (Tolnay, 1948, pp. 55f.).

The tomb of the Magnifici was not started until August 1533 (Corr., p. 114). Michelangelo finally returned to Rome in 1534, leaving the statues strewn about the floor of the chapel. Visitors were not admitted until 1545, when Tribolo and Montelupo finished the carving and put them in order (Paatz, 1952, p. 578). In 1559 a sarcophagus for the remains of the Magnifici was assembled from scraps in Michelangelo's studio. Vasari's proposal of 1563 to restore the chapel on the basis of Michelangelo's original project, with four more allegorical statues, eleven frescoes, and stucco reliefs (*Nachlass*, I, pp. 712, 720ff., 737ff., 741f.) came to nothing.

II. THE DESIGN

No architectural study by Michelangelo has survived, except the rapidly sketched plan [27]. There are several drawings for the tombs, both for a free-standing monument in the centre of the chapel and for wall-tombs (compare analyses of Tolnay, 1948, p. 33ff. and Wilde, 1953, p. 47ff; 1955, p. 58ff.). Two studies lead to the final solution for the Ducal tombs (British Museum, 26r [26] [T. 180; P. & Z. 114]; 27r [T. 185; P. & Z. 116]) and two for the Magnifici tomb (British Museum, 28r, v [28]; T. 189; P. & Z. 118, 117).

Both these pairs are drawn precisely to the proportions of their intended architectural framework (see Popp, 1922, p. 125 and plates 5-8 [30]); Michelangelo's insertion of these piers is related to the decision to abandon the elevation of the Old Sacristy and to raise the entire elevation of the chapel, completely altering the proportions and lighting system. Since the piers support the relieving arches over the tomb niches, statics combined with an emerging formal predilection for verticality prompted Michelangelo to abandon the broader wall-tomb design and to substitute the narrower openings. Elam (1979) demonstrated that the change must have occurred before the 1519 contract rather than after the start of construction in 1520, as I had proposed earlier.

Other surviving drawings are of details. Casa Buon. 105 (T. 205; P. & Z. 129) is a sketch of the window in the pendentive zone. Profile studies of the tomb architecture are Casa Buon. 9, 10, 57, 59, 61 (T. 202, 201, 195, 204, 203; P. & Z. 126, 125, 120, 124, 122). Several charcoal studies for details of the tombs were discovered in 1976 on the walls of the altar chapel of the New Sacristy (Dal Poggetto, 1979, pp. 181–95). Dal Poggetto, who discovered them, dates them after the full-scale drawings of the Laurentian library windows on the same wall, documented to April 1525; Caroline Elam (1981, p. 594f.) persuasively proposes that they were done during the previous year or so.

There are sketches relating to the friezes of masks (British Museum, 33r and v [T. 236; P. & Z. 132, 131]; and Windsor Castle Library, 12672r [T. 236 bis]) and to the 'thrones' that surmount the double pilasters of the Ducal tombs – truncated in execution (Casa Buon. 72 [T. 199; P. & Z. 130]). The group is analysed by Tolnay, *Corpus*, pp. 23-49 and Tolnay, 1948, p. 41ff.

III. THE PAPAL TOMBS

In May 1524, Jacopo Salviati persuaded Clement VII that the scheme of

the chapel should be expanded to include tombs for Clement and for Leo X (*Briefe*, pp. 228-88 passim; summarized by Popp, 1922, p. 167ff., etc.). Michelangelo suggested putting the papal monument in 'quello lavamani, dove è la Scala' (Briefe, p. 230), which may be identified as the small sub-sacristy to the left of the chapel choir [19]. In August 1524 blocks for two papal statues were excavated at Carrara (Tolnay, 1948, p. 235) probably for the 'lavamani' site.

Clement, however, advocated a more important location, such as the choir of San Lorenzo (*Briefe*, p. 233, of July 1524); and the question of the site was still not settled in mid-1526 (*Briefe*, p. 284 [June], p. 288, [September]).

Wilde has proposed (1953, p. 75) that the tomb-designs on Ashmolean, 307 (T. 187; P. & Z. 119) and Casa Buon. 52 (T. 188) are for the 'lavamani' site. A group of drawings may be associated with the proposal for tombs in the choir of San Lorenzo: Casa Buon. 128 (T. 279; P. & Z. 387) and 46 (T. 277; P. & Z. 386). British Museum, 39 (T. 192; P. & Z. 384); Arch. Buon. V, 38, fol. 213 (T. 278); also perhaps British Museum, 38 (T. 561) and Oxford, Ashmolean, 308 (T. 191; P. & Z. 385, 388). A few quick sketches on the walls of the altar chapel appear to be related to the papal tombs but are of little importance for the design history (Dal Poggetto, 1979, pp. 192-5; Elam, 1981, p. 594).

Florence, San Lorenzo, Reliquary Tribune, 1531-2

On 14 October 1525, Michelangelo was instructed by Pope Clement VII to design a ciborium in the choir of San Lorenzo for the storage and exhibition of the relics of the church (*Briefe*, p. 260; further instructions, pp. 262, 265). Michelangelo preferred a reliquary tribune or balcony constructed over the entrance portal on the inner side of the façade (HBE pl. 14c; for bibliography, see Paatz, 1952, II, p. 538n). On 4 February 1526 drawings for both arrived in Rome.

Drawings:

I. Casa Buon. 76r (T. 285; P. & Z. 391) is a measured plan of the central chapel showing the rectangular ciborium covering the altar. The sheet contains an unrelated *ricordo* dated 8 February 1525 (= 1526).

Detail studies on the verso relate to the tribune project.

2. Oxford, Ashmolean, 311 [14]; T. 260; P. & Z. 392. Horizontal section through the centre of the church façade at the level of the tribune platform. The design, probably that accepted in autumn 1531, differs from the final solution in the placing of the lateral doorways in the tribune (which dates it before Figiovanni's letter of 19 October 1532).

The Tribune was executed during Michelangelo's absence in Rome, and has none of the quality of his work.

Florence, the Library of San Lorenzo, 1523-59

I. HISTORY

The history of the design and construction of the Laurentian library [34, 19 (3-4)] may be reconstructed in detail, chiefly through Michelangelo's correspondence with his agent at the Vatican, Giovanfrancesco Fattucci (in 1523-6) and, after a long period of inactivity during which Michelangelo moved permanently to Rome, with the executors of his design in Florence (1550-59). Wittkower's exemplary study of the library (1934) is superseded in only one detail by the discovery of the *ricordanze* of Figiovanni, which states that library and sacristy were projected together in 1519 (Corti & Parronchi, 1964, p. 27). Michelangelo was not, however, apparently commissioned to design a library for the Medici family collection until 10 December 1523 by the newly-elected Clement VII (*Briefe*, p. 198).

The main events thereafter are as follows:

1524

- March The present site on the upper storey of the west range of the cloister of San Lorenzo selected, after two others had been rejected (cf. Wittkower, 1934, p. 218).
- 13 May Structural solution approved, a system of interior and exterior buttresses that does not interfere with the priests' quarters below (*Briefe*, p. 227; Wittkower, 1934, p. 216f.).
- 9, 21 July Approval given to start foundations; estimates requested (Briefe, p. 232f.).
- August/September Baccio Bigio appointed to direct construction (Briefe, p. 236).

Winter Work on substructure.

- 3 April Entries in Michelangelo's account-books for raising the long walls and carving their exterior window frames (Lettere, p. 597; cf. Gronau, 1911, p. 70ff.).
- 12 April Chapel at end of library to be redesigned as a rare book room. Vestibule stairway to be a single flight (*Briefe*, p. 250).
- 23 December Michelangelo's proposal to light the vestibule by raising the side walls two braccia approved (Briefe, p. 270).

17 June Five of the vestibule columns in place (Lettere, p. 453, misdated April).

July-November Repeated instructions to cut down on expenses, in favour of work on the chapel (Briefe, p. 286f, Lettere, p. 454f.).

1533

August The Pope permits Michelangelo to leave Florence for Rome providing he arranges for completion of decorative work and the stairway (Gotti, I, p. 225); twelve carpenters are at work before Clement dies in September 1534 (Corti & Parronchi, 1964, pp. 12, 30), and five masons contract to build the vestibule stairway and doors, but leave everything unfinished except one of the latter (*Lettere*, p. 707; Wittkower, 1934, pp. 167, 186-95).

1549-50

Probable date of execution of reading-room ceiling, and floor redesigned with emblems of Cosimo I (Vasari, VII, p. 203; Wittkower, 1934, p. 196ff.).

1558-9

Ammanati commissioned by Cosimo I to execute the staircase. Michelangelo sends a model and instructions from Rome; the work is finished in February.

1568

Date painted on reading-room windows.

1571

Date of inscription over entrance door.

In modern times the vestibule façade has been given upper row of windows [34], the articulation on the upper level inside the vestibule completed, and a circular reading-room added south of library (see Wittkower, pp. 123ff., 200ff.).

II. DRAWINGS

There are over thirty original sheets of drawings for the Laurentian library, and many others are referred to in the correspondence. Lost projects or drawings are indicated in the following catalogue by numbers in parentheses.

- I. The Site Plan: January-February 1524
 - (1). 2 January Plan with separate rooms for Latin and Greek books and separate vestibule (Briefe, p. 204).
 - 2. Casa Buon. 10V; T. 201; P. & Z. 197. Site plan with the library on the S. side of the main cloister (cf. Briefe, p. 209).
 - 3. Casa Buon. 9V; T. 202; P. & Z. 198. Sketch of cloister showing library on E. side, orientated E.-W. Nos. 2 and 3 were drawn on the same sheet and later separated.
 - 4. Casa Buon. 81; T. 543; P. & Z. 196. Sketch showing ownership of property before the church.
 - 5. Arch. Buon. vol. I, 160, fol. 286; T. 545 (Tolnay, 1954, pl. 194). Study for the buttress-system.

II. Designs for the Reading-Room and Rare Book Room, 1524-33

- (1). 10 March 1524 The Pope requests rare book studies at four corners of the reading-room, and a sketch of the ceiling (Briefe, p. 221).
- (2). 13 April Michelangelo's plan for a reading-room with a crociera

 i.e. a wing at right-angles, where modern rotunda appears in
 [34] (Briefe, p. 224).
- (3). April-May Studies of the support system (Briefe, p. 226f.).
 - 4. Casa Buon. 42 [38]; T. 541; P. & Z. 199. Interior elevation of the reading-room, prior to the solution of the support system in the spring of 1524.
 - 5. Casa Buon. 96r, v; T. 551; P. & Z. 201, 235. Recto: framing elements related to No. 4. Verso: scale drawing of the door. Probably early 1524.
- (6). Sketch for an 'unusual ceiling' with 'small figures', as requested by the Pope (*Briefe*, p. 224).
 - 7. Casa Buon. 126 [39]; T. 542; P. & Z. 203. Study for one bay of the ceiling, alternative to (6).
 - 8. Oxford, Ashmolean 308v; T. 191; P. & Z. 204. Rapid sketch of the ceiling scheme, suggesting same proportions as in the final solution. Summer, 1524.
- (9). July 1524 The Pope agrees to 'quella agiunta che viene in testa della libreria' (Briefe, p. 234f.). This may be the chapel of No. 10.
- 10. Casa Buon. 89r; T. 524; P. & Z. 211. Plan at upper left is probably for chapel with oval dome. Chapel cancelled in April 1525, but the drawing may be as much as a year earlier.
- (11). April 1525 Final (?) sketches for interior tabernacles and windows are sent to Rome (Briefe, p. 250). Among the mural drawings discovered in 1979 in the altar chapel of the New Sacristy are two full-scale drawings – ruled, but with freehand corrections made on the cornice profiles – for the interior and exterior

elevations of the Laurentian library windows; they evidently were models from which the stone carvers could make templates to guide the carving of the mouldings (Dal Poggetto, 1979, pp. 168-79; Elam, 1981, p. 593ff.). The same series includes sketches of an edicola, portals or tabernacles, and profiles.

- 12, 13. Casa Buon. 79, 80 [50]; T. 559, 560; P. & Z. 205, 206. Alternative plans for a triangular book study in place of chapel at S. end of reading-room, as requested in April and accepted in November 1525 (*Briefe*, p. 265).
 - (14). April 1526 The Pope asks for revised seating with consequent revision of floor and ceiling design (Briefe, p. 279). Not done.
- 15, 16. Casa Buon. 94; T. 558; Arch. Buon, vol. I, 80, fol. 218; T. 556;
 P. & Z. 229, 230. Sketches of uncertain date for the reading desks.
 - 17. British Museum 37r, v; T. 554; P. & Z. 231, 233. Frames for the main door of the reading-room, both sides; final drawings approved in April, returned in June 1526 (*Briefe*, pp. 279, 280, 284e).
- 18, 19, 20. Casa Buon. III, 98, 53; T. 555, 550, 534; P. & Z. 234, 232, 236, 237. Scale drawings for No. 17r, and v, and moulding profiles respectively, all probably by an assistant. Contract for the carving signed in 1533.
 - 21. Casa Buon. 95; T. 549; P. & Z. 240. Scale drawing of the exterior entrance door to the vestibule. This door was partially carved, but not erected, in 1533.
- III. Designs for the Vestibule and Staircase
 - (1). March 1524 First plan for the present site.
 - (2). 29 April 1524 Stairway of two flights approved (Briefe, p. 226).
 - 3. Arch. Buon., vol. I, 80, fol. 219, pp. 3, 4; T. 523; P. & Z. 208. A sketchy vestibule plan with two flights of stairs.
 - 4. Haarlem, Teyler Museum 33V [41]; T. 218; P. & Z. 209. An early elevation of the W. wall of the vestibule, attempting to carry through a version of the final reading-room elevation into the vestibule. This solution was quickly abandoned.
 - 5. Casa Buon. 89v; T. 524; P. & Z. 210. Possibly for the tombprojects referred to on p. 311; but probably a sketch for a four-bay elevation of the vestibule, which proved intractable (Wittkower, p. 153f.).
 - 6. Casa Buon. 897 [47]; T. 524; P. & Z. 211. Plan of the vestibule (lower centre), with corner piers to support a vault, i.e. drawn earlier than summer 1524, when the supports were started. The shortened wall flights of steps in this plan recur, however, in No. 12 of 1525.

- (7). 12 April 1525 The Pope agrees to a single, central flight of stairs and requests that a small triangular study for precious books be designed for the end of the reading-room in place of the chapel originally proposed (*Carteggio*, DCXCV; *Briefe*, p. 270).
 - 8. Casa Buon. 48r [42]; T. 527; P. & Z. 212. Elevation of the W. wall of the vestibule, datable between Nos. 7 and 10, showing a vault, and total height not greater than the reading room.
 - 9. Casa Buon. 48v; T. 527; P. & Z. 216. A quickly sketched tabernacle with flanking pilasters, related to the recto, No. 8.
- (November) 1525 Vault abandoned. Michelangelo's suggestion of overhead windows under roof skylights rejected (*Briefe*, p. 268). It is agreed that walls should be raised by 2 *braccia* to allow wall windows (*Briefe*, p. 270). Eventually the walls are raised higher still (see [37, 44] and Wittkower, p. 123ff., Figs. 2, 3).
- 11, 12. Casa Buon. 92r and v [48, 49]; T. 525; P. & Z. 213, 214. Sketches for the staircase and for base mouldings, drawn shortly after No. 7: April 1525?
- 13, 14. British Museum 36r [43] and v; T. 528; P. & Z. 215, 221. The recto [43] has a careful study of the base and lower part of the main storey of the vestibule, in transition from No. 8 to the final project; done over earlier jottings, including a wall section close to No. 8. On the verso, mouldings, cf. Nos. 11 and 12. Last quarter of 1525?
 - 15. Casa Buon. 39r and v; T. 553; P. & Z. 217, 218. Two sketches for windows in the clerestory, close to the final scheme. Since the present windows may not be Michelangelo's, No. 15 could be nearer to his intentions. Dated 1525/6 by Tolnay; 1532/3 by Wilde, 1953, p. 93. Cf. No. 16.
 - Casa Buon. 37r and v; T. 226; P. & Z. 219, 227. Recto: clerestory window, door pediment; verso: pedestal of the stair railing? Dating as No. 15.
- 17-19. Uffizi, Arch., 816, 817, 1464. Copies by Antonio da Sangallo the Younger of alternative designs for a free-standing stairway – variants of [48]. (See Wittkower, p. 161ff.)
 - (20). Final vestibule scheme, accepted in February, partly executed in June 1526.
 - (21). A clay model of the stairs by Michelangelo serves as the basis of the contract of August 1533. The lower seven steps designed with '*rivolte*' (see Wittkower's deductions, p. 175ff.) probably were used in the existing stairway.
 - 22. Cod. Vat. 3211, fol. 87v; T. 526; P. & Z. 228. A rough sketch illustrating Michelangelo's letter of 26 September 1555 to Vasari (*Lettere*, pp. 312, 548, misdated), showing the stairs in a front and a side elevation approaching the final solution.
 - 23. Lille, Musée des Beaux-Arts No. 94v (T. 595; Tolnay, 1960,

Catalogue No. 247). Another quick sketch for the scheme, in Autumn 1555?

(24). December 1558 Michelangelo executes a second clay model for the stairway, used by Ammanati as a guide in building the existing stairway (Lettere, pp. 344, 348f.).

Florence, Sant'Appollonia, Portal, c. 1525-35

I originally rejected the attribution of this work (made by Tolnay, 1967, p. 66 and pl. 22, 2 and 3 on the basis of an inscription assigning it to Michelangelo on an anonymous undated drawing of the later sixteenth century in the Metropolitan Museum, in sketchbook no. 49.92) on the grounds that there was no support for it in contemporary documents and that the style appeared too brittle for Michelangelo and closer to that of his follower Giovannantonio Dosio, who made several drawings of it (Uffizi, Arch. 3018, 3019; Davis, 1975, figs. 9, 11, 12). Such support has now been provided by Charles Davis (1975, p. 264ff.) from a dialogue by Cosimo Bartoli, Ragionamenti accademici, published in Venice in 1567, which discusses the architectural fantasy of Michelangelo and compares the portal to those of the vestibule of the Laurentian library. Davis demonstrates on internal evidence that Bartoli's text was composed in 1550-51. He suggests that parallels with the portals of the San Lorenzo library and indications that the dialogue is set in the early 1530s iustify dating the design of the portal in the decade following 1525.

Fortifications of Florence, 1528-9

I. HISTORY

In 1526 the Medici Pope, Clement VII, commissioned Antonio da Sangallo and Niccolò Machiavelli to report on the defensive perimeter of Florence, and the following year the tall medieval towers [51], believed to be ineffectual against artillery, were levelled to the height of the walls. In May 1527 the populace overthrew the Medici rule, establishing a republican government. Early in 1529, Clement enlisted the help of the Imperial forces to regain the city by conquest (see Cecil Roth, *The Last Florentine Republic*, London, 1925). Michelangelo was appointed to a committee, established in January 1529, to complete the fortifications begun by the Medici in 1526, and on 6 April he was made Governor-General and Procurator of Fortifications (*Lettere*, p. 701; Tolnay, 1948, p. 10f.). Already in September 1528, he had been engaged in the im-

provement of the defences; and throughout the war, except for the brief period of his desertion in September 1529 and flight to Venice, he devoted his entire energy to the fortifications (Manetti, 1980, *passim*).

Contemporary accounts agree that Michelangelo was occupied mainly with the hill of San Miniato (Varchi, bk X, p. 146; and an anonymous report in Gotti, I, p. 183). Construction was under way in April 1529. The San Miniato defences were experimental in design, with a 'cavaliere' protected by systems of bastions and curtain walls, all placed 'marvellously' according to the nature of the terrain. The construction was of packed earth mixed with straw and revetments of unbaked bricks. After 1534 the Medici had Antonio and Bastiano da Sangallo replace them in masonry. Manetti (1980, p. 126ff.; fig. 33) has published an autograph plan by the Sangallos (Uffizi, Arch. 757) which he believes registers Michelangelo's earthworks along with their proposed changes.

II. DRAWINGS

Michelangelo's surviving drawings for the fortifications of 1528-30 are preserved in the Casa Buonarroti. They were classified and analysed first by Tolnay (1940, p. 131ff.). Their dynamic formal character has been discussed by Scully (1952, p. 38ff.).

All the drawings are studies for bastions at the city gates and angles of the medieval walls [51]: none is for San Miniato. Tolnay located some of the projects.

I. Identified Drawings

A. Bastion for the angle at Prato d'Ognissanti, at the western limit of Florence on the city side of the Arno, the site which required the most elaborate fortification.

a. Cancroid Trace

Four groups of studies (Casa Buon. 17, 17v, 16, 16v; T. 579, 582; P. & Z. 406, 407, 405) for a final, pen-and-wash drawing (Casa Buon. 15 [55]; T. 581; P. & Z. 404). No. 17v has a *ricordo* of a loan dated 1528.

b. Stellate Trace

Two groups of studies (Casa Buon. 30, 13V; T. 580, 583; P. & Z. 408, 412) for a final, pen-and-wash drawing (Casa Buon. 13r [56]; T. 583; P. & Z. 411).

B. Bastion of the Porta al Prato, the city gate immediately to the north of the above angle. The gate is identified on Casa Buon. 14.

Two groups of studies (Casa Buon. 20, 20v; T. 578; P. & Z. 413, 415) for a final, pen-and-wash drawing (Casa Buon. 14 [53]; T. 577; P. & Z. 414). Casa Buon. 14 has a *ricordo* of July 1528, on the verso.

C. Bastion for the Porta alla Giustizia, the easternmost gate on the north bank of the Arno, just across the river from the Colle San Miniato.

One study (Casa Buon. 19; T. 576; P. & Z. 403) identified 'la porta alla iustitia'.

D. A sketch (Casa Buon. IIr; T. 563; P. & Z. 394) of the existing medieval wall 'dalla torre del maricolo insino al bastione di San Piero Gattolino' (the present Porta Romana, the southernmost city gate).

II. Unidentified Drawings

A. Bastion for a gate in a straight stretch of city wall.

Casa Buon. 24 and 22r; T. 573, 574; P. & Z. 399, 400, are crustacean schemes with three claw-like salients on either side of the bastion. The trace is simplified in Casa Buon. 21, 23 and 18; T. 570, 569, 568; P. & Z. 396, 395, 398.

B. Bastion for other gates.

Casa Buon. 22v and 25 (finished drawing) [54]; T. 574, 572; P. & Z. 397, 402, have fantastic claw-like salients. Casa Buon. 26 and 18; T. 571, 566; P. & Z. 402, 401, have simpler, straight-flanked traces.

C. Later drawings for gate bastions.

Casa Buon. 27V, 27 [57]; T. 567; P. & Z. 418, 419. Similar schemes for a towered gate. Ravelins (outworks) appear for the first time. (A separate study for ravelins in Casa Buon. 29; T. 566; P. & Z. 420.) Casa Buon. 28, 28V; T. 564; P. & Z. 409, 410. The recto is related to the Porta al Prato. These are the only drawings in the series in which no curve is employed, and No. 28 is militarily the most practical of them all.

D. Unidentified.

Arch. Buon. I, 78, 213v (T. 575). Quick sketch of a segment of the fortification walls.

The studies are for permanent fortifications in masonry, as the wash technique – used also to identify medieval masonry – shows. Earthworks planned are not shown in wash, but are labelled 'terra'. Such complex forms and fine details could anyway not be constructed except in masonry. Extensive permanent fortifications could not have been contemplated after the start of the war early in 1529. Varchi mentioned masonry only once. Probably then Michelangelo's drawings were made in 1528 when he was a consultant on fortifications. The two *ricordi* of 1528 jotted on the drawings support this assumption.

Rome, Piazza and Palaces of the Capitoline Hill, 1538

Throughout the Middle Ages the Capitoline Hill had served as the focus of the political life of Rome. A Senate house (here called Senatore) was

built in the twelfth century, on the ruins of the ancient Tabularium, and enlarged in 1299-1303 and 1348, on the model of North Italian communal palaces, and given an interior court, projecting corner towers, and a high campanile [62]. On the history of the hill, see Siebenhüner 1954.

A second palace was started c. 1400 on the south border of the plateau; it was intended to house the *bandieri*, who kept the banners of the several *rioni* of Rome, and offices of the major guilds and of the Conservatori. This palace was remodelled in the mid fifteenth century ([61], right).

The haphazard and ragged condition of the two palaces can be seen in [61]. In the late 1530s Pope Paul III took the initiative in planning a programme of rehabilitation.

I. HISTORY, THE MID SIXTEENTH CENTURY

1535

December Temporary programme 'ornare la piazza de Campidoglio' in view of the visit of the Emperor Charles V in April 1536 (Hess, 1961, p. 250). Nothing done.

1537

Autumn A decision taken by the representative council of the city to restore the Conservatori. Nothing done. (Lanciani, 1902, II, p. 68f.; Pecchiai, 1950, p. 36f.)

Paul III proposes to move the bronze equestrian statue of Marcus Aurelius from its site before the Lateran Basilica to the Campidoglio. Michelangelo objects to the project (Gronau, Jhb. pr. Kunstslg., 1906, Beiheft, p. 9). Reference made to a person 'chi ha cura di farvi la nuova basa'.

1538

January The statue is moved to the newly levelled piazza of the Campidoglio (Pastor, Geschichte, V, p. 755; cf. Künzle, 1961). The inscription on the side of the base of the statue is dated 1538 (Künzle, 1961, p. 268, fig. 195); shortly after, the statue was sketched by Francisco d'Ollanda [68], who omitted the date.

1539

22 March 320 scudi set aside to be spent 'partim in reformatione statue M. Antonii in platea Capitolii existentis secundum iudicium d. Michaelis Angeli sculptoris et partim circa muros fiendos in dicta platea.' (Lanciani, II, p. 69). Probably the 'muros' are the retaining walls below Santa Maria in Aracoeli [63].

8 July Supervisor cited for deficiencies in the construction of the apartments within the Senatore.

1544-54

Account books kept by Prospero Boccapaduli (published by Pecchiai, 1950) record payments for work done in this decade. (N.B. Payments may be for work done some time earlier.)

1544

3 March Accounts for work on the three-bay loggia (not by Michelangelo) at the head of the steps leading to the transept of the Aracoeli [63].

1547

12 October Estimate of work done on the Senatore to remove the medieval loggia [62], rebuild the tower at the right corner, and construct the stairway. [64] shows the tower as projecting substantially forward from the medieval tower behind, but incomplete. This drawing and [63] show the old tower on the left unchanged, though foundations for its new sheathing must have been laid together with the stairway foundations. Michelangelo's design was followed up to the level of the stairway platform and abandoned after 1550 (Thies, 1982, pp. 135-49).

c. 1550

Accounts for 'primo fondamento del muro che fa parapetto della scala verso la consolazione' (west side, towards the church of Santa Maria della Consolazione); 'pezo di muro che farrà parapetto alla loggia' (possibly the base for the baldachin intended for the top of the stairway [66, 67]; the base exists, but the superstructure was abandoned along with Michelangelo's project for the second and third storeys); 'cornizia del pilamidone' (cornice over the central pilasters).

1552

21 May Last payments for carving on the Senatore steps. Payments for balusters and for moving and mounting the second River-god.

1553

8 November Accounts for work on the southern three-bay loggia.

1554

25 April Estimate of the completed central doorway of the Senatore. The doorway was remodelled in the 1590s (De Angelis d'Ossat and Pietrangeli, 1965, p. 75).

17 August Payment for remodelling the balcony cantilevered from the third storey of the palace.

1555-9

Construction virtually halted.

1561

- 30 April Payment for the front balustrade of the piazza (Tolnay, 1930, doc. 2).
- 30 July Payments for the three oval steps in the piazza and for travertine platforms at the foot of the Senatore stairway and at the summit of the *cordonata*; final payment 24 April 1564 (Tolnay, docs. 2, 17).
- 15 October Pius IV demands that the building be begun and that the cordonata be finished (Tolnay, doc. 5; Pecchiai, pp. 44f., 221).

- 1 February Payments for walls and roofing of the Senatore and for work on the two corner towers and the bell tower. The fee is estimated by Giacomo della Porta, who appears now for the first time. This work completed before April 1564.
- After 11 March orders given to shore up the old façade of the Conservatori and strip off the decorative membering and roofing (Pecchiai, p. 123).
- 8 June Foundations for the first pier of the portico of the Conservatori, on the right, western, end (Pecchiai, p. 123f.).
- 26 July Payment to Guidetto Guidetti 'quale si è preso per eseguire li ordini di M. Michelangelo Buonarruoto in la fabrica di Campidoglio' (Tolnay, doc. 12; Pecchiai, p. 230).

- 24 April Payment for walls of 'the parapets under the balusters' of the *cordonata* (Tolnay, doc. 15); and (5 June) for removing earth on either side of the ramp since April 1562 (*ibid.*, doc. 19; Pecchiai, p. 43).
- 26 April Payments for raising the statue of Marcus Aurelius for the masonry foundation under it (Pecchiai, p. 46f.), in order to strengthen the foundation (Thies, 1982, p. 151) and to raise it to the height demanded by the domical form of Michelangelo's central oval. The payments of the early 1560s for the remodelling of the base of the statue (Künzle, 1961, p. 263n.) should probably be assigned to this campaign.
- Payments for foundations and walls at the right corner of the Conservatori 'sino al piano del primo cornicione' (i.e., up to the top of the ground floor portico; Tolnay, doc. 18; Pecchiai, p. 123).
- 31 October Payment for travertine facing of the Conservatori and the first two pilasters (Tolnay, doc. 20).

¹⁵⁶⁴

12 December Della Porta first recorded as completely in charge. On 24 August 1565 he was paid for a wooden model for the cornice and a pilaster capital of the Conservatori. The two western bays of the Conservatori were probably completed early in 1565, at least to the height of the entablature (cf. the drawing published by Siebenhüner, fig. 50).

II. HISTORY: POST-MICHELANGELO

Only those elements of the Campidoglio that had been begun by 1564-5 followed Michelangelo's design.

Palazzo de' Conservatori

Della Porta was paid in 1568 for the design of the central window. The exterior was finally completed in 1584. The interior court was constructed between 1570 and 1587.

A second bay was added to the short western front c. 1660.

Palazzo del Senatore

The remodelling of the Salone on the piano nobile into a great twostoreyed vaulted hall was begun in 1573-4. Prior to this, perhaps in the later 60s or early 70s, an interim design was initiated as recorded in a drawing attributed to Dupérac in Berlin, KdZ, 16,798 (Winner, 1967, no. 3, pl. 2). The final construction by Giacomo della Porta involved radical alteration to Michelangelo's façade design, reducing the upper windows to small rectangles. The façade was complete only in the 1500s.

In 1577, the palace Campanile was destroyed by lightning. In June 1578 a model and design for a new tower by Martino Longhi were discussed. The tower, which departed from Michelangelo's design, was completed in November 1583.

Michelangelo's design was further compromised in 1588-9, when a fountain designed in competition by Matteo da Città di Castello was built about the base of the triangular stairway [60]. In 1592 the central niche received the seated statue of Minerva as *Roma*.

The Cordonata and Piazza

The area at the foot of the *cordonata* was enlarged in 1576 and lowered in 1577, to extend the ramp beyond the entrance to the Aracoeli steps. Della Porta's *cordonata* design of September 1578, gradually diminishing the width of the ramp towards the base, seems to have followed Michelangelo in other respects.

The Dioscures were mounted by the top of the ramp in 1585 and 1590.

The present paving of the piazza was laid in 1940.

The Palazzo Nuovo

The third palace planned for this site by Michelangelo [66] was founded in June 1603, but not completed until the 1650s or 1660s.

III. MICHELANGELO'S DESIGN

1. The Engravings

1. Plan [65] published by B. Faleti; dated 1567.

2. Perspective from the west by Dupérac, dated October 1568 (De Angelis d'Ossat and Pietrangeli, 1965, fig. 24).

3. Emendation of No. 2 by Dupérac, dated 1569 [66].

4. Elevation of the right side of the Conservatori [71] published by Faleti, dated 1568. Based on the building rather than on Michelangelo's design.

Vasari's description in 1568 (VII, p. 222f.) adds some minor points: the Senatore façade was intended to be built of travertine; a statue of Jupiter was to occupy the central niche of the double-ramped stairway; the balustrade of the *cordonata* as well as that of the piazza was to support the statues already on the Campidoglio.

2. Drawings by Michelangelo, possibly for the Campidoglio

I. Oxford, Ashmolean 332v (T. 605; P. & Z. 422), contains plans and elevations of a corridor with encased paired columns on the exterior and the note 'porta' on one of the interior openings. Tolnay interprets the sheet as a group of studies for the ground floor portico of the Conservatori and for an interior elevation of the drum and base of the dome of St Peter. On the recto is a design apparently for the niche on the first landing of the grand staircase of the Conservatori (De Angelis d'Ossat and Pietrangeli, 1965, p. 106ff.).

2. Oxford, Ashmolean 333v (T. 589; P. & Z. 423) contains the elevation of a palace façade with a colossal order embracing arched apertures on the lower storey. The system is closest to the Campidoglio palaces, but no connection can be verified. The recto contains overlaid window designs; beneath a design for the windows of the upper storey of the Farnese court is a simpler one, apparently intended for the Conservatori façade (Hedberg, 1972, p. 64, fig. 3).

3. Casa Buon. 19 F (T. 368; P. & Z. 424) contains a roughly sketched

elevation of a double-ramped stairway which has been associated both with the Senatore and the Belvedere.

De Angelis d'Ossat and Pietrangeli (1965, p. 74, fig. 45) have associated Casa Buon. 58 (T. 494; P. & Z. 780) with the tabernacle planned for the Senatore steps, a possible but not probable relationship.

The Date of the Designs

When Michelangelo designed an oval base for the Marcus Aurelius statue in 1538, placed it more or less in its present position, and erected a retaining wall on the north side of the plaza [63, 64], he must already have worked out the definitive overall plan with an oval within a trapezoid [65].

Michelangelo may have planned the three-arched loggias at the summit of the lateral steps [63], but they were designed and executed by a minor architect.

Inconsistencies between the engravings suggest that the elevations were not fully recorded at the time of Michelangelo's death. In style however the design is wholly foreign to Michelangelo's late manner, but suitable in every respect to a period preceding St Peter's and the Farnese palace. Details of the Conservatori façade are closely related to details of the apse of St Peter's. Furthermore the structural system of the Conservatori, in which the loads are borne by broad piers into which pilasters are carved, is repeated on St Peter's but with a purely expressive function, independent of the structure. Thus it seems likely that the façade was worked out essentially before 1546, though certain details may have remained unsolved at Michelangelo's death. 1538-9 is the most probable date, since there is no reason to suppose that the plan and elevation were not contemporaneous.

Rome, Farnese Palace, 1546

Antonio da Sangallo the Younger began to build a palace near the Campo di Fiori for Cardinal Alessandro Farnese in 1515. After the Cardinal's election to the Pontificate as Paul III in 1534, Antonio revised the design, 'seeing that he had to make no longer a cardinal's but a pontiff's palace' (Vasari, V, p. 469).

SANGALLO'S FIRST DESIGN

The design of the 1515 palace as convincingly reconstructed by Christof Frommel (1981, pp. 134-45; see also *idem*, 1973, II, pp. 103-48) was, contrary to my original suggestion, close to the final version in plan,

though the grand stairway was designed in flights that ascended to the left of the present stair entrance, towards the piazza façade, rather than to the right, and would thus have occupied the two corner bays of the façade, leaving the grand *salone* substantially less space than the later solution (Pagliara, 1976, pp. 257-61). The façade wing, of which the ground floor and at least part of the *piano nobile* was completed by 1517, appears in a drawing by a French architect (Jean de Chenevières? [Munich, Staatsbibliothek, Cod. icon. 1951]) that I had originally identified with the 'pontiff's palace', but which Frommel shows to be of c. 1525.

SANGALLO'S SECOND DESIGN

Construction of the redesigned palace was begun in earnest only after 1541, the date of a new contract (Gnoli, 1937, p. 209), at which time the palace was reconceived as the residence of the the Pope's son Pier Luigi, since 1537 the Duke of Castro and after 1545 of Parma and Piacenza. In some parts foundations still had to be laid. Sangallo had not yet produced a complete design. In the autumn of 1546, the date of Sangallo's death, the façade wing was complete up to just short of the cornice, the southern wing had risen one storey, and the northern and rear wings had only partially risen above ground. Evidence of the state of the Palace at the time of Michelangelo's entrance on the scene is provided by the following sources.

1. The numerous drawings of this period in the Uffizi (see Giovannoni, 1959, figs. 43, 99ff.; Frommel, 1981, pp. 175-224). The plan ([86]; Uffizi, Arch. 298) inscribed in Antonio's hand on the verso is dated by Frommel c. 1540. It differs significantly from the present building only in the rear wing. The drawing of the court elevation (Uffizi, Arch. 627) showing arcades with five open bays on each level, is proved by measurements to be an early project (c. 1514), superseded once construction was begun. Drawings for the facade elevation show that Antonio first intended to terminate the facade with corner quoins (Uffizi, Arch. 1752) and, when construction was almost completed, shifted to a giant order binding the two upper storeys (Uffizi, Arch. 998r), only to return just before his death to the first solution. Sketches for the great sala at the left corner of the façade (Uffizi, Arch. 998r, 1009r, v) suggest that Sangallo planned to make it two storeys high, as it is today, the same in plan-dimensions, but lower. Plans and ceiling projects for the rooms at the centre and right half of the piano nobile close to the existing scheme show that Antonio must have been decorating this suite at the time of his death (Uffizi, Arch. 734, 1000).

2. Contract of June 1545 for extensive carving in travertine, continuing the ground floor portico of the court.

3. Letter of Nardo de' Rossi of 9 January 1546, and two drawings of the second-storey façade windows (Uffizi, *Arch.* 302; the letter transcribed by Milanesi in Vasari, V, p. 487f.). His words can be interpreted to mean that the *piano nobile*, at least on the left corner, was then complete. He mentions also work on the right wing and on the base of the left side of the rear façade.

4. Progress report by Prospero Mochi, 2 March 1547 (Gotti, 1875, I, p. 294f.; Rocchi, 1902, p. 252f.), indicating the portions completed at that date.

Vasari tells us (V, p. 470) that a competition for the cornice design, won by Michelangelo, was held before Antonio's death, when the third storey had been completed at least in part to the height at which Sangallo had intended to place his cornice; no reason is given why he was not permitted to complete his work. I suggested in earlier editions that Vasari, a great partisan of Michelangelo, may have muddled the chronology, remembering that Michelangelo defeated Sangallo when he may simply have replaced him after his death in 1546.

MICHELANGELO'S DESIGN

The Façade

I. The cornice was designed before 2 March 1547, when P. Mochi (see above) reported that a trial piece had been set up. This was a wood model (Vasari, VII, p. 223). The cornice was completed at least partly in July 1547 (Navenne, 1914, p. 427).

2. The central window and the coat of arms. Sangallo's central window is known from an anonymous design for completing the façade made before January 1546 (Munich, Graph. Slg., No. 34356; see also Antonio's drawings, Uffizi, *Arch.* 734, 1000. Tolnay, 1930, p. 35, fig. 22). It shows that Michelangelo merely substituted a straight lintel for Sangallo's two concentric semicircular arches, gaining space for a greatly enlarged coat of arms. He added the second pair of *mischio* columns (see HBE, plate 49b) behind the first for structural rather than for expressive reasons.

A drawing of May 1549 [85] shows the lintel, but not the new papal arms, in position.

3. Michelangelo increased the height of the façade by 1.7 to 1.9m (Frommel, 1981, p. 159) counting the frieze of *fleurs de lis* at the base of the cornice (cf. Vasari VII, p. 224). He made no change in the window design (see Antonio's designs, Uffizi, *Arch.* 998, 1109).

Project for the Court and Rear Wing

1. The second-storey gallery, or ricetto, is attributed by Vasari (VII,

p. 224) to Michelangelo. The Ionic pilaster order, with 'half-oval' vaults that spring from over the entablature rather than from the capitals, still leaves overhead room in the lateral ranges for a mezzanine with servants' quarters [77, 79] (see the penetrating analysis of Frommel, 1981, p. 163ff.). The Ionic columns and arches of the court façade [81], however, must have been carved under Sangallo's supervision.

2. The court façades. The second-storey windows [81], too distant from ancient and Renaissance conventions to be by Sangallo, too clean-cut and simple to be Michelangelo's, probably were designed by Vignola, who, it appears, took over from Michelangelo as chief architect in 1549-50. Michelangelo's hand is seen in the second-storey frieze [81] and third-storey windows [82], with their fantasy and the marble-like handling of the travertine. A chalk sketch of a window in Oxford ([83], Ashmolean, 333; T. 589; P. & Z. 664) is reasonably close to the final version, and may be Michelangelo's sole surviving sketch for the palace. Ashmolean, 332 is probably unrelated.

3. A remodelling of the early nineteenth century filled in the open gallery arches on the second floor of the front and rear wings (cf. [77] and [80]). Michelangelo did not plan the five open arches that his successors built in the rear wing. His design is recorded by the engraving of 1560 [79], which probably represents the 'modello delle loggie del palazzo verso il giardino' paid for in July 1549 (Rome, Archivio di Stato, Camerale, I, Fabbriche, No. 1515, fols. 23, 24v).

Michelangelo's project was merely a screen one bay deep with loggias overlooking the court and the garden. Vasari (VII, p. 224) explains that the open loggias were related to an overall plan involving the palace garden with an ancient sculptural group called the *Farnese Bull* to be used as a fountain on the central axis, a bridge across the Tiber, and a second garden on the far side of the river, all designed to be seen from the main entrance of the palace.

Another proposal for the rear wing, dated 1549 (Uffizi, Arch. 4927; Frommel, Lotz, 1981, fig. 6) has a narrow corridor in the centre of the range, an idea too clumsily handled to be Michelangelo's. A design of c. 1560 (Vienna, Albertina Ital. arch., Rom., 1073; *ibid*, fig. 7) improves this corridor scheme. A project, perhaps by Ammanati, Uffizi, Arch. 3450, *ibid*, fig. 16, HB Catalogue, pl. 48a) incorporates earlier improvements but reverts to the original loggia scheme of Sangallo. The existing rear wing preserves most of Sangallo's design in the lower portions.

COMPLETION OF THE PALACE

Cardinal Ranuccio Farnese (1530-65) decorated the first-floor suite of rooms on the façade and in the forward half of the right wing. A group of drawings in Berlin [87] (Ehemals Staatliche Kunstbibliothek, Hdz. 4151, fols. 97ff.) show the state of the building some time between 1557

and 1564: the garden front remained as it had been since 1546; the first-floor court elevation was finished to a height of two storeys except for two windows on the right wing, and two arches on the rear wing.

The garden façade of the rear wing was completed in 1589 according to its inscription. Although the lower two storeys have been attributed traditionally to Vignola, it now appears (Lotz, 1981, p. 236ff.) that Giacomo della Porta executed all three storeys starting in 1575. The design of the lower two, however, simply repeats Sangallo's Doric and Ionic orders; apparently it was originally intended to leave the three arches in the centre of the *piano nobile* open, making a loggia; della Porta's loggia above reflects that scheme.

The Basilica of St Peter, 1546-64

I. HISTORY

Julius II (1503-13) decided to replace the hallowed but decaying Early Christian Basilica of St Peter shortly after his election and, in 1505, together with his architect Donato Bramante, developed a series of studies that promised a monument of unparalleled grandeur. Bramante first designed a central-plan structure, with a great dome over the crossing [88] and [89]; but the final project of 1506 probably compromised with tradition in having its eastern arm (the Basilica is unconventionally orientated with its choir towards the west) extended into a proper nave. The crossing piers were completed and joined in 1510-11 by great coffered arches. Bramante also completed Rossellino's mid-fifteenthcentury choir, and built a temporary Doric altar-house [104].

Bramante's successors, Giuliano da Sangallo, Fra Giocondo and Raphael, prepared plans for a less costly continuation of the building. In 1520, on the death of Raphael, Antonio da Sangallo the Younger was put in charge, with Baldassare Peruzzi as assistant. For the next two decades little progress was made. Sangallo built a vast model from his drawings, 1539-46 [88, 92]. Work began, in accordance with the model, in walling up the niches in the four principal piers and in closing off the ambulatories around the hemicycles. From 1543 to 1546 building went on busily on the vaults of the east and south arms, the walls of the eastern hemicycle and the pendentives of the central dome. The following summary indicates what portions of the Basilica had been established so definitely by 1547 that Michelangelo was constrained to accept them with only superficial changes [90, 91].

The four piers of the main crossing; the arches connecting them; and the pendentives defining the base of the drum.

The four main arms of the church with their barrel vaults, and the

easternmost of their terminal hemicycles (although only two of the arms had been built, there could be no question in a central-plan church of a different design for the remaining two).

The barrel-vaulted transverse aisles between the crossing piers and the buttressing piers (four of the eight vaults planned were completed).

The side aisles of the eastern arm, up to the narrow doorway alongside the hemicycle.

Michelangelo's appointment as architect took place some time in the two months after Sangallo's death in September 1546. Then aged 71, Michelangelo accepted the post reluctantly (Condivi, ch. LIII; Vasari, VII, p. 218ff.), but by I January 1547 a clay model had been made (Vasari, loc. cit. as interpreted by Tolnay, 1930, p. 3ff.) and a wooden one started (Pollak, 1915, p. 52). In a letter of 1546-7 (K. Frey, 1914, p. 324f.) Michelangelo expressed his views on the designs of his predecessors.

One cannot deny that Bramante was as worthy an architect as any since ancient times. He laid down the first plan of St Peter's, not full of confusion, but clear and pure, full of light, and did no damage to any part of the palace. And it was regarded as a beautiful thing, and it is obvious now, so [one can say] that whoever departs from this order of Bramante, as Sangallo has done, has departed from the truth. That this is so, anyone with unimpassioned eyes can see in his model.

Both Michelangelo's first models are lost. A painting by Passignani of 1620 [102] is the only evidence for the appearance of the wooden model. As this model seems to have been completed as early as the autumn of 1547 it cannot have been large or worked out in all details. The only supplementary studies of which we know are a large-scale model of the interior drum cornice executed in 1548-9 (K. Frey, 1916, p. 67), and another made sometime before 1557 for the vaulting of the hemicycles (Nachlass, I, pp. 481-4); the latter was inserted into the large model of Sangallo and survives (Millon and Smyth, 1976, figs. I, 21, 24, 25, etc.).

No drawings other than those for the dome survive. In October 1549 the Pope ordered that the model be respected, and we assume that construction of the Basilica up to the base of the drum essentially followed the design of the model, although Michelangelo introduced certain changes (cf. Vasari, VII, p. 232).

Vasari (VII, p. 221) explains the principal departures of Michelangelo's model from that of Sangallo (cf. [88] and [91]). His account, interpreted with the assistance of the sixteenth-century views and engravings, may be summarized as follows:

I. Bramante's four secondary piers at the entrances to the northern and southern hemispheres, pierced by Sangallo with passages, were filled with spiral stairs by Michelangelo [105].

2. He made the ring 6.1m. high, placed upon the pendentives as a base for the great drum.

3. He removed Sangallo's outer hemicycles (with their eight tabernacles) and thus made the inner hemicycles into an outer wall [91].

Other major changes in plan, put into effect later, were:

4. The reduction of the four corners to give the minor domed areas direct access to interior light.

5. The elimination of Sangallo's twin-towered porch and forenave in order to restore a central-plan scheme [88c, d].

These innovations, by greatly reducing the dimensions of the Basilica, avoided the problem of encroachment on existing palace structures, brought direct light into all parts of the interior, and saved incalculable time and expense in construction. The chronology of the construction of the Basilica under Michelangelo can be established fairly accurately by analysing the documents of the papal treasury (K. Frey, 1916, pp. 22-135), contemporary views and perspective plans, and Vasari's *Lives*. Here only a summary can be given of the condition of St Peter's at Michelangelo's death in February 1564; the bulk of this work was executed in the years 1549-58.

Façade arm and crossings apparently left as finished by Sangallo [91].

Southern arm and Cappella del Re: complete both inside (the Cappella vault being of finished travertine without decoration) and out (the attic remaining unadorned as in [103]). (Millon and Smyth, 1969, p. 491ff.).

Western arm: the Rossellino-Bramante apse still untouched [104].

Northern arm and Cappella del Imperatore: vaulting of the arm not started; chapel vault half constructed. The existing attic, departing from Michelangelo's design for the southern arm, was begun here by Pirro Ligorio immediately after Michelangelo's death.

Drum: largely completed up to the level of pilaster- and buttresscapitals; imposts and entablatures executed on the eastern but not the western half [104].

Corner chapels: foundations begun on the north side.

Models of the dome: a clay model complete by July 1557 (K. Frey, 1916, p. 81); the wood model, which still survives, altered by della Porta [96], made November 1558-November 1561 (K. Frey, 1909, p. 177ff.; 1916, pp. 81ff., 87).

Construction after Michelangelo's death continued under Pirro Ligorio (1564-5), who altered the attic design, and Vignola (1567-73), who added the minor domes. Giacomo della Porta, chief architect from 1574, concentrated at first on the Cappelle Gregoriana and Clementina, 1580?-85, while the western arm was under construction. In 1586 della Porta's new design for the main dome was approved. The dome was built 1588-90, the lantern 1590-93, and the interior of the dome decorated 1598–1612. In 1607 Carlo Maderno won the competition for the design of a long nave and façade. These were executed 1608–15.

II. MICHELANGELO'S DESIGN

The abundant archival, graphic and literary sources for the reconstruction of Michelangelo's design are so frequently contradictory that their interpretation has become the most controversial problem in the study of the Basilica. The chief cause of confusion is the fluid nature of Michelangelo's approach to the design: his scheme was not definitively formulated at the outset but evolved gradually in the course of seventeen years of construction. Here no more can be given than a list of the documents, and a revised summary of the conclusions in the HB Catalogue, 1964, on the respective designs of the side elevations, the façade, and the major and minor domes. Of the models mentioned in section I, only the large wooden drum/dome model of 1558-61 and the model for the apse vault of the Cappella del Re inserted into the large Sangallo model survive, the former in a drastically altered state. This slight evidence is supported by the following records:

I. The letter of Michelangelo and Vasari's *Lives*, which includes a lengthy and detailed description of the partly surviving model (VII, pp. 250-57).

II. Drawings executed by Michelangelo or under his direction:

a. Haarlem, Teyler Museum, 29r [97]; T. 596; P. & Z. 514. Lantern elevations; dome section. Verso: plan of a podium for the lanterns on the left side of the recto.

b. Casa Buon. 118v; T. 587; P. & Z. 516. Lantern elevations. Immediately following 'a'.

c. Uffizi, Arch. 92, by Giovannantonio Dosio. Half-section of the dome and lantern with the upper portion of the drum (Wittkower, 1964, fig. 9a).

d. Casa Buon. 117v; T. 586; P. & Z. 519. Dome section and lantern elevation; drawn plan. Contemporaneous with 'b'. Associated by Joannides, 1981, p. 686, with San Giovanni de' Fiorentini.

e. Lille, Musée des Beaux-Arts, Coll. Wicar, 93 [98]; T. 595; P. & Z. 519 (originally attached to Lille 94: studies for an unidentified door and stair). Elevation of drum and lantern; dome section.

f. Casa Buon. 31; T. 600; P. & Z. 522. Partial plan of the drum and buttresses by an assistant with notes by Michelangelo. Contemporaneous with 'd'.

g. Oxford, Ashmolean Museum, 344r; T. 601; P. & Z. 517. Rapid sketch of crown of the dome, and lantern section, tentatively dated 1557 by the fragment of a letter (HBE, plate 55b).

h. Arezzo, Casa Vasari, Cod. 12, cap. 22, 24; T. 593, 594; P. & Z.

520, 521. Letters from Michelangelo of the summer of 1557 with sketches of the vaulting system of the Cappella del Re (HBE, plate 55b).

i. Bayonne, Musée Bonnat, no. 681v; quick sketch of the elevation of the vault of the Cappella del Re, 1557? (Millon and Smyth, 1976, p. 102, fig. 43).

j. Paris, Louvre, Cabinet des desseins, no. 842v, T. 422. Structural diagram of a portion of the vault of the Cappella del Re, 1557? (Millon and Smyth, p. 102, fig. 44).

k. Codex Vaticanus, 3211, fol. 92v; T. 592; P. & Z. 524. Quick sketch showing the relation of the proposed façade of St Peter to the Vatican Palace; its entrance porch is three columns deep and five wide (probably intended to be six).

III. Contemporary copies of Michelangelo's drawings and models.

a. Uffizi, Arch. 95r, v. Recto: exterior elevation of one of the hemicycles without the attic (Coolidge, 1942, fig. 11 and my HB Catalogue, 1964 [dated 1546/7] – misquoted as Uffizi, Arch. 96r.; Millon and Smyth, 1969, p. 497, fig. 26 [dated pre-1555]; Saalman, 1975, p. 386, fig. 14 [dated 1546/7]). Verso: partial drum elevation (Millon and Smyth, op. cit., fig. 280) drawn later than the recto by another draughtsman, the same as nos. h. and i. below.

b. Uffizi, Arch., 96r, v. Plan of attic and second level of the southern hemicycle; section of drum (Millon and Smyth, 1969, p. 488ff. and figs. 12-15, recto dated 1556-64; Saalman, 1975, p. 389ff., recto dated prior to 1547 model). A portion of 96r appears in a less precise drawing in the Metropolitan Museum, Scholz scrapbook 49.92.22v (Tolnay, 1967, p. 68, pl. 24, 2).

c. Uffizi, Arch. 93r, v. Details of exterior chapel and drum elevations (Millon and Smyth, 1969, p. 492ff; figs. 22, 23).

d. Uffizi, Arch. 94, by Giovannantonio Dosio. Section of the dome with interior perspective; profile (HBE, pl. 57a; Wittkower, 1964, fig. 8a). Verso: detail of drum. Like e. to g., drawn from model completed in 1561.

e. Uffizi, Arch. 2031, by Dosio. Section of the dome and lantern; plan of the stairway between the shells (*ibid.*, fig. 14). Verso, a version of f. below.

f. Uffizi, Arch. 2032, by Dosio. Drum plan at four levels (*ibid.*, fig. 12).

g. Uffizi, Arch. 2033, by Dosio. Detail of the drum section; drum-column with measurements of entasis (*ibid.*, fig. 11).

h. Casa Buon. 35r, v; T. 603; P. & Z. 523, 525. Measured freehand half-section of the dome model (*ibid*, p. 21, pl. 9b).

i. New York, Metropolitan Museum, Scholz Scrapbook, 49.92.92r, v. Half-section of the dome (Wittkower, 1964, p. 101ff., with a listing of eleven other studies of the cupola based on the model attributed to Dupérac, dated 1564-5; illustrated by Tolnay, 1967, pl.24, 1).

IV. Records which combine information from the models, drawings, and the Basilica itself.

a. Italian, Private Collection, album attributed to Dupérac. Sketch of the eastern (façade) elevation in perspective (HBE, plate 62a). Here dated 1558-64 (Wittkower, 1963; Thoenes, 1965).

b. V. Luchinus, engraved elevation of the exterior of the hemicycles, dated 1564 [103].

c. Naples, National Library, ms. XII.D.74, fol. 22v. Section and front elevation of the Basilica showing emendations (not including the attic) of Michelangelo's project by his successors (Keller, 1976, figs. 1-3, there dated c. 1564-5).

d. E. Dupérac, engraved plan, dated 1569 [105].

e. E. Dupérac, engraved southern elevation (1569? [99]).

f. E. Dupérac, engraved longitudinal section (1569? [100]).

g. New York, Met. Mus., No. 49. 92. Iff.; sketchbook of an anonymous French architect with drawings after the dome model and the Basilica (Wittkower, 1964, Appendix II, p. 101ff. and figs. 10, 15).

h. T. Alfarani, plan superimposed on the plan of old St Peter's (c. 1580? Schiavo, 1953, fig. 48).

i. Uffizi, Santarelli, 174. Plan variant of 'c' (unpublished).

j. Windsor Castle Library, 10448. Plan, datable after 1560 (A. Noach, Burlington Magazine, XCVIII, 1956, p. 376f., fig. 40).

From these documents the following conclusions can be drawn. For the argumentation to support them the HB Catalogue, 1964 must be consulted, and the specialized studies cited in each section.

1. The Side Elevations

In 1547 construction began on the exterior of the southern hemicycle; it must have followed the design of Michelangelo's first wooden model. In the HB Catalogue (p. 103f.), I claimed that the attic as shown in the model and in [103] was a temporary solution, and that Michelangelo intended to cover the simple surfaces with a decorative veneer such as that which appears in the engravings of the project [99]. I now accept the arguments of Millon and Smyth (1969, 1975) that Michelangelo intended to leave the attic unadorned as in [103] and that the existing attic was interpolated by his successors, who evidently were inspired by one of the master's designs (Lille, Musée Wicar, no. 93r [IIe above]) which they read as for a gate (cited by Hirst, 1974, and Saalman, 1975, note 100, who believe it to be for the attic). The existing attic facing appears already in an engraving of 1565 (HBE, plate 53b). This conclusion has brought about a radical reinterpretation of Michelangelo's design.

The design of the attic and of the hemispherical vaults terminating the arms was altered in 1551 (Vasari, VII, p. 232) and a model of the vaults made before July 1557 (date of letters to Vasari explaining how the masons during his recent absence had departed from the model). In rebuilding to correct the errors, he made further revisions, giving more depth to the gores of the vault and increasing the light from the windows (Millon and Smyth, 1976, *passim*. They show that I was in error to assume in earlier editions that Michelangelo considered putting two levels of windows in the vault).

2. The Façade

Michelangelo did not start building the façade before he died. Our knowledge of his design is based on graphic documents that are so inconsistent and inaccurate that it is impossible to make a convincing reconstruction. Thoenes (1968) suggested that the façade shown in Etienne Dupérac's engravings [99, 100, 105] was interpolated by Vignola, and that Michelangelo's tentative solution, representing his last design, is reproduced in the drawing from the so-called Dupérac album cited in section IVa on the preceding page. The subsequent discovery of the Naples drawing, IVc, offers another alternative closer to that of the engravings (Keller, 1976).

3. The Main Dome

Michelangelo's model for the main dome was made in 1558-61 [96]. It survives, with its outer shell replaced by one of more elevated form by della Porta in the period 1585-90. For the most recent account of the reasoning leading to this conclusion see Wittkower, 1964, pp. 26-35. Modern controversy over the design has focused on the issue of whether Michelangelo's *hemispherical* dome as projected in the model represents his final decision, or whether the *elevated* dome of della Porta follows a decision made by Michelangelo before his death. We know that in other respects Michelangelo felt free to modify the model project after 1561.

Vasari's description (VII, pp. 248-57) and Dosio's drawings (IIIb-f above) of a structure with a hemispherical dome are based partly on the model, partly on observation of the actual drum, started in 1555, and up to entablature level by 1561. Vasari describes the theoretical system determining the form of the inner and outer shells – a construction calculated with a compass from the three apexes of a triangle at the base of the dome. Dosio was clearly aware of it too, but in taking measurements from the model introduced certain inconsistencies. Dupérac's engravings [99, 100], on the other hand, apparently were made without knowledge of Michelangelo's drawings, by combining the dome of the model with the drum as executed by Michelangelo. The scale of the engravings is too small for the method of constructing the dome shells from three centres to be observed.

The only drawings that survive, however, are for a dome of elevated profile. The proposal recorded in the Haarlem sketches [97] is tentative and must represent an early stage in the design, sometime after the 1547 model of the lower portions of the Basilica. It shows an octagonal lantern, which suggests a dome with only eight ribs. In 1554 columns were prepared for the buttresses of the drum. The Lille drawing [98], which has the sixteen buttresses and paired columns of the final project, must antedate 1554, as the columns are Tuscan, not Corinthian as executed. The Oxford lantern sketch (HBE, plate 55b) is accompanied by a note referring to a model, which must be the model of 1558-61. The sketch shows that even as late as this the profile of the dome was not vet fixed, nor was the decision taken whether the lantern was to be open inside into the dome. In short, the concept of an elevated dome was originally Michelangelo's, and appears in the earliest sketches, but probably he had decided that the hemisphere of the model was the final solution. Della Porta returned to the elevated profile, raising it higher than Michelangelo had first planned, and made many changes in detail that greatly altered the effect of the dome.

4. The Minor Domes

The minor domes first appear on an anonymous drawing attributed to Dupérac from a private collection and in the Naples section-elevation (nos. IVa and c above); they are shown also in Dupérac's engravings [99, 100]. The versions are different, but neither is in any way related to Michelangelo's style. The fact that Dupérac shows minor domes suggests that Michelangelo intended that they should be built; but apparently he never formulated a design for them. These designs have been convincingly attributed to Vignola (Coolidge, 1942); the existing minor domes were redesigned and executed by della Porta.

Vatican Fortifications, 1547-8

In 1537 a vast and costly programme of strengthening the ancient and medieval walls of Rome was initiated by Paul III. Antonio da Sangallo the Younger was the architect in charge. Work began on the defences on the left bank of the Tiber, and continued from 1543 on the walls surrounding the Borgo (Vatican quarter).

In 1545 a controversy broke out over the extent of the walls to be built behind the Cortile del Belvedere. Sangallo wanted an extended

system embracing the hills; Gianfrancesco de Montemellino advised restricting it to the nearer valley. In a large conference called by the Pope early in 1545 Michelangelo opposed Sangallo. In a letter of 26 February 1545 (*Lettere*, p. 499) to the Castellan of Castel Sant'Angelo, Michelangelo said he would collaborate in the programme if Montemellino were put in Sangallo's place. He was not however called in until after Sangallo's death in the autumn of 1546, when he gave assistance on problems of design to Jacopo Meleghino, Sangallo's successor (Rocchi, 1902, p. 278f.). Michelangelo insisted that an additional bastion of two flanks was required to cover the curtains between the tower of Nicholas V and the Spinelli palace (defences along the eastern corridors of the Cortile del Belvedere facing the Tiber).

Less than a year later, the famous military engineer, Jacopo Castriotto, arrived in Rome to take charge of the fortifications, and Michelangelo's name disappeared from the documents (Rocchi, 1902, p. 281).

The attribution of the eastern Belvedere fortifications to Michelangelo is generally accepted because of their vigorous and monumental style; but the evidence cited gives it equivocal support.

Vatican, Stairway in the Upper Garden of the Cortile del Belvedere, 1550–51

The only certain evidence for Michelangelo's authorship of the Belvedere stairway [107] is Vasari's (VII, p. 228). Vasari dates the design in 1550-51, which is borne out by other documents (Ackerman, 1954, pp. 75, 165). Sketches for a double-ramped stairway of this type on Casa Buon., 19 F. (T. 368; P. & Z. 424) are related to the Belvedere project by Wilde (1953, p. 109) and to the Senatore by other critics (most recently, De Angelis D'Ossat and Pietrangeli, 1965; Tolnay, *Corpus*). A plan by an anonymous draughtsman, possibly of the 1550s, shows the stair and hemicycle with a central niche under the forward balustrade rather than the rectangular panel executed by Michelangelo [107]; the existing arrangement [106] is modern (as is made clear by the plan after the original stair, New York, Metropolitan Museum, Scholz Scrapbook, no. 49.92.72; Tolnay, 1967, p. 68, pl. 24, 3.)

The substitution of Michelangelo's stairway was the first step in the transformation of Bramante's one-storey wall and exedra at the short end of the huge theatre-garden into a two-storey villa [107]. Probably Michelangelo shaped the whole programme of the villa of Julius II, begun in 1550-51, though he left the design to others. The great Nicchione created by Pirro Ligorio in 1562-5 [106] seems not to have been anticipated.

The bronze *Pigna* was set up shortly before 1615; the original peperino balustrade was replaced by Clement XI (1700-1721), so that little of Michelangelo's detailing survives.

Padua, Cathedral Choir, 1551-2

On 2 January 1551 the Chapter of Padua Cathedral chose a *modello* for the choir by 'the most ingenious and famous Michelangelo'. On 5 January it was definitely approved and ratified, and Andrea della Valle and Agostino da Valdagno were elected to execute the model (G. Montese, *Arch. veneto*, ser. v, XCV, 1964, pp. 28-41; Barbieri and Puppi in P. & Z. 1964, p. 937f.; Tolnay, 1965, p. 247).

Michelangelo cannot have controlled the execution of the choir in detail, but the giant order of Corinthian pilasters and the groined apse vault are vaguely Michelangelesque; the design is close to the tribunes of St Peter's as originally projected (see the engraving by Dupérac and Tolnay, loc. cit., pl. 58, 1).

Rome, San Giovanni de' Fiorentini, 1559-60

I. HISTORY

Construction of a new church to replace the small oratory of the Florentine colony in Rome situated on a triangular plot between the Via Guilia and the Tiber river [115] was decided upon in 1518 (A. Nava, 1935, 1936). After a competition Jacopo Sansovino was awarded the commission, and by 1520 the model had been completed and the foundations started. At the outset, Sansovino was replaced by Antonio da Sangallo the Younger, who proposed both central-plan and longitudinal schemes. One of the latter was selected, but the cost of building the foundation on the river bank exhausted the funds when the substructure had reached only 'several ells over the water' (Vasari, V, p. 455). A temporary chapel was raised on the foundation platform and Sangallo began the construction of the facade, as seen in Dupérac's map of 1577. Pinardo's map of 1555 [115] shows that the foundation was incomplete not in height but in extension, permitting construction only up to the point where Sangallo's crossing - and the crossing of the similarly dimensioned final structure of 1582-1614 - was to be built (the foregoing has been revised from earlier editions on the grounds of Schwager. 1975, passim).

By 1559 (late October) the Florentine colony was prepared to continue construction and persuaded Michelangelo, now 84 years of age, to submit designs. He submitted five studies, one of which was selected, and his young assistant, Tiberio Calcagni, executed measured drawings and a clay model, and later supervised the construction of a wooden model (Vasari, VII, p. 261ff.; Gaye, III, pp. 16-21; *Lettere*, pp. 551-3). In April 1560, Calcagni travelled to Pisa to show Michelangelo's drawings to Cosimo I, and on his return in May (*Briefe*, pp. 377-8), a conference was held on the site of the church to consider a new stretch of foundation wall along the river (Nava, 1936, p. 354f.); but by June of 1562 Calcagni had been replaced by another official. This is the last surviving evidence for Michelangelo's project.

II. THE DESIGN

Three major plan studies are preserved in the Casa Buonarroti, identified and isolated from a number of other central plan studies by D. Frey (1920, pp. 57-69). The earliest is Casa Buon. 121 [108]; (T. 609; P. & Z. 711), and not sufficiently developed to be a presentation drawing. Casa Buon. 120 [110]; (T. 610; P. & Z. 713) is annotated in Michelangelo's hand for the benefit of laymen. Casa Buon. 124 [111], (T. 612; P. & Z. 712), or a development of the same scheme, was selected by the commission. The focal platform in [108] and [111] must be an altar, and not a supporting wall in a hypothetical crypt, as Frey interpreted it. Casa Buon. 36 (T. 611; P. & Z. 716) is a preliminary study for the support system of [111]. A few small tentative plan studies, in chalk, appear on [110]. Probably the plan on the recto precedes the main drawing, while those on the verso (T. 610; P. & Z. 710) follow, providing a transition to [111]. Joannides (1978, p. 176, figs. 1, 2) has assigned to San Giovanni a drawing of a tomb beneath a niche formerly associated with the Cappella Sforzesca, Casa Buon. 103v (T. 613), once attached to Casa Buon 124v (T. 612); the recto of the latter has Michelangelo's final plan project cited above.

The wooden model is known from seventeenth-century engravings, by Jacques Le Mercier [116] and Valerian Régnard ([117] from G. G. de' Rossi Insignium Romae templorum prospectus, Rome, 1683); cf. the livelier chalk drawing from the Berlin Kupferstichkabinett, No. 20.976, published by K. Nohles, La chiesa dei SS. Luca e Martina nell'opera di Pietro da Cortona, Rome, 1969, fig. 56. The model plan – apparently Calcagni's working drawing – in Uffizi, Arch. 3185 [112] required major revision before reaching the model stage. An intermediate design between Michelangelo's sketches and the model is recorded in the sketch-book of Oreste Vannocci Biringucci (Siena, Bibl. Comunale, S.I.VI, fol. 42; P. & Z. 718; executed shortly before 1585). It is close to [111] but, like the model, moves the free-standing columns of the central space so that they become attached, as plastic relief, to the piers. The dimensions of Michelangelo's scheme can be deduced from measurements on this drawing and on the plan in an album of Fra Giovanni Vincenzo Casale in the National Library, Madrid (Battisti, 1961, p. 185ff. figs. 1-3; P. & Z. 717, 722, 723), which show that Sangallo's foundations could have been partly utilized for at least the porticoes and the apse.

Giovanni Antonio Dosio's drawing [114] identified by Luporini (1957, p. 442ff.), on the other hand, is a perspective view of the interior of a model, sufficiently different in details from the engraved model to suggest that a second wooden model was made. Its character makes it unlikely as a record of the clay model. Schwager has attributed to Vignola (1975, p. 151ff., fig. 1) an oval-plan project for the church recorded in a copy by Vincenzo Casale (Madrid, National Library, 16-49, fol. 86); he suggests that it was conceived for Julius III in 1550-51 when the Pope planned to put his tomb in the church. The design was copied in a drawing by Dosio (Uffizi, *Arch.* 233) which I cited earlier as being Dosio's invention.

Rome, Santa Maria Maggiore, Cappella Sforza, c. 1560

Vasari's statement (VII, p. 264) that Michelangelo 'assigned to Tiberio (Calcagni) following his instructions, a chapel begun at Santa Maria Maggiore for the Cardinal di Santa Fiore (Guido Ascanio Sforza, d. 1564), which remained incomplete on account of the death of that Cardinal, and of Michelangelo and Tiberio ...' suggests that Michelangelo was entirely responsible for the plan and the remarkable choice of material for the internal membering, travertine – heretofore used only out of doors. The principal features of the elevations, however, are dully classicizing, and must have been left to an assistant. Only the splayed windows in the vaults of all four arms suggest Michelangelo's participation.

The two tablets at the entrance to the chapel commemorate its foundation in 1564 and decoration and consecration in 1573. Probably the travertine chapel façade, destroyed in 1748 [122], was designed after Michelangelo's death, at the time of its erection, c. 1573. A medal of Pius IV shows a design, probably by Michelangelo, which may have been his project for the façade (suggested by Schiavo, 1966, pl. XXV and text).

Drawings

I. Casa Buon. 104 (T. 624; P. & Z. 726, HBE, plate 72c). Chalk sketches of a chapel plan, plan details and an elevation of three small

niches. Only the small plan can be associated confidently with the chapel.

2. British Museum, 84 (T. 623; P. & Z. 727). A plan roughly sketched over ruled lines, probably drawn before no. 1. Tolnay now tentatively assigns it to Santa Maria degli Angeli.

Related Drawings

I. Casa Buon. 109 (T. 625; P. & Z. 725). Plan and elevation studies of a chapel.

2. Oxford, Ashmolean, 344v (T. 601; P. & Z. 728). Plan and elevation studies of a chapel.

3. Casa Buon. 123 (T. 608; P. & Z. 714 attributed by both to S. Giovanni de' Fiorentini). Chapel plan (Joannides, 1981, p. 686: 'conceivably... Sforza Chapel').

4. Formerly Newbury, England, Gathorne-Hardy Coll. (Dussler 1959, no. 593). A sheet by an assistant or follower.

Rome, Porta Pia, 1561-5

I. HISTORY

In 1560 Pius IV initiated a major planning programme, the construction of a great street, the Via Pia, from the Quirinal to a point just short of the church of Sant' Agnese a mile beyond the city walls. It involved realigning the ancient Via Nomentana and building a new gate, the Porta Pia, where the street passed through the ancient walls. The foundation ceremony took place on 18 June; the agreement for the construction of the Porta on 2 July.

In August 1561 the Salaria and Nomentana gates were ordered to be sealed. In May 1562, Jacomo Siciliano (del Duca) and 'Luca' were paid for carving the papal arms, intended initially for the exterior façade. In 1563-4 Michelangelo was receiving 50 scudi monthly, but not specifically for work on the Porta. In 1565 Nardo de' Rossi was paid for the travertine angels that flank the arms (Schwager, 1973, first noticed that these were substituted for the wingless *ignudi* projected by Michelangelo which appear on the 1568 engraving ['B' below]. Schwager proposes that the angels carved after Michelangelo's design were used in the pediment of S. Luigi dei Francesi in Rome). The last construction record is of December 1565.

The attic cannot have been finished under Michelangelo's supervision. It seems to have collapsed before long. Mario Cartaro's large plan of Rome of 1576 and Dupérac's plan of 1577 [129] both show it in place; but in the fresco of 1587 in the Lateran palace [126] and in views of the seventeenth and eighteenth centuries (Zanghieri, 1953, figs. 9-17) it appears with a ragged silhouette. The damaged attic was restored and completed in 1853 by Virginio Vespignani, who in 1861-8 built barracks in the enclosure behind and executed the exterior portal.

II. THE DESIGN

According to Vasari's report (VII, p. 260):

Michelangelo, urged by the Pope at this time to provide a design for the Porta Pia, made three, all extravagant and beautiful, from which the Pope chose the least costly to execute, which may be seen today and is much praised: and since the Pope had in mind to restore the other gates of Rome as well, he made other drawings for him.

Several sketches by Michelangelo and his assistants, the foundation medal, and an engraving of 1568 support Vasari's account. The material is analysed in detail by Schwager (1973, with references to earlier literature).

A. The Medal [134], commissioned before April 1561, records a design that may be the one to which Vasari referred. In earlier editions I have shared the opinion of other authors that the lateral crenellated walls, represented as projecting forward, suggest that the gate was to have faced away from the city or that there were to have been two monumental façades. Schwager proposes (p. 43ff.) that it shows an initial project for the city façade (the lateral walls being awkwardly represented in reverse perspective) and that the surviving autograph drawings were related to this design. The final project would thus represent a second stage. The most recent commentary returns to the earlier view (Millon, 1979, n. 5).

B. Faleti's engraving [124] of 1568 represents the executed gate except for minor details on the portal and windows and for the upper portions, which differ from it considerably. Probably the gate was not finished in 1568, and the engraver turned to projects in the hands of Michelangelo's successors. The projects, dull and conventional, were probably not Michelangelo's.

C. Sketch for the whole gate. Casa Buon. 997 (HBE, plate 77a; P. & Z. 781). The proportion of the lightly sketched gate is close to the medal. Hard, ruled lines indicate the portal, with a rectilinear opening that approaches the form carried out.

D. Drawings for the portal

I. Casa Buon. 106r [130]; (T. 619; P. & Z. 783). Drawings from different sheets pasted together.

2. Casa Buon. 102r [131]; (T. 618; P. & Z. 784).

Though finished in wash by an assistant, these drawings probably were begun by Michelangelo; they have his characteristic superimposing of successive ideas.

3. Windsor Castle Library, 12769v [132]; (T. 271; P. & Z. 789), by Michelangelo. Several chalk sketches, concerned with the tympanum and pediment design. The two plans at the top of the sheet do not appear to be related to the Porta Pia.

4. Tiberio Calcagni? Uffizi, Arch. 2148 (Schwager, fig. 23)

This sheet appears to be copied from a working drawing in Michelangelo's atelier. Pen, with additions in chalk.

Nos. 1-4 must be in proper chronological order, but since the final solution is a combination of elements in 2 and 3, these two may be regarded as contemporary.

E. Sketches for free-standing portals. Nos. 1-3 are by Michelangelo, and probably were not conceived for the Porta Pia; no. 4 is by an assistant with possible additions by Michelangelo; no. 5 is generally regarded to be by an assistant.

1. Haarlem, Teyler Museum, A29, bis. [133]; (T. 621; P. & Z. 788).

2. Casa Buon. 97v (T. 616; P. & Z. 790).

Portal study and quick sketches of portal or window frames, not all connected with Porta Pia.

3. Casa Buon. 84 (T. 614; P. & Z. 787).

A fragmentary section of the two shells of St Peter's suggests a connection with the Basilica.

4. Casa Buon. 73 bis. (T. 615; P. & Z. 785).

The proportions and underlying construction lines link the drawing with the Porta Pia.

5. Casa Buon. 108r (T. 622). Aperture with archivolts like those of the Porta Pia (Joannides, 1978, p. 176 attributes to Michelangelo).

F. Details. Casa Buon. 106v (T. 619; P. & Z. 782).

Two drawings in the centre of this sheet are studies for the cartouches over the windows of the Porta Pia. The upper one is close to the final solution.

Rome, Santa Maria degli Angeli, 1561-

I. HISTORY

The huge central hall of the Baths of Diocletian was preserved almost intact into the Renaissance, and the idea of converting it into a church was entertained during Michelangelo's early days in Rome: Giuliano da Sangallo and Baldassare Peruzzi both left drawings for the reconstruction (Siebenhüner, 1955, figs 17, 18). In 1541 a Sicilian priest, Antonio del Duca, was inspired by a vision to demand from the papacy the establishment in the Baths of a church consecrated to the cult of the angels (see the account, covering construction up to the 1580s, of del Duca's friend Mattia Catalani [*Vat. Lat.*, 8735, cf. excerpts in A. Pasquinelli, *Roma*, 1925, p. 349ff.]).

In 1550 del Duca was allowed to install fourteen temporary altars. An entrance was cleared at the NW end of the great hall.

In 1561 Pius IV gave del Duca's scheme enthusiastic support, as it complemented his urbanistic scheme along the Via Pia. Michelangelo was chosen to design the church (Vasari, VII, p. 260f.; Pasquinelli, 1925, p. 350f.). Catalani describes Michelangelo's scheme: he proposed to 'design it as a cross, restricting the size and removing the low chapels where the vaults had collapsed, so that the highest parts would constitute (the main portion of) the church, the vault of which is supported by eight columns on which the names of the martyrs and angels are inscribed; and he designed three portals, one to the (S-)W, another on the N(-W), and the third on the S(-E) as they may be seen now; and the main altar toward the (N-)E' [137].

In a Bull of 27 July 1561 the Pope assumed the responsibility for building the church, and on 5 August he laid the foundation stone under the altar. Construction seems to have begun at once, but by 1563 progress was hampered by lack of funds. In January 1565 a bronze ciborium for the main altar based on Michelangelo's design was ordered from Giacomo del Duca and Jacopo Rocchetto (Schiavo, 1949, fig. 142; and contract 1953, p. 287ff.). The ciborium is now in the Naples Museum. In 1565 payments were made for columns to be used on the altar of one of the chapels, and for replacing one of the ancient capitals of the colossal columns in the great hall [136]. The first Mass was said in May of that year.

An inscription of 1565 records the foundation of the cloister [129], the construction of which was in the hands of the Carthusian Order. There are no documents indicating whether Michelangelo was involved in its design. The church had been assigned to the Carthusians in 1561, but in May 1565 it was made a titular church.

II. THE DESIGN

Catalani summarizes the programme of Pius IV: 'he first covered the main vaults in tile, built the main chapel with the apse from the foundation up, opened the (S-)W portal, and reduced the body of the church by two walls, in one of which he made the N(-W) portal, and in the other the S(-E) portal, and began to stucco the inside of the vaults' (Pasquinelli, p. 352; cf. [137]). Siebenhüner's analysis of drawings and prints of the Baths before the remodelling (1955, pp. 180-84) shows that the portions used by Michelangelo were excellently preserved. He used the central rotunda (tepidarium) as the principal vestibule [137 G, H]. Only the altar chapel at the opposite end of the short axis had to be specially designed.

Contemporary drawings and engravings supply evidence of the few new elements ([129, 135, 138, 139, 140]; Ricci, 1909, figs. 8-11; Schiavo, 1949, fig. 1, 135; Siebenhüner, 1955, figs. 9, 22, 28, 29, 30).

I. The vestibule portal [140] on the SE of the main hall seems to have been quite conventional and was probably not designed by Michelangelo.

2. Michelangelo inserted two simple mullions in each of the windows of the main hall [139].

3. The chancel appears in an exterior view of 1577 [129], which shows the apse. The interior, [135] and [138], had a long barrel-vaulted chamber, terminating in the apse. The ancient chamber leading from the great hall to the frigidarium was used as the first bay. The altar consecrated in 1561 must have been placed here. Michelangelo must have intended to leave it there, as the chancel had to act as the Carthusian monks' choir.

III. SUBSEQUENT HISTORY

In the 1570s the church was paved, but the floor level not raised (Schiavo, 1954, p. 19ff., fig. 6). New column bases were probably inserted then. Two chapels with ornamental portals were planned for the chamber at the entrance to the chancel [137A, B], one in 1574, the other perhaps at the same time, but certainly before 1608. The side chambers of the entrance rotunda [137] were transformed into chapels in 1575 and 1579. The pilasters of the Ionic tomb tabernacles between the four axial openings probably belong to this period. The concave entrance façade was formed by the removal of a niche of the ruinous tepidarium in 1587–9 and the decoration of the walls with an order of pilaster strips some time between 1625 and 1676. Also in the seventeenth century the interior window frames shown in [138] were added.

From 1700 the interior was gradually transformed until all traces of the original treatment were buried. The choir was remodelled from 1727. The vestibules were closed off to form chapels (NW vestibule in 1700, SE in 1746). In 1746 the architect Clemente Orlandi closed off three of the four chambers on the sides of the main hall. Luigi Vanvitelli, appointed architect for the Carthusians in 1749, closed off the fourth, and covered the entire interior, except the vaults of the main hall, with stucco and veneer. He added six columns along the entrance axis, and replaced the rotunda lantern. The chancel was extended and redecorated some time after 1763 and before 1794. The façade was restored and Vanvitelli's lantern removed in 1911.

Recorded Commissions for which no project survives

Rome, Palace of the Cardinal Santiquattro, 1525 (*Briefe*, p. 245ff., and Tolnay, 1947, p. 255).

Venice, Bridge of the Rialto, 1529? (Condivi, Ch. XLVII, and Vasari, VII, p. 199).

Florence, House of Baccio Valori, c. 1532 (Briefe, p. 323ff.).

Rome, strengthening of Ponte Sta Maria, 1548-53 (Vasari, VII, p. 234f. confirmed by documents published by Podestà, 1875, p. 130ff.); Spezzaferro, 1981, p. 118, shows that Michelangelo was active for four months in the design of a wooden bridge.

Rome, advice on the design of the Villa Giulia, 1550 (Vasari, VII, pp. 223, 233, 694).

Rome, façade for the Palace of Julius III, 1551 (Condivi, Ch. LI; Vasari, VII, p. 233. Payments for a model, first cited by Podestà, 1875, p. 136, are reproduced by Millon (1979), p. 776f.), who reconstructs from them the general aspects of the design. The documents reinforce the accepted opinion that the model being presented to the Pope in a painting of 1615-17 by F. Boschi in the Casa Buonarroti in Florence is not Michelangelo's.

Rome, Il Gesù, 1554 (Pirri, 1941, p. 201; Uffizi, Arch. 1819, a plan project by an earlier architect with jottings by Michelangelo, published and discussed by Popp, 1927, p. 413ff.).

Rome, Systematization of Trajan's Column, 1558 (Gnoli, Nuova antologia, XC, 1886, p. 542ff.; Lanciani, 1902, II, p. 125).

Rome, Triple Stairway from the Piazza Venezia to the Quirinal, 1558 (R. Ancel, 'Le Vatican sous Paul IV', *Rev. Bénédictine*, XXV, 1908, p. 70 n.).

Florence, Ponte Santa Trinita (designed 1560?), 1567-72 (Gaye, III, p. 29; Nachlass, I, p. 559).

Rejected Attributions

Rome, Sapienza, 1514–20. Marmirolo, Gonzaga Villa, 1523.

Catalogue of Michelangelo's Works · 335

Civitavecchia, Upper Portion of the Fortress Keep, 1535. Rome, Porta del Popolo, 1561-4. Porta San Giovanni, c. 1580. Fortress of San Michele at the Tiber Mouth, 1560-70. Rome, Sant' Andrea della Valle, Strozzi Chapel, before 1616.

BIBLIOGRAPHY

For abbreviations see pp. 289-290

Ackerman, James S.

- (1954), *The Cortile del Belvedere* (Studi e documenti per la storia del Palazzo Apostolico Vaticano, III), Vatican.
- (1954 bis), 'Architectural Practice in the Italian Renaissance', Journal of the Society of Architectural Historians, XIII, pp. 3-11.
- (1956), Review of H. Siebenhüner's Das Kapitol in Rom, Art Bulletin, XXXVIII, pp. 53-7.
- (1957), 'Marcus Aurelius on the Capitoline Hill', Renaissance News, X, pp. 69-75.

Alker, H. R.

- (1920), Die Portalfassade von St Peter nach dem Michelangelo-Entwurf, dissertation (manuscript), Karlsruhe.
- (1921), 'Das Michelangelo-Modell zur Kuppel von St Peter in Rom', Repertorium für Kuntstwissenschaft, XLIII, pp. 98-9.
- Ancel, D. René

(1908), 'Le Vatican sous Paul IV', *Revue Bénédictine*, XXV, pp. 48-71. Apolloni Ghetti, Bruno M.

- (1934), Opere architettoniche di Michelangelo a Firenze (I monumenti italiani, II), Rome.
- (et al.) (1951), Esplorazioni sotto la confessione di San Pietro in Vaticano, Vatican, 2 vols.

Appolloni, A.

Arrigoni, Paolo and Bertarelli, A.

Arslan, W.

- Ashby, T.
 - (1904), 'Sixteenth Century Drawings of Roman Buildings Attributed to Andreas Coner', *Papers of the British School at Rome*, II, pp. 1-96.
 - (1916), Topographical Study in Rome in 1581, London.
 - (1927), 'The Capitol in Rome: its History and Development', Town Planning Review, XII, pp. 159-73.

^{(1912), &#}x27;Vicende e restauri della statua equestre di Marco Aurelio', Atti e Memorie della R. Accademia de San Luca, II, pp. 1-24.

^{(1939),} Piante e vedute di Roma e del Lazio conservate nella raccolta delle stampe e disegni, Milan.

^{(1926-7), &#}x27;Forme architettoniche civili di Giacomo della Porta', Bollettino d'Arte, VI, pp. 508-28.

338

Atti del Convegno di Studi Michelangioleschi, Firenze, 1964.

(1966), Rome. (Articles by G. de Angelis d'Ossat, L. Moretti, R. Pane, A. Parronchi and P. Portoghesi.)

Baglione, Giovanni

(1642), Le vite de' pittori scultori et architetti ..., Rome.

Bardeschi-Ciulich, Lucilla

(1977), 'Documenti inediti su Michelangelo e l'incarico di San Pietro', *Rinascimento*, XVII, pp. 235-75.

Barocchi, Paola

(1962-4), Michelangelo e la sua scuola, I, II, Disegni di Casa Buonarroti e degli Uffizi, III, Disegni dell' Archivio Buonarroti, Florence.

Bartoli, A.

(1914–22), I monumenti antichi di Roma nei disegni degli Uffizi di Firenze, Rome, 6 vols.

Bartoli, Cosimo

(1567), Ragionamenti accademici, Venice.

Battisti, E.

(1961), 'Disegni cinquecenteschi per San Giovanni dei Fiorentini', *Quaderni dello Istituto di Storia dell'Architettura*, ser. vi-vii, fasc., 31-48, Rome, pp. 185-94.

Beltrami, Luca

(1901), 'Michelangelo e la facciata di San Lorenzo in Firenze: Disegno e note inediti', *Rassegna d'Arte*, I, pp. 67-72.

(1929), La cupola vaticana, Vatican.

Berenson, Bernard

(1938), The Drawings of the Florentine Painters, 2nd ed., Chicago. Bertolotti, A.

(1875), 'Documenti intorno a Michelangelo Buonarroti trovati ed esistenti in Roma', Archivio storico-artistico, archeologico, e lettarario della città e provincia di Roma, I, pp. 74-6.

Bianchini, Francesco

(1703), De kalendario et cyclo Caesaris ... dissertationes duae ... his accessit enarratio ... de nummo et gnomone Clementino, Rome.

Boffito, Giuseppe and Mori, A.

(1926), Piante e vedute di Firenze, Florence.

Bonanni, Philippo

(1699), Numismata Pontificum Romanorum, Rome, 2 vols.

Bonelli, Renato

(1960), Da Bramante a Michelangelo, Venice.

Borgatti, M.

(1931), Castel Sant' Angelo in Roma, Rome.

Bourdon, Pierre

(1907), 'Un plafond du Palais Farnèse', École française de Rome: Mélanges d'archéologie et d'histoire, XXVII, pp. 3-22. Bourdon, Pierre and Laurent-Vibert, Robert

(1909), 'Le palais Farnèse d'après l'inventaire de 1653', École française de Rome: Mélanges d'archéologie et d'histoire, XXIX, pp. 145-98.

Brinckmann, A.E.

(1921), 'Das Kuppelmodell für San Pietro in Rom', Repertorium für Kunstwissenschaft, XLIII, pp. 92-7.

Brockhaus, Heinrich

(1909), Michelangelo und die Medici-Kapelle, 1st ed., Leipzig.

Broglie, R. de

(1953), Le palais Farnèse, Paris.

Bruschi, Arnaldo

(1979), 'Michelangelo in Campidoglio e l'invenzione' dell'ordine gigante', Storia Architettura, IV, p. 7ff.

Buddensieg, Tilman

(1969), 'Zum Statuenprogramm im Kapitolsplan Pauls III', Zeitschrift für Kunstgeschichte, XXX, p. 177f.

Buonarroti, Michelangelo

(1960), Rime, a cura di Enzo N. Girardi, Bari.

Burckhardt, Jacob

(1912), Geschichte der Renaissance in Italien, 5th ed., Esslingen.

Burger, Fritz

(1908), 'Uber zwei Architekturzeichnungen Michelangelos in der Casa Buonarroti in Florenz', *Repertorium für Kunstwissenschaft*, XXXI, pp. 101-7.

Burns, Howard

(1979), 'San Lorenzo in Florence Before the Building of the Old Sacristy: An Early Plan', *Mitteilungen des Kunsthistorischen Institutes* in Florenz, XXIII, pp. 145-54.

Caflisch, N.

(1934), Carlo Maderno, Munich.

Cecchelli, Carlo

(1925), Il Campidoglio, Rome, Milan.

(1944), 'Il Campidoglio nel medio evo e nella rinascità', Archivio della R. Dep. romana di storia patria, LXVII, pp. 209-32.

Chastel, André, et al.

(1981), Le Palais Farnèse: École française de Rome, Rome.

Clausse, Gustave

(1900-1902), Les San Gallo: Architectes, peintres, sculpteurs, médailleurs, XV^e et XVI^e siècles, 3 vols., Paris.

Clements, Robert J.

(1961), Michelangelo's Theory of Art, New York.

Coolidge, John

(1942), 'Vignola, and the Little Domes of St Peter's', Marsyas, II, pp. 63-123.

(1948), 'The Arched Loggie on the Campidoglio', Marsyas, IV, pp. 69-79.

340

Corti, G., and Parronchi, A.

(1964), 'Michelangelo al tempo dei lavori di San Lorenzo in una "ricordanza" del Figiovanni', *Paragone*, 175, pp. 9-31.

Dal Poggetto, Paolo

(1979), I disegni murali di Michelagniolo e della sua scuola nella Sagrestia Nuova di San Lorenzo, Florence.

Davis, Charles

(1975), 'Cosimo Bartoli and the Portal of Sant'Appolonia by Michelangelo', *Mitteilungen des Kunsthistorischen Institutes in Florenz*, XIX, pp. 261-76.

De Angelis d'Ossat, G.

(1966), 'Un sconosciuto modello di Michelangelo per S. Maria del Fiore', Arte in Europa. Scritti di Storia dell'arte in onore di Edoardo Arslan, Milan, pp. 501-4.

De Angelis d'Ossat, G., and Pietrangeli, C.

(1965), Il Campidoglio di Michelangelo, Milan.

De Maio, Romeo

(1977), 'Michelangelo e il cantiere di San Pietro', *Civiltà delle macchine*, XXV, pp. 115-20.

de' Rossi, G.G.

(n.d.), Disegni di vari altari e cappelle ... di Roma, Rome.

Di Stefano

(1963), La cupola di San Pietro: storia della costruzione e dei restauri, Naples.

D'Onofrio, Cesare

(1957), Le fontane di Roma, Rome.

Dorez, Léon

(1917; 1918), 'Nouvelles recherches sur Michel-Ange et son entourage', Bibliothèque de l'École des Chartes, LXXVIII, pp. 448-70; LXXIX, pp. 179-220.

Dougill, W.

(1927), 'The Present Day Capitol', *Town Planning Review*, XII, pp. 174-80.

Dussler, Luitpold

(1959), Die Zeichnungen des Michelangelo; kritischer Katalog, Berlin.

Egger, Hermann

(1911-32), *Römische Veduten*, I, Vienna, Leipzig, II, Vienna. (In the second edition of volume I, published in 1932, the plate numbering differs from the first edition, which is cited here.)

(1935), 'Turris campanaria Sancti Petri', Mededeelingen van het Nederlandsch historisch Instituut te Rome, 2nd ser., V, pp. 59-82.

Ehrle, Francesco

(1908), Roma prima di Sisto V (the Dupérac-Lafreri Rome plan of 1577), Rome.

Ehrle, Francesco-contd.

- (1911), *Roma al tempo di Giulio III* (the Bufalini Rome plan of 1551), Rome.
- (1932), Roma al tempo di Clemente VIII (the A. Tempesta Rome plan of 1593), Vatican.

Elam, Caroline

- (1979), 'The Site and Early Building History of Michelangelo's New Sacristy', *Mitteilungen des Kunsthistorischen Institutes in Florenz*, XXIII, pp. 155-86.
- (1981), 'The Mural Drawings in Michelangelo's New Sacristy', Burlington Magazine, CXXIII, pp. 593-602.
- Ettlinger, L. D.

(1978), 'The Liturgical Function of Michelangelo's Medici Chapel', Mitteilungen des Kunsthistorischen Institutes in Florenz, XXII, pp. 287-304.

Fasolo, Vincenzo

- (1923-4), 'La Cappella Sforza di Michelangelo', Architettura e arti decorative, III, pp. 433-54.
- (1926-7), 'Disegni architettonici di Michelangelo', Architettura e arti decorative, VI, pp. 385-401; pp. 433-55.

(1965), Michelagniolo architettor poeta, Genoa.

Ferrerio, P.

(1665?), Palazzi di Roma de' più celebri architetti, Rome.

Ferri, P. N.

(1885), Indici e cataloghi, III: Disegni di architettura esistenti nella R. Galleria degli Uffizi in Firenze, Rome.

(1904), 'Disegni e stampe del secolo XVI riguardanti la basilica di San Pietro a Roma', *Rassegna d'Arte*, IV, No. 6, pp. 91-4.

Ferri, P. N., and Jacobson, E.

- (1903), 'Desegni sconosciuti di Michelangelo', Miscellanea d'Arte, I, pp. 73-87.
- (1904), 'Nuovi disegni sconosciuti di Michelangelo', *Rivista d'Arte*, II, pp. 25-37.
- (1905), Neuentdekte Michelangelo-Zeichnungen in den Uffizien zu Florenz, Leipzig.

Fichard, J.

(1815), 'Italia', Frankfürtisches Archiv für ältere deutsche Literatur und Geschichte, III, pp. 48ff.

Fontana, Carlo

(1694), Templum Vaticanum ..., Rome.

Fontana, D.

(1589), Del modo tenuto nel trasportare l'obelisco vaticano e delle fabbriche fatte da N. S. Sisto V, Libro primo, Rome.

Förster, Otto H.

(1956), Bramante, Vienna-Munich.

Francia, Ennio

(1977), 1506-1606: Storia della costruzione di San Pietro, Rome. Frankl, Paul

(1914), Die Entwicklungsphasen der neueren Baukunst, Leipzig-Berlin. Frey, Dagobert

- (1915), Bramante-Studien, I: Bramantes St. Peter-Entwurf und seine Apokryphen, Vienna.
- (1920), Michelangelo-Studien, Vienna.
- (1922), 'Eine unbeachtete Zeichnung nach dem Modell Michelangelos für die Fassade von San Lorenzo', *Kunstchronik und Kunstmarkt*, N. F., XXXIV, pp. 221-8.
- (1923), Michelangelo Buonarroti architetto, Rome.
- Frey, Hermann-Walther
 - (1951), 'Zur Entstehungsgeschichte des Statuenschmuckes der Medici-Kapelle in Florenz', Zeitschrift für Kunstgeschichte, XIV, pp. 40-96.

Frey, Karl

- (1895), 'Studien zu Michelagniolo I', Jahrbuch der königlichen preuszischen Kunstsammlungen, XVI, pp. 91-103.
- (1896), 'Studien zu Michelagniolo II', Jahrbuch der königlichen preuszischen Kunstsammlungen, XVII, pp. 5-18; 97-119.
- (1907), Michelagniolo Buonarroti; Quellen und Forschungen zu seiner Geschichte und Kunst, Berlin.
- (1909), 'Studien zu Michelagniolo Buonarroti und zur Kunst seiner Zeit', Jahrbuch der königlichen preuszischen Kunstsammlungen, Beiheft zum XXX, pp. 103-80.
- (1909-11), Die Handzeichnungen Michelagniolos Buonarroti, 3 vols., Berlin, supplemented by F. Knapp, Nachtrag zu den von K. Frey herausgegebenen drei Bänden, Berlin, 1925.
- (1911), 'Zur Baugeschichte des St. Peter', Jahrbuch der königlichen preuszischen Kunstsammlungen, Beiheft zum XXXI, pp. 1-95.
- (1913), 'Zur Baugeschichte des St. Peter', Jahrbuch der königlichen preuszischen Kunstsammlungen, Beiheft zum XXXIII, pp. 1-153.

(1916), 'Zur Baugeschichte des St. Peter', Jahrbuch der königlichen preuszischen Kunstsammlungen, Beiheft zum XXXVII, pp. 22-135.

Frommel, Christoph Luitpold

- (1967), 'S. Eligio und die Kuppel der Cappella Medici', *Stil und Überlieferung in der Kunst des Abendlandes* (Akten des 21 Internationalen Kongresses für Kunstgeschichte in Bonn, 1964), vol. II, Berlin, pp. 41-54.
- (1973), Der römische Palastbau der Hochrenaissance (Römische Forschungen der Bibliotheca Hertziana, 21), Tübingen, 3 vols.
- (1977), 'Cappella Julia. Die Grabkapelle Papst Julius II in Neu-St.-Peter', Zeitschrift für Kunstgeschichte, p. 26ff.

^{(1914),} Die Briefe des Michelagniolo Buonarroti, Berlin.

Frommel, Christoph Luitpold-contd.

(1979), Michelangelo und Tommaso dei Cavalieri, Amsterdam.

(1981), 'Sangallo et Michel-Ange (1530-1550)', Le Palais Farnese: École Française de Rome, Rome, pp. 127-224.

Frommel, Christoph Luitpold; Ray, Stefano; and Tafuri, Manfredo, eds. (1984), *Raffaello Architetto*, Milan.

Frutaz, Amato P.

(1956), Piante e vedute di Roma e del Vaticano dal 1300 al 1676 (Studi e documenti per la storia del Palazzo Apostolico Vaticano, I), Vatican.

Fulvio, A.

(1588), L'antichità di Roma di Andrea Fulvio con le aggiuntioni e annotationi di Girolamo Ferrucci, Venice.

Gaudioso, Eraldo

(1976), Michelangelo e l'edicola di Leone X: Mostra didattica fotografica, Catalogo, Rome.

Gaye, Giovanni

(1839-40), Carteggio inedito d'artisti dei secoli XIV-XVI, Florence, 3 vols.

Geymüller, Heinrich von

(1875), Les projets primitifs pour la basilique de Saint-Pierre de Rome, Paris-Vienna, 2 vols.

(1904), Michelagnolo Buonarroti als Architekt nach neuen Quellen, vol. VIII of Die Architektur der Renaissance in Toscana, Munich.

Gioseffi, Decio

(1960), La cupola vaticana; un'ipotesi michelangiolesca (Ist. di storia dell'arte antica e moderna, 10), Università degli studi di Trieste.

Giovannoni, Gustavo

(1921-2), 'Tra la cupola di Bramante e quella di Michelangelo', Architettura e arti decorative, I, pp. 418-38. (Republished in the author's Saggi ..., pp. 145-76.)

(1935), Saggi sull' architettura del Rinascimento, 2nd ed., Milan.

(1941), 'Spigolature nell'archivio di San Pietro in Vaticano', Istituto di studi romani; quaderno II (Storia dell'architettura).

(1959?) Antonio da Sangallo il giovane, 2 vols, Rome.

Gnoli, Umberto

(1937), 'Le palais Farnèse (notes et documents)', École française de Rome: Mélanges d'archéologie et d'histoire, LIV, Fasc. I-IV, pp. 200-210.

Goez, Werner

(1963), 'Annotationes zu Michelangelo's Mediceergräbern', Festschrift für Harald Keller, Darmstadt, pp. 235-54.

Gotti, Aurelio

(1875), Vita di Michelangelo Buonarroti ..., 2 vols, Florence. Gramberg, Werner

(1964), Die düsseldorfer Skizzenbücher des Guglielmo della Porta, 2 vols, Berlin.

Gronau, Georg

- (1911), 'Dokumente zur Entstehungsgeschichte der neuen Sakristei und der Bibliothek von San Lorenzo in Florenz', Jahrbuch der königlichen preuszischen Kunstsammlungen, Beiheft zum XXXII, pp. 62-81.
- (1918), 'Über zwei Skizzenbücher des Guglielmo della Porta in der Düsseldorfer Kunstakademie', Jahrbuch der königlichen preuszischen Kunstsammlungen, XXXIX, pp. 171-200.
- Guasti, Cesare
 - (1857), La cupola di Santa Maria del Fiore illustrata con i documenti dell' archivio dell'opera secolare, Florence.
- Guglielmotti, Alberto
 - (1887, 1893), 'Storia delle fortificazioni nella spiaggia romana risarcite e accresciute dal 1560 al 1570' (vols V, X of *Storia della marina pontificia*), Vatican.

Hagelberg, L.

- (1931), 'Die Architektur Michelangelos in ihren Beziehungen zu Manierismus und Barock', *Münchner Jahrbuch der bildenden Kunst*, N. F., VIII, pp. 264-80.
- Hartt, Frederick
 - (1971), Michelangelo Drawings, New York.
- Hedberg, Gregory

(1972), 'The Farnese Courtyard Windows and the Porta Pia. Michelangelo's Creative Process', Marsyas 15 (1970-72) p. 63ff.

Hess, Jacob

(1961), 'Die päpstliche Villa bei Araceli', *Miscellanea Bibliothecae Hertzianae* (Röm. Forsch, der Bibl. Hertziana, xvi), Munich, pp. 239-54-

Heydenreich, L. H. and Lotz, W.

(1974), Architecture in Italy, 1400-1600, Harmondsworth.

Hibbard, Howard

(1967), 'Maderno, Michelangelo, and Cinquecento Tradition', *Stil und Überlieferung in der Kunst des Abendlandes* (Akten des 21 Internationalen Kongresses für Kunstgeschichte in Bonn, 1964), vol. II, Berlin, pp. 35-40.

Hirst, Michael

(1972), 'Addenda Sansoviniana', Burlington Magazine, CXIV, pp. 162-5.

(1974), 'A Note on Michelangelo and the Attic of St Peter's', Burlington Magazine, CXVI, p. 662ff.

Hofmann, Theobald

(1928), Entstehungsgeschichte des St Peter in Rom, Zittau.

Hubala, Erich

(1964), 'Michelangelo und die florentiner Baukunst', Michelangelo Buonarroti, Würzburg, pp. 157-80.

Hubala, Erich-contd.

(1965) 'Eine Anmerkung zu Michelangelo's Grundrissskizze für die Medici-Kapelle in Florenz', *Kunstchronik*, XVIII, pp. 37-42.

Huelsen, C., and Egger, H.

(1913, 1916), Die romischen Skizzenbücher von Marten van Heemskerk, Berlin, I, 1913; II, 1916.

Insolera, Italo

(1980), Roma. Immagine e realtà dal X al XX secolo, Bari.

Jackson, Robert S.

(1968), 'Michelangelo's Ricetto of the Laurentian Library: a Phenomenology of the Alinari Photograph', *The Art Journal*, XXVIII, p. 57f.

Jacobsen, Emil

(1904), 'Die Handzeichnungen der Uffizien in ihren Beziehungen zu Gemälden, Skulpturen und Gebäuden in Florenz', *Repertorium für Kunstwissenschaft*, XXVII, pp. 113-32; 251-60; 322-31; 401-29.

Joannides, Paul

(1972), 'Michelangelo's Medici Chapel: Some new Suggestions', Burlington Magazine, CXIV, pp. 541-51.

(1978), Review of Charles de Tolnay, Disegni di Michelangelo nelle collezioni italiani, Art Bulletin, LVIII, pp. 172-7.

(1981), Review of Charles de Tolnay, Corpus dei disegni di Michelangelo, Art Bulletin, LXIII, pp. 679-87.

Keller, Fritz-Eugen

(1976), 'Zur Planung am Bau der römischen Peterskirche im Jahre 1564-1565', Jahrbuch der berliner Museen, XVIII, pp. 24-50.

Keller, Harald

(1977), 'Michelangelo als Bauplastiker', Festschrift W. Braunfels, Tübingen, pp. 177-99.

Kiel, Hanna

(1977), 'San Lorenzo: neue Beiträge zu Michelangelo. Die architektonischen Wandzeichnungen in der Apsis der Sagrestia Nuova', *Pantheon*, XXV, p. 167f.

Körte, Werner

- (1932), 'Zur Peterskuppel des Michelangelo', Jahrbuch der preuszischen Kunstsammlungen, LIII, pp. 90-112.
- (1932 bis), Review of Luca Beltrami, La cupola vaticana, Zeitschrift für Kunstgeschichte, I, pp. 161-2.
- (1933), 'Giacomo della Porta', *Allgemeines Lexikon der bildenden Künstler*, XXVII, Leipzig.

Kriegbaum, F.

(1941), 'Michelangelo et il Ponte a S. Trinita', *Rivista d'Arte*, XXIII, pp. 137-44.

346

Künzle, P.

- (1956), Review of H. Siebenhüner, Das Kapitol in Rom, Mitteilungen des Institut für österreichische Geschichtsforschung, LXIV, pp. 349-51.
- (1961), 'Die Aufstellung des Reiter vom Lateran durch Michelangelo', *Miscellanea Bibliothecae Hertzianae* (Röm. Forsch. der Bibl. Hertziana, xvi), Munich, pp. 255-70.

Lanciani, R.

(1902-12), Storia degli scavi di Roma e notizie intorno le collezioni romane di antichità, Rome, 4 vols.

Letarouilly, P.

(1849-66), Édifices de Rome moderne, Liège, 3 vols.

Limburger, Walther

(1910), Die Gebäude von Florenz: Architekten, Strassen und Plätze in alphabetischen Verzeichnissen, Leipzig.

Linnenkamp, Rolf

(1980), 'Michelangelos Entwurf für das Steinmuster auf dem Kapitol in Rom', *Weltkunst*, 50, xii, p. 1846ff.

Lotz, Wolfgang

- (1955), 'Die ovalen Kirchenräume des Cinquecento', *Römisches Jahrbuch für Kunstgeschichte*, VII, pp. 7–99.
- (1956), 'Das Raumbild in der italienischen Architekturzeichnung der Renaissance', Mitteilungen des kunsthistorischen Institutes in Florenz, VII, pp. 193-226.
- (1958), 'Architecture in the Later 16th Century', College Art Journal, XVII, pp. 129-39.
- (1967), 'Zu Michelangelos Kopien nach dem Codex Coner', *Stil und Überlieferung in der Kunst des Abendlandes* (Akten des 21 Internationalen Kongresses für Kunstgeschichte in Bonn, 1964), vol. II, Berlin.
- (1968), 'Italienische Plätze des 16. Jahrhunderts,' Jahrbuch der Max-Planck Gesellschaft, pp. 41-58.

(1981), 'Vignole et Giacomo della Porta (1550–1589)', Le Palais Farnèse: École française de Rome, Rome, pp. 225–41.

Lowry, Bates

(1958), 'High Renaissance Architecture', College Art Journal, XVII, pp. 115-28.

Luporini, Eugenio

(1957, 1958), 'Un libro di disegni di Giovanni Antonio Dosio', Critica d'Arte, N.S., IV, pp. 442-67; N.S., V, pp. 43-72.

MacDougall, Elizabeth

(1960), 'Michelangelo and the Porta Pia', Journal of the Society of Architectural Historians, XIX, pp. 97-108.

Machiavelli, N.

(1929), 'Relazione di una visita fatta per fortificare Firenze', L'arte della guerra e scritti militari minori, Florence, p. 207.

Mackowsky, Hans

(1925), Michelagniolo, 4th ed., Berlin.

Manetti, Renzo

(1980), Michelangiolo: le fortificazioni per l'assedio di Firenze, Florence. Marchini, Giuseppe

(1956), 'Quattro piante per il San Pietro di Roma', *Bollettino d'Arte*, XLI, pp. 313-17.

(1976), 'Le finestre "inginocchiate" ', Antichità viva, XV, 1, pp. 24-31.

(1976*), 'Postilla alle "finestre inginocchiate"', Antichità viva, XV, 5, pp. 27-8.

- (1977), 'Il ballatoio della cupola di Santa Maria del Fiore', Antichità viva, XVI, 6, pp. 36-47.
- Marcuard, F. von

(1901), Die Zeichnungen Michelangelos im Museum Teyler zu Haarlem, Munich.

Mariani, Valerio

(1943), Michelangelo e la facciata di San Pietro, Rome.

Meliù, A.

(1950), Santa Maria degli Angeli alle Terme di Diocleziano, Rome.

Meller, Simon

(1909), 'Zur Entstehungsgeschichte des Kranzgesimses am Palazzo Farnese in Rom', *Jahrbuch der königlichen preuszischen Kunstsammlungen*, XXX, pp. 1–8.

Metternich, Franz Graf Wolff

(1965), 'Eine Vorstufe zu Michelangelo's Sankt-Peter Fassade', Festschrift für H. von Einem, Berlin, pp. 162-70.

Millon, Henry

(1979), 'A Note on Michelangelo's Façade for a Palace for Julius III in Rome. New Documents for the Model', *Burlington Magazine*, pp. 770-77.

Millon, Henry, and Smyth, Craig H.

(1969), 'Michelangelo and St Peter's, I ...', Burlington Magazine, CXI, no. 799, pp. 484-501.

- (1975), 'A Design by Michelangelo for a City Gate. Further Notes on the Lille Sketch', *Burlington Magazine*, pp. 162-6.
- (1976), 'Michelangelo and St Peter's. Observations on the Interior of the Apses, a Model of the Apse Vault, and Related Drawings', *Römisches Jahrbuch für Kunstgeschichte*, XVI, p. 137ff.

Nava, Antonia

- (1936), 'La storia della chiesa di San Giovanni dei Fiorentini nei documenti del suo archivio', Archivio della R. deputazione romana di storia patria, LIX, pp. 337-62.
- (1935-6), 'Sui disegni architettonici per San Giovanni dei Fiorentini in Roma', *Critica d'Arte*, I, pp. 102-8.

Navenne, F. de

(1895), 'Les origines du palais Farnèse à Rome', *Revue des deux mondes*, 4^e pér., CXXXI, pp. 382-406.

(1914), Rome. Le palais Farnèse et les Farnèse, Paris.

Orbaan, J. A. F.

- (1917), 'Zur Baugeschichte des Peterskuppel', Jahrbuch der königlichen preuszishen Kunstsammlungen, Beiheft zum XXXVIII, pp. 189-207.
- (1919), 'Der Abbruch Alt-Sankt-Peters 1605-15', Jahrbuch der königlichen preuszischen Kunstsammlungen, Beiheft zum XXXIX, pp. 1-139.
- Paatz, Walter and Elizabeth
 - (1952-5), Die Kirchen von Florenz, 2nd printing, Frankfurt am Main, 6 vols.

Pagliara, P. L.

(1976) 'Due documenti per l'architettura del '500 a Roma', B.S.A.: ricerche di storia dell'arte, 1-2, pp. 257-63.

Panofsky, Erwin

- (1920-21), 'Bemerkungen zu D. Frey's "Michelangelostudien"', Archiv für Geschichte und Ästhetik der Architektur als Anhang zu Wasmuths Monatshefte für Baukunst, V, pp. 35-45.
- (1922), 'Die Treppe der Libreria di San Lorenzo', Monatshefte für Kunstwissenschaft, XV, pp. 262-74.
- (1923), 'Die Michelangelo-Literatur seit 1914', Wiener Jahrbuch für Kunstgeschichte, I (XV), Buchbesprechungen, cols.1-64.

(1924), Idea ..., Leipzig, Berlin.

- (1927), 'Bemerkungen zu der Neuherausgabe der haarlemer Michelangelo-Zeichnungen durch Fr. Knapp', *Repertorium für Kunstwissenschaft*, XLVIII, pp. 25-58.
- Papini, G.

(1949), Vita di Michelangelo, Florence.

Parker, K. T.

(1956), Catalogue of the Collection of Drawings in the Ashmolean Museum, II, Italian Schools, Oxford.

Parronchi, A.

(1968), 'Una ricordanza del Figiovanni sui lavori della cappella e della libreria Medici', *Opere giovanili di Michelangelo*, Florence, pp. 165-87 (version of the author's paper in *Atti del Convegno*, 1966).

Pasquinelli, Pio

(1925), 'Ricerche edilizie su Santa Maria degli Angeli', Roma, III, pp. 349-56; 395-407.

(1932, 1935), 'Santa Maria degli Angeli: la chiesa di Michelagniolo nelle Terme Diocleziane', Roma, pp. 152ff.; 257ff.

Pastor, Ludwig von

^{(1885-1933),} Geschichte der Päpste seit dem Ausgang des Mittelalters, Freiburg im Breisgau.

Pastor, Ludwig von-contd.

(1922), Sisto V, creatore della nuova Roma, Rome.

Pecchiai, P.

(1950), Il Campidoglio nel Cinquecento sulla scorta dei documenti, Rome.

(1952), Il Gesù di Roma, Rome.

Pietrangeli, Carlo

(1976), Guide rionali di Roma: Rione X: Campitelli, II (Guida del Campidoglio), Rome.

Pirri, Pietro

(1941), 'La topografia del Gesù di Roma e le vertenze tra Muzio Muti e S. Ignazio', Archivum historicum societatis Iesu, X, pp. 177-217.

Podestà, B.

(1875), 'Documenti inediti relativi a Michelangelo Buonarroti', *Il Buonarroti*, X, pp. 128-37.

Pollak, Oskar

(1915), 'Ausgewählte Akten zur Geschichte der römischen Peterskirche (1535–1621)', Jahrbuch der königlichen preuszischen Kunstsammlungen, Beiheft zum XXXVI, pp. 21–117.

Pommer, R.

(1957), 'Drawings for the Façade of San Lorenzo by Giuliano da Sangallo', unpublished thesis, New York University.

Popham, A. E., and Wilde, J.

(1953), Summary Catalogue of Exhibition of Drawings by Michelangelo, London (British Museum).

Popp, Anny E.

(1922), Die Medici-Kapelle Michelangelos, Munich.

(1927), 'Unbeachtete Projekte Michelangelos', Münchner Jahrbuch der bildenden Kunst, N.S., IV, pp. 389-477.

Portoghesi, P.

- (1964), 'Michelangelo fiorentino', Quaderni dello Istituto di storia dell' architettura, XL, 62, pp. 27-60.
- (1967), 'La biblioteca laurenziana e la critica michelagniolesca alla tradizione classica', *Stil und Überlieferung in der Kunst des Abendlandes* (Akten des 21 Internationalen Kongresses für Kunstgeschichte in Bonn, 1964), vol. II, Berlin 3-11.

Portoghesi, P., and Zevi, B., eds.

(1964), Michelagniolo Architetto, Turin.

Prater, Andreas

(1979), 'Michelangelos Medici-Kapelle: "ordine composta" als Gestaltungsprinzip von Architektur und Ornament', *Schriften aus dem Athenaion des Salzburger archäologischen Institutes*, ed. Hans Walter, Waldsassen.

Puppi, Lionello

^{(1980), &#}x27;Prospetto di palazzo e ordine gigante nell'esperienza architettonica del '500', Storia dell'arte, 38/40, pp. 267-77.

Ray, Stefano

(1973), 'II recinto, il vuoto, la luce: l'autobiografia neo-platonica nell'architettura di Michelangelo', *Architettura*, 19, December, pp. 478-86.

Reymond, M., and C.-M.

(1922), 'Vanvitelli et Michel-Ange à Sainte Marie-des-Anges', Gazette des Beaux-Arts, 5^e sér., VI, pp. 195-217.

Ricci, Corrado

(1900), Michelangelo, Florence.

(1906), Cento vedute di Firenze, Florence.

(1909), 'Sta Maria degli Angeli e le Terme Diocleziane', Bollettino d'Arte, III, pp. 361-72; 401-5.

Rocchi, Enrico

(1902), Le piante icnografiche e prospettiche di Roma del secolo XVI, Turin, Rome.

(1908), Le fonti storiche dell'architettura militare, Rome.

Rodocanachi. E.

(1904), Le capitole romain antique et moderne, Paris.

Rose, Hans

(1924), 'Michelangelo als Architekt von St Peter', Münchner Jahrbuch der bildenden Kunst, N.F., I, pp. 304-6.

(1925), Commentary to H. Wölffin, Renaissance und Barok, 4th ed., Munich.

Rossi, Giuseppe Ignazio

(1739), La libreria mediceo-laurenziana architettura di Michelagnolo Buonarruoti, Florence.

Rufini, Mons. Emilio

(1957), S. Giovanni de' Fiorentini (Le chiese di Roma illustrate, No. 39), Rome.

Saalman, Howard

(1975), 'Michelangelo. S. Maria del Fiore and St Peter's', Art Bulletin, LVII, p. 374ff.

(1977), 'Michelangelo at Santa Maria del Fiore: An Addendum', Burlington Magazine, CXIX, p. 852f.

(1985), 'The New Sacristy of San Lorenzo Before Michelangelo', Art Bulletin, LXVII, pp. 199-228.

Saxl, F.

(1957), 'The Capitol during the Renaissance: A Symbol of the Imperial Idea', Lectures, London, pp. 200-214.

Schiavo, Armando

(1949), Michelangelo architetto, Rome.

(1952), 'La cupola di St. Pietro', Bollettino del Centro studi di storia dell' architettura, no. 6, pp. 14-26.

(1953), La vita e le opere architettoniche di Michelangelo, Rome.

Schiavo, Armando-contd.

- (1954), Santa Maria degli Angeli alle Terme, Rome (reprinted from Bollettino del centro studi di storia dell'architettura, no. 8).
- (1960), San Pietro in Vaticano, forme e strutture (Quaderni di storia dell'arte, IX), Rome.
- (1961), 'll modello della cupola di San Pietro nel suo quarto centenario', *Studi romani*, IX, pp. 519-32.
- (1965), 'Questioni anagrafe e techniche sul modello della cupola di S. Pietro', *Studi romani*, XIII, pp. 303-27.
- (1966), 'Autografi di Michelangelo nell'Archivio della Fabbrica di San Pietro', *Strenna dei romanisti*, Rome, pp. 426-31.
- (1966), 'Uno sconosciuto disegno di Michelangelo per la cappella Sforza di S.M. Maggiore', *Studi romani*, XIV, pp. 179-82.

Schmarsow, August

(1888), 'Aus dem Kunstmuseum der Schule zu Rugby', Jahrbuch der königlichen preuszischen Kunstsammlungen, IX, pp. 132-6.

Schottmüller, Frida

(1927), 'Michelangelo und das Ornament', Jahrbuch der kunsthistorischen Sammlungen in Wien, N.F., II, pp. 219-32.

Schüller-Piroli

(1950), 2000 Jahre St Peter, Olten.

Schwager, Klaus

- (1973), 'Die Porta Pia in Rom: Untersuchungen zu einem verrufenen Gebäude', Münchner Jahrbuch der bildende Kunst, XXIV, pp. 33-96.
- (1975), 'Giacomo della Portas Herkunft und Anfänge in Rom', *Römisches Jahrbuch für Kunstgeschichte*, XV, p. 109ff.
- (1975), 'Ein Ovalkirchen-Entwurf Vignolas für San Giovanni dei Fiorentini', *Festschrift für Georg Scheja*, Sigmaringen, pp. 151-78.

Scully, Vincent, jun.

- (1952), 'Michelangelo's Fortification Drawings, a Study in the Reflex Diagonal', *Perspecta*, I, pp. 38-45.
- Sedelmayr, Hans
 - (1931), 'Die Area Capitolina des Michelangelo', Jahrbuch der preuszischen Kunstsammlungen, LII, pp. 176-81.
 - (1934), 'Das Kapitol des Della Porta', Zeitschrift für Kunstgeschichte, III, pp. 264-74.

Serlio, Sebastiano

(1584), Tutte l'opere d'architettura, Venice.

Siebenhüner, Herbert

- (1952), 'Der Palazzo Farnese in Rom', *Wallraf-Richartz-Jahrbuch*, XIV, pp. 144-64.
- (1954), Das Kapitol in Rom: Idee und Gestalt (Italienische Forschungen, 3rd ser., I), Munich.
- (1955), 'S. Maria degli Angeli in Rom', Münchner Jahrbuch der bildenden Kunst, 3rd ser., VI, pp. 179-206.

Siebenhüner, Herbert-contd.

(1956), 'S. Giovanni dei Fiorentini in Rom', Kunstgeschichtliche Studien für Hans Kauffmann, Berlin, pp. 172–91.

(1961), 'Umrisse zur Geschichte der Ausstattung von St Peter in Rom ... (1547-1606)', Festschrift für Hans Sedelmayr, pp. 229-30.

Sinding Larsen, Staale

(1978), 'The Laurenziana Vestibule as a Functional Solution', Acta ad Archaeologiam et Artium Historiam Pertinentia, VIII, p. 213ff.

Spezzaferro, L., and Tuttle, R.

(1981), 'Place Farnèse: urbanisme et politique', Le Palais Farnèse: École française de Rome, Rome, pp. 85-123.

Steinmann, Ernest

(1913), Die Porträtdarstellungen des Michelangelo, Leipzig.

(1930), Michelangelo im Spiegel seiner Zeit, Leipzig.

Steinmann, Ernest and Pogatscher, Heinrich

(1906), 'Dokumente und Forschungen zu Michelangelo', Repertorium für Kunstwissenschaft, XXIX, pp. 387-424; 485-517.

Steinmann, Ernest, and Wittkower, Rudolf

(1927), Michelangelo Bibliographie 1510–1926, Leipzig.

Summers, David

(1972), 'Michelangelo on Architecture', Art Bulletin, LIV, p. 146ff.

(1981), Michelangelo and the Language of Art, Princeton.

Supino, I. B.

(1901), 'La facciata della basilica di San Lorenzo in Firenze', L'Arte, IV, pp. 245-62.

Tacchi-Venturi, Pietro

(1899), 'Le case abitate in Roma da Ignazio di Loiola secondo un inedito documento del tempo', *Studi e documenti di storia e di diritto*, XX, pp. 287-356.

(1930-51), Storia della Compagnia di Gesù in Italia, 2nd ed., Rome, 2 vols.

Tafuri, Manfredo

(1966), L'Architettura del manierismo nel Cinquecento europeo, Rome.

(1975), 'Michelangelo architetto', *Civiltà delle macchine*, XX, pp. 49-60. Thies, Harmen

(1982), Michelangelo: das Kapitol (Italienische Forschungen, Kunsthistoriochen Inst. in Florenz, XI), Munich.

Thode, Henry

(1908), Michelangelo, kritische Untersuchungen über seine Werke (Supplement), Berlin, 3 vols. (Although vol. III was published in 1913, all three volumes are designated here by 1908.)

Thoenes, C.

- (1963), 'Studien zur Geschichte des Petersplatzes', Zeitschrift für Kunstgeschichte, XXVI, pp. 97-145.
- (1965), review of Wittkower, 1963, in Kunstchronik, XVIII, pp. 9-20.

Thoenes, C.-contd.

- (1968), 'Bemerkungen zur Petersfassade Michelangelos', Munuscula Disciplinorum, Berlin, pp. 331-41.
- Tolnay, Charles de
 - (1927), 'Die Handzeichnungen Michelangelos in Codex Vaticanus', Repertorium für Kunstwissenschaft, 48, pp. 157-205.
 - (1928), 'Die Handzeichnungen Michelangelos im Archivio Buonarroti', Münchner Jahrbuch der bildenden Kunst, N.F., V, pp. 377-476.
 - (1930, 1932), 'Zu den späten architektonischen Projekten Michelangelos', Jahrbuch der preuszischen Kunstsammlungen, Part I, LI, pp. 1-48; Part II, LIII, pp. 231-53.
 - (1934), 'Michelange et la façade de St Lorenzo', Gazette des Beaux-Arts, 6^e sér., XI, pp. 24-42.
 - (1934 *bis*), 'Studi sulla capella Medicea', *L'Arte*, N.S., V, pp. 5-44, 281-307.
 - (1935), 'La bibliothèque Laurentienne de Michel-Ange', Gazette des Beaux-Arts, 6^e sér., XIV, pp. 95-105.
 - (1940), 'Michelangelo Studies', Art Bulletin, XXII, pp. 127-37.
 - (1948), The Medici Chapel, Princeton.
 - (1949), Werk und Weltbild des Michelangelo (Albae Vigiliae, N.F., VIII), Zurich.
 - (1951), Michelagniolo, Florence.
 - (1954), The Tomb of Julius II, Princeton.
 - (1954 bis), 'Un dessin inédit représentant la façade de Michel Ange de la Chapelle Sforza à Sainte Marie Majeure', Urbanisme et architecture, Études écrites et publiées en l'honneur de Pierre Lavedan, Paris.
 - (1955), 'Michelangelo architetto', Il Cinquecento, Florence.
 - (1955 bis), 'Un "pensiero" nuovo di Michelangelo per il soffitto della libreria Laurenziana', Critica d'Arte, N.S., II, pp. 237-40.
 - (1956), 'Unknown sketches by Michelangelo', *The Burlington Maga*zine, XCVIII, pp. 379-80.
 - (1960), The Final Period, Princeton.
 - (1964), The Art and Thought of Michelangelo, New York (translation of Tolnay, 1949).
 - (1965), 'A Forgotten Architectural Project by Michelangelo: The Choir of the Cathedral of Padua', *Festschrift für H. von Einem*, Berlin, pp. 247-51.
 - (1967), 'Newly Discovered Drawings Related to Michelangelo', Stil und Überlieferung in der Kunst des Abendlandes (Akten des XXI internationalen Kongresses Kunstgeschichte), II, pp. 64-8.
 - (1969), 'Nuove osservazione sulla Cappella Medici', Accad. Naz. dei Lincei, CCLXVI, no. 130, pp. 3-18.
 - (1971), 'Alcune recenti scoperte e risultate negli studi michelangioleschi,' Accad. Naz. dei Lincei, CCLXVIII, no. 153, pp. 1-24.

354

Tolnay, Charles de-contd.

(1972), 'I progetti di Michelangelo per la facciata di S. Lorenzo a Firenze: nuove ricerche,' *Commentari*, XXIII, pp. 53-71.

- (1975), I disegni di Michelangelo nelle collezioni italiani, Catalogue, Florence.
- (1975-80), Corpus dei disegni di Michelangelo, 4 vols., Novara.

(1980), Michelangelo e i Medici, Florence.

(1980*), 'La cancellata del coro dei canonici di S. Mariadel Fiore a Firenze nella versione concepita da Michelangelo: un'ipotesi', Antichità viva, XIX, pp. 32-6.

Tormò, E.

(1940), Os disenhos das antigualhas que vio Francisco d'Ollanda, Madrid. Tosi, Luigia Maria

(1927-8), 'Un modello di Baccio d'Agnolo attribuito a Michelangelo', *Dedalo*, VIII, pp. 320-28.

Uginet, F.C.

(1980), Le Palais Farnèse à travers les documents financiers (1534-1612), Rome.

Valentini, Roberto, and Zucchetti, Giuseppe

(1940-53), Codice topografico della città di Roma, Rome. (Fonti per la storia d'Italia, LXXXI, LXXXVIII, XC, XCI.)

Varchi, Benedetto

Vasari, G.

(1927), Le vite de' piu eccellenti pittori, scultori ed architetti, first edition of 1550, ed. C. Ricci, Milan, Rome.

(1962), La vita di Michelangelo nelle redazioni del 1550 e del 1568, curata e commentata da Paola Barocchi, 5 vols, Milan.

Vignola, G. Barozzio

(1602), Regola delli cinque ordini with Nuova ed ultima aggiunta delle porte d'architettura di Michel Angelo Buonaroti, Rome, 1602, 1607, Amsterdam, 1617, Siena, 1635, etc.

Wachler, Ludwig

(1940), 'Giovannantonio Dosio, ein Architekt des späten Cinquecento', Römisches Jahrbuch für Kunstgeschichte, IV, pp. 143-251.

(1953), Italian Drawings in the British Museum; Michelangelo and his Studio, London.

(1955), 'Michelangelo's Designs for the Medici Tombs', Journal of the Warburg and Courtauld Institutes, XVIII, pp. 54-66.

Winner, M.

(1967), Zeichner sehen die Antike (catalogue), Berlin.

^{(1888),} Storia fiorentina di Benedetto Varchi con i primi quattro libri e col nono secondo il codice autografo; quale fu pubblicata la prima volta per cura di Gaetano Milanesi, Florence, 3 vols.

Wilde, Johannes

Wittkower, Rudolf

- (1933), 'Zur Peterskuppel Michelangelos', Zeitschrift für Kunstgeschichte, N.F., II, pp. 348-70.
- (1934), 'Michelangelo's Biblioteca Laurenziana', Art Bulletin, XVI, pp. 123-218 (reprinted in Idea and Image, London, 1978, pp. 11-71).
- (1949), Architectural Principles in the Age of Humanism, London.
- (1962), 'La cupola di San Pietro di Michelangelo', Arte antica e moderna, XX, pp. 390-437 (translation, with revisions, of Wittkower, 1933). (Republished as a book, La cupola di San Pietro di Michelangelo, Florence, 1964, with a supplement on drawings of the dome in the Metropolitan Museum, New York; see also, Idea and Image, London, 1978, pp. 73-89.)
- (1963), editor, Disegni de le ruine di Roma e come anticamente erono, 2 vols, Milan.

Wolf, Peter

(1964-5), 'Michelangelo's Laurenziana and Inconspicuous Traditions', Marsyas, XII, pp. 16-21.

Zanghieri, Giovanni

(1953), Il Castello di Porta Pia di Michelagniolo (1564) al Vespignani (1864) e ad oggi, Rome.

Zevi, Bruno

(1964), 'Michelagniolo e Palladio', Bollettino del Centro internazionale di studi di architettura Andrea Palladio, VI, 2, pp. 13-28.

INDEX

Numbers in square brackets refer to illustration numbers

Agostino da Valdegno, 326 Alberti, L. B., 35, 36, 54, 63, 136, 155, 195, 218-19 Alfarani, T., 322 Ammanati, B., 113, 196, 281, 305, 316, [104] Ancona, 124 Andrea del Sarto, 270 Andrea della Valle, 326 Architecture Ancient and Roman, 26--8, 31, 35, 38, 45, 54, 59, 74, 80, 95, 178-9, 184, 195, 197, 202, 216, 242, 256, 264, 267, 274, 280 Early Christian, 54, 240, 247, 257, 280, 317 Byzantine, 197, 203 Medieval and Gothic, 28, 35, 54, 99, 110, 174, 193, 196, 203, 210, 212, 216, 240, 242, 256, 272, 280 Quattrocento/fifteenth-century, 28, 29, 36, 38, 40, 43-5, 47, 54, 57, 74-5, 80, 82, 92, 94, 97, 100, 113, 121, 126, 135, 138, 154-5, 171, 192, 195 High Renaissance, 25, 27, 30, 33-5, 94, 195-7 Mannerist, 64, 259 Baroque, 20, 34, 103, 125, 132, 184, 210, 216, 230, 248, 250, 262-3, 277

Baccio d'Agnolo, 61, 292–3, 295 Baccio Bigio, G., 300 Bandinelli, Baccio, 292 Barbo, Cardinal, see Paul II Barozzi, Giacomo, see Vignola Bartoli, Cosimo, 297, 305 Bernini, G. L., 230, 263, 271, 276 Blois, Château, 193 Boccapaduli, P., 309 Borromini, F., 239, 250, 263 Bramante, D., 26-34, 43-5, 48, 122, 140-41, 155, 159, 172, 176, 183, 193, 196-7, 200, 203-4, 209, 211, 216, 220, 240, 270, 281, 296, 317, 319, 325, [88a, 88b, 89, 101] Brunelleschi, 54, 58, 73-5, 89, 154, 195, 236, 280, 291, 295, [18, 19]

Buonarroti, M., see Michelangelo

Buoninsegni, D., 292

Buontalenti, B., 281

Calcagni, T., 227, 229-30, 233, 327-8, 331, [112] Carrara, 65, 293-4, 297, 299 Cartaro, Mario, 330 Carthusian Order, 263-4, 266, 332, 334 Casale, Fra G. V., 328 Castriotto, J., 325 Castro, 124, 137, 171 Catalani, M., 265, 332-3 Cesariano, C., 40, 167, [2] Chambord, Château, 122 Charles V, Emperor, 150, 162, 308 Chartres, Notre Dame, 193, 271 Chenevières, Jean de, 314 Cività Castellana, 123 Civitavecchia Fortress keep, 325 Port, 122-3 Clement VII, Medici, 31, 97-8, 101, 108, 124, 296-301, 305

358

- Clement XI, 326 Colonna, Marcantonio, 165 Colonna, Vittoria, 165 Condivi, A., 41, 292, 318 Constantinople, Hagia Sofia, 197 Cortemaggiore, 137 Cosimo I, *see* Medici family Cronaca, S., 75
- Delphi, Shrine of Apollo, 169 Donatello, 162 Dosio, G.-A., 214, 281, 305, 320-21, 323, 328, [107, 114, 140] Duca, A. del, 261, 263, 265-7, 332 Duca, G. del, 281, 332 Duca, J. del, 329 Dupérac, E., 211, 311, 321, 323-4, 330, [66, 99, 100, 105]
- Dürer, A., 41-2, 121, [3]

Farnese family, 33, 172, 174 Cardinal Alessandro, see Paul III Cardinal Ranuccio, 316 Pier Luigi, 171, 314 Fattucci, G., 300 Federigo da Montefeltre, 123 Ferrara, fortifications, 123 Ferucci, G., 243 Figiovanni, G. B., 296-7, 299, 300 Filarete, 137 Florence, city, 30-31 (see also Florence, San Lorenzo) Altopascio house, 296, [33] Baccio Valori house, 334 Baptistery, 242 Cathedral, 57, 195, 210, 215, 273-4; studies for Ballatoio, 295 Environs, Poggio a Caiano, 113 Fortezza da Basso, 124 Fortifications, 120-35, 305-7, [51]; Michelangelo's drawings, 47, 125-35, 154, 275, 277, 279, 305-7, [52-7] Foundling hospital, 154, 236 Nelli houses, 296-7

- Pal. Medici, 76, 173-4; windows by Michelangelo, 96, 270, 278, 295, [32]
- Pal. Pandolfini, 32, 176, 296-7
- Pal. Pitti, 171
- Pal. Rucellai, 171-2
- Pal. Strozzi, 172-3
- Pal. degli Uffizi, 281; drawings in, 33, 55-6, 123, 294, 314-16, 320-21, 327-31
- Ponte Sta Trinita, 258, 285, 334
- St Apollonia, portal, 305
- San Marco monastery, 96
- Santa Maria Novella, 63
- War of Independence/siege, 135, 305-6
- Florence, San Lorenzo, 31, 54-5, 57, 69-75, 96, 155, 195, [14, 19, 33, 34]
 - Façade, 53-69, 109, 195-6, 269-71, 278, 291-6; contract, 65, 293-4; design, 55-69, 195-6, 293-5, [7-13, 15-16]; models, 61, 64, 65, 67, 292-4, [13]
 - Library, 19, 69, 75, 95-119, 126, 135, 257, 269, 272, 275-9, 298, 300-305, [19, 34-50]; drawings, 301-5; small study, 118-19, 275, 300, 303-4, [50]; readingroom, 99-100, 102, 104, 106, 113, 118, 301-4, [35, 389]; vestibule, 104, 106, 108, 111, 118, 275, 279, 300-301, 303-5, [36, 40-45, 48-9]; vestibule stairway, 113, 114, 126, 275, 300-301, [37, 46-9]
 - Medici Chapel, 65, 69-94, 126, 154, 195, 199, 269-71, 277, 278-9, 291, 293, 296-300, [17-24, 26-31]; design, 257, 297-8; dome, 75, 298; Ducal tombs, 77-92, 94, 296-8, [22-4, 26, 30]; *Madonna*, 89; Magnifici tombs, 88, 90, 94, 296-8, [28-9]; tabernacles, 90-94, [31]

New Sacristy, *see* Medici chapel Old Sacristy, *72-3*, *74-5*, *296-8*, [18] Reliquary Tribune, *269*, *299*, [14] Fontainebleau, Château, *193* Fontana, D., *248-50* Francesco di Giorgio Martini, *35*, *39*, *123*, *137*, *140*, [1] Francisco d'Ollanda, *150*, *308*

Ghiberti, L., 242 Gianfrancesco de Montemellino, 325 Giocondo, Fra, 317 Giovanni Dalmata, 80, [25] Giovanni Pisano, 57 Giovanni da Udine, 78, 297 Giulio Romano, 30-31, 33, 281 Grifoni, Ugolino, 296 Guidetti, G., 281, 310-11

Innocent VIII, 160 Isidor of Seville, St, 167, [74]

Julius II, 25-7, 30, 32, 57, 150, 172, 247, 317 Julius III, 196, 262, 328, 334

Kepler, J., 167 Kosmokrator symbolism, 170

Laon, Notre Dame, 193 Le Mercier, J., 327, [116] Leo X, Medici, 30-32, 55-7, 59-60, 63, 160, 270, 291, 293, 296, 299 Leonardo da Vinci, 27, 41-3, 120-22, 126, 136, 140, 164-5, 296, 319, 326 Ligorio, P., 163-4, 319, 326 Lodovico il Moro, 26, 120 Lombardy, 26 London, St Paul's, 282 Longhi, Martino, 311 Lorini, B., 134 Luchinus, V., 322, [103] Lyons, 259

Machiavelli, 124, 305

Maderno, C., 202, 320

Manetti, Antonio, 295

Mantua, 30, 219

Ducal palace, Pal del Tè, 33

Sant' Andrea, San Sebastiano, 63

Marius, see Rome, Trophies of Marius

Marmirolo, Gonzaga Villa, 335

Martini, Simone, 162

Matteo da Città di Castello, 317

Medici family, 31, 55, 96, 171, 174, 296, 300, 306

Cosimo I, 96, 301, 327

Giovanni, see Leo X

Giulio, see Clement VII

Lorenzo the Magnificent, 96, 173, 296

Meleghino, J., 325

Michelangelo Buonarroti

Life: start of architectural career, 30; excluded from Roman commissions, 31; claims he is not an architect, 37; claims to have surpassed the Greeks and Romans, 45; correspondence with Clement VII, 97-101; inspects Ferrara defences, 123; awarded Roman citizenship, 142; contrasted to Sangallo, 175-89, 199-202, 221, 317-19, 326; consultant for construction of Villa Giulia, 196; his influence in architecture, 281-2; correspondence with Domenico Buoninsegni, 292; Carrara contract ended, 293; flight to Venice, 306; letters on St Peter's, 323

Catalogue of works, 291-335

Works, architecture, theory-drawings-practice, *passim*; recorded commissions for which no project survives, 334; rejected attributions, 335; *see* Florence, city, Fortifications, Pal. Medici, Ponte Sta Trinita; Florence, Michelangelo Buonarroti-cont.

Works-cont.

San Lorenzo, Façade, Library, Medici chapel; Rome, city, Capitoline Hill, Castel Sant'Angelo, Pal. Farnese, Porta Pia, San Giovanni de' Fiorentini, Santa Maria degli Angeli, Santa Maria Maggiore, Sforza Chapel; Rome, Vatican palace, Cortile del Belvedere, Rome, Vatican, St Peter's

Works, sculpture and painting, 29-31, 47-8, 50, 55-6, 68, 92-4, 117, 231-2, 269, 272-4, 277; Cappella Paolina frescoes, 213; David, 69; Julius II tomb, 31, 150, 278-9, 292; Moses, 117-18; Passion drawings, 213, 234; Pietas, 234, 269

Michele da Leone, 124 Michelozzo, 96 Mino da Fiesole, 80 *Mirabilia Urbis Romae*, 160 Mochi, Prospero, 314 Montelupo, 297

Naples, 124 Nardo de'Rossi, 314, 329 Nepi, 124, 171 Nettuno, 123

Orlandi, C., 334 Ostia, fortress, 122

Padua, Cathedral Choir, 326 Palladio, Andrea, 35, 49, 281–2, 296 Paris Louvre, 193 Notre Dame, 193 Parma, 171 Passignani, D., 318, [102] Paul II, 80, 172, [25] Paul III, Farnese, 31, 137, 142, 161–2, 164, 171, 261, 308, 313, 318, 324 Pavia, Certosa, 57, 195 Perugino, Pietro, 218 Peruzzi, Baldassare, 30–33, 124, 150, 153, 196, 266, 281, 317, 332, [51, 88] Piccolomini family, 96, 138 Pienza, 137, 172 Pal. Piccolomino, 172 Pinardo, Ugo, 326

n mardo, Ogo, 520

Perugia, 124

Pius II, 96, 137, 172

Pius IV, 247, 249-50, 260, 262, 264, 267-8, 328-9, 332-3

Plato, 40

Pontelli, B., 123

Pontormo, Jacopo Carrucci da, 270

Porta, Giacomo della, 77, 156, 183, 209, 215-16, 281-2, 310-11, 317, 319, 323-4, [96] Pythagoras, 40

Raphael Sanzio, 26, 30-32, 34, 45, 55, 176, 196, 270, 281, 292, 317 Ravenna, San Vitale, 242 Régnard, V., 229, 232, 327, [117] Riario, R., Cardinal, 172 Rimini, San Francesco, 63 Rocchetto, J., 332 Rodolfo Pio, Cardinal, 37 Rome, city (see also Rome, Vatican Palace; Rome, Vatican, St Peter's), 25, 136 Alta semita, 243 Aqua Felice, 250 Arch of Constantine, 59 Banco di Santo Spirito, 34 Baths, 242; of Diocletian, 260-61, 264, 266-7, 274, 332-3, [137] Campidoglio, see Capitoline Hill Campo di Fiori, 188, 192, 313 Capitoline Hill, 69, 126, 136-70, 192, 201, 203, 213, 215, 248, 257, 275-6, 278-9, 281, 307-13,

[60-73]; Antiquities, 35, 54, 160-67; Arx, 136; Conservators' palace, 136-170, 272-3, 278-281, 308, 310-13, [70-72]; Cordonata, 153, 310-11; Marcus Aurelius monument, 136, 141-4, 150-53, 161-3, 166, 170, 308, 310, 313, [68-9]; Pal. Nuovo, 146-7, 312; Senator's palace, 136, 140-41, 144, 153-4, 159, 162, 166, 251, 276, 279, 307, 309-13, 325

- Castel Sant'Angelo, 50-51, 122, 269, 291, [56]
- 'Cavalli di Tiridate' (Quirinal Dioscures), 243
- Domus Aurea, 242
- Forum, 136, 166, 169
- House of Antonio da Brescia, 270
- House of Raphael, 159
- Il Gesù, 69, 334
- Pal. Branconio d'Aquila, 32
- Pal. Cancelleria, 172, 175
- Pal. of Cardinal Santiquattro, 334
- Pal. dei Conservatori, *see* Capitoline Hill
- Pal. Farnese, 34, 49, 69, 154, 171-92, 258, 277-8; 280, 291, 313-17, [76-87]; cornice, 49, 178-9, 184, 314-15, [76, 82]; court, 182-6, 315, 317, [77-82]; engravings, 188-90, 276, 316, [79, 84]; façade, 171-92, 276, 314-15, [75, 84-5]; Farnese Bull, 316; Michelangelo's unexecuted scheme, 188-9, 316; Sangallo's projects, 175-80, 183-7, 186-7, 314-15
- Pal. Julius III, 334
- Pal. Laterano, 160-61, 240
- Pal. Massimi, 155
- Pal. de' Senatori, see Capitoline Hill
- Pal. Spinelli, 325
- Pal. dei Tribunali (or della Giustizia), 27, 172, 183
- Pal. Venezia (or San Marco), 172, 243
- Palatine, Flavian Palaces, 242

- Pantheon, 59, 75, 202, 260, 274
- Pincio, 250
- Ponte Sta Maria, 334
- Porta Maggiore, 256-8
- Porta Nomentana, 245, 329
- Porta and Via Pia, 155, 192, 243-60, 262, 269, 274, 277-8, 329-32, [123-34]; drawings, 250-57, 269, 330-31, [130-33]; engravings, 250, 330, [124]; Medal, 330, [134]
- Porta del Popolo, 335
- Porta Salaria, 329
- Porta San Giovanni, 335
- Quirinal, 243, 329; Dioscures, 161, 164, 243; triple stairway, 334
- Sack of Rome (1527), 123
- San Carlo alle Quattro Fontane, 239, 250
- S Giacomo degli Incurabili, 33
- S Giovanni de' Fiorentini, 33, 45, 69, 135, 210, 214–15, 221–34, 236, 258, 266–7, 274, 277, 279, 326–9, [108–17]; dome, 210, 233–4, 273; drawings, 135, 213, 221–9, 266, 320, 327–8, [108– 11]; engravings, 327, [116–17]; models, 213, 229–33, 327–8, [114, 116–17]
- S Giovanni in Laterano, 308
- S Luigi dei Francesi, 329
- S Pietro in Montorio, Tempietto, 27, 140, 159, 240
- S Stefano Rotondo, 240
- Sant'Agnese in Piazza Navona, 239, 243, 263, 329
- Sant'Andrea al Quirinale, 230, 263
- Sant'Andrea della Valle, Strozzi Chapel, 335

Santa Costanza, 242, 260

- Santa Maria in Aracoeli, 144, 308-9, 311
- Santa Maria degli Angeli, 69, 260-68, 274, 277-8, 329, 332-4, [129, 135-40]

Rome - cont. Santa Maria Maggiore, 250, 328-9; Sforza chapel, 234-42, 258, 277, 279-80, 327-9, [119-23] Santa Maria della Pace, 27, 155 Santa Maria Rotonda (Pantheon), 260 Santo Spirito in Sassia, 34, 195 SS Cosma e Damiano, 260 Sapienza, 335 Tabularium, 136, 308 Tarpeian rock, 144 Tempietto, see S Pietro in Montorio Theatre of Marcellus, 183 Tiber river, 136, 163, 171, 188-9, 192, 276, 326, 335 Trajan's column, 334 Trastevere, 188 Trophies of Marius, 165, 169 Via Giulia, 188, 246, 326 Via Nomentana, 243, 245, 329 Via Sistina, 250 Villa Farnesina, 30, 188-9 Villa Giulia, 196, 326, 334 Villa Madama, 32, 196 Rome, Vatican Palace, 27, 29, 30, 34, 101, 196, 216, 276, 321 Borgo, 325 Cortile del Belvedere, 27, 32, 34, 126, 140-41, 159-60, 279, 313, 325-6, [106-7] Cortile di San Damaso, 32, 155 Fortifications, 125, 135, 324-5 Library of Sixtus IV, 96 Library of Sixtus V, 216 Torre Borgia cupola 211, [101] Rome, Vatican, St Peter's, 27-31, 33-4, 44, 49, 55, 69, 77, 135, 156, 159, 175, 184, 193-220, 234, 240, 242, 267, 273-4, 276, 278-9, 281, 296, 312-13, 317-25, [88-105] Apse, [95] Attic, 214-15, 322-3 Bramante's project, 28-9, 44, 159,

193, 196-7, 200, 203-4, 209-11,

216, 220, 270, 317-19, 325, [88a, 88b, 89, 101] Dome, 44, 49, 202, 204, 208-16, 234, 273-4, 279, 318-22, 324, 331, [96-8] Drawings, 197, 208-9, 211, 214-15, 317-18, 320-24, [97-8]; Engravings, 214-15, 322-4, 326, [99-100, 103, 105] Fabbrica, 31, 196 Façade, 49, 155, 198, 202-3, 208, 219, 321-3, [99-100] Models, 204, 208, 210-11, 317-24, [96, 101-2]Della Porta's changes, 77, 199, 209, 215-16, 281-2, 319, 323-4, [96] Sangallo's project, 34, 198-202, 317-20, [88c] Tomb of Paul II, 80, [25] Rossellino, B., 137-8, 317, 319 Ruskin, J., 94 Salviati, J., 298 Sangallo family, 123, 125 Antonio the Elder, 55, 122 Antonio the Younger, 30-31, 33-5, 48, 123, 134, 140, 155, 175-87, 189, 196, 198-202, 221, 281, 286, 291, 294, 304-6, 313-20, 324-6, 328, [88c, 109] Aristotile, 110, 291, 293 Bastiano, 306 Giovanni Batista, 291, [6] Giuliano, 27, 55-8, 63, 113, 122-3, 125, 137, 266, 270, 292, 317, 332, [6, 7]San Michele fortress, 335 Sanmicheli, Michele, 123-5, 259, 281 Sansovino, A., 55, 82 Sansovino, Jacopo, 30, 55, 281, 292, 326 Sarzanello, 122 Serlio, Sebastiano, 26, 216, 240, 246, 258, 281, [125, 128] Sforza, Lodovo, see Lodovico il Moro

Sforza, Ascanio, Cardinal di Sta Fiore, 328 Siena, 30, 32-3, 57 Cathedral, 54, 96, 171 Fortifications, 124 Town planning, 171 Sixtus IV, 96, 160 Sixtus V, 248-50, 267 Strozzi, F., 172-3

Titian, 251 Tivoli, Hadrian's Villa, 242 Tribolo, 297 Turin, 124

Uccello, Paolo, 162 Umbilicus symbolism, 166-7, 169-70 Urbano, 294 Urbino Ducal palace, 174, 195 Duchy, 123

Vannocci-Biringucci, O., 226, 328 Vannucci, P., *see* Perugino Vanvitelli, L., 334 Varchi, Benedetto, 306-7 Vasari, Giorgio, 45, 55, 73, 78, 82, 90, 124, 171, 175, 186-8, 192, 196,

211, 242, 263, 281, 291-2, 297, 304, 312-13, 315-20, 323, 325-6, 328, 330, [90] Vatican, see Rome, Vatican Vauban, 132-4, 135, [58] Venice, 30 Doge's Palace, 195 Procuratie, 154 Rialto bridge, 69, 334 Verona Fortifications, 124, 259 Gates, 259 Verrocchio, Antonio del, 162 Vespignani, V., 330 Vicenza, Pal. Chiericati, 281 Vigevano, 137 Vignola, Giacomo Barozzi da, 167, 183-4, 196, 216, 316-17, 319, 323-4, 328 Violet-le-Duc, E., 94 Vitruvius, 31, 34-5, 38, 74, 90, 167, 179, 246, 259, 273

Washington, D.C., Capitol, 282 Wölfflin, Heinrich, 25, 210

Zodiac Symbolism, 167-9